W9-BFH-806

Perfect Digital Photography

Second Edition

About the Authors

Photo by Lauren DeBell

Jay Dickman is a Pulitzer Prize–winning photographer who has worked on more than 25 assignments for the National Geographic Society. A partial client list also includes *TIME* magazine, *Men's Journal*, *Condé Nast Traveler*, *BusinessWeek*, *Forbes* magazine, *Fortune* magazine, *Sports Illustrated*, *American Way*, and nearly all the *"A Day in the Life of…"* projects, including *America, Soviet Union, China, Italy, Ireland,* and *Spain.*

A member of the Olympus Visionary Educator Program, a Lexar Elite Photographer, and an HP Pro Photographer, Jay has been shooting professionally for more than 35 years. He is the recipient of the Goldeneye Award from the World Press Competition, the Sigma Delta Chi Journalist of the Year award, and many other national and international awards.

Jay Dickman operates his own FirstLight Workshops. He has hosted workshops in France, Scotland, Spain, the Eastern Shore of Maryland, and Dubois, Wyoming, with future workshops scheduled for Italy and Colorado.

Jay Kinghorn is an Adobe Certified Expert, an Olympus Visionary photographer, and a full-time digital workflow consultant and trainer. He specializes in helping corporations use their photos efficiently and effectively by streamlining workflow processes and improving employee skills using Adobe Photoshop, Adobe Lightroom and color management. Jay lectures and presents to businesses and universities internationally. His presentations focus on digital photography workflows, color management, image optimization, and the future of photography. His clients include Olympus, Sony, Adobe, Cabela's, Vail Resorts, and Pearl Izumi.

Jay is often found climbing the rock walls, biking the trails, or scaling the mountains near his home in Salt Lake City, Utah.

About the Technical Editor

Frank Varney is the photography chair for The Art Institute of Colorado. He holds an MFA in photography from the Maine Media College. An active editorial photographer for 30 years, Frank's work has appeared in numerous publications, including *AARP The Magazine, ELLE, Glamour, First for Women,* and *Ladies Home Journal,* along with *The Book of Alternative Photographic Processes* (by Christopher James, Delmar Cengage Learning, 2008) and *Photography for the 21st Century* (by Katie Miller, Delmar Cengage Learning, 2006). He is a member of the American Society of Media Photographers and the Society of Photographic Educators.

Perfect Digital Photography
Second Edition

JAY DICKMAN
JAY KINGHORN

New York Chicago San Francisco
Lisbon London Madrid Mexico City
Milan New Delhi San Juan
Seoul Singapore Sydney Toronto

The **McGraw·Hill** Companies

Cataloging-in-Publication Data is on file with the Library of Congress

McGraw-Hill books are available at special quantity discounts to use as premiums and sales promotions, or for use in corporate training programs. To contact a special sales representative, please visit the Contact Us page at www.mhprofessional.com.

Perfect Digital Photography, Second Edition

Copyright © 2009 by The McGraw-Hill Companies. All rights reserved. Printed in the United States of America. Except as permitted under the Copyright Act of 1976, no part of this publication may be reproduced or distributed in any form or by any means, or stored in a database or retrieval system, without the prior written permission of publisher, with the exception that the program listings may be entered, stored, and executed in a computer system, but they may not be reproduced for publication.

1234567890 QPD QPD 019

ISBN 978-0-07-160166-5
MHID 0-07-160166-X

Sponsoring Editor	Megg Morin
Project Editor	Patty Mon
Acquisitions Coordinator	Meghan Riley
Technical Editor	Frank Varney
Copy Editor	Lisa Theobald
Proofreader	Paul Tyler
Indexer	Karin Arrigoni
Production Supervisor	Jim Kussow
Composition	Jimmie Young / Tolman Creek Media
Art Director, Cover	Jeff Weeks
Cover Designer	Jeff Weeks

Information has been obtained by McGraw-Hill from sources believed to be reliable. However, because of the possibility of human or mechanical error by our sources, McGraw-Hill, or others, McGraw-Hill does not guarantee the accuracy, adequacy, or completeness of any information and is not responsible for any errors or omissions or the results obtained from the use of such information.

*I'm dedicating this book to my wife, Becky, who also happens to be my best friend and editor;
she's been my main supporter-in-chief all these many years. To my kids, Kristi, Gavin, Matt, and
Maggie, who have to put up with my travels and the stories that come from those trips.
To my sister, Susan, who lives vicariously through my travels. And, finally, to Beverly Skelton,
for your support and for creating the person I married.*

—Jay Dickman

*This book is dedicated to the two most important women in my life:
To my mother, who instilled in me a sense of curiosity about life and a thirst for knowledge.
Her untimely passing meant she never had a chance to see her own dreams through to fruition.
I hope to carry on the work she started. This book is also dedicated to my wife,
Jessica, who picked up the pieces when my world fell apart, listened patiently,
and helped me get back on my feet. She is a patient editor, listens to my wild ideas,
and helps me apply them to the real world. I owe both of you a tremendous debt of gratitude.*

—Jay Kinghorn

Contents at a Glance

SECTION II | The Digital Darkroom

Contents

SECTION I | Creating the Image

SECTION II | The Digital Darkroom

Acknowledgments

Without these folks, this book would have been impossible: John Knaur of Olympus; Jeff Cable and Michele Pitts with Lexar; Addy Roff at Adobe; Heather Tomlinson at HP and Frank Varney of Colorado Institute of Art; Joe McNally, of whom I am fortunate to count as a friend and photographer nonpareil; Hákon Ágústsson, who hosts the incredible site PhotoQuotes .com, where I found the great words of other photographers; Bert Fox of National Geographic and longtime friend; Skeeter Hagler, my Pulitzer Prize–winning best friend; Dennis Walker of "Camera Bits" and Michael Gaskins of WiebeTech. And, to those who have been instrumental in my career: John Mazziotta of the *Dallas Times Herald*, who saw enough raw potential in a 21-year-old kid to hire me; Ray Adler, who became director of photography at the *Times Herald*, and today, Jim Bullard at *National Geographic Expeditions*, who makes it possible to blend my two passions: teaching and photography. Can't forget Bobby Brent; we go back a long way. And finally, Megg Morin and Patty Mon for supporting this second project when I didn't think I could do it.

—Jay Dickman

Writing a book is a collective effort. Lot of players worked behind the scenes to make this book a reality. I thank my editors Megg Morin, Patty Mon, and Lisa Theobald for keeping the project moving forward and ensuring consistency and accuracy in the finished book you now hold in your hands. To Frank Varney for his technical expertise and invaluable skills as a sounding board. To James Dimagiba for testing and evaluating software programs and imaging techniques.

Finally, I owe thanks to George Jardine, Michael Gaskins of WiebeTech, Jennifer Dreyer and Eric Ullman of EMC Retrospect, Joe Weiss of Soundslides, Bo at Imaging Luminary, Andreas Schomann of FDRTools, Geraldine Joffre of HDRsoft, Patricia Monteson at Apple, Gene Mopsik of American Society of Media Photographers, Bert Fox of the *Charlotte Observer*, Liz Quinlisk at X-Rite, C. David Tobie at Datacolor, Eddie Murphy and Rick Day at Epson, Tom Gadbois of EIZO, and the Adobe Lightroom and Photoshop teams who patiently answered questions and provided information on the technical workings of both applications.

—Jay Kinghorn

Introduction

There has never been a more exciting time to be a photographer. With rapid advances in camera technologies and a competitive marketplace, you can purchase a superior camera for a fraction of the cost of the previous year's models. This fact, combined with the advancements in Adobe Lightroom and Photoshop, along with the rise of the Internet as a publishing platform for photographers, means that you can unlock the true potential of your digital photos. This book is expressly designed to help you make the most of your digital photos, whether you are a beginner wanting to progress beyond the Auto mode on your camera or a seasoned shooter looking to make your photos shine in Lightroom. Either way, you will benefit from the sage advice, step-by-step tutorials, and philosophical guidance harvested from our years as professionals.

The first part of this book, "Creating the Image," written by Jay Dickman, helps you become familiar with your camera's settings so you can use them comfortably in any situation, like a craftsman using a favorite tool to ply his or her trade. By drawing from Jay's 30-plus years of experience as a professional photojournalist, you can heed his advice for photographing travel, action, and landscapes to ensure that your portfolio will look better than ever before.

Once you've photographed your masterpiece, Jay Kinghorn walks you through the steps required to build an efficient workflow in Lightroom—from editing through image correction to printing. His advice comes from years of working as a workflow consultant to professional photographers and larger corporations, and he offers a pragmatic and effective approach to help you take advantage of the latest tools and techniques for digital imaging.

Together, these two professional halves give you a complete road map for improving your digital photographs.

Digital photography is a dynamic, growing field. To keep you up-to-date on the latest equipment, techniques, and software available, we've created the *Perfect Digital Photography* companion website at www.PerfectDigitalPhotography.com. Here, you'll find bonus material; the authors' recommendations on favorite hardware, software, and techniques for creating and managing digital photos; and advice on selecting cameras, inkjet printers, papers, and monitors. To stay abreast of the latest information in the world of digital photography, visit www.PerfectDigitalPhotography.com or join the Perfect Digital Photography group on Facebook.

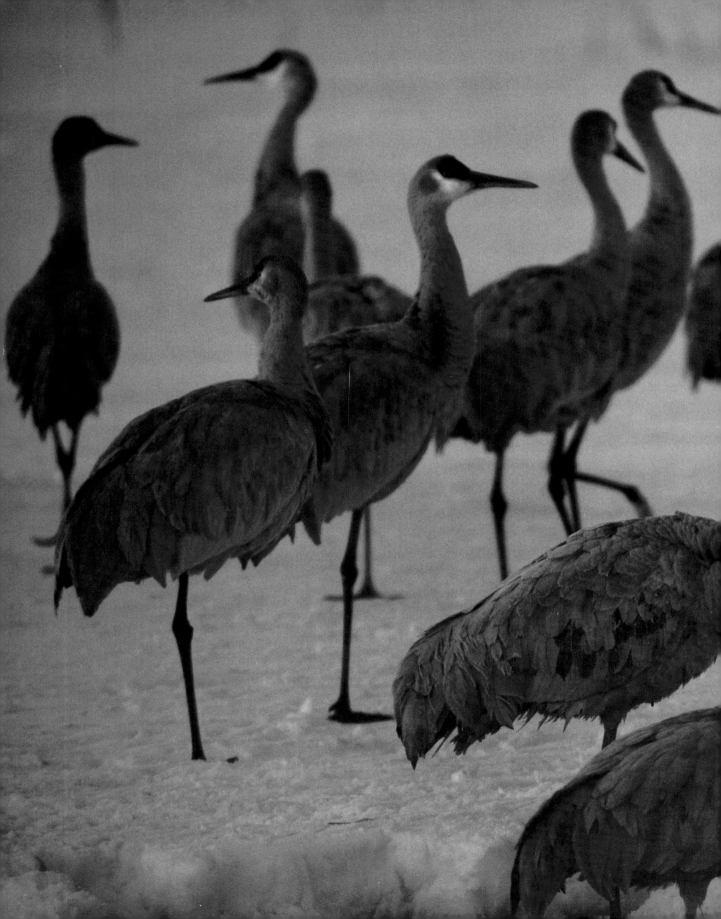

CREATING THE IMAGE

Photographed and written by Jay Dickman

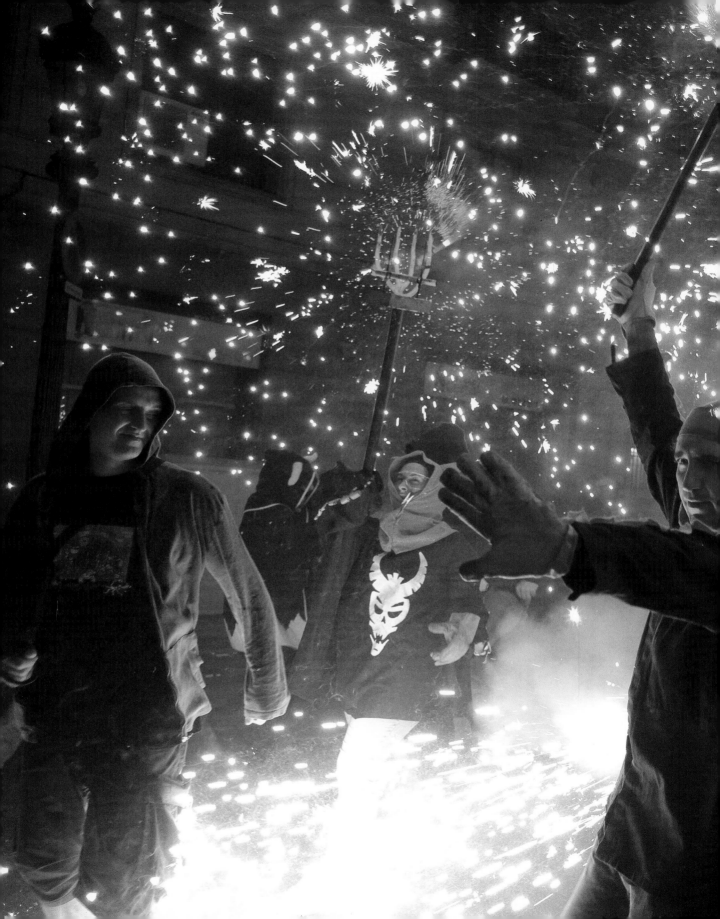

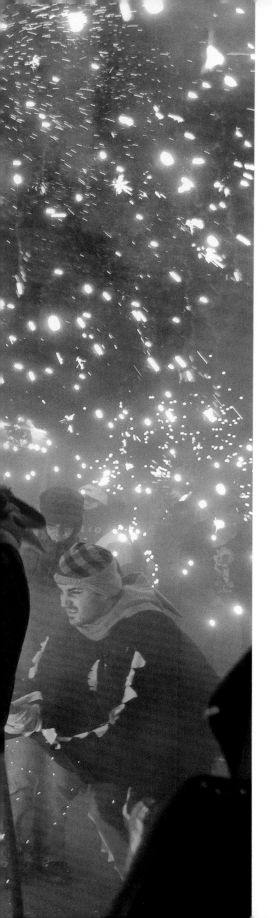

THE POWER OF PHOTOGRAPHY

*Photography records the gamut of feelings written on the human face,
the beauty of the earth and skies that man has inherited, and the
wealth and confusion man has created. It is a major force in explaining
man to man.*

—Edward Steichen

We are a nation of photographers. With millions of film cameras in
homes and a hugely growing market in digital photography, our lives
and times are the most documented events in history. Magazines
and newspapers have the capability of going to press with photos
shot only moments earlier. Television newscasts use viewers' digital
images, sent in via the Internet, with photos ranging from news
events, to weather photos, to beautiful sunsets. We send our relatives
electronic photo albums of our vacation or the baby's first year.
We now have the ability to produce high-quality books containing
photos and text at the click of a mouse and at a next-to-nothing cost.

The *Correfoc* (fire run) is one of the most striking visual events
of the week-long La Mercè festival in Barcelona, Spain. Set
amidst a cacophony of fireworks, the parade travels for several
blocks in the heart of the city. To celebrate the end of summer,
"spirits" are exorcised. Many participants in the Correfoc are
dressed as devils, sprites, or monsters...the event is amazing!
14–35mm lens, 1/60 second at f2, 1250 ISO

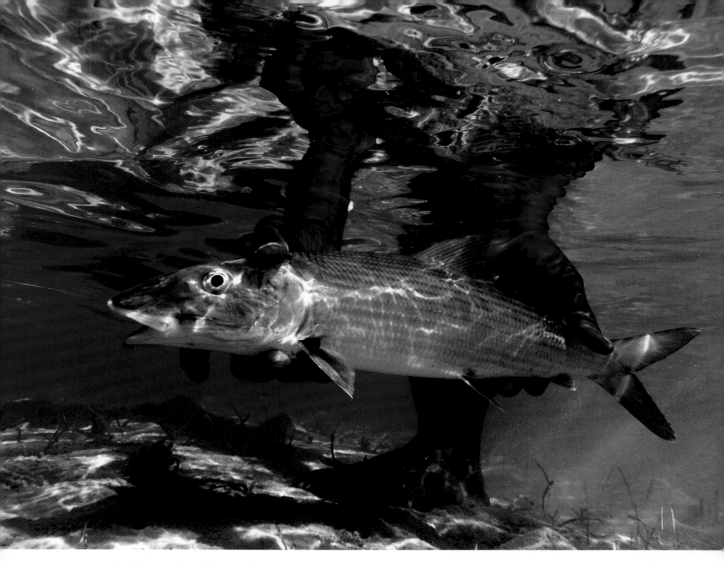

A fish-eye view of a bonefish, moments after it was caught by a fly fisherman in the Bahamas. Bringing a unique perspective, you can make your photos more engaging. Underwater housing with a 8-megapixel camera, 8mm lens, 1/250 second at f4, 100 ISO

Not only are we a nation of photographers, but we're a nation of digital technology. Photography archives our history, linking us to our past by creating a visual diary that defines us for future generations. This simple box ties us to our past and connects us to our future. Point-and-shoot cameras, known affectionately as PHD (push here, dummy) cameras, are mastering the once arcane task of exposure, producing consistent results.

Today's generation is visually sophisticated; young people are bombarded with intelligent, well-composed, and compelling images hundreds of times a day. To put a weak image in

front of this audience is almost unforgivable. So why is it that most people's photos lack the "oomph" that makes an image stick in your mind, if not become an icon?

In this chapter, I'll talk about the power of photography and how it impacts our lives, as well as how to become comfortable with the equipment and working with people, one of the most difficult areas for aspiring photographers. It's like exercise; as a famous ad slogan says, *Just do it*. The first few times will be challenging, but soon it will become second nature.

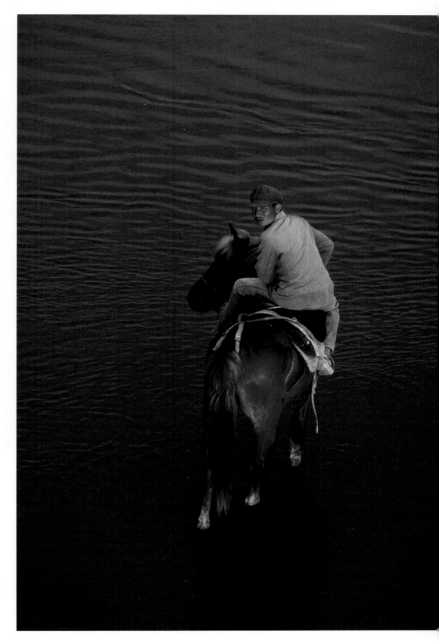

One of those moments that lasts for two frames. I was photographing the Kazakh peoples of far western China for *A Day in the Life of China*. Wandering around a collective horse farm near the village of Yining, I walked to a bridge crossing a small river, saw this fellow watering his horse, shot two frames, and the moment was gone as he looked away and the light fell off. 300mm lens, 1/125 second at f4.5

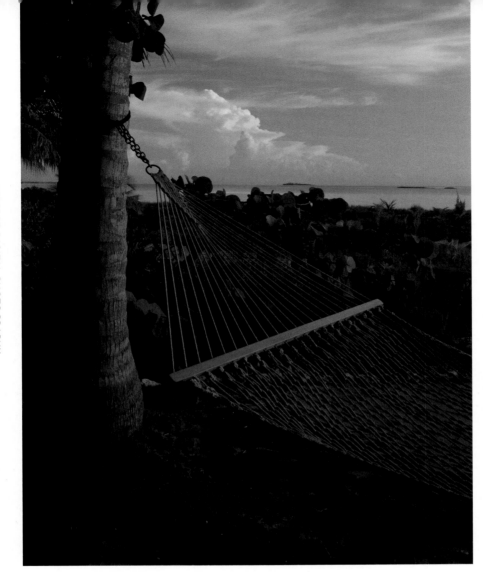

Part of the job of the photographer is to create an image that makes the viewer want to be in that photo, in that place. On assignment at Kamalame Cay resort in the Bahamas, I spotted this hammock in the late afternoon sunlight. When I look at this, I just want to be in that hammock. 12–60mm lens, 1/60 second at f6.3, 100 ISO

EVERYONE IS A PHOTOGRAPHER NOW

Part of the problem is that today, everyone *is* a photographer, with the ready availability of sophisticated photo equipment, the attendant technology, and falling prices of top-quality equipment. But few people desire to put the time and effort into producing good photography. Few understand the idea that the camera is very objective. It records everything—*everything*—it sees. The aspiring photographer puts the camera to his eye, and then lets the eye become the zoom lens, mentally moving in and out until the photo is perfect in his mind's eye. The simple trick of physically moving in closer is not actually done, just the zooming of the eyeball. And

the response once the photos are viewed is almost always the same: "It doesn't look like I remember it looking."

A mantra to repeat as you're composing your award winner: "If your pictures aren't good enough, you aren't close enough." This maxim by the great photojournalist Robert Capa will hold true for many situations. Move around. Get closer. Fill the frame. Think close, think low, look around, up and down. Don't be so zoned into one view that you miss other elements that may make your photo better.

Do you remember going to your Uncle George's house for a slideshow of his latest trek to Africa, Asia, or other exciting destination, and being near tears with boredom by the fifth slide (of a stack of hundreds)? The images had nothing going for them, nothing to grab you, to transport you to the location, to make you feel what that place felt like. In other words, no magic.

As a kid, I used to race home to check out the latest *LIFE* magazine, to see what was going on in space, or Vietnam, or whatever "hot moment" had occurred somewhere in the world. And the rush when I saw the latest *National Geographic* arriving—TV could not hold a candle to these publications. And what made them great was the power of their photography.

The mind thinks in terms of images. If I mention 9/11, your wedding day, your first day of school, your first family pet, the Vietnam War—as your eye scans these words a still image comes to mind. Our mind grabs

Family heirloom photographs are not only touchstones to the past, but they define who we are by freezing the subject at that moment in time. Many old photographs contain visual keys to an era by clothing or signage, as seen here in an old photo of my wife's family.

the first image stored in that data bank of our memory—it doesn't start the projector rolling with a 10-second clip of a film. Think of the Vietnam War, and more often than not, Eddie Adams's photograph of the Viet Cong suspect being executed by a gunshot to the head comes to mind. The *Hindenburg* is a

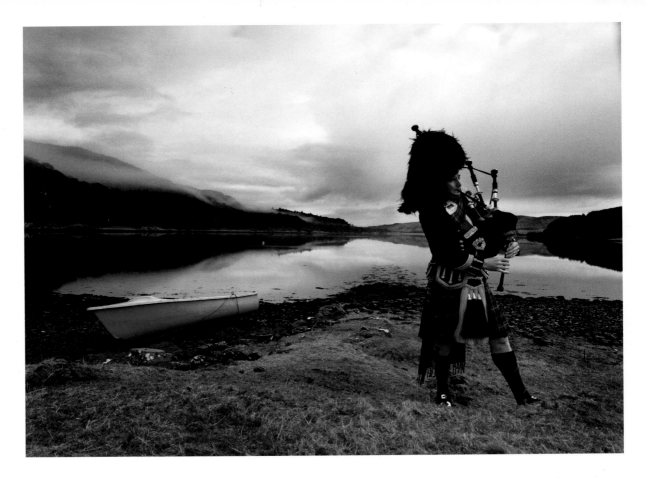

Oban, Scotland, was the site for our FirstLight Western Highlands photography workshop. I photographed piper Ian MacDonald on the banks of Loch Feochan (Lake of the Winds) as he played the bagpipe. The clouds and overcast sky provided a dramatic background as well as "soft light" under which this photo was made. 11–22mm lens, 1/60 second at f6.3, 100 ISO

name that instantly brings up the image of the airship coming down in flames. The tragedy of 9/11 will be remembered with mental images. Photographs remind us of so many historical moments. The history of our own lives are also archived in photos. In the brief time it took to gather everyone together at a family picnic in the 1920s for a photo, little did they realize how we would study those images today, defining who we are by examining our visual history.

Some Key Elements to Great Photography

When you employ the understated power of KISS (keep it simple, shutterbug), many great photographs have a commonality in their simplicity and directness. But this simplicity is part of the photo's elegance; the photographer has used the viewfinder like a canvas. Everything in the photo is relevant to the message of the image. You pick up the image, study it, move it closer or farther away,

and absorb the moment. The beauty of still photography is in how personal and powerful it can be, when it is at its peak.

Great photography consists of a few key elements: composition, lighting, and a great moment. Sounds easy, but these three components, in various forms, are missing in most photographs you see. To combine the three is the aim of all good photographers, and a time-consuming, laborious, frustrating effort it can be. But when it does come together, when that magic image appears on your screen, not much can touch that feeling.

This is one of the major differences between still photography and video images—the personal aspect of the still image. Television or video requires a person to watch from start to finish, in a continuum, the story contained in the clip. The still image, at its peak, is that perfect moment that speaks volumes in 1/125 second. "A picture is worth a thousand words" may fall short—think of how many words are required to describe certain photos. The mind absorbs, describes, and defines the photo rapidly, leaving the viewer, at the least, with a sense of place and event.

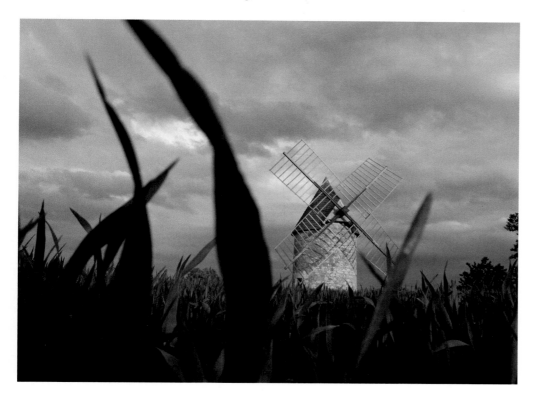

By sitting in the field of grass, I caught a slightly different look of this old windmill near the Midi-Pyrenees village of Auvillar in France. Using the grass in the foreground to frame the image also provided a foreground "layer" of interest. This was shot with a point-and-shoot 5-megapixel Olympus 5050 camera. 14mm lens, 1/60 second at f3.2, 64 ISO

Improvisation is a powerful modality to the emotional things we love—music and cooking come to mind as examples. When we have instinctual control of our craft, we can stir up images that have more feeling than imagery that follows a recipe, typical of the unstudied, uninvolved, and emotionally unattached photographer. At no time in the history of photography have we had more control of the image-making process, and now is the perfect time to get really good at making images.

Still photography archives our personal lives, just as it archives our history as a people. With a few basic principles of composition, along with an understanding of what different lenses and other tools can do for you, you can improve the power of photography in your own work.

Digital Photography: The Future Is Here

Digital technology is one of the greatest tools ever to impact photography. No longer do we have to wait hours, if not days, to see the results of our photographic endeavors. The image appears instantly in the monitor, allowing us to check exposure, composition, and content. The power of this availability cannot be overemphasized. As photographers, we all try to work a situation to capture the decisive moment. To be able to check out images while you are still in the moment, not two days later when that moment is just a memory, facilitates better photography.

Another obvious advantage: no film costs! A great photojournalist and friend, Joe McNally, shot *National Geographic*'s first assigned digital story, "Aviation," which ran in early 2004. I talked to Joe and he made the surprising comment that he actually shot *less* on this story than he would have on a film-based shoot. Normally, Joe would have shot about 500 to 700 rolls of film on an assignment like this; digitally, he shot about 7500 images (the equivalent of about 200 rolls of film). Shooting a lot of "static" scenes, such as portraits and photos of stationary planes, Joe was linked by a cable to the computer, so the images showed up on the computer screen as he shot. Thus, the tendency to bracket and overshoot was not necessary. While on assignment for a publication such as *National Geographic*, photographers tend to overshoot, sometimes using two or three rolls on the same image to make sure they've got it, and sending the film in a couple of different mailings to ensure against loss. Digital photography, by nature, creates a "reduction in paranoia," as Joe eloquently puts it.

We now have the ability to use a *closed system*—that is, from shooting the photo, to editing and correcting on our computer, to outputting or printing on our own printers—that has given the photographer even more control over his or her images. The closed system means the photographer, with camera, computer, and printer, never has to go outside his or her own work area. Computer-produced prints, with an expected lifetime that rivals or exceeds a commercially created print, are available to anyone who wants to invest the time and effort. We can share our images from web-based services that store images, allowing virtual photo albums to be constructed at the

click of a mouse and shared instantly with friends and relatives.

Apple's iPhoto (for Macintosh) and Adobe's Photoshop Album (for PC) are two simple yet powerful software programs that facilitate your closed system. These programs give the photographer the power to download, edit, and catalog photos along with a powerful search capability. You can print images within a very intuitive framework. We'll discuss these applications in depth in later chapters. We'll also discuss Adobe Photoshop Lightroom, an all-in-one application that allows you to ingest, rename, catalog, print, build web pages, and do your laundry—well, maybe not the last, but it is a huge and all-encompassing piece of software that can simplify your photographic life. Jay Kinghorn will discuss this software in depth later in the book.

Photography is a powerful form of communication; it's how I connect with my world. I've had the good fortune to travel throughout the world with my cameras, and I've found that the camera has opened worlds to me. From covering the war in El Salvador, to hanging from a helicopter photographing Venezuela's Angel Falls, to hunting with Yupik Eskimos on the Yukon, the camera has taken me to places beyond my imagination.

While traveling on assignment, I used to carry a Polaroid camera so I could hand over an image immediately to a prospective subject. I was on a shoot for *National Geographic* in Papua New Guinea, living in a stone-age village for almost three months. Being able to hand someone a Polaroid I'd shot of him helped

him understand what I was doing there, and it was a great door opener. Almost everyone was pleased to see his or her likeness on the spot. More common today is a photographer on location, with the subject of the photograph and others huddled around the digital camera, looking, commenting, and enjoying the photograph displayed on the monitor. That's the power of digital photography.

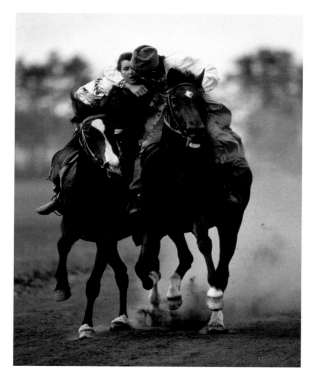

In the Ukraine, two expert equestrians perform a traditional horse-riding drill, Kiss a Maiden, as part of a demonstration of their horsemanship. Shot for *A Day in the Life of the Soviet Union*, this photo illustrates the power of still photography to freeze an otherwise fleeting moment, allowing the viewer to study the many aspects of the photo. 600mm lens, 1/250 second at f4

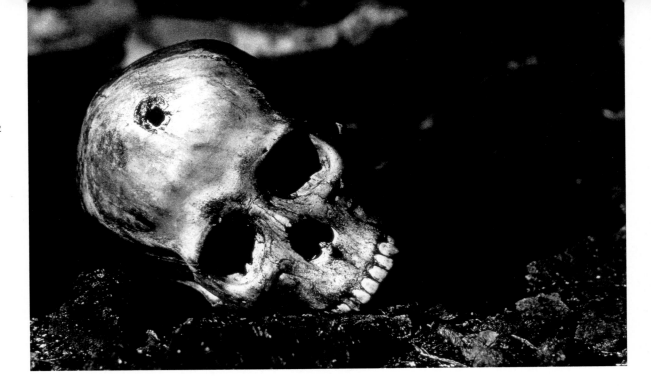

The power of the camera to affect change in the world is huge. We document events, and those images can impact the thinking and opinions of the viewer. Eddie Adams's photo of the Viet Cong suspect being shot in the head has been credited with having great impact on the Vietnam War finally drawing to a close, as Americans were graphically shown the horrors of war. I photographed the war in El Salvador in the early 1980s, and this photo is from the Pulitzer Prize–winning series. This skull belonged to a death squad victim who had been executed in a remote area outside the capital city of San Salvador. 300mm lens, 1/500 second at f8

What Is There to Photograph?

As a working photojournalist, I either propose stories or I am assigned a shoot. Publications have space to fill every month, so stories must be generated by staff or from outside story proposals. Part of the luxury of being assigned a story is that the subject material has been researched and found to be credible and having interest for the readership. Upon accepting the assignment, the photographer goes into research mode, deciding how to visualize the story. Every publication is different in its makeup, in what visual flow the photographer is trying to create. What story are you trying to tell?

I've found one major concern for aspiring photographers is determining what to photograph. I teach my own series of photographic workshops (www .firstlightworkshop.com), and we provide assignments for the participants in the area where we are hosting the workshop. These assignments have been arranged beforehand on a scouting trip. (FirstLight has hosted workshops in France, Scotland, Spain, the Eastern Shore of Maryland, and Dubois, Wyoming, with many other locations slated.) But you don't have to venture too far, because there is a lot to shoot in your

own neighborhood. Check out your local newspaper to see what outdoor events are going on, such as street fairs, community events, or youth soccer games. These can provide an abundance of photographic subjects. If a national or state park is nearby, venture out to check the location, deciding where you want to be at *the Golden Hour*, that time of day in the late afternoon when the sun bathes everything in a golden glow. It takes only a bit of research to come up with many such locations.

The camera is a tremendous passport, not a barrier, as I've heard a lot of aspiring photographers claim. Countless times, I've walked up to people, domestically or internationally, and used words or gestures to ask if I can take their photo. I have made

friends around the world as a result of this simple and direct act of showing interest. Next time out, if you take a deep breath and approach a person you'd like to photograph, you'll probably get the okay, and one of the first steps toward becoming a better photographer will have been accomplished. Everyone has a comfort zone—a distance where coming closer becomes an invasion of space. Time will teach you how closely you can work with a person, so you're not invading his or her zone. And, above all, create a photograph that will do justice to your subject.

We are a nation of photographers, and throughout this book, we will give you hints, show you tools, and—we hope—inspire you to take this marvelous craft to greater heights.

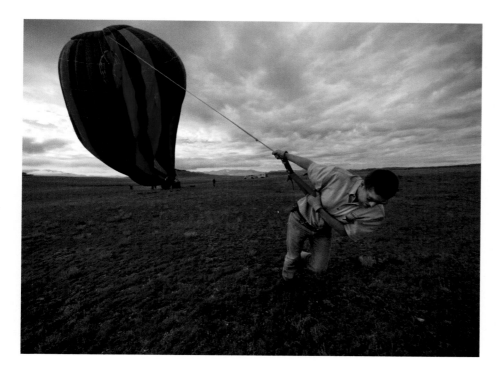

We take our cameras everywhere we go to document our travels and our lives. I was working with Kevin Gilbert and Reed Hoffman of Blue Pixel in Colorado, where they'd created an event using the launch of several balloons. After the flight, I saw one of the ground crew pulling a line attached to the top of the balloon as it collapsed. 7–14mm lens at 7mm, 1/640 second at f4, 100 ISO

How To: Respecting Human Dignity, Promoting Social Change
by John Isaac

I served as a photojournalist for the United Nations and UNICEF for over 20 years. During that time my work focused mostly on international social issues such as wars, refugees, and the plight of humanity in general.

I feel that I am a human being first and a photojournalist second. During my career, I followed one simple guideline: Never take away someone's dignity, just as I would not want someone to take away my dignity. I learned about human dignity from three important people: my own mother, Mother Teresa, and Audrey Hepburn. They all emphasized human dignity in their own way. This guideline has prompted me to put down my camera in several situations where it would not have been appropriate for me to be making pictures. Sure, I may have produced some powerful photographs, but only at the expense of another human being.

Many years ago, I covered the plight of the Vietnamese boat people in Southeast Asia. For over 10 weeks in 1979 I traveled around that region photographing the beleaguered people who had washed ashore after several days adrift in the ocean in small boats. I met a young Vietnamese girl who had been raped by several Thai pirates while she was in a boat with no food, water, or protection. She had lost her father and her mother during the scuffle with the pirates and was very alone. When I heard the story and saw her sitting by the beach staring into the sky, tears rolled down my cheeks. She had not spoken a word to anyone in days. I had no desire to take her photograph. All I wanted was to show her that there was somebody in this world who cared for her. I had taped some Vietnamese music in my tape recorder in another camp a few days before. I played the music while sitting next to her on the beach. I had some chocolates in my hand that I offered her. I was praying that she would just look at me and take the chocolates from my hand. After some time she finally looked at me and took the chocolates. That was all I wanted from her. Several days earlier, I had met a few Catholic nuns who were doing aid missions in that area. I went and got them in the middle of the night and rescued this little girl to a better life. I know she is living somewhere in California today. I did not take a single photo of this girl nor did I take her name and particulars. I have many stories like this from my career, where I did not point my camera at situations where I felt that I would diminish someone's dignity.

There were many people who did not agree with me. Many felt that my job as a photographer was to document a situation and tell the world the story and not to play the role of rescue worker. When I was covering the Ethiopian

famine in 1984, I saw a woman who had fainted on the ground with her newborn child still attached to her umbilical cord. She had traveled several miles to get to a medical tent, but had fallen before she could reach help. She was naked, her clothing having come unwrapped. My first reaction was to put her clothing back in place, since it was taboo for a woman to be naked in front of strangers. After clothing her, I ran to get the doctor. At the same time, a TV crew that witnessed this scene had gone back to their Jeep to get their equipment to film her in her incapacitated state. When the cameraman returned to the scene, he was not happy to see her with her clothes on. He almost punched me for interfering with his subject and the situation.

I have told you of times when I didn't take a picture. Thankfully there are many more times when taking pictures can make a positive difference, and not only in the midst of famines, war zones, or social emergencies. Start with community issues where you live. *Think globally and act locally.* The first step in addressing a community issue is to bring attention to it. Words alone often are insufficient to arouse the public's interest, but one photograph can speak a thousand words. The best way to let large numbers of people know about your cause is through the news media. You'll be surprised how easily you can get local newspapers, or even national magazines, to run your story if it is compelling and well illustrated. A poster that I donated to UNICEF showing a collage of children's faces from around the world sold more than 100,000 copies (in several languages)—and raised more than a quarter-million dollars to benefit children in need.

Perhaps you could arrange a personal or group exhibit, with proceeds from photo sales benefiting a charity. How about taking pictures of the animals at a pound or pet adoption agency? Ask the manager of your local mall or shopping center to let you hold an exhibit to attract people to adopt them. I have been photographing tigers and donating my images to make posters to benefit the Save the Tiger organization, and I show the images in my presentations at schools and colleges. I want people to be aware of the delicate position of tigers in today's rapacious world.

How about sharing some of your photographic enjoyment with others? Residents of retirement communities, shut-ins, and hospital patients, for example, always can benefit from additional attention and a change in routine. Showing pictures from your travels can bring pleasure to those whose travel opportunities are unavoidably more limited. Or consider giving a talk on photographic tips and techniques liberally illustrated with examples of your own pictures. A little of your time can go a long way. We are all busy with tight schedules. But no matter how busy you are, you can always swing a little time to share your photos in a retirement home. You will surely cheer those people on a lonely cold night with your images. The smiles you will receive in return for sharing the joys of your photography will be such a huge reward for you. Probably more than winning first place in a photo contest.

There is another simple guideline I try to follow. As Antoine de Saint Exupéry writes in *The Little Prince*: "It is only with a heart that one can see rightly; what is essential is invisible to the eye." I try my best to capture images with my heart and not just with my eye alone.

EQUIPMENT

There is only you and your camera. The limitations in your

photograhy are in yourself, for what we see is what we are.

—Ernst Haas

Photography is a technical art. As a consequence of this, many
photographers become equipment junkies, and the many
options available to the digital photographer certainly can satisfy
the equipment junkie's cravings. But all these options make
choosing a camera more difficult for someone new to the world
of digital photography. Ultimately, when it comes time to head
out on the shoot, every photographer should be looking at ways
to minimize the amount of equipment and weight needed for
the type of photography he or she likes to shoot. None of us
wants a camera bag to get in the way of what we love to do:
shoot photos.

Choosing the correct camera does not have to be a daunting
task if you buy according to your needs. Cameras courtesy of
Englewood Camera, Englewood, Colorado

This chapter is dedicated to helping you choose a digital camera that fits your needs, your budget, and, ultimately, your photography. Don't lose sight of the fact that the camera is a tool, and the primary function of that tool is to make photographs. The best camera on the planet won't turn you into a great photographer, but an inadequate camera can interfere with your ability to get the shot. I've compiled a list of sage advice for camera selection based on more than 30 years as a professional photographer.

If you're a first-time digital buyer or the prosumer moving up to a top-of-the-line model, this chapter will help you find the right gear for your needs.

THE FIRST-TIME DIGITAL BUYER

You've been taking photos for many years and you're contemplating making the big switch to digital. What are your needs? Will your existing body of 35mm equipment become obsolete? How much of your film equipment can be used with the new digital technology?

Since you're reading this book, more than likely you were a 35mm point-and-shoot or a 35mm SLR (single lens reflex) user. Easily providing the most functionality and depth of equipment, 35mm was the benchmark in upper-end consumer and professional photographic gear. The benchmark for digital to the working pro happened when the quality of the digital image finally equaled that of the 35mm film image—and that time is now.

The last decade has been witness to the evolution of ultra-sophistication in camera gear. More technology and better glass were added to a broader range of cameras than ever before. Highly capable auto-exposure and auto-focus became standard with almost every level of camera, and this trend has continued in the digital realm. Digital cameras are evolving at a blistering pace, with new cameras improving on the quality and speed of their predecessors. So how do you buy the right camera so you don't feel like the day you walk out of the store your equipment is already outdated? With all the voices giving advice on the Internet, whose advice should you follow?

Camera Types

Cameras fall into three classes: consumer, prosumer, and professional. Although the dividing line between the classes can be a bit fuzzy, I'll point out features you can use as a landmark to help compare apples to apples and oranges to oranges.

Consumer-Level Cameras

Consumer-level cameras encompass a range from the basic point-and-shoot camera with little or no control over exposure up to pricey point-and-shoots that provide quite a bit of creative control. These are all fixed-lens cameras, eliminating your ability to change lenses. To many entry-level shooters out there, this is a plus, as these cameras can be small enough to fit in a pocket and the automatic exposure features are great for snapshots.

With the current state of the art of digital equipment, this level of camera has a few inherent problems. Generally they have a lag time between when the shutter release is pushed and when the photo is made, due

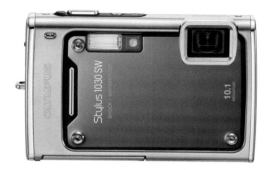

This consumer camera from Olympus is an excellent choice for the casual photographer, yet it is also highly sophisticated in its ability to photograph underwater, to 33 feet, and will withstand a drop of nearly 5 feet. Video capability is also onboard this camera.

to the large amount of information—such as exposure and focus—that has to flow through the cameras' circuits. For a serious photographer, this can cause hair loss, as you'll spend a lot of time yanking follicles out in frustration at the missed moments.

It's a direct correlation—the more you spend the less lag time there will be. If you are shopping in this range, one of the first questions you should ask would pertain to the lag time. While you are in the camera store, try shooting the camera several times and gauge whether the lag time could be an issue.

Be aware of these consumer-level considerations:

- **Lag time** Make certain the camera reacts quickly to the shutter press.
- **Speed of the lens** This dictates how much light the lens allows to pass and therefore will affect the shutter speed. The little pocket cameras are cute, but they

will generally have a slow lens, probably an f4 or f5.6, which can slow things down.

- **Speed of the in-camera processor** After you take the photo, it's stored in the camera's buffer (memory) as it processes the image and downloads it to your capture media. The buffer also has a limited amount of images it can hold. Ask about this, as the less expensive models will hold fewer images. This can be extremely frustrating on a limited buffer because the camera will not allow you to shoot more photos until it has cleared its buffer.

- **Zoom length of the lens** Most consumer-level cameras will provide a 3x or 4x lens. For most amateurs, this will be enough until you want to photograph the elk bugling in the state park. If photographing animals or sports is of interest, consider one of the new breed of "ultra-zoom" cameras, such as the Olympus 5060. Digital zoom will offer greater length, but the quality goes downhill quickly the more you use this zoom.

- **Image quality** The cost of a consumer camera is lower than that of the prosumer or professional DSLR for a reason. The chip (the electronic device that captures the photo, analogous to film) is generally smaller, and enlarging the image will show less quality than the images of this camera's bigger siblings.

- **File size** The same issues apply here as with the image quality—in general, the more money you spend, the larger the file size. And the size of the file indicates the maximum size to which the image can be enlarged while retaining quality.

■ **Noise** In film images, *noise* refers to graininess. Due to the smaller sensors on point-and-shoot cameras, greater noise is the natural byproduct of the smaller sensor size. This will show up more readily in shadows and dark areas.

■ **Pixel size** Smaller sensors typically have smaller pixels. Smaller pixels hold fewer electrons and are therefore noisier than bigger pixels.

■ **ISO settings** The consumer-level camera has a narrower window of ISO (image speed) settings. Limited to the lowest ISO of 100 to 400 or so, this restricts the camera's (and thus the photographer's) ability to increase the ISO to shoot faster exposure in lower light. This can be an issue if you enjoy photographing sporting events. The ability to shoot at a higher shutter speed requires either a lot of light or an increased ISO setting. The pro cameras will go up to 3200 ISO and beyond, which enables very fast shutter speeds necessary to stop action.

Prosumer-Level Cameras

The Canon PowerShot G10 shown here straddles the line between the consumer camera and the pro model. Usually in the 10–14 megapixel range, such cameras often provide a fixed lens with a zoom range from 3:1 all the way to 6:1. In addition, most prosumer cameras have fast apertures and fast processors for moving the images from buffer to the media card with little or no lag time.

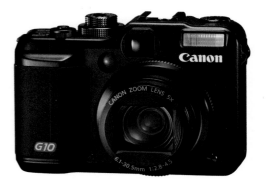

The Canon PowerShot G10 camera bridges the gap between the ease of a point-and-shoot and the full control of a pro-level DSLR.

Prosumer features include the following:

■ Short or no lag time between the time the shutter is depressed and the time the picture is taken.

■ Good zoom range of 4:1 or 5:1 is ideal.

■ Most pros prefer a wide-angle length in the zoom equivalent to about a 28mm.

■ Fast aperture—the wide setting of f2.2 to f2.8 is preferable.

■ Ergonomics to fit your hands and shooting style.

■ More control over the exposure modes for shooting. This would include the ability to set the camera to overexpose or underexpose by an amount determined by the photographer.

■ A greater range of available ISO settings. This feature may approach the pro DSLRs in providing an extended range of available ISO.

- Larger chip for better quality.
- Availability of a hot shoe, so an auxiliary flash can be used with the camera. The hot shoe is a receptacle on the camera that accepts the foot of the strobe to attach a flash to the camera, allowing manual, automatic, or TTL (through the lens) flash capability.

Professional or Expert–Level Cameras

The advantages of the SLR camera are multifold: the method of focusing and composing through the lens; being able to see exactly what the lens is seeing; the accuracy of the metering as it, too, is able to meter off the composed image; and so on. Several top-of-the-line digital cameras, such as the Olympus E-3, the Nikon D3, and the Canon EOS-1Ds Mark III, give you 100 percent of the image you see in the viewfinder. Others are somewhere in the 90 to 94 percent range, a holdover from the days when most avid amateurs and pros were shooting slide film, and the slide mount cut off 4 to 6 percent of the edges. Another advantage of the SLR is that any effect from filters—such as polarizers, graduated filters, and special effect filters—is readily seen through the viewfinder.

Other advantages include interchangeable lenses, state-of-the-art buffers and processors for moving images rapidly to the media card, and nonexistent lag. When you press the shutter, the camera reacts. Cameras relatively new to the market, such as the Nikon D90 and the Canon 5D Mark II, with limited video recording capability, may in some cases eliminate the need to carry a second, video

camera. Like any works in progress, these cameras have some limitations—they do not change focus automatically and are limited to about a 5-minute shooting burst (due to the chip becoming hot as the current passes through it). But video ability will become a popular feature for the prosumer.

The pro camera also offers you manual control over every aspect of your photography. This may seem like too many decisions to have to make at your current knowledge level, but throughout this section of the book, I will show you how to use the manual features to improve your photographs. The pro-level camera also offers better metering, faster shutter times, more control over ISO, less picture noise, and a greater choice of lenses. Other features include the following:

- **Very fast processor** Most top-of-the-line cameras are capable of shooting a minimum of 25-plus high-quality JPEGs (SHQs, or super high quality) at a frame rate of five to nine frames per second. This may sound like overkill, but when you're shooting something like the running of the bulls in Pamplona or porpoises leaping, the importance of being able to keep shooting without being hampered by the camera stopping while processing images cannot be overstated.
- **Sturdy construction** Check the lens mount. It is preferable to have a steel lens mount instead of a plastic or synthetic mount. Steel will support larger and longer lenses and will withstand the abuse of quickly changing lenses many times, which will make the camera last longer.

- **Olympus E-3, Nikon D3X, Canon 1Ds Mark III, Pentax K20D, and Sony DSLR-A900** These top-of-the-line digital SLRs are constructed with water-resistant seals, gaskets, and O-rings to provide a pretty secure barrier against splashes and moderate amounts of rain. Combined with a weather-resistant lens, these cameras offer the photographer the ability to work in some less-than-ideal situations, where rain or dust might damage lesser cameras.

- **Proprietary lenses, especially in the wide range, that are digital-specific** Many manufacturers build digital cameras that will allow you to use existing 35mm lenses on the body. But there is an issue with the film lenses' method of focusing the light from the rear element to the chip. Evidence has mounted that 35mm wide-angle lens design has the light striking the chip array at an angle, causing softness on the edges of the frame due to a shadowing by the sensor containing the pixel grid. Following Olympus's lead, most companies are now producing digital-specific lenses.

- **Dust on the sensor** Pro-level cameras all have a sensor-cleaning function to deal with the Achilles' heel of the digital realm. When current is flowing through the sensor, it acts like a magnet, attracting dust to its surface. By various methods, each camera brand deals with this problem—some more successfully than others. I've taught a couple of workshops to the US Navy Combat Photographers Group, and the dust these folks get on their sensors is pretty amazing—and understandable.

- **Image stabilization** Along with reducing the dust on the sensor, many cameras have image stabilization built into either the lens or the camera body. Lens stabilization works through a series of "accelerometers" (similar to small gyroscopes) that correct movement (shake) in the lens by countering that motion in the lens. Body stabilization provides a "sensor-shift" to counter the movement/shake of the camera in slow shutter speed conditions.

Whose Advice Should You Take?

An older neighborhood pro is always a good bet for advice, and this photographer will usually have plenty of it. Years of experience working with good and not-so-good equipment provides a lot of insight into the performance of camera gear. An informed camera shop salesperson can be a good source of information as well, as long as you don't feel you are constantly getting the sell job. Find a shop that doesn't mind your hanging around for extended lengths of time while handling several different cameras.

Your neighborhood pro will often have a favorite camera store and salesperson he or she deals with. And how do you find that friendly pro? Try attending a local American Society of Media Photographers (ASMP) meeting. This professional organization has monthly meetings in most major markets, and guests are welcome for a small fee. Talk to the photographers there and ask about the best stores in town. While at the meeting,

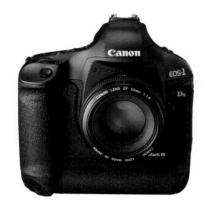

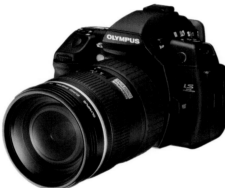

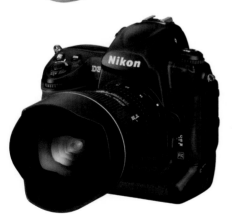

Three professional-level digital SLR cameras: the 22 megapixel (MP) Canon EOS-1Ds Mark III, the Olympus E-3, and the Nikon D3X

ask the professionals what they think is the best equipment on the market. While the camera salesperson probably has a better overview of the products on the market, the professional offers a lot of experience in the field. Problems with durability or failures due to environmental conditions are acutely registered by professional users.

The Internet has provided a venue for a lot of camera critics, but I read misinformation all the time on many photographic review sites. Take most of this information with a large grain of salt. Computer magazine reviews of equipment can often be ignored, because these are written by computer geeks who may not have photographic talent, and therefore they are providing their review from a realistically irrelevant perspective. The bottom line on those reviews is that the magazines are financially driven by the advertising of the camera manufacturers and large stores. There is no way a magazine is going to slit its own financial throat by panning a camera from a company that is paying its way. Look at the general quality of photographs accompanying the articles: most reviewers are not photographers, so how can someone without a sense of what photography is about really review a piece of gear?

Local camera clubs will include aspiring photographers who will know the ins and outs of the local markets and should be more than happy to share that information. Go through the yellow pages in the photographic supplies area, call a major store, and ask about local clubs. Before giving credence to someone's opinion, look at his or her photography to see if the photographer is legitimate. There

are a lot of wannabes out there with a lot of opinions based on camera brand cheerleading. If the photographer's work is good, I would be much more inclined to respect his or her opinion on gear.

DON'T BE INTIMIDATED BY GOING DIGITAL

I think this is as revolutionary a time in photography as the invention of the glass plate in the mid-1800s. This is a new learning stage of technology, but it is still about photography. The idea was and still is to capture the moment before you with this little box with a lens on it. Photographers are still dealing with light, the moment, composition, storytelling, and every other component of silver-based technology. I've yet to meet a photographer who has decided to make the move back to film only. This is another tool in your bag.

With these thoughts in mind, head to the local camera store and explore your options. Part of the process of buying smart is understanding your needs. The following checklist can be used as a general guideline for different types of photography and what to look for in the equipment for that discipline.

General

- Compact size
- 5–10 megapixels
- Fixed lens
- Built-in flash
- Built-in sensor cleaning for dust reduction

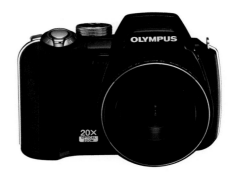

An ultra-zoom camera may be the perfect camera for the non-pro photographer who wants to capture junior playing hockey, football, or another sport. This Olympus camera offers a 20-power zoom that provides a super-zoom of 520mm. A nonchangeable lens makes it a simple tool that gives the photographer a lot of lens for the buck.

Sports

- Interchangeable lenses
- 6+ megapixels
- Fast processor and buffer

Travel

- Compact size and weight
- Weatherproofness
- Interchangeable lenses

or

- 4–6 power zoom on a fixed-lens camera
- Built-in flash

Outdoors/Wildlife

- Rugged body with weather resistance
- Interchangeable lenses with long telephotos available
- Zoom lenses in the 10–12 power range

- Telephoto lenses as long as 600mm for outdoor photography
- Image stabilization, either in the camera body or in the lens
- Lenses that have a fast aperture: In a long telephoto of 400–600mm, really fast lenses are in the f4 maximum aperture range and very expensive. A lens in this length in the f5.6 or f8 range is a good choice for wildlife.
- Quick processor and buffer
- Sensor cleaning for dust reduction or elimination

Portrait/Wedding

- 10–22 megapixels
- Prosumer level may work with a fixed lens and moderate zoom
- Quick processor and buffer
- External flash capability

Regarding the Megapixel "Myth"

All the figures I've provided regarding chip size and megapixels should be viewed as interesting but not totally relevant information. Camera manufacturers have been creating larger, more densely packed chips, and many photographers assume that better quality is a natural consequence of larger chips. Not so. Recently, a "movement" to reverse this thinking is underway, and I would like to add my voice to the revolution.

When digital cameras arrived at the 6 to 8 megapixel range, that technology addressed probably 95 percent of the amateur, nonprofessional photographers' needs. Beautiful prints up to 16 × 20 can be made with those cameras, and now with prosumer cameras in the 10 to 14 megapixel range, prints up to 20 × 24 and larger are manageable. *Do not buy into a salesperson's push* that you need to move up from your 8 megapixel to a 16 megapixel camera, because the differences will not be that great—unless you are printing billboards.

Pixels and Resolution

In the 3/2 format, for cameras that produce images in the same proportion as 35mm film cameras, the following list provides image sizes and how they are marketed in megapixel lingo:

$2816 \times 2112 = 5{,}947{,}392$ megapixels = 6 megapixel camera

$4288 \times 2848 = 12{,}212{,}224$ megapixels = 12 megapixel camera

$4992 \times 3328 = 16{,}613{,}376$ megapixels = 16 megapixel camera

$5616 \times 3744 = 21{,}026{,}304$ megapixels = 21 megapixel camera

$6048 \times 4032 = 24{,}385{,}536$ megapixels = 24.4 megapixel camera

The 4/3 format is supported by a number of manufacturers, including Olympus, Kodak, Fujifilm, Sanyo, and Sigma. The 4/3 format is quite convenient because it prints almost a perfect 8 × 10—or, for the pro market, it is almost the exact size of a standard magazine double-page spread.

Here are pixel dimensions in the 4/3 world:

$3648 \times 2736 = 9{,}980{,}928$ megapixels = 10 megapixel camera

$4032 \times 3024 = 12{,}192{,}768$ megapixels = 12.3 megapixel camera

David Pogue, technology writer for *The New York Times*, addressed this in a couple of his columns, actually hanging large prints shot with cameras ranging from 4 megapixels up to 10, and 95 percent–plus of viewers could not differentiate between the two. Other considerations, such as optical quality, file quality, and steadiness of the camera, add or detract from the image quality.

Leica camera developer Oscar Barnack designed the first 35mm miniature camera in the 1920s, using 35mm movie film and turning it sideways to double the size of the movie film image. No aesthetic or compositional consideration drove the design thinking, just the reality of what was available. Thus was born a photographic revolution, the easy-to-handle, fast-to-use, and nonobtrusive camera that allowed the photographer to react to a scene instead of considering a response. Not only was photojournalism enabled, but street, documentary, reportage, and travel photography styles were hugely empowered.

Now, with the advent of the huge megapixel-capable cameras, the form factor has changed. The large megapixel camera produces great results, but in the vast majority of cases it is simply overkill. Why use a cannon to kill a fly? As I mentioned earlier, the 8 to 12 megapixel camera is absolutely more than sufficient for most photographers' needs.

I believe that these megapixel behemoths will become the new "medium format" of photography—a tool needed when the largest size file will benefit the photographer when shooting for that billboard or bus sign. But for images up to 20 × 24, cameras within the 8 to 12 megapixel range will more than suffice. Plus, it's just easier on the photographer when

he or she can easily carry the equipment needed for a particular shoot without having to visit the chiropractor afterward.

Using the Files for Printing

Let's say you want to print an image from a 12 megapixel camera. That camera produces a file size of 4288 × 2848 pixels. To establish the size—width by height—that this file would print, you'll divide the pixel dimensions by the resolution. Generally, the resolution will be 300 dpi (dots per inch), which produces a very nice looking print. Ideally prints should have a dpi in the range of 100 (anything less than this will start to look bad as the pixels will be very evident) to about 360 (more dpi at this point will not be seen by the naked eye). Images can be printed at a resolution of 200 dpi with little loss in detail to the eye. Divide 4288 (the number representing the longer of the two pixel dimensions in the image) by 300 (the intended dpi of the image). This will result in the size the image can be printed on the longer dimension.

A 12 megapixel camera, based on a 3/2 format, will contain 4288 pixels per inch (ppi) on the long dimension. Dividing the 4288 ppi by 300 ppi (contained in the photo) results in 14.29, which is the size in inches the photo will measure on the long side. Here's that formula: *Width dimension of the photo ÷ desired resolution = the resulting width of the photo when printed as the file comes out of the camera.*

The relatively new 4/3 format allows an 8 × 10 print to be made with almost no cropping, as well as a double-page magazine spread. This is an "open" format, meaning that all lenses will fit all 4/3 manufacturers' bodies.

Changing the resolution (dpi) of the image will change the size of the finished

print. If you went to 200 dpi on the same 8 megapixel image, the finished print would be 3265 divided by 200, equaling 16.36 inches on the long side of the photo and 12.24 inches on the short side.

The short dimension divided by the desired resolution (300) equals the resulting size of the short side of the image when printed as the file comes out of the camera.

Enlarging or reducing the image size from the native file size is easily done, and the tools in Photoshop give the digital darkroom quite a lot of power. Printing at different sizes is discussed at depth in Chapter 18.

How Do I Know the Camera Is Right for Me?

Digital cameras aren't cheap. To help you prevent buyer's remorse, I've compiled a few tips to help you find the camera that is right for you.

- **What is the maximum size you can imagine you'll print from the files?** For an 8 × 10, a 5-6-10 megapixel camera should easily suffice. If you love printing images in the 16 × 20 size, you should be looking for equipment in the 8 megapixel range. Be aware of Photoshop's ability to *upsample* images well. This means that the software takes your smaller file and uses algorithms to sharpen the photo for larger prints.

- **What will you be shooting primarily?** If you'll be shooting the family vacation and documenting the life of your brood, a Canon EOS-1Ds Mark III (a 22 megapixel, expensive body) would be a major case of overkill. Look

----------4288 Pixels----------

|----2848 Pixels----|

The standard for 35mm photography for decades, the 3/2's box provides a good horizontal image format.

--------- 3264 Pixels ---------

|----2448 Pixels----|

A bare-bones illustration of the 4/3's format

at the Olympus E-520, which is a step down from that company's top-of-the-line camera, at a considerable cost savings. Not quite as rugged, as it does not have the weather resistance of the Olympus E-3, but that may not be an issue if you don't plan on shooting regularly in rain.

- **How does the camera feel?** Is it an extension of your hand, heart, and eye? The camera should never get in the way and should enable the process of picture taking.

- **Will the camera grow with you?** Does the system you are looking into have the expandability for your future growth as a photographer? A point-and-shoot will not accept much in the area of an expanded system of lenses. If photography is a passion, this is an important consideration.

In the course of workshops or assignments, I'm often asked for good guidelines to follow when buying a digital camera. Here's a list of my ideas, combined with buying pointers from other pros:

- How much can you spend? Be specific and set a realistic maximum price that you are able to afford.

- Realize that generally price, quality, and features go hand in hand. Expect to pay more for a top-of-the-line DSLR than for a compact point-and-shoot camera.

- Don't entirely fall into the "megapixel myth." I'm shooting with a 10 megapixel camera and getting very good results up to 24 × 18 inches (and larger). The quality and size of the image sensor often plays a more pivotal role in the quality of the finished image than the sheer number of megapixels.

- As I mentioned earlier, know what equipment you need for the type of photography you prefer. If you don't need lens interchangeability, a prosumer camera may very well suffice. However, if you are passionate about wildlife and sports photography, you'll be hamstrung by a camera that doesn't have interchangeable lenses.

- If you already have a 35mm camera system going, and the lenses will work on a digital camera of the same brand, consider purchasing a DSLR by the same manufacturer as your film camera. You'll be able to use your old lenses and upgrade to digital lenses as your budget allows.

If you take anything useful from this chapter, I would hope it would be that our focus is still about photography, and the digital camera is simply another tool in your bag.

The core elements of a great photograph stay the same: composition, exposure, content, and the decisive moment. A great photograph transcends equipment. The camera is the vessel to help you capture your artistic vision.

What to Look for in the Camera Store

- Look for an organized display with multiple brands out and available to test. You need to know how the camera feels in your hands. Are the dials and knobs easy to access? This is a particular concern for people with small hands. Does the camera feel like an extension of your arm, or is it a lead weight requiring finger gymnastics to access the controls?

- Does the salesperson have a real working knowledge of the equipment brand? If you note a bit of hesitation or uncertainty, ask for a clerk who is knowledgeable in the specific brands in which you are interested. Be leery of anyone reading you the camera's specifications from the manufacturer's literature. Spec sheets don't have much value out in the field.

- Is the salesperson working with you to fit your needs to a specific camera, or is he or she trying to "upsell" the equipment?

- Ignore any talk that a store has quit selling a brand because of too many returns or too many failures. Just doesn't happen with the quality of today's equipment. If you hear this, go on to the next store.

- Don't expect to get the same level of knowledge and expertise when visiting one of the "box stores." Support your local camera store. The salespeople are often more knowledgeable and are better able to answer questions. You may save a few dollars by going to a discount store, but you are losing the knowledge infrastructure that a store with expert salespeople can provide.

- Used equipment is also an option. If the camera is in good shape *and* has been checked out by a reputable source, I would not hesitate in buying a used piece of gear. Look in the yellow pages under "Photographic Equipment: Used."

- Turn around and leave the store if the advertised price on a camera in which you are interested is raised because you need the battery or cables that were not part of that great price. A digital camera will come with all accessories necessary to shoot photos—more than likely a minimal capture card, but cables, covers, and the obvious pieces will be included. However, with upper-end equipment, lenses are often *not* included in the price unless noted.

- If it sounds too good to be true, it probably is.

The World of Buying Online

- Over the years, I've had great luck with B&H (www.bhphotovideo.com) and Roberts Imaging (www.robertsimaging.com). If you know what you're looking for, online can be a great way to go, as reputable firms allow returns within reasonable lengths of time on equipment, giving you the opportunity to check out the equipment at your leisure.

- Do not—repeat, *do not*—pay via Western Union, cash, or money orders for online purchases. This is a world where your credit card can offer tremendous protection against unscrupulous sellers. Cash and money orders can leave you hanging if the seller is a thief.

- If you can't pay with a credit card, then use PayPal or another third-party payment system that holds the funds for you until the equipment is in your hands and verified.

- Some companies advertise unbelievable prices for equipment. Once you call them, usually the story is the camera is sold for that price when it is purchased as part of a "kit," which usually consists of a bunch of stuff: bag, cheesy flash, snazzy neck strap, cleaning fluid, perhaps extra lenses—almost always stuff you could purchase separately for less money. Again, beware of offers that sound too good to be true.

Photography is an art form that requires equipment, and this gear can be dizzyingly attractive—one reason so many people collect cameras. But as I stated earlier, remember why we have this gear: to provide access to this magical art form we love.

DEVELOPING TECHNICAL PROFICIENCY WITH YOUR CAMERA

There is only you and your camera. The limitations in your photography are in yourself, for what we see is what we are.

—Ernst Haas

Such a simple little box, yet the complexities of today's cameras are staggering. Precise exposure, the closely guarded secret of all serious photographers, is now just a half-pressed shutter button away. Even the lowly PHD ("push here, dummy") cameras, which account for the majority of cameras sold, possess technical capabilities that could only be dreamed of a decade ago. Programmed into the camera's memory are perhaps thousands of sample photos that the onboard computer scans to judge the likely shooting situation for each shot. Say, for example, that

A photographer uses the latest technology in a high-end digital SLR—50–200mm lens at 137mm, 1/20 second at f16, 100 ISO

you're shooting your white dog against a snow bank. The camera manufacturer has already stored a similar shot, and those conditions are stored in the onboard computer for comparison.

The bottom line is this: Your camera, in all of its resplendent glory, is still a box with a small hole at one end and a sliver of light-sensitive material at the other end. The sole purpose of this box is to let an instant's worth of light fall on the light-sensitive material. All the technology in the world can't change this fact.

The first photographic plate, a heliograph, was exposed in 1827 by Joseph Nicéphore Niépce. Since then, billions upon billions of images have been shot in billions of cameras. Niépce's camera was as simple as it gets: a box with a lens and a treated metal plate. The exposure was relatively quick for the state of the art at the time—about eight hours. The scene was a dovecote viewed from his window in Le Gras, France.

Flash forward to today. Dad is arranging the family for a picture at the Grand Canyon. The camera is lifted and the shutter is pushed, setting off a chain of events. In several milliseconds, the camera reads the light levels and sends that information through the onboard computer. The processing chip then sends a signal to adjust the lens aperture and opens the shutter for the correct duration. If needed, the flash will fire, and the light pulsing out will be measured during the exposure and turned off at the exact moment to produce a proper exposure. Also during this time—from the lowly disposable camera to the top-of-the-

line Nikon D3x 24.5-megapixel camera—the auto-focus will determine correct focus, and the camera will auto white balance the exposure. All this happens in the time it takes Dad to put the camera to his eye and fire.

What components make up this scenario? The camera, the flash, the tripod, and so on, obviously—but, more important, the comfort level and knowledge the photographer has of his equipment also translates into better photographs. This chapter takes a look at the parts of your camera, its settings and controls, and some critical accessories. Then we'll look at some guidelines for developing the technical proficiency that empowers your creativity: different media, white balance, file types, all the tools at hand that help make you a better photographer.

THE PARTS OF YOUR CAMERA

More than likely, you've owned cameras of varying complexity over the years. These have all included some common elements.

A digital or film-based camera will contain a shutter that opens and closes, allowing a measured amount of light to fall on the camera sensor. Some variation of a viewfinder will also be present. The simplest is an *optical viewfinder*, a small window above the lens that gives you a pretty good idea of what you're shooting. Next, the *single lens reflex (SLR)* (see Chapter 2) uses a system of prisms and mirrors to "see" exactly what the lens is seeing, as it is sighting through the lens. This type of viewing system is found on almost all professional-level digital cameras. Another

viewing system is the *electronic viewfinder (EVF)*. This small screen provides an electronic image, like a mini-TV, of what the lens is seeing. To some people, the EVF takes a bit of getting used to, as it does not visually replicate reality very well. These types of viewfinders are used on consumer- and prosumer-level cameras, primarily with lenses with extended zoom range or very wide-angle capabilities, as an optical viewfinder could not give you an accurate approximation of the image through those types of lenses.

A modern digital SLR (DSLR) is great for all-around photography. Accuracy of exposure, speed in handling, and great image quality are hallmarks of this type of equipment.

An LCD display screen provides information about almost all camera settings. From shutter speed to ISO to file type, all the user-controlled settings appear here. With a quick glance, the photographer knows where he or she stands, technically speaking.

In addition, many modern DSLRs now include a variation on a *live view* function, which lets you compose photos using the LCD screen and the viewfinder. The monitor is able to display the image as "seen" by the camera. At the far end of the monitor feature spectrum is an articulating monitor. This looks like the normal LCD monitor display on the back of the camera, but it is hinged so it can move out and away from the camera body, allowing the photographer to place the camera at ground level, or hold the camera over their head (a "hail-mary" as it is called in the business) or shoot from waist level, all while using the Live View monitor to frame and compose the image.

Also found on the camera body is a multitude of buttons that address many digital-specific settings, such as white balance, file type, monitor review, menu access, erase, auto-exposure lock, and information. Such settings will be discussed a little later on in the chapter. You need to know and understand the functions of these buttons to understand the photographic process. Developing proficiency with these basic components will allow you to focus on the photograph, rather than the process.

What Are Those Camera Settings All About?

Today's digital cameras do have many settings available, but they are not radically different from those available for a 35mm camera. Several of the settings are directly correlated between the digital and film technologies, and some are unique.

Upon startup of the camera, several figures, icons, and numbers will appear in various forms, depending on the camera manufacturer. Following are some common ones:

- **Shutter speed** Shutter speed is represented as either a whole number (250, 500, 1000, and so on) or a fraction (1/250, 1/500, 1/1000). If, for example, you divided 1 second into exactly 250 equal parts, the result would be 1/250 of a second. This setting tells you the duration the shutter is staying open. Obviously, the longer the shutter stays open, the more light and movement will be recorded.

- **Exposure compensation** This icon looks like a small ruler, with markings running from the center, to the left to –2 stops and to the right to +2 stops. Have you ever shot a photo in bright snow, only to have the subject of the photo appear as a silhouette? This was due to the camera trying to compensate for that terribly bright level of light reflecting off the snow, sacrificing the exposure on the subject. With the exposure compensation, the camera can be forced to *underexpose* or *overexpose* the photo, by whatever degree you want.

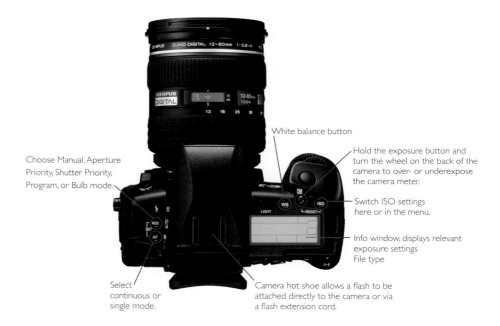

White balance button

Hold the exposure button and turn the wheel on the back of the camera to over- or underexpose the camera meter.

Choose Manual, Aperture Priority, Shutter Priority, Program, or Bulb mode.

Switch ISO settings here or in the menu.

Info window, displays relevant exposure settings
File type

Select continuous or single mode.

Camera hot shoe allows a flash to be attached directly to the camera or via a flash extension cord.

Many critical settings, such as autofocus points, ISO, and white balance, can be set in the camera menu for the photographer's ease. Several of those commonly used settings are accessed with buttons on the camera, so photographer does not have to go back into the menu. Instead, she can press one of several buttons on the camera, immediately accessing those settings.

■ **Aperture** Aperture is the variable opening in the lens that controls the amount of light striking the light-sensitive material. This figure will be 1.4, 2, 2.8, 4, 5.6, 8, 11, 16, 22, or some fraction in between. The aperture setting controls the depth of field; the larger the number, the larger the zone of focus (area that is in focus) from front to back.

Shutter Speed Equivalents

Shutter Speed	Aperture Setting
1 second	f22
1/2 second	f16
1/4 second	f11
1/8 second	f8
1/15 second	f5.6
1/30 second	f4
1/60 second	f2.8
1/125 second	f2.0
1/250 second	f1.4

These shutter speed and aperture combinations all result in the same exposure. The photographer can use shutter speed or aperture to increase their creative control—one of the best reasons to learn and use manual exposure!

A photographic example to illustrate depth of field is shown on the following page. I started wide open at around f2.8 and progressively stopped the lens down to f22, illustrating the increased depth of field impacted by the aperture. The first photo was shot at f2.8, which is

the maximum aperture on the 100mm lens I used to shoot these photos. Notice the rolls in the foreground and in the background—they are out of focus and the only real area of sharpness is the film in the middle of the frame. As the lens is progressively stopped down, f4 in the second frame, f5.6 in the third, f8 in the fourth, all the way to f22 in the final image, the depth of field, or area of apparent sharpness, deepens with the stopping down of the aperture.

■ **ISO setting** Back in the old days, when I was shooting film for a major daily newspaper, we'd carry Tri-X black and white film (this was before daily color usage in the paper) and we'd physically change the ISO setting on the camera (it was ASA then), which affected the sensitivity of the film to light when the situation called for it. Using a higher ISO, we could go to a higher shutter speed. We'd even push the film to 12,000 ISO with some exotic blends of developers. The grain was the size of your fist, but we could actually photograph high school football in dimly lit stadiums without using a flash. However, we were stuck with the speed of the film in the camera. If a great event took place in front of me, and it required going higher or lower on the ISO, the other images on the roll would have to be sacrificed.

With digital, each frame is its own event. ISO can be changed accordingly for one frame, or several, and then

1/250 second at f2.8

1/125 second at f4

1/60 second at f5.6

1/30 second at f8

1/15 second at f11

1/8 second at f16

1/4 second at f22

I finally found something to do with all those rolls of film sitting in the freezer.

changed back. This empowers the photographer with the ability to react to the moment by setting a higher ISO to capture high-speed action in lower light or dropping it back to a low ISO for the better quality it produces.

ISO can also be a creative tool, using the ISOs in the range of 3200 or more to create a *grainy* (called *noise* in the digital age), ethereal-looking image. As my friend John Knaur of Olympus describes it, "Film ISO is the standard by which the industry described the sensitivity of film to light." When digital cameras began to appear in the early 1980s and late 1990s, it became commonplace to use the same terminology to describe the imagers' (sensors') light-gathering abilities with ISO terms familiar to the consumer. So cameras showed equivalent ISO settings, such as ISO 100, ISO 200, and so on. The reality is that the imager has a native sensitivity to light, which often is expressed as the lowest equivalent ISO. This setting, such as ISO 100, is the starting place for the imager chip's sensitivity. To increase the sensitivity, or ISO, the gain on the imager is increased in steps, such as +1, +2, and so on. This can be likened to turning up the volume in your audio player or television. The higher the volume, the greater the amount of hiss or noise. A similar thing happens with the camera—when the gain is increased, the noise becomes more visible in the image, hence the noise in higher

"ISO" settings such as 1600 or 3200. To counter this problem, noise reduction technologies have been developed to control the noise in digital photography.

- **WB indicator** This may appear as a small icon, such as a cloud or a light bulb, indicating the white balance setting to which the camera is set, or an Auto mode setting. We'll cover this in detail a bit later in the chapter.

- **File type indicator** Wonder what that *SHQ, HQ,* or *TIFF* means? These tell you the type of file the camera is saving. Most point-and-shoots provide the JPEG (Joint Photographic Experts Group) format, a universally accepted format that compresses the image. Cameras also generally provide raw files, and several manufacturers no longer include TIFF (Tagged Image File Format) capabilities. SHQ stands for Super High Quality, and HQ stands for High Quality. Each of these file types provides images of different sizes and different capabilities.

Deciphering the MAPS Settings

Looking at the controls on a camera, you might see a dial that shows the choices M, A, P, and S (MAPS). Is this a compass device? Nope. *M* gives you the power to manually control your settings, *A* is for aperture priority, *S* is for shutter priority, and *P* is for program mode. They're all pretty easy to use, so let's take a look.

- **Manual** mode is often the choice of avid enthusiasts, advanced amateurs, and pros. In this mode, the full power of the camera is in your hands. You must know the basics of exposure to use this setting to its fullest. All modern cameras have meters built in, and Manual is one setting with which you will be using the meter religiously. You set the shutter speed, the aperture based on the meter, and fire away.

- **Aperture priority** mode is a semi-automatic mode that allows you to control the aperture (the f-stops), and the camera will then set the proper shutter speed. Many pros I know use this setting often. You have the ability to control the depth of field, which is directly impacted by the aperture. The more you close down the lens, the deeper the zone of focus you create in your photos. If you are photographing Aunt Martha in a field of flowers, for example, and you want the flowers in the foreground to be in focus, the more you "stop down" the aperture, the more in focus the flowers closer to the camera will be, as well as those on the other side of Aunt Martha. When looking through the camera, you will see (in the display) numbers representing the shutter speed and the aperture. The shutter speed is the number represented in steps of 1, 1/2, 1/4, 1/8, 1/15, 1/30, 1/60, 1/125, 1/250, 1/500, and 1/1000. The f-stops, or aperture, will appear as f2, f2.8, f4, f5.6, f8, f11, f16, and f22. These numbers tell you the actual size of the opening that

the blades in the lens create relative to the length of that particular lens. The larger the number, the more closed down the lens and the deeper that zone of focus. Every f-stop is doubling or halving the quantity of light striking the digital chip. Also, wider lenses have more inherent depth of field than do long, telephoto lenses. Think of photos you may have seen in *Sports Illustrated*—the receiver leaping for the ball, all in perfect focus, with the background out of focus. Those shots are taken with very long lenses, often shot wide open or with the aperture set at a smaller number. Look for a more detailed explanation about depth of field a little further on.

- **Program** mode authorizes the camera to take control and set optimum shutter speed and aperture. Other settings, ISO, and white balance often remain in your control.

- **Shutter priority** mode allows you to slow down the shutter speed manually. You have control of the shutter speed and can allow the camera to take over setting the correct f-stop or aperture. This allows you to slow down the shutter—say, to 1/60—to track and shoot a runner passing by and to get that cool blurry background, maybe with a little motion in the athlete's body, but keeping the focus fairly sharp on the runner. This is a good way to create a sense of motion in a still photograph. Set the shutter speed up to around 1/1000 of a second, and that

shot of a helicopter flying overhead will look like it is about to fall out of the sky, because the blades are not moving.

Other Shooting Modes

Designers of modern digital cameras have figured out that a lot of their customers do not want to deal with the perceived complexity of the controls discussed so far, so they have taken it another step and included modes for different types of scenes. These modes set the camera to function best for the style of photography indicated by the icon.

- **My Mode/Custom**, or something similar, allows you to make and save specific settings on the camera to use later. You can use this setting, for example, to create a quick way to switch the camera to a black and white mode or to a higher ISO (to be able to shoot in lower light).

- **Movie** mode is indicated by an image of a movie camera. Many cameras also have a movie mode that will capture an MPEG (Moving Picture Experts Group) video. Movies can last several minutes, but are limited in time because the sensor generates heat as the current is passed through the circuitry. The inclusion of high-definition (HD) video capability in still cameras is a growing trend within the industry.

- **Landscape** mode is indicated by an image of a mountain. This mode will set the camera to help you achieve the maximum depth of field, gaining as much sharpness foreground to background. Be aware,

Mode indicator

however, that if the photo is taken in late daylight or other low light conditions, the shutter speed will drop accordingly, and you should think about using a tripod. Many cameras will optimize the color settings to emphasize blues and greens, figuring you are probably shooting natural scenery.

- **Sports** mode is usually indicated by an image of a running person. The camera will set the exposure, pushing the shutter speed to its highest point, taking in the exposure for the scene to "freeze" the motion in the image.

- **Portrait** mode is indicated by a likeness of a person's head. The camera will set itself so the aperture will lessen the depth of field, throwing the background out of focus. This will make the subject stand out against a "soft" background. Try and zoom the lens out and fill the frame with the person you're photographing, as the closer you are, and with the lens wide open, the shallower that zone of focus will be.

■ **Night** mode is indicated by a moon and/or star. The camera will operate at slower speeds than normal, so you can shoot a night view of San Francisco and capture details. Often, this can be combined with flash, so both the flash-illuminated foreground and the background will have correct exposure, making the photo more interesting. I often see people shooting pictures of someone in the foreground with a flash, but utilizing the Auto or Program mode, which will not compensate correctly for the background. The resulting photo resembles a person floating in a sea of black, as the camera exposes for the flash, but sets a default shutter speed, probably 1/60, that does not create enough exposure for the background. Often this mode will also compensate for the "hot pixels" that show up in some long exposures. Caused by the heat buildup in the chip that a long exposure creates, these hot pixels look like specks of light in your image. The camera will actually make a "second" exposure, equal to the first, but recording only black, using this to reduce or remove the effects of the long exposure. Pretty cool.

■ **Landscape and Portrait** mode is usually indicated by a mountain and a variation of a face. This will keep both foreground and background in focus, so the person in the foreground will be sharp, as will the scene behind. This is done by closing down the aperture to create a greater depth of field.

I hear a lot of amateurs talk about reducing the quality to get more photos on a card. Why would you purchase a 10 to 24 megapixel camera if you are not going to take advantage of the big beautiful chip? The cost of CompactFlash cards and other media is dropping, and you'll never be able to increase the quality of that small file you shot to squeeze out a few more photographs. What if you capture that once-in-a lifetime photo, and the camera is set to shoot a 640 × 480 image? You'll never be able to print anything larger than a wallet-sized print.

Image Sizes: Two Different Chips

10MB Camera	
Smallest JPEG	About 0.1MB
Medium quality JPEG	5.3MB
Best quality JPEG	6.8MB
Raw	11MB
22MB Camera	
Smallest JPEG	2.2MB
Medium quality JPEG	11MB
Best quality JPEG	21MB
Raw	21MB

Shooting the same image with different chip sizes produces a variety of image quality.

Sooner or later, the camera industry has to "stop the madness" of the megapixel race. I have printed 30 × 40 inch images from a 5 megapixel camera that are stunning; however, if you are a commercial photographer who shoots images used on billboards, you may need the latest and largest megapixel camera. These huge files also impact storage, forcing you to purchase more storage space as well as significantly slowing down your editing software. However, if you are shooting like 98

percent of the market out there, and a 16 × 20 print will be an ultimate goal, then a 10 to 14 megapixel camera (a DSLR) will more than suffice. Do be aware that *not all megapixels are the same*: a point-and-shoot 10 megapixel camera that uses a smaller sensor, with smaller pixels to fill that smaller space with that 10 megapixel number, will *not* produce the same quality image as a full frame or four thirds camera (camera with a 4:3 aspect ration) with a larger sensor.

As a rule of thumb, unless you are shooting for very high quality reproduction or printing needs, a high quality JPEG will suffice. TIFFs are usually four to five times the size of a JPEG, but TIFFs suffer none of the compression problems that affect a JPEG. Every time you open a JPEG image, make a change, and save that change, the quality of the file deteriorates, and information is thrown away; this is not true with a TIFF, however.

A raw file is essentially pure data. The camera white balance settings, sharpness, and other camera processing issues do not apply to this type of file. The raw format is closest to an undeveloped color negative that can be developed over and over again, until you achieve satisfaction, and this gives you the most control over your image. Many photographers are hesitant to use raw because they're afraid of the technical mystique of this file type, but when opening a raw file in a raw converter for the first time, that photographer will realize the power of this file: many corrections are available in that raw converter that allow the image to be corrected to near perfection.

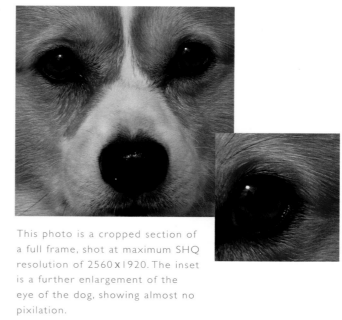

This photo is a cropped section of a full frame, shot at maximum SHQ resolution of 2560×1920. The inset is a further enlargement of the eye of the dog, showing almost no pixilation.

The same dog, the same cropped area, and the same enlarged section of that photo shows a lot of image degradation caused by the poor image quality of the 640x480 SQ image.

CHOOSING A FILE TYPE

Within the controls of the digital camera, the photographer is given a choice of file types ranging from the low quality Standard Quality (SQ), to the very large TIFF, to the color negative of the digital world, raw. Your choice will forever impact your ability to edit, print, and manage the image.

- **Standard or High Quality** If you are shooting images for web use, and the images will *always* remain small or for web only, you should consider using this file type. Limited by its small (640 × 480 or a bit larger) file size, a 4 × 6 inch photo is about as large as you can print this file. In addition, any work on the image done in photo editing software will further deteriorate the quality of the file. Generally, these image files will be less than 1MB in size, which is a good size for sending as e-mail attachments or for web gallery display.

- **Best Quality with least compression JPEG** A great, all-around file type to shoot, JPEG has been available since 1986. Compressible in varying degrees, this file will take up less space on your hard drive than a raw image and will print quite well. However, remember that you should always do your editing/tweaking to a TIFF or PSD (Photoshop) file that you have converted from the original JPEG, not the original JPEG. For the *A Day in the Life of Africa* book project, we all shot JPEGs. These images

were reproduced in a large coffee table book, and they looked beautiful. On a 5 megapixel camera, these files are each about 3MB in size.

- **Raw** Think of this file type as closest to a color negative. This is pure data, meaning that no in-camera processing (sharpness, white balance, saturation, or contrast) will be imposed on the file. In raw, the image, as it is seen, is recorded. Many pros shoot only this file type, because it gives them the greatest control over their images. However, you must convert the raw files in either the proprietary software that comes with the camera or with Photoshop CS43 or CS4. This can slow down the editing process, as each image has to be opened and then saved as either a JPEG or TIFF. A side benefit to this, however, is that if anyone claims a photo has been altered or manipulated, you can show the raw file, which is unalterable. *National Geographic* has decided to handle the controversial manipulation issue by requiring that all digital shoots for the magazine be done in raw.

The raw algorithms written by each manufacturer are a closely guarded secret. Conversion in anything but the proprietary converter does not take full advantage of the raw file, and doing this type of conversion can cause noise in the image and imperfections in shadow detail. Proprietary conversion is being challenged by Adobe Camera Raw, as it is suggesting that proprietary development of raw is

unnecessary and that Adobe can do as well or better. The Adobe DNG (Digital Negative) format was developed to address the lack of an open standard for raw files created for each digital camera. DNG allows photographers to archive their raw camera files to a single format (DNG) for easy access and cataloging of those files.

Upon opening raw files in a raw converter, the photographer has the choice of an 8-bit or 16-bit file. This is very important, as a 16-bit file provides a much larger well of color on which to draw. This allows you to perform critical adjustments such as levels and curves with far less deterioration of the image file.

If you want to function well within the digital darkroom, you should use the raw format for its absolute controllability.

■ **TIFF** Fewer manufacturers are incorporating TIFF files into the working file types. Raw provides more control of the image at a smaller size. TIFF files will be the largest files to reside in your media card or hard drive. About five times bigger than a JPEG, a TIFF file offers a great advantage, in that it will not lose data when it is opened, tweaked, and saved, regardless of how many times this is done. Because a "lossless" compression can be used, the image file can take up less space. TIFF is a good file format for shooting large prints, as the artifacts (tiny, jagged edges that appear as the file is enlarged) that inhabit JPEGs will not be evident in a TIFF.

All digital cameras record images at a bit depth of 12 or 14 bits. When you shoot TIFFs and JPEGs, the camera uses its internal settings to create an 8-bit image, throwing away perfectly usable image information. A raw file will allow a file with more bit depth to be created, giving the photographer far more color information to draw from when working on the file.

Flash Modes

The flash is one of the most underused, underappreciated, and, conversely, overused tools on the camera. In national parks, I often see tourists visiting the sights and shooting photos like crazy at the worst time of day— noon. Invariably, they are disappointed with the washed-out colors and harsh shadows that result. A simple yet highly effective trick in such situations is to turn on your flash.

The Dawning of the Digital Age

A Day in the Life of Africa was one of the first all–digitally produced coffee table books published. I shot for this 2002 project as a newbie in the digital realm, as did the majority of the photographers working on this project. Many went on assignment hesitant and questioning this technology, and most came back digital converts. All assigned photographers were required to shoot SHQ files on all images. The book, with open spreads measuring 20 x 12.5 inches, is a testament to the unbelievably high quality of the file. Take a look.

You can also move a bit closer to the person you're shooting. The flash, even those on the point-and-shoots, will fill the shadows in eye sockets created by the sun directly overhead. This results in a kinder, gentler photo that will make your significant other much happier to pose for your endless photos next trip. Moving closer fills the frame and brings the center of attention, the main subject, closer to the viewer of the photo. The simple trick here is to "force on" the flash, turning the setting on your controls so the lightning bolt shows in the display. This makes the flash fire with every exposure, and it's a great tool for very bright and high-contrast days.

I also see people shooting photos with a flash at night, usually in Program mode, and then wondering why the picture of Uncle Joe looks like he's floating in a black universe. Again, utilizing the Night mode, or slowing down the shutter speed so the exposure on the background is correct, will place the subject in the environment, giving the viewer a sense of place. This is why you shoot such a photo in the first place—to communicate that idea.

- **No flash** This is good for scenic shots, very wide shots, and shots in which the subject is too far to be lit by the flash. Remember that digital cameras are power-hungry beasts, so the energy you save by not using flash may keep you shooting at the end of the day. Be wise, and don't energize (when you don't need to).

- **Flash** This setting is often represented by a lightning bolt. It tells the camera to fire the flash with every exposure, regardless of other settings.

- **Auto-flash** This setting is indicated by a lightning bolt with the letter *A* beside it. You are turning over control to the camera to decide when you need the flash. The downside to this setting occurs when you are taking an "available light" photo, with hopes of capturing the ambience of the scene, and the flash fires. This not only can disrupt the scene, but the camera (in the Auto mode or Program mode, where this function is applicable) may not go to a slow-enough exposure to capture the image.

- **Red-eye flash** We've all seen this: a group stands ready to have its photo taken, and several pulses of light are emitted from the photographer's flash. The purpose of this light is to force the pupils in the subjects' eyes to close down, using a series of weak rapid flashes, so the back of the eye with its many blood vessels won't bounce back a red that would look great only in a Dracula movie. You may want to tell your subjects that the camera will do this; otherwise, the group might start to walk away after the first flash fires!

- **Rear-curtain sync** When a photographer is shooting in the dark or near dark, and moving items with lights (a car, for example) are in the shot, using normal flash has inherent problems. The headlights become streaks of light moving through the body of the car, which looks

very unnatural. The desired effect is to have the lights appear behind the vehicle, in a more natural-looking scene. This is accomplished by using *rear-curtain sync*, a technical sounding term meaning that the camera is instructing the flash to fire at the end of the exposure, instead of the normal flash time at the start of a longer exposure.

Working with White Balance

One of the "magic tools" of digital photography, white balance enables the photographer to control the filtering of the light with a button set on the camera. This is one area where shooting digital is vastly superior to film.

Years ago, on assignment for a magazine, I used film to photograph the president of a major railroad. I scouted the location as usual and found the conditions abysmal, to be polite. The main light source was faded-out sodium vapor lights. This required several gel filters over the camera lens to bring the source at least close to daylight, which reduced the exposure by several stops. Attempting to shoot on a slower speed film wasn't possible, because of the loss of light the gels created, so I had to use a higher speed film, with its inherent quality sacrifice. Plus, I had to shoot Polaroids to check how he looked, and a lot of these folks give you a minimum of time. Now, if this had been on digital, I could have walked in, done a white balance by pointing the camera at a white card and pressing the WB button, and the camera would have neutralized the heavy off-coloring of the sodium lights. Plus, I could have checked the image with the actual photographs I was taking, not a Polaroid simulation.

White Balance Can Be a Creative Tool

White balance is a very powerful child of digital technology that you can use as a creative tool, as well. In my film days, I always had an 81A filter mounted on the front of all my lenses. This filter creates a slight warming effect, making many scenes more pleasant in their ambience. Now, if I'm shooting digital, I put my white balance setting on 6000 Kelvin, which is also shown on most cameras as a setting to use on cloudy days. Thus, the little cloud that appears in my monitor tells me I've got the white balance set to a bit of a warming "filter." Settings in the white balance area will also neutralize the greenish cast from fluorescent lighting or the very orange cast from tungsten lighting, the most common lighting used in homes. The little icons for these settings show—you guessed it—a fluorescent bulb and a regular light bulb. These manufacturers are on to something!

Note Kelvin, simply put, is the measurement standard for the temperature of light. The higher the temperature, the cooler or more blue the light. The lower the temperature, the warmer or more orange/yellow the light. Sometimes I like to shoot a daylight white balance under tungsten light because it imparts a warm, snuggly cast, like being at home. Or I might shoot outdoors at dusk with the camera set on a lower Kelvin setting to emphasis the coldness of the evening with the extra blue this WB setting will provide.

White Balance Tips

White balance is our bag of filters in one simple button. I am always aware of the WB setting and have used it often for control or effect.

The following tips illustrate how you can capture more compelling images no matter what actual light is available:

- Don't use the Auto white balance setting. This may provide an uneven response from frame to frame, as the camera—with even a slight shift of perspective—may establish its white balance from a different "white" it finds in the frame. Also, since the purpose of white balance is to bring white back to true white, the beautiful "golden hour" hue may be removed from the photo!

- Carry a white card or piece of cloth (or make sure you always wear a clean, all cotton T-shirt), so you always have a white sample available to take the reading from. If your white shirt has an optical brightener in it, it will fluoresce under the strobe's UV illumination. Just like white colors in a funhouse, the white shirt will glow bluish, but you may not notice it if you're not in a funhouse dark environment (although it can balance your scene oddly). Consider pretesting your shirts under a UV source. I find that a folded piece of white typing paper is a practical thing to include in a camera bag. Use it folded to make it opaque, and photograph at least one image of this paper, shot in the same illumination in which you'll ultimately shoot your primary captures.

Here are some typical color temperatures:

Temperature	Ambient Lighting Conditions
20,000+K	High mountain open shade
9000–18,000K	A blue sky (the higher your altitude, the higher the temperature)
6500–7500K	An overcast sky
5300–5650K	Electronic flash
5500K	Daylight, around noon on a sunny day
5000–4500K	Xenon lamp
3400–3600K	"Golden hour," one hour before sunset or after sunrise
4000K	Warm white fluorescent bulbs
2750–3000K	A tungsten lamp, found in most homes (the lower the wattage, the lower the temperature)
3000K	Early sunrise or late sunset
1500K	Candlelight

Color temperature measured in Kelvin (K)

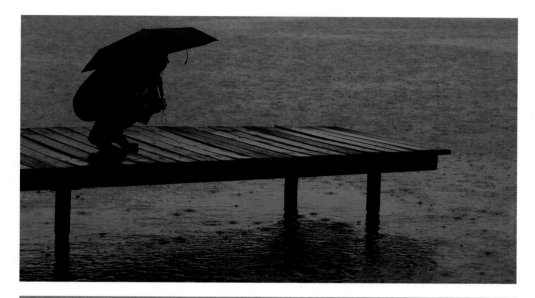

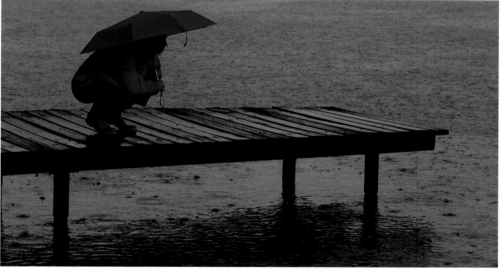

These two photos, shot within seconds of each other, illustrate how the photographer can use the Kelvin setting as a filter. The photo at top was shot at a white balance setting of 3000 Kelvin, usually thought of as a tungsten setting. I wanted the intense blue cast, normally used to balance out the extreme warmth of tungsten, to create a mood. In the photo at bottom, I shot at the white balance setting of 6000 Kelvin to warm the photo slightly. 50–200mm lens, 1/125 second at f4

■ As mentioned, use the white balance as a warming filter or a slight cooling filter by dialing in appropriate Kelvin degrees.

■ Use the custom settings on your camera if you intend to return to and shoot in an area that required an unusual white balance. This way, a twist of the dial will ready your camera immediately, so you can come in from outdoors and resume shooting in that room that uses fluorescent lighting.

■ Get your white balance (and exposure) correct while shooting! Photoshop is a powerful tool, but the more you have to tweak the photo file, the more you will negatively impact the quality of the final image. The old saying "garbage in, garbage out" holds true.

■ Now, after the preceding discussion, let me emphasize the power of shooting raw files. Most mid-level DSLR's on up are able to shoot raw and shoot it quickly. Without question, this file format provides the most power to the photographer. See Jay Kinghorn's Chapter 11 for a thorough discussion of raw.

Achieving Sharpness

Digital cameras often come with a setting to control the sharpness of the JPEG or TIFF image. This setting is actually an algorithm that the computer in the camera applies to the image. Be careful in setting the sharpness too high, as you will produce artificial looking edges in the photograph. Many, if not most, professional photographers do their sharpening in Photoshop, preferring to keep the camera on a medium setting while shooting. In the raw file mode, sharpening will *not* be applied to the image.

Nothing is nicer than a well-focused, sharp image, and this is one of the first things a photographer checks when viewing a photo. As with brightness, the viewer's eye seeks the area in a photo that is in sharp focus. Many factors impact sharpness, including unwanted movement, or shake, of the camera; improper focus; and depth of field. Often, a precise use of focus that intentionally causes an out-of-focus area is desired.

Sharpening Tips

A new aspect of the digital world is the ability to heighten the apparent sharpness of the image, either in the camera or during postprocessing in Photoshop. Some manufacturers provide a default file from the camera that, upon initial viewing, may not appear as razor sharp. Many pros want to sharpen their images in postprocessing, in the computer, believing that the microprocessor in the camera will not do as good a job as the full-blown computer application. Remember these tips when sharpening your images:

■ Don't do the sharpening in the camera; leave that to Unsharp Mask or Smart Sharpen in Photoshop or another sharpener application.

■ Never, *never* sharpen the original. Always work on duplicates, so you always have the original file to go back to.

Note For a more in-depth discussion of sharpening, see Chapter 15.

Contrast and Saturation

Back in the old days of film, a photographer could choose from various emulsions to achieve a specific look for an image. Kodachrome was the standard by which all others were judged for years; its accuracy was unparalleled. Velvia, the supersaturated transparency film, is a favorite of mine, though it's too saturated for some. I always thought it replicated how your memory remembered the scene, slightly exaggerated across its palette.

With digital technology, we now have the ability to "dial in" the contrast and saturation we require. This, too, is a function of the algorithms in the software.

Use the Histogram to Get Brighter Whites

The histogram is another powerful informational tool of the digital realm. It displays the distribution of tones in the digital image and resembles a cross-section of a mountain range. It can be displayed on your camera monitor, either separately or superimposed over the image just shot. The breadth of the range the histogram displays, from left to right, represents 256 levels of brightness—from pure black at 0 to pure white at 255. The "mountain peaks" tell you the number of pixels that are being used, or stacked, in that particular brightness level. The higher the peak, the more saturated that color or tone.

It's impossible to say that a perfect or normal histogram can exist, as the tones used depend on what you are trying to accomplish in your photograph. A histogram heavily weighted to the left, toward black, could, for example, appear for an image of a bow wave of a ship, the dark water and light wave tops each being correctly exposed. On the other hand, an Arctic explorer's face in the snow could be heavily peaked toward the right, the bright end of things. Often you'll have to decide whether the image works, regardless of what the histogram tells you.

As a camera setting, the histogram can be displayed immediately after shooting a photo, or it can be called up on the monitor via menu or button pushes.

The image on the next page is a good example of not reading the histogram literally. The wave in the image is lit well, and the background appears as it should. This image would not produce a "classic" histogram of the evenly spaced mountain range. Again, the histogram is *information*, not creative genius. As a tool, the histogram will tell you, with a fairly straightforward image, if the exposure is over or under, by indicating the location of the peak of the range. Adjustment to the exposure can be made at that point.

When you've gone into Photoshop and made Level or Curves corrections, the histogram displayed will be more evenly distributed.

Using the histogram's power, the photographer can check the exposure immediately to determine whether the photo is within the range the chip can handle. You'll often see "blinkies" in one form of

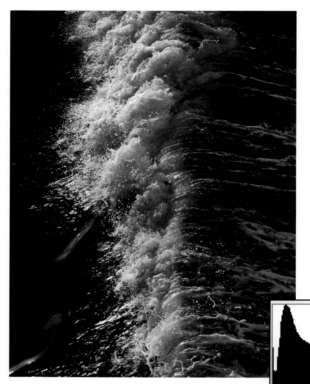

The bow wave of the *National Geographic Endeavour* is properly exposed: the highlight on the wave top and the dark water below are in their correct density range, yet the histogram is heavily indicating an overly dark exposure. This is a classic example of understanding that the histogram provides information relative to the image at hand—the photo is exposed well. 50–200mm lens at 69mm, 1/2000 second at f3.2, 100 ISO

the histogram—that is, a warning that the camera senses an overexposed area. This will literally appear as a small patch of white, overexposed area blinking to black on your camera monitor. The blinkies tell you that the chip cannot hold any detail in the blinking area when viewed or printed. Personally, I don't give the blinkies much attention, because I like to concentrate on the image at hand. However, if you are photographing a static scene, and not an event, this warning can be of tremendous benefit, as lighting and exposure can be adjusted or changed to eliminate the overexposed area.

UNDERSTANDING STORAGE MEDIA

Heading out on a *Geographic* shoot, I used to carry two bags on the plane: One held all my cameras, a full set of gear (discussed in depth in Chapter 2) that I needed to get the shoot done, a couple of camera bodies, necessary lenses, and a strobe. The other bag contained film. Lots and lots of film. If I was to be gone a month, this probably meant around 250 rolls of slow emulsions and fast, and possibly a bit of tungsten balance film for indoor

photography. It was a nice balance with the bags resting on either shoulder, about 25 pounds each. Added to the mix was having to get to the airport early to request a "hand check" on this mass of rolls, making sure the film never got too hot, and captioning each and every roll. Plus, I would regularly have to ship film in, partly to make sure no equipment problems would require a reshoot.

These days, I still arrive at the airport early, but there's no need to request a hand check on my digital media, as it will not be impacted by the x-rays used at the security check.

Several types of media are available to photographers now: CompactFlash (CF, the professionals' choice) and Microdrive, xD cards (developed jointly by Olympus and Fujifilm), Sony's Memory Stick (MS), Secure Digital (SD) cards, MultiMedia Cards (MMC), and SmartMedia (SM) cards. All these cards serve the same purpose in photography: they store images.

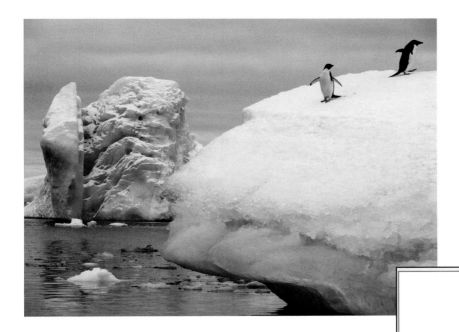

This image of penguins running for cover was shot in the Antarctic, and in the accompanying histogram, it would appear to be too bright, as the histogram is heavily weighted toward overexposure. This is where the histogram provides relative information with which you can react accordingly—here, the whites are not overexposed, and the darker areas are properly exposed. 50–200mm lens at 96mm, 1/400 second at f6.3, 100 ISO

A recent trend in digital camera design is the support of multiple types of media cards—the Olympus E-3 camera, for example, can use a CF or xD card, the newest Nikon D3x holds two CF cards, and the Canon EOS-1Ds Mark III holds a CF and an SD card. This second card allows the photographer to back up or copy an important image and provides additional storage.

A 16GB CompactFlash card

- **CompactFlash** Most professional cameras use this old-timer of the digital realm. The early version of CF cards is Type 1, and the next and current version is Type II (2). Type II cards are thicker than Type 1 cards. Be aware that the Type II holder in your camera can handle a Type 1 card, but a Type 1 slot cannot hold a Type II. CF cards are currently available in sizes ranging from 16MB to a 16GB monster, and these cards also are available in different write speeds, which dictate the speed at which the image is written to the card. The faster the write speed, the better. Upping the speed level, Lexar introduced the Ultra Direct Memory

Access (UDMA) card, and SanDisk created Extreme.

According to Jeff Cable, Lexar's Director of Marketing, "UDMA technology enables CF cards to reach blazing new speeds. The new Lexar UDMA cards reach speeds of 300x, which translates to 45MB per second. To take full advantage of these cards, you must use the cards in a UDMA-enabled device (camera, card reader, and so on). Many of the new DSLR cameras support UDMA, which means that they can clear their internal buffers faster than ever, and the newer card readers, such as the Lexar Professional UDMA FireWire 800 Reader or the Dual-Slot USB Reader, are UDMA compatible as well."

Note Cards of 2GB or larger generally are FAT32 compatible. (FAT stands for the File Allocation Table.) FAT32 supports large drives along with an improved disk space efficiency better than the older FAT technology, which used 16 bits to address each cluster, up to a maximum card size of 2GB versus the 816GB capability of FAT32. Your camera must be compatible with the newer FAT32 system to be able to use those larger cards. Check out Steve's DigiCams site at www.steves-digicams.com/high-capacity_storage.html for a more thorough discussion and reference to other great sites. Steve's site has links to Rob Galbraith's excellent site on CompactFlash, as well as manufacturers' compatibility sites.

- **Microdrives** While these cards have the same dimensions and physical looks of a CF card, they are actually mini–hard drives used to store images. These cards will fit in a camera that is capable of holding a Type II CF card.

Note While you'll save considerable money if you buy a 4GB Microdrive versus a 4GB CF card, the Microdrives do have an Achilles' heel. The drives are somewhat fragile, due to the moving parts enclosed, and are sensitive to hard bumps, drops, or other physical mishandlings. However, I do know photographers who do the same kind of work I do and have had no problems with their Microdrives.

- **Secure Digital or MultiMedia Card** These two cards are identical physically, but they vary internally. SD and MMC cards can be used interchangeably in some cameras, while others will recognize only the SD cards. These cards might be the wave of the future, offering connectivity between many devices, fast speed, and potential huge capacity.

- **Memory Stick** This Sony card is used primarily in Sony cameras and videocams and is available in sizes up to 4GB. The Memory Stick Select card allowed older Sony cameras to use a 256MB MS card by using a switch on the back of the card. Memory Stick PRO cards are the latest version, with capacities up to 4GB. However, unless you are using the Cyber-shot F717 that can utilize both types of MS cards, the Memory Stick PRO will not work in cameras that were manufactured before 2003.

- **xD Cards** A joint effort between Olympus and Fujifilm, these cards are very compact (about the size of a postage stamp) and have capacities of up to 8GB.

Note When using an Olympus camera, writing to an xD card is the only way to use the panoramic function.

Media Card Tips

A few years ago I was photographing my son, Matt, working through his Eagle Scout project as part of an assignment for *Boys' Life* magazine. This was early in my conversion to digital, and I hadn't had the opportunity to make the big mistakes and learn from those ugly processes. Sure enough, I had a major hard disk crash, with no retrievable files left of a number of images of Matt and his project—and I had not backed up those files. Learn from my mistake so you don't lose valuable photos! The following are some storage tips I've learned and tips I've picked up from talking to other pros:

- If you've bought a camera with 6, 10, 14, or 24.5 megapixel potential, make sure you use it! I hear amateurs say they are going to shoot smaller files on their cameras, SQs (super quality) or HQs (high quality), which will allow more images per card. But those space-saving 640 × 480 photos won't have the quality

to print that once-in-a-lifetime photo large. Camera media is relatively cheap; buy as large as you can afford. I always carry at least two additional cards as a minimum. Presently, I'm using 8GB cards in each camera.

- After you have downloaded images to your computer and to a separate CD or DVD (as part of that redundant storage), and you are ready to erase the card to shoot more, don't do a simple erase. Instead, do a format after reinserting the card. Your camera model will write specific data files to the card, and it's better to start clean with a card formatted for your camera. An erase leaves the data from prior uses on the card. Also, when placing a new card in the camera, format it immediately.

- Carry a "digital wallet" to store extra cards, both empty and full. Get into the habit of marking cards that have been shot as well as those that are empty. Lexar makes a great media wallet with mesh pockets topped with red and green flags. The flag with the red side showing indicates a used card, and the empty cards are flagged with green.

- Your camera purchase should be influenced by the card type. Is the card technology going to be around in five years? CF and SD are a very safe bet at this point.

- This sounds obvious, but write your name on whatever kind of media card you're using. I've seen photographers working

together on projects and inevitably media cards will be brought out for downloading. When five Lexar 4GB cards are lying on the table, it's a lot of effort to load, open, and determine which card belongs to whom.

The following definitions are applicable to both film and digital, and any photographer should fully understand them.

Depth of Field (DOF)

You will hear this term tossed around by photographers who are discussing their images. Simply put, *depth of field* is the *zone of focus*, from foreground to background, that is sharp. This zone of focus increases if you close down the lens to a larger aperture number (toward f22), and the DOF zone will become shallower the wider open you have the lens (f4, f2.8, or a smaller number). The focal length of the lens you are shooting with adds other dimensions as well. A wide-angle lens, 35mm or wider, will have a greater DOF than a longer lens.

As a rule, the wider the angle of your lens, the more DOF it offers. Conversely, a longer lens, from 50mm, to 85mm, to 120mm and so on, will give you shallower zones of focus or DOF. And this DOF becomes shallower and shallower with longer and longer lenses. A long lens with a shallow DOF is very often used for creative effect, and you can press a button, usually located on the front of the camera or lens, to close down the lens to the predetermined aperture so that you can preview the DOF through the viewfinder.

How Aperture and Shutter Speed Affect Exposure

Your camera lens has internal blades that open or close, allowing light in or decreasing the amount of light. These *f-stops* are represented by the numbers f1.4, f2, f2.8, f4, f5.6, f8, f11, f16, f22, and so on. Moving from one f-stop to the next doubles or halves the amount of light striking the chip. These numbers represent the ratio of the aperture's opening created by the blades to the focal length of the lens. The f-stops work interactively with the shutter speed to control exposure. In other words, the two factors that affect exposure are shutter speed and aperture. These are interrelated; to maintain the same exposure, the shutter speed is moved up accordingly, and the aperture is changed in the other direction. If the exposure is 1/125 at f4, and you want to increase the shutter speed to stop the action more effectively, then you could go to 1/250 at f2.8, or 1/500 at f2.

If you wanted to change the aperture to get greater or less DOF, and your exposure was 1/125 at f4, you could move the aperture to f5.6, and the shutter speed would then drop to 1/60, to maintain the same exposure.

Shutter Speed

I used to shoot NFL football, and my rule of thumb was to use a shutter speed of 1/500 of a second to stop the action. If I went to 1/250, a bit of blur would start to appear in moving feet and arms. Remember that the longer the shutter stays open, the more movement will be recorded.

Shutter speed can also be used for creative effect, using a long exposure—say, 1/2 second—to capture the effect of a lot of movement in the frame, such as people moving on the street. Another example would be opening the shutter in a long exposure to capture the rotation of the Earth shown by the stars streaking across the frame in a two-hour exposure.

THE GRAND MANTRA OF PHOTOGRAPHY: *THERE ARE NO RULES*

I've seen phenomenal photos taken with $7 disposable cameras, and—at the other end of the photographic spectrum—we've all seen the beauty of Ansel Adams's exquisite environmental images. Modern "edgy" photography, the catchword of editors requesting the latest look, has created wonderful images. I really think the bottom line in photography is this: Does it work? Does the photo convey the message the photographer is trying to express? Photography is a totally subjective craft; what I think is great, you may think stinks, and vice versa.

As I said earlier, the camera is a tool. The better we know our tools, the easier our work is—and the more we can focus on our craft and not the mechanics.

How To: Panoramic Photography

It's almost impossible not to be impressed when viewing a well-shot panoramic photo. This format brings to the viewer a version of reality that cannot be revealed with the human eye, and this is part of the fascination. Creating panoramic photos has become easier with today's software and, in some cases, with the cameras themselves.

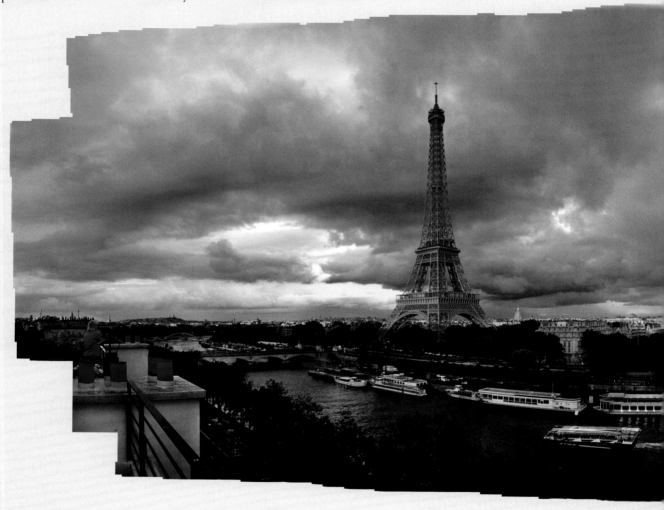

As I shot from the balcony of a friend's apartment in Paris, the only way I could do justice to this amazing panorama was to shoot a number of images, stitch them together, and work on the final file in Photoshop to brighten up the dark foreground and bring down the value of the sky. I even like the rough edges, caused by my not shooting a perfect circuit of images. 12–60mm lens at 24mm, 1/60 second at f5.6, 100 ISO on each frame

Your first attempt at a panoramic may result in an image only a mother could love—the component images do not "stitch" together well, a bit of wide-angle distortion may create a slightly warped look, and the sky may have some unusual dark areas. But you will be so elated with the final product, that these issues can be overlooked—that is, until you pull off a really good one.

Here are some tips that should be helpful for any photographer, from an informal shooter who just wants to put together a panoramic view of a vacation site, to the very serious photographer who wants the image's construction to be transparent and flawless.

- *Use a tripod.* This can help keep the camera on a true horizontal axis, allowing greater accuracy of the stitching. This also allows the camera to swing on a tighter axis. A bubble level or a self-leveling tripod can be of immense help to keep the line of the horizon so that the image doesn't "drop" down, which is caused by the camera not being level.

- *Don't shoot wide angle.* This is one of the most common errors photographers make. The distortion of the wide-angle lens makes for an uneven and distorted horizon line. Use a *minimal* lens length of 35 to 50mm.

- *Think about shooting vertical.* This provides more depth to the image, and it lets you shoot just a few more frames to complete the breadth of that panoramic image.

- *As you move the camera across the scene, be sure to allow a 15 to 25 percent overlap of each image.* This provides a "fudge factor" that allows the software to combine the images without encountering gaps where the images are not quite wide enough.

- *To help the stitching process, and to make sure that each image is perfect in terms of joining its neighbor,*

learn about the nodal point of your particular lens. This is not a necessity, but it makes things a ton easier when you're putting the images together. The *nodal point* is the area within the lens where the light rays cross before striking the chip. If you have the camera mounted to a tripod and tripod "pan head" that allows adjustment for the nodal point, each frame will intersect more perfectly with the preceding and following frames.

Each lens is different, as is the nodal point on varying lengths on a zoom lens. Here's a fairly easy way to determine the nodal point:

Step 1
Mount the camera on a tripod that has been leveled.

Step 2
Looking through the camera, find something vertical in the frame that is close to the tripod (within 4 to 15 feet). Also, find a second vertical component in the background, at a greater distance than the up-front reference point. These two verticals (telephone poles, fence poles, or buildings) should be almost lined up, with very little space between.

Step 3
As you rotate the camera, watch how the perspective on these two vertical poles changes. It will start out pretty close, and as you swing the camera around, the distance between them will change.

Step 4
Using a nodal point head, move the camera back and forth on the rig while looking at that scene, until those two vertical poles maintain their perspective throughout the arc of movement.

Step 5
Lock down the rail, and you have established the nodal point for that particular lens perspective. You can then start photographing the different images that will make up this panoramic image, knowing that the overlap of images will be smoother and more consistent.

Putting the Images Together

After the shoot comes the part that seems magical—putting those separate photos together to create a sweeping panoramic landscape. Olympus has actually integrated the technology of the xD capture card with the Olympus Master software, which walks the photographer through this process from capture, by providing site "guides" in the camera, so that when it's switched to the panoramic mode, the software is told to stitch the images together.

Here's how to do it in Photoshop and Photoshop Elements:

Step 1
After capturing and downloading the images, use the Bridge or some other photo editing software to select the images you want to stitch together.

Step 2
Open Photoshop and choose **File > Automate > Photomerge**.

Step 3
In the Photomerge window, you will see several options. On the left side of the window, under **Layout**, you'll see five choices: Auto, Perspective, Cylindrical, Reposition Only, and Interactive Layout. Choose **Auto** to make the final image look both pleasing and natural.

Step 4
Under **Source Files**, choose **Browse**, which will allow you to find the files you want to open. Select all the files you want to use.

Step 5
These files will then appear in a dialog box in the center of the Photomerge window.

Click **OK** in the upper-right corner, and the magic will begin.

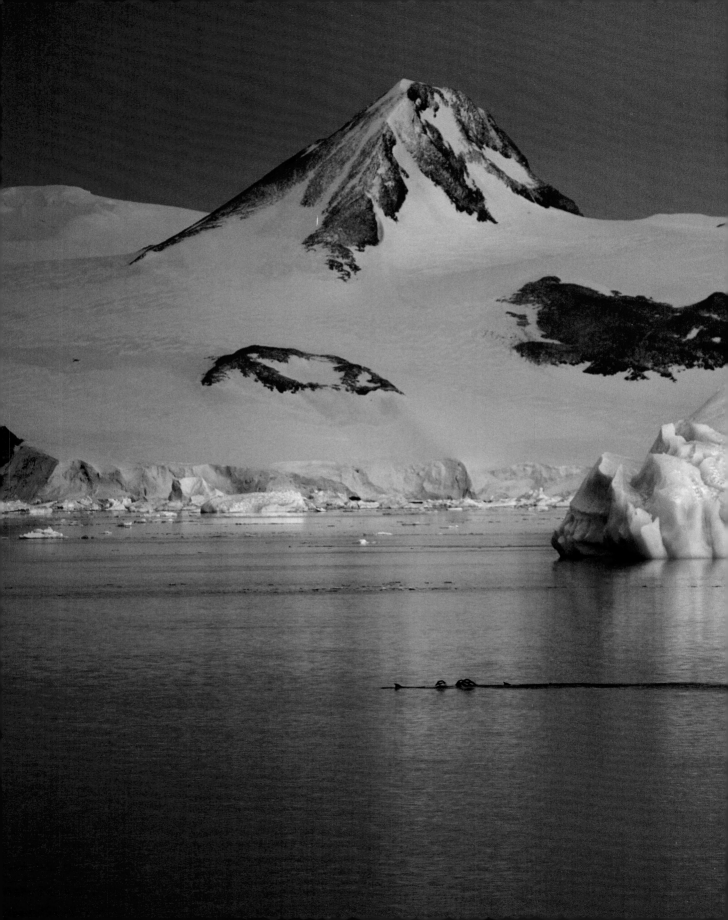

UNDERSTANDING LIGHT

Available light is any damn light that is available!

—W. Eugene Smith

Edward Hopper's painting *Nighthawks* is as representative of the realist movement in American paintings as any work in that genre. College students have posters of the painting hanging in their dorms, and it's been reproduced so many times that it has become an iconic image. The painting, a view into a well-lit diner from the gloomy outside street, is an excellent example of

My first opportunity to travel to the Antarctic was aboard the *National Geographic Endeavour* as the "expert" on this ship. My job was to make myself available to the expedition travelers, providing my expertise and advice on all things photographic. It was an exhausting trip, as the light was stellar for most of the day, with early morning starting at around 4 A.M. and sunset occurring near 11 P.M. In the entrance to Terror Gulf, we passed the sensory overloading scenery of the Antarctic Peninsula. Everything started coming together—the boat slowly passing the peninsula, an iceberg moving into position, and penguins "porpoising" through both air and water in graceful leaps. Rays of the sun illuminated the rugged peaks in the background and painted the edges of the iceberg, its blue ice electrified by the light. 50–200 lens at 158mm, 1/160 second at f3.5, 125 ISO

how adding or removing light affects an image. Starting with a white canvas, and adding dark colors intersected by coldly bright hues, directs the viewers' attention to the stark and fluorescent-lit interior of this lonely place.

The photographer does the same within his or her own "canvas," adding, removing, and controlling the light to "paint" the subject. Without light, we wouldn't have much to work with. This chapter deals with different types of light and the issues of controlling and/ or creating light.

The camera allows light in to strike its sensor, recording the image. Too much light, and the image is washed out; too little light, and the image is too dark to make out. The correct amount of light is the correct exposure.

The streets of central Loreto, Baja California Sur, Mexico, are colored a deep and rusty red. I was working with National Geographic/ Lindblad Expeditions, when we came upon a street crew paving a new stretch of road. I watched them work for a while, and as the late afternoon light improved, the workers began tossing red powder on the surface of the wet concrete to embolden the hue. I love the look of the powder floating away from this fellow's hand. The backlighting emphasizes the structure and provides definition to the dust as it rolls off his fingers. 50–200 lens at 200mm, 1/500 second at f5.6, 100 ISO

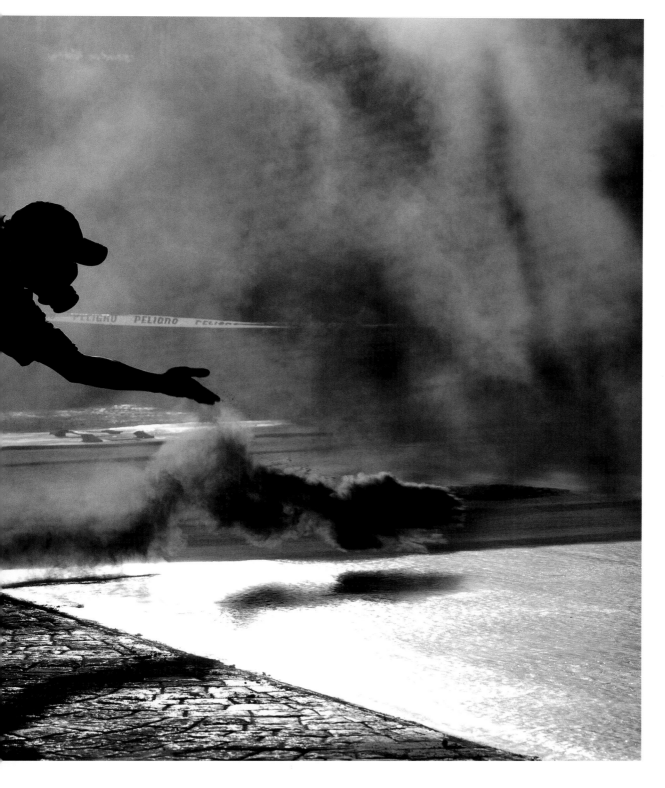

The Viewfinder Is Our Canvas and Light Is Our Paint

Available Light

Available light is the most common form of lighting that all photographers use. If we're shooting outdoors, available light is the light from the sun or other available sources. Indoors, it's the light provided by lamps and other light sources in the room. Using the available light to your benefit is the key.

We have at our disposal six "flavors" of available light:

- **Frontlight** This is the light coming over your shoulder and falling on the subject. Frontlight creates a flat, often dull light. If you want to shoot in frontlight, try moving around the subject so the light comes more from behind, and try using a flash.

- **Sidelight** As the name implies, this light comes directly from the side. Great for landscapes and scenic shots, this light is pretty severe for people pictures, unless you're trying to emphasize character in a face (lines, crags, and the like). Be kind here, because you want to be remembered in Aunt Bettie's will. This being such perfect light for landscapes, as it creates dimension in your photos, you can perhaps include a person in the shot to provide a sense of scale, placing him or her at the edge of the shot, and shooting wide—just establishing the human presence.

- **Toplight** Noon, with the sunlight illuminating the subject from the top down, is not a favorable light for photographing people, because it creates harsh shadows and tends to be colorless. This is a *great* time of day to scout areas, however, so you can decide when to come back. If you have to shoot in this light, use a graduated filter, which will help saturate the sky's color and create a bit more interest. It's also a great time, if you are photographing Aunt Bettie, to use the on-camera flash to "fill" the harsh shadows with light.

- **Backlight** This light comes directly from behind and can create an ethereal look, emphasizing the spray in ocean waves, adding depth and magic to smoke, and creating halos when used in portraits. This is wonderful light, but it does weaken the saturation of color. Try popping in a little flash to bring up the light on the backlit side and strengthen the colors.

- **Overcast/shade** This is one of the kindest types of light for photographing people. Clouds create a giant "soft box," softening the light and smoothing out the skin. This light also helps out the exposure, as the dynamic range of light that the chip can capture is within range; often side/front/toplighting will provide an exposure range greater than the sensor can capture in the frame.

- **Twilight** Twilight can be the "magical hour" for taking great shots. The sun has nearly or just passed the horizon, and

the ambient (aka available) light starts moving toward the blue range. Shooting on a daylight setting will emphasize this effect, but do *not* set auto-white balance, because that will remove this cool/cold effect. Try setting the camera to the correct exposure, manually, for the scene, and then use a strobe to fill-flash the subject. This will create a wonderful dichotomy in light—the warm light from the flash and the cool ambient light.

The Golden Hour

It's noon at the Grand Canyon. Everyone is standing in herds on the South Rim, photographing the giant expanse of canyon. The noon light is sterile, with no character of its own—yet this is the most common time that the tourists turn out. Inevitably, their images are a disappointment—horribly bright and with a lot of contrast, almost monochromatic images.

This scenario is a perfect introduction into a discussion of *The Golden Hour*. The light during this magical time, the hour before sunset, produces a gigantic warming filter, and it's almost difficult *not* to take a good photograph in this environment. One benefit of air pollution is that light passing through all that crud in the air is softened and warmed, creating a beautiful glow.

I'll often arrange shoots so I can benefit from this great light, which occurs not only in the early evening, but in the early morning as well. Shooting at either of these times can result in better photos. I like shooting in the evening best, not only because I don't have to get up at the crack of dawn, but because, as night approaches, the light keeps getting better and better, reaching its crescendo in the final minutes before the sun touches the horizon. The photographer working in the late afternoon/early evening light has the opportunity to work the subject, moving around the shot to find the best place to be when the light reaches its peak. Early morning light is also beautiful, but we have to be in place as the sun crests the horizon, and the quality of light deteriorates the longer we work into the morning, away from the crescendo that occurs at the moment of sunrise.

Back to that scene at the Grand Canyon; I'll head out for these scenic vistas and other "photo-op spots" in the late afternoon or early morning, and I'll usually be shooting alone or with little company, save for other serious photographers. The tourists are filling the restaurants or sleeping in (which *is* one of the benefits of a vacation). However, with just a little rearranging of their schedules, these folks could make time for visiting spectacular views that coincide with The Golden Hour.

Chimping

Most experienced digital photographers are familiar with the term "chimping." Not a reference to our Simian cousins per se, but it does take on one characteristic of those critters.

The next time you are at a function that may draw a number of digital photographers, say a sporting event, watch the clutch of photographers from the sidelines. After a play

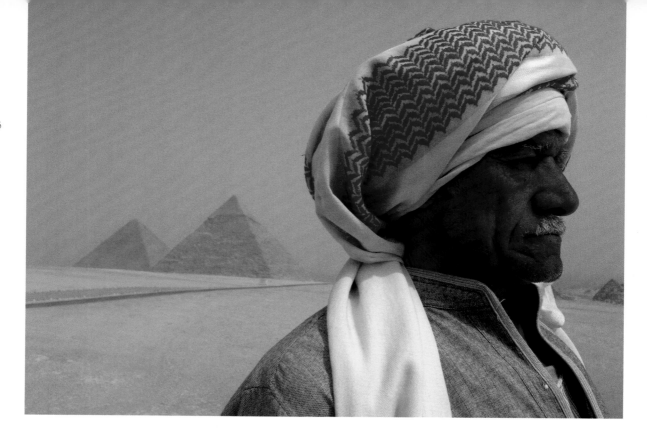

It's always great to be able to photograph in the best light possible, but sometimes that's not realistic. This was the case on a shoot in Cairo, Egypt, when I had a very short window to photograph the pyramids—at noon, not a good time of day. I ran into this fellow at a classic overview of all three Pyramids…and I had less than three minutes to figure out a photo as our bus was leaving for the airport. Hours before there had been a sandstorm in the area, and enough of the particulate matter was still hanging in the air to cause a diffusion of light. I placed him looking out of the frame, positioning him asymmetrically with two of the three pyramids, finishing off the composition. The overhead and diffused light worked in my favor in this simple portrait as the sand-filled air acted as a giant "lightbank," causing a soft and flattering light. 12–60mm lens at 20mm, 1/80 second at f13, 100 ISO

is over, you'll see a number of those digitally-equipped individuals direct their vision, and attention, to the monitor on the back of their digital cameras. As their latest and greatest work of art is displayed on the screen, you can almost hear the "Ooh, ooh, ooh!!!" utterances of admiration coming from their lips over that image.

This is all well and good when photographing an event that has a defined start and finish of action, but it can be a habit that mistakenly diverts the photographer's attention from the subject they are photographing. There's nothing worse than snapping the shutter at what you think is a perfect moment, stopping to admire your work on the monitor, look up to see the real moment occur before your eyes, and then not have the camera ready. So remember, no chimping!

Tips for Golden Hour Photography

Here are a few hints for using that Golden Hour light:

- Add the tiny strobe atop many consumer and prosumer cameras to the mix of Golden Hour light, and you have the recipe for successful people pictures.

- Plan your day to make the most of The Golden Hour. Use the middle part of the day to scout and reconnoiter the area to determine where you want to be during the late afternoon.

- Use a compass! I always carry one in my photo vest. A number of websites offer exact compass points for finding the location of sunrise and sunset from your present or projected location. Carrying this information, along with a compass, can help you choose your spot with the knowledge of where the solunar event will occur (sunrise or sunset, I mean).

- I also carry a page I've printed from the website of the US Naval Observatory, "Sun or Moon Rise/Set Table for One Year": http://aa.usno.navy.mil/data/docs/RS_OneYear.php. This information tells you, for a specific domestic or international location, the exact times of sunrise and sunset. Another great site for determining sunrise/sunset in addition to moon phases, moonrise, and moonset is www.sunrisesunset.com/custom_srss_calendar.asp.

Guadalupe Peak is the tallest mountain in Texas, at 8479 feet. This image was shot for *Texas Highways* magazine, part of a story on the "Seven Great Wonders" of the state. I found pilots George West and Richard Davies to fly me over the rugged terrain shortly before dusk, so I could take advantage of the low setting sun to emphasize the structure and striation of the landscape. I intentionally included the wing of the Cessna because I thought it provided a bit of human perspective to this stunning landscape. 12–60mm lens at 12mm, 1/250 second at f5.6, 200 ISO

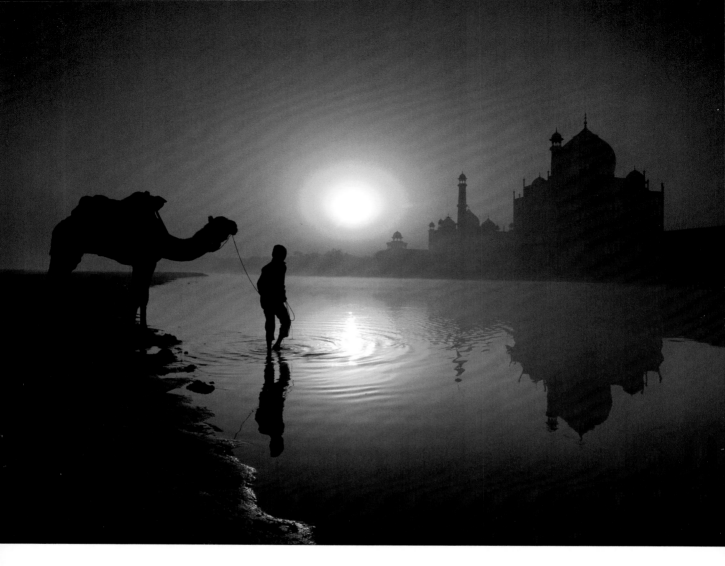

One of the most beautiful monuments in the world and one of the most thoroughly photographed sites, the Taj Mahal in India is a challenge for the photographer to come up with something different. I was part of a National Geographic Expedition, the Taj being one of the stops. Pre-dawn, I gathered a group of the photographically-driven Expedition members and headed out to photograph the building. I'd been there before, and I knew there is a classic vantage point just across the Yamuna River. We arrived early, photographers spreading out to capture dawn from different angles. Shortly after the sun rose, this camel driver appeared, taking his camel to drink for the Yamuna. The scene was illuminated by the heavily-diffused sunlight (pollution is good for something—adding so much particulate matter to the air, acting as a giant "lightbank," softening and warming the harsh light), but I still had to use a Singh Ray Galen Rowell Graduated Neutral Density filter to allow the exposure on the foreground to balance out the brighter exposure value of the sky. 12–60mm lens at 12mm, 1/500 second at f6.3, 100 ISO, Singh Ray Galen Rowell 2-stop, hard step Graduated Neutral Density filter

■ Take a tripod. To quote the Boy Scout motto, *be prepared*. You may want to extend your shooting into the evening hours, and there's nothing more frustrating than not having a simple piece of gear that can make a huge difference in your ability to keep shooting.

■ A graduated filter can make the difference between a successful shoot and one that is *almost* there. A scene where the sky is brighter than the foreground is the perfect situation for this type of filter. These filters are dark at the top, graduating, either sharply or in a soft change, to clear at the bottom. This allows the photographer to capture the bright sky and the darker foreground in the frame; without using a filter, this would be impossible, due to the great difference in exposure in those two areas. Singh-Ray makes some very good filters; I like them because they are rectangular and can be moved up and down in front of the lens, giving you far more control over where the impacted area will be (see www.singh-ray.com/grndgrads.html). The Singh-Ray filters can be purchased in varying degrees of density, from one stop all the way to five full stops. The filters can also be purchased with different colorations for different effects.

Note: Filters should be oriented with darkest edge at top
Singh-Ray Galen Rowell Graduated Neutral Density - (L) 2-stop soft-step. (R) 3-stop hard-step

Singh-Ray graduated filters, seen in both hard step and soft step. The hard step is for an exact horizon line, and the soft step is for a more subtle change. Photo courtesy Singh-Ray

■ Many photographers carry a neutral density (ND) filter. This filter reduces the overall amount of light entering the lens. Why not just stop the lens down? If you want to use a low ISO setting and shoot a slow exposure, perhaps a waterfall at midday, using an ND filter is a great idea.

NDs can be purchased with one, two, or more stops. Singh-Ray sells a Vari-ND filter that allows the photographer to dial in the amount of reduction infinitely from one to eight stops.

The same neutral density filter, Singh-Ray Vari-ND, offers three phases of controllability.

Sometimes the Simplest Light Is the Best

I always carry a flashlight with me for lighting purposes—just a small one, either a standard bulb or a halogen, with an adjustable beam. A flashlight can offer a spot of light for a dramatic effect. I was on Alaska's Yukon River, working for National Geographic, photographing a story about the river. The day was cold and dark, and the village, Kotlik, was nearly empty. This was an important village in that it is the last outpost on this mighty river. An old man walked by and I started a conversation with him. Turns out Tom Prince was the oldest

man in the village, and I felt that warranted a photograph. I wanted to maintain the icy cold, blue look of the scene, so instead of using a warming filter or white balancing the blue out of the frame, I shot it as is, a daylight balance, and lit Tom's face with my flashlight. The exposure was about 1/15 of a second; I had to move the flashlight slightly to smooth out the light. The effect is exactly the look I was hoping to capture. His face is very warm, tending toward an orange-gold, because the flashlight bulb provided a tungsten light source, and I knew that it produced that warmth when recorded on a daylight-based setting. The village in the background appears in a bluish cast, which is exactly what I was after.

Cloudy days can provide a beautiful soft light that is ideal for close-ups of people. The light is very kind to human complexions, and your subjects' eyes won't be squinting, as they can be when the subject faces the sun.

Dynamic Range

The human eye is amazing in its adaptability. We look over a scene, and our eyes are able to see the full range of light, from shadowed areas to the parts lit by full sun. The eye has the ability to see a dynamic range, or ratio of dark to light, of about 100 to 1, where the camera sensor is able to see a range of only about 10 to 1. Photographers are often surprised when they look at their images and the shadows are totally black or the highlights are completely washed out. The histogram on the back of the camera can display the five-stop range that the sensor can cover.

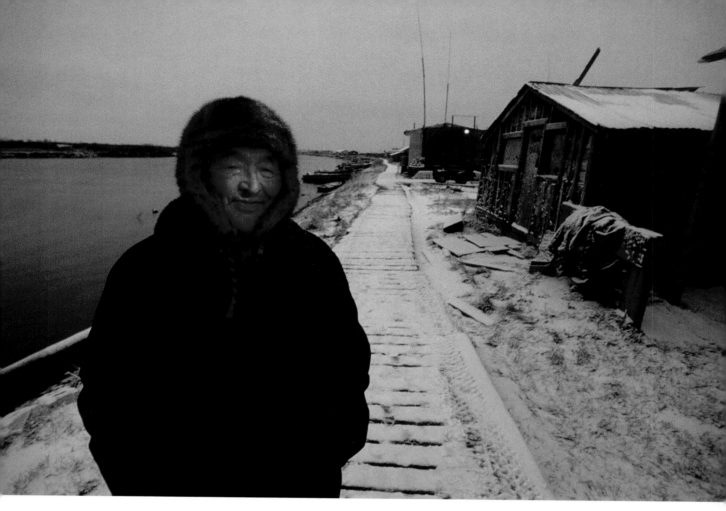

Tom Prince is the oldest fellow in Kotlik, Alaska, the last village on the Yukon River. I used a small flashlight to illuminate his face. 20–35mm lens, 1/15 second at f3.5

We can now address the limited dynamic range of the camera by using software packages featuring High Dynamic Range (HDR). The photographer captures several different exposures, exposing the first for the very darkest areas of the photo, with the next frame closed down one or two stops, and so on, until the final exposure captures the very brightest area in the photo. Using HDR, the software "averages" the images together, using the broad range of exposures to create an image that more closely matches what the eye is seeing. The power of this is that the photographer can create an image with an even greater dynamic range than the eye can see.

1/125 second at f4 1/15 seconds at f4 1/2 second at f4

 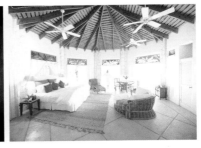

These three images were "combined" using Photomatix Pro, one of several software applications specifically built to blend or "tone map" HDR images. I shot the first image exposing for the brightest area outside, another exposing for midtones in the interior, and the last exposing for the shadowed areas of the cabin. The final image shows a dynamic range far greater than the sensor could have captured in a single frame. All images shot with 7–14mm lens at 7mm, 100 ISO

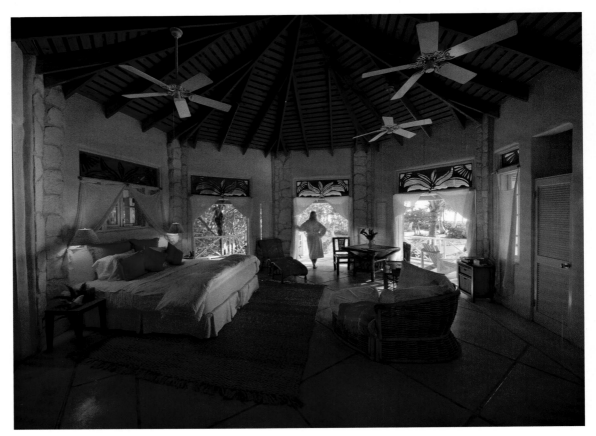

The final image, a combination of the three images

Reflectors

A reflector offers an easy way to add a little light to a face in the shadow to bring interest to the subject. I always travel with these tools, and I use them often. Sometimes, all it takes is just a little bit of extra light thrown in somewhere to make the picture work. You want your photos to be noticed for the image content; you don't want a viewer to comment that you've used too much/too hard/too unflattering light. This is often a case for simplification of the lighting—a little strobe fill, a little reflector fill.

Reflectors can be as simple as a piece of paper used to redirect, or bounce, light into the desired area. If you're photographing flowers in a field, try using something as simple as a piece of paper to reflect, or bounce, light into a shadowed area of the scene. This simple trick can take an image from ordinary to exquisite.

Reflectors come in lots of styles and sizes—from models small enough to fit in your pocket, to those so large they require an assistant, or two, to set up. In my car, I carry four reflectors: a large one, 54 inches across, that comes with a reversible cover and provides five functions; a medium-size one of the same type; a very small one that folds to about 6 inches across and fits in my vest pocket; and a large scrim, used to soften the light. All of these fold to smaller sizes and are very portable.

Here is a list of reflectors that you may want to make a permanent part of your shooting kit:

- **Large** A 54-inch reflector is large enough to bounce light back and cover a standing person, or it can be used for portraits. The benefit of the 54-inch size is the softness of the light reflected from such a large area. Move the reflector in for the softest light. Seem like a contradiction? It's not—the closer a light source, the softer the light will be. Think of moving away from the subject with the reflector, until it's about the size of a flashlight from the subject's perspective. The light would be very focused, from a very small point. This type of reflector offers several options, and your choice on which option to use is a matter of taste. One side is a solid gold color that reflects a very warm light. This side reflects about 85 percent of the light, which can be too warm when shooting people. The next side is usually a gold/silver mixed surface that is not as warm as the solid gold, and is a bit more efficient—about 90 percent in the amount of light it reflects. The solid silver side reflects about 95 percent of the light, but this light can be a little too harsh. The other side may be black, which can be used to reduce light—if, for example, you're shooting a portrait and a bit too much shadow appears on one side, the black side can be placed on the side of the subject to cut down on the light.

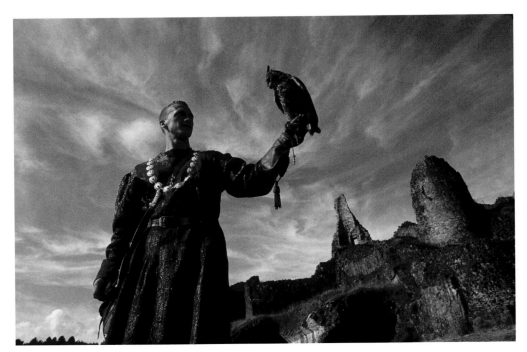

As a mentor for an American Photo Mentor Series trek, I was visiting Belgium's Ruins de Montaigle fortress for an early morning private visit. I wanted to show the trekkers how much impact a reflector could have on a photo. This photo is shot without any additional light, either flash or reflector. It's a nice photo, nothing special.

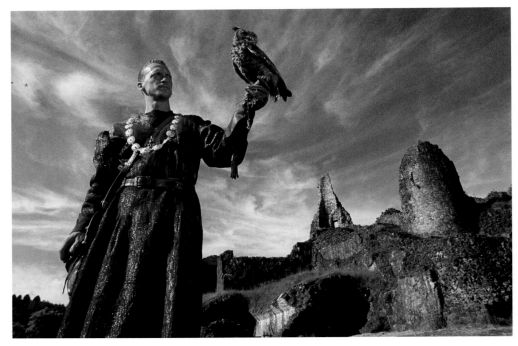

The same scene, with the addition of a reflector that bounced light into the shadowed area of the falconer's face and on the falcon. This light opens up the photo, making it much more interesting. 17–35mm lens, 1/125 second at f5.6

Medium The medium-size reflector is used in situations for which a little harder light is desired—say you are photographing your pet black lab. The large reflector would provide such soft light that the dog's black coat would absorb a lot of the light; this is an ideal situation for a smaller reflector that creates a more direct light source, effectively brightening his coat.

Very small A small reflector is easy to keep with you always, because it fits in a vest pocket or in the pocket of a camera bag. When I was on an assignment photographing scientists collecting bugs on the Amazon, I needed a simple light source to use for shooting the bugs they collected. This small reflector (about 12 inches across, unfolded) worked perfectly. I could get it in close, and it could be pivoted to create the exact light I needed.

Scrims These are a Hollywood favorite, as their purpose is to soften a direct light source, which is very nice for portraits taken on a direct-sun day. Open the scrim, have your assistant (spouse, traveling companion, innocent bystander) hold it in between the light source, such as the sun, and the subject. It creates a very pretty light. I often use a scrim to soften the direct overhead sun, and I'll use another reflector or flash as my main light. This is called controlling your environment.

Understanding light does not always mean working with an abundance of light.

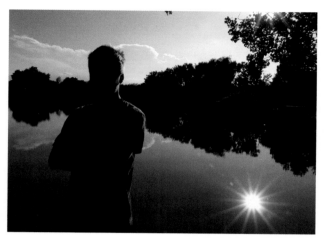

Often, simply using your flash in midday light will make all the difference in a photo being a disappointment, as shown here, or...

...a success, as shown here. Balancing the foreground and background is necessary, and this can simply mean pointing the camera at the general scene in the background, and holding the shutter button halfway down to lock in the exposure. Then, with the flash set to TTL (Through the Lens), point the camera toward your subject and press the shutter. 11–22mm lens, 1/60 second at f5.6

At times you'll want to use the selective ray of light coming through a window to partially light the subject's face and create an air of mystery. This involves seeing and thinking out of the box. Watch a professional work a scene; he or she will work harder at getting the lighting right than at just about any other aspect of the picture-taking process. Light is everything.

FLASH, ON OR OFF CAMERA

The flash can be either the most overused tool or the most underappreciated feature of the camera. Properly used, a flash can fill in harsh shadows and turn a ghastly lit midday photo into a pleasing portrait. Here are some tips for using your in-camera flash or accessory flash:

- If shooting at midday, turn on the flash and allow it to fill the shadows, creating an evenly lit image. You can use your camera's Program mode for this: go into your flash control and turn it on; it's usually indicated by a lightning bolt icon. Or, in Manual mode, turn on the strobe and set the exposure to the ambient light.

- If using an off-camera flash, consider purchasing a remote cord. This lets you move the flash off to the side, and this trick alone will either eliminate or dramatically lessen the effect of red eye. Red eye occurs when light from the flash bounces off the back of the subject's eyeball, creating an image in which the subject sports bizarre red eyes.

- Try bouncing the light—if you are shooting inside a place with a roof of a normal height and a colored light source, you can point the flash toward the ceiling during shooting. This disperses the light, flooding the scene with it. It creates an image with a much more natural look than direct flash can provide, producing a more even light across the frame.

- You can also use a "bounce card," which can be as simple as a piece of white paper taped to the strobe (make sure the paper is on the backside of the flash, from the perspective of the subject). This setup still uses the flash bouncing off of the ceiling, but it will direct a wee bit of light directly on the closest subject. This creates a nice fill light, but it still takes advantage of the light illuminating the area—providing a much more natural look. LumiQuest offers several bounce devices as well as mini light boxes that fit on the flash. I always carry the ProMax 80-20, a reflector that I can attach to my strobe; it allows 80 percent of the light to hit the ceiling, with 20 percent used to fill in shadows on the subject.

- Get really creative and use the flash with a reflector. Have your fabled assistant hold the reflector to direct the light just to the side of the subject's head or torso. Then, use the flash as the main light. With this method, you can create a more "dimensional" light source. Try not to go overboard with the reflector—just bring up the level of light, or use it to light a shadowed side of your subject.

In the old days of film, many pros using hand-held flashes would tape a filter over the business end of the flash. I kept a very soft gold colored gel attached at all times to "warm up" the light a bit, and this helped quite a lot, by making skin tones look more natural. Inherently, flash light tends to be a bit blue. You can acquire little sample packs of filters from many theatrical lighting companies, or some top photo shops carry them. I carried the Roscolux filter pack. Conveniently, they fit perfectly on many popular strobes, with no cutting necessary. Many different samples of the full range of lighting filters are included, so don't limit your experimentations to one.

This inexpensive pack of theatrical filter samples makes a perfect warming/cooling/softening filter that will fit over the business end of an external flash. Use a little electrician's tape or gaffer's tape to secure it. Don't use duct tape, as it will leave sticky residue. Gaffer's tape (available at the same theatrical supply or pro photo store) will not leave a residue, even under heat.

The LumiQuest ProMax 80-20 device attaches to your external flash with hook-and-loop fasteners; the reflector can be attached quickly or pulled off at a moment's notice.

In the digital era, the effect of this trick is usually white balanced out. However, if you are shooting in Raw, this will work. Remember that Raw is how the scene looks, and white balance will not impact the file, so the effect of filters on the lens of the camera, or on the strobe, will be recorded.

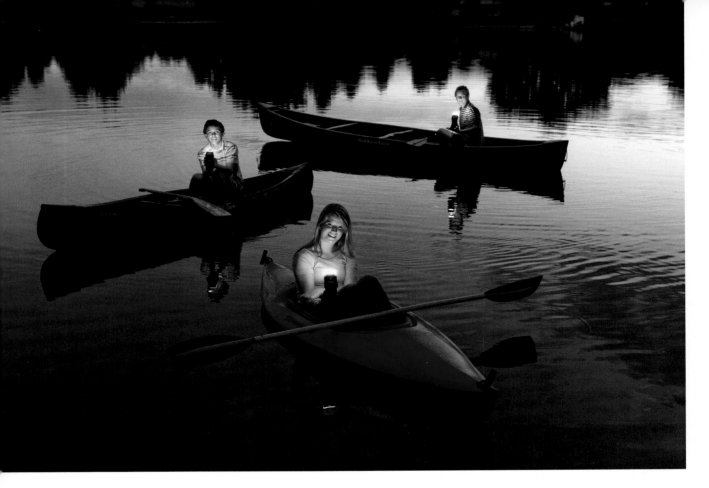

Kids, don't try this at home! One of the last places a photographer likes to use flash units is around water: splashes can cause short circuits that fry equipment, and cords are everywhere—the list of potential problems is long. By using these self-contained flash units, however, I was able to control the light output on each strobe using the TTL capability of the flash. To get this shot, I set the camera to the onboard radio controlled mode to get a window on my camera's LCD panel that allowed me to set my controls on each flash unit. Then, using the onboard flash of the camera to trigger the flashes, each unit fired a precise amount of light on the boaters' faces. 12–60mm lens at 23mm, 1/30 second at f4, 200 ISO.

Remote Radio Controlled Flash Photography

High technology has empowered the photographer greatly with the advent of the radio or infrared remote controlled flash unit. Olympus, Nikon, and Canon now offer these sophisticated, small flash units that allow the photographer to control, remotely and without any wiring connected to the camera, a large number (10-plus) of remote flash units for complex, sophisticated, or just fun lighting setups. Using this technology in a photograph of boaters, I was able to place three strobe units with people in three different boats, and I controlled the light output from the camera on each strobe unit. Remote control certainly opens up an entire world of lighting possibility to anyone interested in this style of photography.

A Bit of Control from the Menu

Within the menu on digital camera are white balance settings, which can be used as a "filter pack" of sorts. The white balance settings offer different Kelvin degree settings (the standard by which we measure the temperature of light), which are represented on the menu by several icons. The light bulb icon setting represents 3000K. In Kelvin degrees, the lower the temperature, the warmer the light, and the higher the temperature, the cooler the light. A fluorescent bulb icon represents 4000K, and other fluorescent bulb icons represent 4600K—the 4000K bulb being close to daylight, the 4600K bulb creating the ugly green cast seen under that particular lighting. The 5300K setting is considered the daylight setting; 6000K is a setting for cloudy conditions; 6600K is yet another fluorescent setting, closest to daylight; and near the top of the thermometer, 7500K is used to offset the extreme bluish cast that shadows in the sun will create.

How is this like a filter pack? On a cold and rainy day, you might want to capture an image that emphasizes the cold feeling by "pumping up" the blue setting. Press the WB (White Balance) button, and set the camera to 3000K, which is a tungsten light setting. Tungsten light, common in house lamps, produces a very warm coloration, and the 3000K WB setting neutralizes that by adding blue. So if you use the 3000K setting in an outdoor scene, you add blue, or a certain moodiness, to the image.

Conversely, you can set the WB to 6000K, adding a lot of warmth to the photo. Remember that this setting is a default for shooting in open shade—a very blue lighting condition—and the camera will actually use a mathematical algorithm to correct that color cast by pumping up the warmth.

Tips for Using White Balance

- When shooting in an area with tungsten lighting, set the WB to 5300K, the setting for outdoor light. This will record the light from those lamps in very warm mode, which in a home setting creates a warm and toasty atmosphere in the photo.

- If you're shooting on a rainy, cloudy afternoon, you can emphasize the cold feeling by setting the WB to 3600K, the setting for indoor light, to create a cooler environment in the photograph.

- Don't use the auto-white balance setting; this takes away much of your control, as the function of this setting is to take the predominant white area in a photo and make it whiter. If you are shooting in a beautiful Golden Hour situation, the WB auto setting will often "correct" the golden hue right out of the photo. If the light is a very strong gold, use a 5300K daylight setting or a 6000K cloudy setting.

INDOOR LIGHTING

Generally speaking, our homes are not quite as bright as the outdoors, so when the photographer moves indoors, ISO is a good way to deal with the lesser amounts of light. ISO settings increase the speed, or sensitivity, of the chip to light. The higher the ISO, the more light sensitive the chip—or, to be more accurate, the camera uses ISO algorithms to increase the sensitivity. This allows us to photograph in darker environments at higher shutter speeds. ISO 100 will not work, for example, if you're trying to photograph an indoor sporting event and capture frozen action. The beauty of digital is that we can specify exactly on which frames we want to use an increased ISO.

The downside of increasing ISO is that the image becomes more "noisy," which is similar to the image grain you got when you pushed film speed up to higher settings. The ISO setting is dependent on the amount of light, not the quality. Photographers often use a higher ISO setting to create an ethereal look or ambience, which is a result of that speed increase.

The following situations may require a boost in the ISO:

- **Indoor sports photography** When photographing inside a gym, increase the ISO to 1600 or 3200. This will often provide a high enough shutter speed to freeze the action. Try combining this with flash fill, so the environment of the arena is included—not just a flash-lit subject rising out of a sea of black. Take an exposure reading of something in the gym that is a midtone or gray, use this to establish the manual exposure, and turn the strobe to a TTL setting. The strobe, along with the higher shutter speed, will help freeze the action.

- **Indoor events** Increase the ISO setting at birthday parties or other indoor events where you would prefer to photograph without a flash.

- **Special effects** There are times when the photographer may want the increased noise in a higher ISO image to impart a special look or feeling to the photo.

Too often, the photographer shoots moments like this with a direct flash, eliminating all warmth in the photo. Here, I increased the ISO to 800 and exposed the photo for the candlelight on the face. 85mm lens, 1/30 second at f2

UNDERSTANDING FRONTLIGHT, SIDELIGHT, AND BACKLIGHT

An understanding of the three basic types of lighting is essential if you intend on taking control in the lighting process.

Frontlight, as described in this chapter, is the light coming from behind the photographer and striking the subject. Depending on the time of day, using the sun as your main lighting source can be harsh (if shot around midday) or beautiful and soft (if using late afternoon light).

A fatal flaw many aspiring photographers make is trying to shoot a nice portrait in midday sun. The light is too harsh and creates hard and unappealing shadows, and the light has no warmth to it.

The late afternoon light can be the only light source the photographer needs. Turning the subject ever so slightly from the light falling directly upon his face can provide enough shadowing to help create depth in the portrait.

Sidelight can come from an artificial light source such as a lamp or flash, or it can come from the sun. Using sidelight effectively can add depth to the photo by turning the subject into or away from the light to control the amount of light striking the face. I shot this photo with full sidelight as well as light from a three-quarter angle.

Here, the soft box was moved to the right of the subject, making a strong shadow across the face. I find this lighting unflattering due to its harshness.

Using artificial lighting, such as a flash in a "soft box" (which emulates late daylight—beautiful light—from a source the size of a window), by placing the unit immediately behind the camera, I created a very flat light that strikes the subject's face equally from the camera's angle.

If you move the light box off to the right of the side of the subject, you create a sidelit photo. By itself, this light is not terribly appealing.

Using the soft box from the side lighting position and using a reflector to fill the harshly shadowed area, you can create a very nicely lit portrait. The beauty of this system is that only one light is required; the backlight can be created by the sun or the ambient light. In this portrait, I used a general manual exposure for the wall in the background, thereby making it a part of the composition.

You can use the ambient available light as your backlighting and the reflector fill light as your *key light* (the main light source, be it sun, flash, or a table lamp—whatever creates the main light on the subject). This method provides a multi-light setup with no lights and just a reflector. But the results look like a photo shot under very controlled lighting conditions.

Now you see why many photographers carry a reflector with them. Adding, controlling, or changing light gives the photographer more options when photographing people.

The power of light is the essence of photography, and photography is what we do and what we love. The mind thinks in terms of images, and those images are awash with light or they wouldn't exist. Our jobs, as photographers, is to use that light, studying it ever so carefully and painting with it in our viewfinder. Watch the light. See how it moves across the land, how it paints and illuminates and creates our reality.

Keeping lighting to a minimum can often produce great results. A main light source, an exposure for the ambient light, and a reflector to fill the shadowed area create a nicely lit photo.

How To: Understanding Light

by Joe McNally

Joe McNally shoots assignments for magazines, ad agencies, and graphic design firms. Clients include Sports Illustrated, ESPN Magazine, National Geographic, LIFE, Time, Fortune, New York Magazine, Business Week, Rolling Stone, *New York Stock Exchange, Target, Sony, GE, Nikon, Lehman Brothers, and PNC Bank. In addition to having been a recipient of the Alfred Eisenstaedt Award for outstanding magazine photography, McNally has been honored for his images by* Pictures of the Year, The World Press Photo Foundation, The Art Directors' Club, Photo District News, American Photo, Communication Arts, Applied Arts Magazine, *and* Graphis. *Joe's teaching credentials include the Eddie Adams Workshop, the National Geographic Masters of Contemporary Photography, the Smithsonian Institute Masters of Photography, Rochester Institute of Technology, Maine Photo Workshops, Department of Defense Worldwide Military Workshops, Santa Fe Workshops, and the Disney Institute. He has also worked on numerous "Day in the Life" projects. One of McNally's most notable large-scale projects, "Faces of Ground Zero—Giant Polaroid Collection," has become known as one of the most primary and significant artistic responses to the tragedy at the World Trade Center. Joe was described by* American Photo *magazine as "perhaps the most versatile photojournalist working today" and was listed as one of the 100 most important people in photography. In January 1999, Kodak and Photo District News honored Joe by inducting him into their Legends Online archive. In 2001, Nikon Inc. bestowed upon him a similar honor when he was placed on their website's prestigious list of photographers noted as "Legends Behind the Lens."*

I have always thought of light as language. I ascribe to light the same qualities and characteristics one could generally apply to the spoken or written word. Light has color and tone, range, emotion, inflection, and timbre. It can sharpen or soften a picture. It can change the meaning of a photo. Like language, when used effectively, it has the power to move people, viscerally and emotionally, and inform them. The use of light in our pictures harkens back to the original descriptive term we use to define this beloved endeavor of making pictures: Photography, from the Greek *phot-graphos*, meaning "to write with light."

Writing with light! As a photographer, it is very important to know how to do this. So why are so many of us illiterate? Or rather, selectively illiterate. I have seen photographers with an acutely beautiful sense of natural light, indeed a passion for it, start to vibrate like a tuning fork when a strobe is placed in their hands. Some photographers will wait for hours for the right time of day. Some will quite literally chase a swatch of photons reflecting off the sideview mirror of a slow-moving bus down the block at dawn just to see if it will momentarily hit the wizened face of the elderly gentleman reading the paper at the window of the corner coffee shop. These very same shooters will look hesitantly, quizzically, even fearfully at a source of artificial light as if they are auditioning for a part in *Quest for Fire* and had never seen such magic before.

I was blessed early in my career by having my self-esteem and photographic efforts subjected to assessment by old-school wire service photo editors who, when they

were on the street as photographers, started their day by placing yesterday's cigar between their teeth, hitching up a pair of pants you could fit a zeppelin into, and looping a 500-volt wet cell battery pack through their belts and snug against their ample hips. Armed with a potato masher and a speed graphic (which most likely had the f-stop ring taped down at f8), they went about their day, indoors and out, making flash pictures. What we refer to now as fill flash, they called "synchro sun." Like an umbrella on a rainy day or their car keys, they wouldn't think of leaving the house without their strobe.

They brought that ethic to their judgment of film as editors. During the 1978 NY–KC baseball playoffs I returned to the UPI temporary darkroom in Yankee Stadium with what I thought was a terrific ISO 1600 available-fluorescence photo of one of the losing Royal players slumped against the wall surrounded by discarded jerseys. Larry Desantis, the news picture editor, never took his eye from his Agfa-loup while whipping through my film as he croaked in his best Brooklynese, "Nice picture, kid. Never shoot locker room without a strobe. I give this advice to you for free."

That advice was pretty much an absolute, but I have survived long enough in this nutty business to know there are no real absolutes. Sometimes the best frames are made from broken rules and bad exposures. But one thing that Larry was addressing—albeit through the prism of his no frills, big city, down and dirty get-it-on-the-wire point of view—was the use of light. What sticks with us, always, is light. It is the wand in the conductor's hand. We watch it, follow it, respond to it, and yearn to ring every nuance of substance, meaning, and emotion out of it. It leads us, and we shoot and move to its rhythm.

I could wax eloquently about how, in a moment of photographic epiphany, I discovered and became conversant with the magic of strobe light. But I would be lying. Any degree of proficiency and acquaintance I have with the use of light of any kind has been a matter of hard work, repeated failures, basic curiosity, and a simple instinct for survival. I realized very early in my career that I was not possessed of the brilliance required to dictate to my clients that I would only shoot available-light black and white film with a Leica. My destiny was to be a general-assignment magazine photographer, by and large, and, to that end, I rapidly converted to the school of available light being "any *** damn light that's available."

Because light is just light. It's not magic, but a very real thing, and we need to be able to use it, adjust it, and bend it to our advantage. At my lighting workshops I always tell students that light is like a basketball. It bounces off the floor, hits the wall, and comes back to you. It is pretty basic, in many ways.

Given the simple nature of light, I offer some equivalently simple tips for using it effectively in your photographs. Mind you, I offer these tips—dos and don'ts if you will—with the caveat that all rules are meant to be broken, and there is no unifying, earth-encompassing credo any photographer can employ in all situations he or she will encounter. All photo assignments are situational, and require improvisational, spontaneous responses. At this point in my career, the only absolute I would offer to anyone is to not do this at all professionally, chuck the photo/art school curricula you're taking that offers academic credit for courses called "Finding Your Zen Central," and get an MBA. (However, if you're reading this, it is probably too late.)

Joe's Lighting Tips, or things to remember when you are on location and the flying fecal matter is hitting the rotating blades of the air-circulating device:

Step 1
Always start with one light. Multiple lights all at once can create multiple problems, which can be difficult to sort out. Put up one light. See what it does. You may have to go no further. (The obvious corollary to this: Look at the nature of the existing light. You just might be able to leave the strobes in the trunk of your car.)

Step 2

Generally, warm is better than cool. When lighting portraits, a small bit of warming gel is often very effective in obtaining a pleasing result. Face it, people look better slightly warm, as if they are sitting with a bunch of swells in the glow of the table lights at Le Cirque, rather than sort of cold, as if they are the extras on *The Sopranos* who end up on a hook in a meat locker.

Step 3

During location assessment—those crucial first few minutes when you are trying to determine how awful your day is about to get—look at where the light is coming from already. From the ceiling? Through the windows or the door? Am I going for a natural environmental look and therefore merely have to tweak what exists, or do I have to control the whole scene by overpowering existing light with my own lights? What does my editor or publication want? How much time do I have? Will my subject have the patience to wait while I set up for two hours, or do I have to throw up a light and get this done? (Lots and lots of practical questions should race through your head immediately, because your initial assessment process will determine where you will place your camera. Given the strictures of location work, deadlines, and subject availability, this first shot may be the only shot you get, so this initial set of internal queries is extremely important.)

Step 4

When wrapped up in the euphoria (or agony) of the shoot, do a mental check on yourself. If you are working with a long lens, try to imagine the scene with a wide lens from the other side of the room. Or think about a high or low angle. Always remember the last thing most editors want to see is a couple hundred frames shot from exactly the same position and attitude. Move around. Think outside of the lens and light you are currently using. This can be summed up by the nagging question that lurks in the back of my mind when I'm on location: "Hey, why don't I do my re-shoot now?"

Step 5

Never shoot locker room without a strobe. (Just kidding!)

Step 6

Remember as an assignment photographer that one "aw s***" wipes out three "attaboys."

Step 7

Remember that the hardest thing about lighting is not lighting, but the control of light. Any idiot can put up an umbrella. It takes effort and expertise to speak with the light, and bring different qualities of shadow, color, and tone to different areas of the photo. Flags, cutters, honeycomb grids, barn doors, gels, or the dining room

tablecloth gaffer-taped to your light source will help you control and wrangle the explosion of photons that occurs when you trip a strobe. If you work with all these elements and practice with them, you will soon see that in the context of the same photo, you can light Jimmy differently from Sally. (A handy tip: If you want something to look interesting, don't light all of it.)

Step 8

A white wall can be your friend or your enemy. White walls are great if you are looking for bounce and fill, and open, airy results. They are deadly if you are trying to light someone in a dramatic or shadowy way. I carry in my grip bags some cutup rolls of what I call black flocking paper (it goes by different names in the industry) that, when taped to walls, turns your average office into a black hole, allowing the light to be expressed in exactly the manner you intended.

Step 9

Experiment! You should have a written or mental Rolodex of what you have tried and what looks good. That is not to say you should do the same thing all the time, quite the contrary. But when you have to move fast, you must have the nuts and bolts and f-stops of your process down cold, so that your vision of the shot can dominate your thinking. All the fancy strobe heads and packs and c-stands and soft boxes you drag along with you should never interfere with your clarity of thought. All that stuff (and it is just stuff) is in service to how you want the photograph to feel, and what you are trying to say, picture-wise.

Step 10

A follow-up to Step 9: Don't light everything the same way! Boring! Clint Eastwood's face requires a different lighting approach than, say, Pamela Anderson's.

Step 11

If you're getting assignments to shoot people like Clint and Pamela, you don't need my advice.

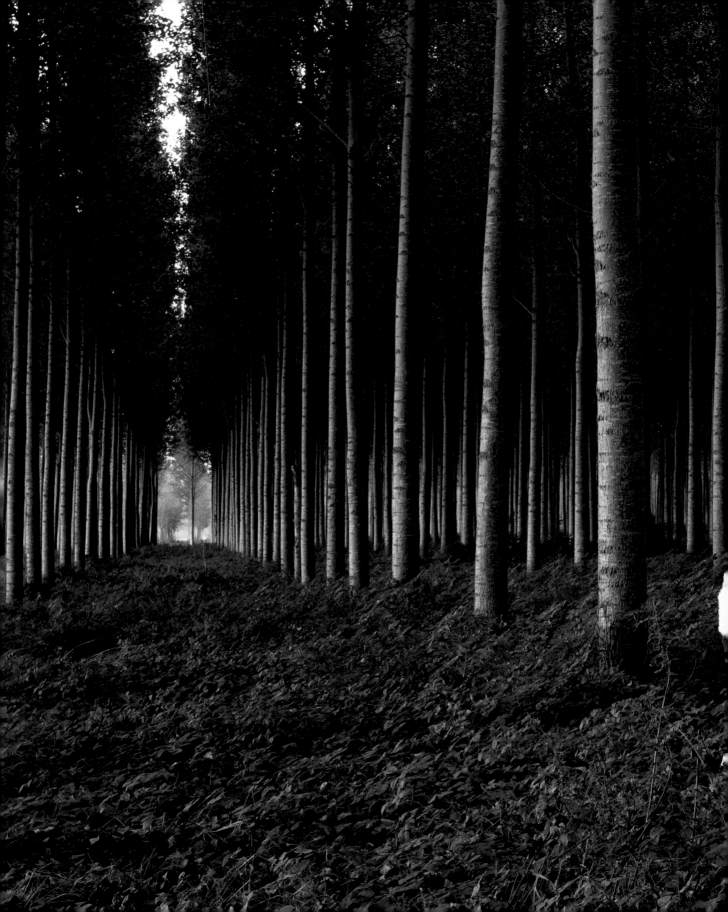

CREATIVE EXPOSURES

Does not the very word "creative" mean to build, to initiate, to give out, to act—rather than to be acted upon, to be subjective? Living photography is positive in its approach, it sings a song of life —not death.

—Berenice Abbott

Photography has been around since 1826, and the digital realm has been publicly available since about 1990—it's still in its technological infancy. The most common question I get asked these days when someone is watching me shoot is, Is that digital? Accompanying that question is the attitude among many amateurs that with the advent of digital photography and the ability to alter images in Photoshop, composition, good exposure, and creativity are no longer required. What needs to be remembered is this, however: a digital camera is simply another tool.

In the Mid-Pyrenees of France, during one of my FirstLight Workshops, I photographed this stand of birch trees that had been carefully planted in a symmetrical form. 12–60mm lens, 1 second at f7.0

Many concepts of photography also exist in painting, such as tension, composition, and freezing a moment so we can study it at our leisure. Until 1872, painters could draw only from mental images of how a horse appeared as it ran, for example. Leland Stanford, former governor of California and owner of a Palo Alto horse breeding ranch, hired photographer Eadweard Muybridge, the most famous cameraman in the American West, to photograph a racing horse as it ran. Racing enthusiasts had long argued about the position of the legs of a running horse, and Muybridge's images proved that at one point in a horse's stride, all four of its feet actually leave the ground at once. This proved to be one of the first collaborations of photography and painting, as painters used these photographs to help them create accurate representations of a running horse.

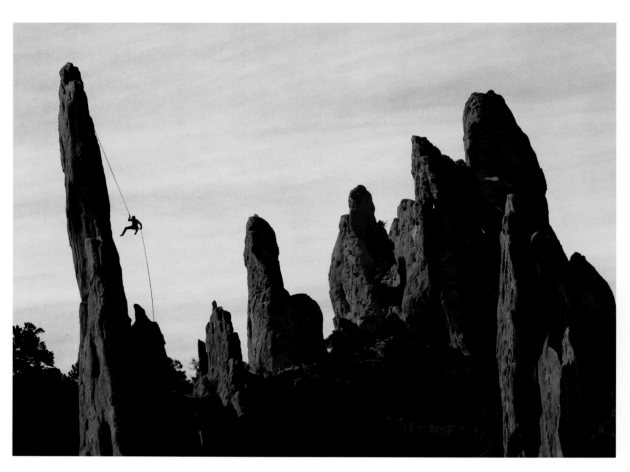

Often, if the photographer has found that perfect scene, such as this rock formation in Garden of the Gods near Colorado Springs, Colorado, which fills the frame perfectly, the simple addition of a "moment"—here the climber leaping out during a rappel—can provide that extra "oomph" that takes the image from a snapshot into a photograph. 50–200mm lens at 150mm, 1/500 second at f7.3, 100 ISO

Just as with a painting, a photo has to work on its own—it should not require a lot of dialogue to convey the sense of what is happening. Some photos are good for the time at which they were shot—perhaps as a record of an event or the family portrait that is legitimate strictly because of its content. Great photos make for great viewing long after they've been shot, however. And what makes them great is content, moment, and composition—and how we use the controls on the camera to achieve creative elements.

In this chapter, you'll learn how to use creative elements to improve your photography. This creative exploration takes photography beyond the mere snapshot. Creative control over the shutter speed and aperture allows you to move beyond capturing normal scenes to begin to use your camera to explore and record your creative visions.

CAMERA CONTROLS

I was on assignment for CH2M HILL, the official environmental advisors to the Atlanta Olympics. My goal was to convey the power of American athletes as they practiced for the Games. I felt that incorporating motion into my photographs would best convey the world of the athlete. The shutter speed and aperture can be set either to stop motion or accent it, and to increase or decrease the zone of focus. On this particular shoot, I planned to use the shutter speed control as my creative tool.

To control the action in an image, you can choose a slower than normal shutter speed, allowing the motion to blur. This can result in a painterly and slightly abstract rendition of the scene. Another technique is to freeze the action with a very fast shutter speed. This hyper-realistic view of the action is the most common

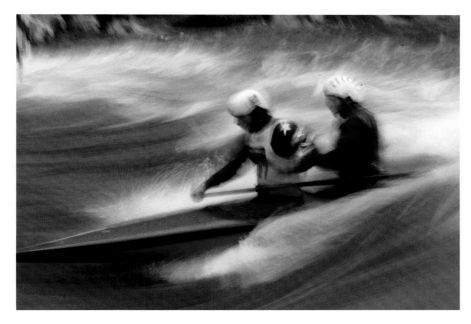

In this corporate shoot for CH2M HILL, I was photographing the US C2 kayak team practicing for their event. Criteria for the shoot were motion and power. 80–200mm lens, 1/15 second at f5.6

type of sports photography, allowing us to capture the athlete at the decisive moment with his or her eyes focused and muscles taut at the peak of concentration and exertion.

Examples of Shutter Speed Control

Stopping motion or accentuating motion is a control at your command. An old rule of thumb in sports photography goes like so: To stop a player in motion, use a shutter speed of at least 1/500 of a second. Anything less will start showing some blur. On the other hand, if you're photographing a waterfall, you could slow the shutter speed down to 1/15 of a second to emphasize the motion of the water.

The photo of the Olympic kayakers is an example of slowing the shutter speed down, here to about 1/15 of a second, and adjusting the aperture accordingly. Instead of an image showing the boat stopped in the wave and the motion of the paddlers' arms frozen, a fluid-looking image was the result. The power of the stroke can almost be felt in the photo. The detail of the water is softened and muted by the long exposure, focusing attention on the two boatsmen. I use this technique when I want to convey a sense of motion in the image and create a more "painted" look.

This slowing down, or "dragging," the shutter can work creatively in a number of

The USS *Hawkbill* surfaces from beneath the Arctic ice. Part of a National Geographic assignment on the SCICEX program, a five-year look at the world under the Arctic ice. 80–200mm lens, 1/250 second at f4.5

scenarios. Photographing lightning by using a shutter speed of 1/2 second to several seconds at dusk can capture several bolts of lightning. I've photographed freeways at night with a long exposure, the taillights and headlights of the vehicles becoming streaks of light in the frame as the long exposure captured the movement of the vehicles.

Long exposures open an entire world of possibilities that call for a tripod—the major requirement for long exposures. Another rule

On a commercial shoot for a client, my job was to photograph "grand scenes" of America. I was in Lake City, Colorado, photographing the wilderness with Uncompagrhe Peak as a background. Art director Tom Kaminsky and I had discussed the idea of shooting these grand scenes with an almost "Where's Waldo?" human presence. Late dusk helped set the scene, the late-day sunset warming the sky slightly, and the car driving through the scene provided the human link. 14–54mm lens, 1/4 second at f4, 100 ISO

of thumb from the pro side of photography is this: When shooting wide angles, the slowest speed that can be comfortably used without a tripod is equal to the focal length of the lens. So, for example, a 24mm lens could be hand-held at 1/30 of a second. I've found, with practice, that I can go a couple of shutter speed settings slower by using the techniques described here. I spread my feet apart and hold the camera up, shooting as I slowly exhale. It works!

Applying the rules of thumb further, let the length of your lens determine the minimum shutter speed at which the camera can be hand-held. If you are shooting with a 105mm lens, the minimum shutter speed you could generally use would be about 1/100 of a second, so as not to show camera shake in the photo. The longer the lens, the more pronounced movement will appear in the exposure. With really long lenses—500mm plus—even the motion caused by your heartbeat can be a factor in sharpness if you're shooting slow exposures without a tripod. So if you're shooting with a 500mm, the minimum shutter speed would be 1/500 by this rule. If you don't have a tripod, try resting the camera and lens against a tree, or try shooting in a prone position, resting the camera on a rock or tree stump.

A Few Hints Regarding Stability and Holding the Camera

One classic flaw I notice among amateur photographers is the tendency when holding the camera to "hang" the lens from the fingers instead of supporting the lens with the hand

Examples of Aperture Control

Think of the aperture as a window shade, increasing or decreasing the amount of light coming through the window. The aperture in a camera does the same in controlling the amount of light coming through the lens.

used for focusing. This may sound silly, but try stretching your arm out and hanging a baseball-sized rock from your fingertips. Now try the same thing by cradling the rock in your palm, face up. You'll find that your arm muscles are much more comfortable supporting the weight versus hanging the weight. I've always told classes that the telltale sign of the amateur is watching how he or she holds a long lens.

In this same spirit, another trick of the trade when shooting slower exposures is to use your body as a camera stand more efficiently, creating a more stable platform. Spreading your feet apart is the first step in this simple trick, and if there is a tree or wall to lean against, you are closer to performing the role of a tripod.

Okay, so you're cradling the camera lens in one hand, and the other hand is holding the camera body. Feet are spread about shoulders' width apart and you are leaning against a convenient tree or other support. Now add controlled breathing, and you have increased your ability to shoot at a slower shutter speed, sometimes up to two or three speeds slower. Controlled breathing means taking a deep breath, exhaling slowly, and pressing the shutter while exhaling.

Sometimes the details tell you as much as the overall photo. Case in point: at one of our Dubois, Wyoming, FirstLight Workshops, our group had the chance to photograph the Dubois Rodeo, which is held every Friday night during the summer...a real- and wonderful-small town rodeo. I was in the back where the riders prepare and was watching a bull rider prepare for his ride, and I was intrigued by his boots as they reflected the toughness of his sport. I wanted more than just the boot, so I waited until he adjusted his spurs, creating an almost "environmental portrait" of this rider. 90–250mm lens at 106mm, 1/160 second at f2.8, 100 ISO

If It Isn't Good Enough, You're Probably Not Close Enough

The fatal flaw of many aspiring photographers' work is not being close enough. As discussed in Chapter 3, learn to use the viewfinder like a painter's canvas, filling the frame so everything going on in the photo is relevant to the image. Moving in close is often the essential key here.

Using this theory and taking it a step further, you can use a portion of your subject to tell the story. Try shooting very close on someone's hands or face. This will work when the viewer knows what the subject is; otherwise, it can be a meaningless abstraction.

Bringing the subject closer to the camera forces the viewer to interact with the photograph. Unless a carefully composed image uses the dead or empty space as part of the composition, a subject that is very small in the frame will not engage the viewer. Remember that your finished piece will often be a 4 × 6 inch card, and a small detail in the image may be lost in a small print. Sometimes your composition needs to shout to get your message across.

ACHIEVING IMPACT IN YOUR PHOTOGRAPHY

We've all seen the *Sports Illustrated* photo of the wide receiver, hands outstretched, fingertips reaching for the ball. This is a great example of impact in a photo. Impact is also about the decisive moment. The power of the athlete is conveyed in the image in an unmistakable way. Shooting with a long telephoto lens that helps to compress the image forces the background out of focus because of the very shallow depth of field. Using a high shutter speed freezes the action, emphasizing the instant of the catch.

A high shutter speed can freeze the runner mid-step, the dancer in flight, or the Frisbee just outside the reach of the dog's jaws. The impact of this style of photography has defined how we think about athletes.

Adjusting Aperture for Maximum Impact

This is where long lenses shine. Try using a lens in the 200mm-plus length. The inherent nature of these lenses in compressing the field of view is amplified the longer the length of the lens. When shooting, try a shallow depth of field, f4 or f2.8. This will force the background out of focus, creating a greater zone of interest on the main subject, being the only area that is sharp.

Shooting fast-moving subjects can be intimidating at first, especially when you're trying to use a long lens. Try prefocusing on a spot on the field where the runner is going to pass, such as a piece of dirt, grass, or anything that marks the spot. Then wait until he is charging toward you and press the shutter at the moment he hits that spot. The more you do this, the more comfortable you'll become with shooting moving targets.

If possible, shoot with the sun or main light source at your back. Not only will this provide better light, but it will be easier to track the subject. Watch for the key moment—the third baseman throwing the ball or scooping up the grounder.

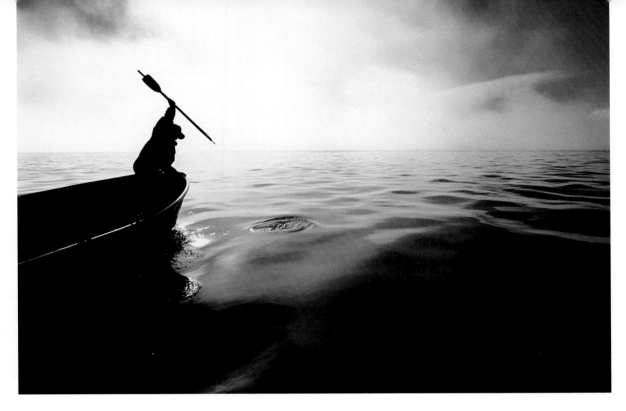

This style of photography isn't exclusive to sports photography. On assignment for *National Geographic* photographing the Yukon River, I was out for almost nine days with the Yupik people, who fish and hunt the river using traditional methods. This photo shows a Yupik man throwing a harpoon at a seal. The effectiveness of the photo is in its simplicity…and its power. In other words, it works by impact. 17–35mm lens, 1/500 second at f4

The Magic of Long Lenses, the Breadth of Wide Lenses

Within our camera bags are mechanical tools we carry: telephoto lenses, wide-angle lenses, and macro lenses. Each lens serves a specific purpose, enabling us to compress our photos, expand horizons, or capture the tiny details of the macro world that exist all around us. The first "long" lens I bought was an 85mm for my 35mm film camera, many years ago. I remember looking through it the first time and marveling at how the slight compression

of this short telephoto lens dramatized an otherwise normal portrait. Shooting wide open, the background dropped slightly out of focus, yet the range of focus encompassed the nose to the ears. I thought it was magical.

Small apertures are used interchangeably with the term "wide open" in the photographic world. These refer to the diaphragm in the lens being open to allow the most amount of light to pass through the lens to the chip. Wide open in an 85mm f2 lens would be f2.

Short lenses and long lenses: You'll hear photographers use these terms in talking about their images and equipment. Short lens is another term for wide angle—anywhere from 14mm up to about 40mm. Long lenses cover lenses from about 85mm up to the super telephotos of 600mm and beyond.

I was fortunate to work in a camera store when I bought my first telephoto lens. I had the opportunity to use or at least "try on" many lenses before purchasing. Because of the sheer number of lenses I could try, my choice was made simple. Looking through a macro lens for the first time, seeing through the viewfinder the life-size rendering of a tiny flower or small bug, opened up another world to me. This was such an exciting visual awakening. At the same time I was absorbing the visual lessons of *National Geographic* magazine, *LIFE* magazine, and other photographically powerful publications. What I learned was that photographs made with a long or short lens did not rely strictly on the lens's compression or expansion effect, but that the photographer was using the physical traits of the lens along with shutter or aperture to create these wonderful moments.

The first time I looked through a 24mm was another visual epiphany. The world literally opened up, bringing a wide, new world into that tiny viewfinder. The lessons came quickly, and I learned to use a wide lens very carefully. The dramatic reduction in size of the subject as it moved away from the camera could reduce or eliminate the impact of the photo. Using wide lenses effectively

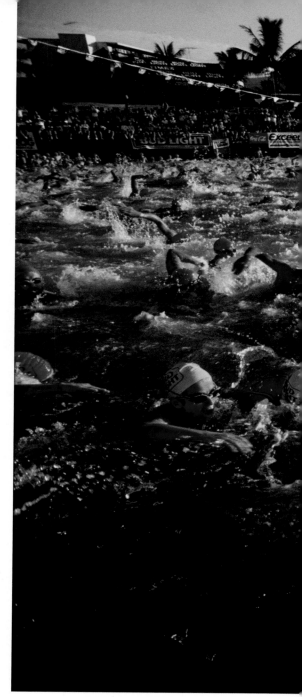

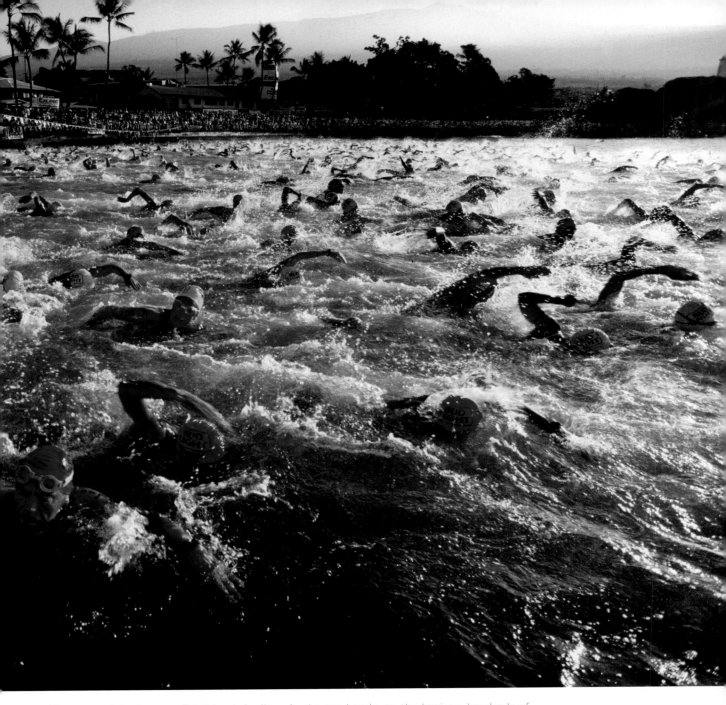

The start of the Ironman Triathlon is bedlam. As the sun breaks on the horizon, hundreds of swimmers explode into the surf for the two-mile ocean swim. I wanted to convey the huge numbers of swimmers, so I shot this with a 24mm wide-angle lens, allowing the sea of arms to carry the eye from foreground to background. 24mm lens, 1/250 second at f5.6

takes practice. Another benefit of digital is that you can shoot and check while you are in the moment.

Using a wide lens, placing the subject close to the camera, and shooting wide open creates a very different look than shooting with the lens closed down for a greater depth of field. Many photographers prefer using a wide lens stopped down to f11 or f16, to obtain maximum depth of field so the image is tack-sharp, front to back. This exaggerates the feeling of distance between subject and background.

Use leading lines with a wide-angle lens to give a dynamic perspective. Train tracks leading from foreground to background, either vertically or on a diagonal, force the eye to move through the photo, following the direction of the lines.

We have so many options, both within our camera bags and within our thinking process, to control creativity in our photos. Learning about your equipment and understanding the traits of particular lenses will enable you to use that knowledge to your own photographic advantage. Remember, the photographer makes the image, not the lens

or equipment. This is a key point of this or any other photo book. The photographer's vision makes the photo, and the camera and lenses are creative tools we have to work with, similar to the painter being able to choose from different brushes.

Digital is the perfect tool for growth as a creative artist. The ability to check your photographic endeavors in "real time" versus looking at them as a historical artifact, as with film, is invaluable in the growth process of a photographer. Experimentation without the costs of film and processing is an obvious benefit. The EXIF file, which is attached to every photo, contains information on the shutter speed, ISO, aperture, and white balance as well as the date the photo was shot. This EXIF file information, found by choosing **File > File Info > Camera Data 1 & 2** in Photoshop, can provide answers for your photographic experimentation. Say you shot photos of your child's soccer game, and the photos were blurred. Look at the EXIF file to determine the exposure used, and then increase the shutter speed for the next game. Your photographic experimentation is documented with digital.

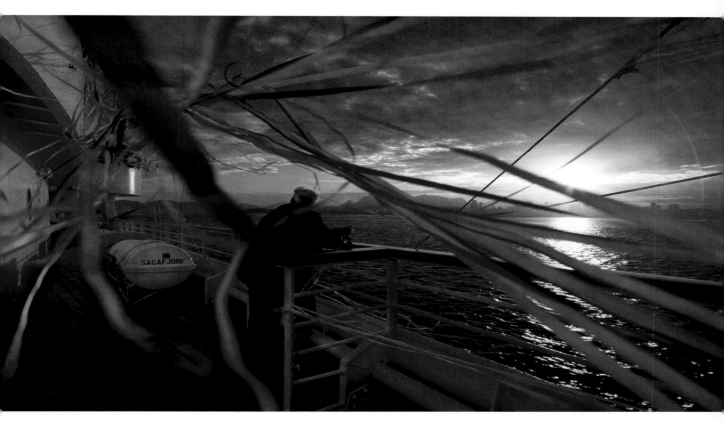

The opportunity to witness a full solar eclipse is not a common occurrence. *American Way* magazine sent me to Rio de Janeiro to meet the cruise ship *Sagafjord*, on which we were to steam 600 miles along the coast of Brazil to position ourselves in the middle of the path of totality—over four minutes' worth. This photo is an example of leading lines, the streamers, pulling your eye into the photo. Telephotos create their own "look" through the natural compression the lens creates. With the telephoto set at f2.8 or f4, the zone of focus is restricted to the subject and the background drops out of focus. If you shoot with a telephoto and the lens closed down to f11 or f16, the background will appear more in focus, which can be either a distraction or a benefit to the photo. 20–35mm lens, 1/125 second at f4

How To: Creative Shutter Control

Since the invention of photography, two constants in the world of the photographer have been shutter and aperture. The equipment may become more and more technically sophisticated, but these two compatriots of the camera are still the core of the mechanical side of the camera. Here are a few ideas on using the shutter as your creative tool.

■ If you are using your camera in the Program mode, you still have control over the shutter in most cameras. Moving the control dial while in the P mode will allow you to change the shutter speed and the aperture in sync. You will notice that the mode indicator will change from P to Ps or some other indicator that you are using as the Program mode, but you are changing the default shutter speed. In the P, S, or A mode, the camera will automatically adjust the aperture to match the new shutter speed you've chosen. A flashing exposure number or exposure warning means that you have either too little or too much light available for that particular shutter speed. If necessary, adjust the ISO to compensate. Moving it to a slower speed will set the aperture correctly.

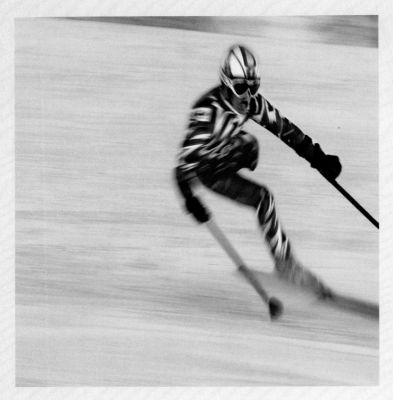

Working with designer Mike Sukle in Denver to photograph an ad campaign for the National Sports Center for the Disabled and that organization's skiing program, I shot this world-class skier running a grand slalom course. Shooting with a slow exposure to create the feeling of speed, I also used a powerful battery-powered flash unit to illuminate the side of his body as it passed, freezing some of the detail on his outfit. 80–200mm lens, 1/4 second at f4.5

- If you're photographing a moving object, try "panning" with the subject as it passes. Panning is the trick of following the motion of the passing subject with the camera. When combined with a slower shutter speed, in the 1/30 of a second or less range, panning will make the background blur with the motion, but the subject will retain some sharpness—creating a feeling of speed in the still photo.

- Along with the preceding method, try using either the pop-up flash or a supplemental flash for fill-in light. Setting the flash to the TTL (through the lens) mode provides the most accurate flash setting as the camera meter is reading the flash as the lens sees it. As the subject moves by you, the flash will help freeze the subject while the background exposure is maintained. I do this in Manual mode, often underexposing the background by about a half stop. This makes the moving subject become more the visual center of the image as the background becomes a little less prominent. I've also found that the camera/flash combination needs to be tested to achieve the perfect balance. For my tastes, the flash is also set about two-thirds of a stop underexposed, creating a more natural looking light.

- Many modern electronic flashes provide an ability to use much higher sync speeds than normal, but only if you're using the proprietary flash for that camera. The Olympus E1 with an FL50 flash allows a shutter speed of up to 1/4000 of a second sync in Special mode versus the maximum 1/180 of a second in Normal mode. The effective guide number is greatly reduced, meaning the power of the flash is limited to very close subjects. But this can work well in brightly lit situations, where you may want to use the flash for fill light, such as a midday portrait with the subject near the camera and the vista in the background, or in an environmental portrait where you want the background to be totally out of focus.

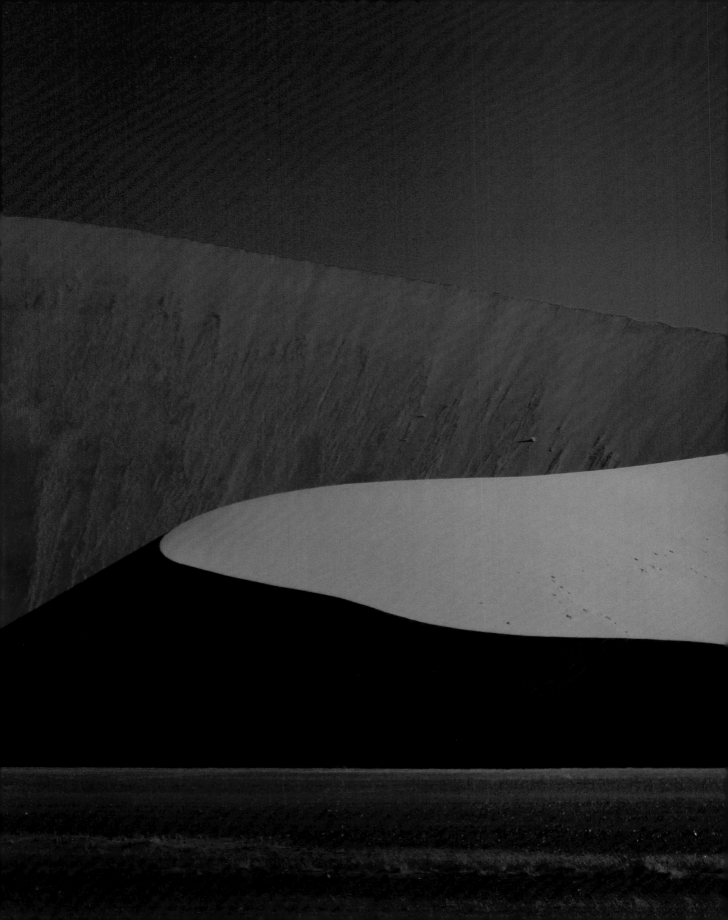

COMPOSITION

Every other artist begins with a blank canvas, a piece of paper...the

photographer begins with the finished product.

—Edward Steichen

In the craft of photography, we work with a small canvas—the

viewfinder—just as the painter works with his or her canvas.

The photographer and the painter construct their images

using moment, content, and composition. One of the main

components of a good photograph, the composition of an image

is often the engine that drives the photo.

The Namib Desert, Namibia, Africa. The tallest and oldest sand dunes on Earth inhabit this huge and photo-rich landscape, providing incredible compositional opportunities for the photographer. Following the S-curve, the eye is drawn into this frame. 14–54mm lens, 1/250 second at f5.6, Singh-Ray warming polarizer

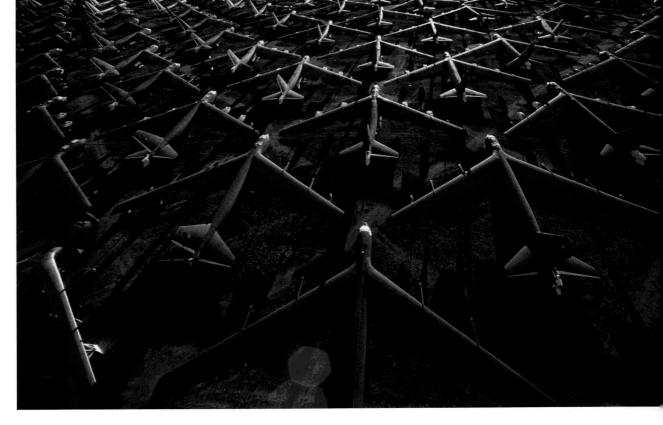

Retired from active duty, these giant B-52s, with a wingspan of 185 feet, resemble a field of toys, and their repeating pattern is what makes this photo work. Shot from a helicopter over Davis-Monthan Air Force Base, Tucson, Arizona. 20mm lens, 1/125 second at f8

By following a few rules of composition, you can create even better photos. What are the rules of composition and how do you apply them in your photography? This chapter offers a discussion of various rules and guidelines, but always remember that these are not written in stone, as composition is a subjective issue. Part of the joy of this craft is using the rules as well as bending them or totally ignoring them. As with painting, we decide whether the image is successful.

RULES OF CLASSIC COMPOSITION

For centuries, painters have followed several rules of composition that are applicable to the world of photography. These include the rule of thirds, leading lines, and tension.

I've had the good fortune of working in the Aeolian Islands of Italy on assignments for *National Geographic* as well as this shoot for *Traveler Overseas* magazine. We'd rented the sailboat *Biligu* to travel between islands. The beautiful afternoon light helped create a layered image: several layers of information reach from the foreground of the captain, to the middle area of the ocean, to the rock structures Spinazzola on the right and Stromboli on the left. 7–14mm lens, 1/125 second at f5.6

The Rule of Thirds

One of the classic compositional theories is the *rule of thirds*. This is a simple but quite effective way of constructing your image so the viewer's eye is drawn to one of several key spots. Applicable in both the art and photographic worlds, this helps you create images that are nicely balanced and pleasing to the eye.

To visualize the rule, divide your viewfinder equally into thirds, both horizontally and vertically. Then compose the photo to allow the subject or center of interest to fall on one of the four intersection points.

S-Curves

The eye is also attracted to the gentle sweep of an S-curve (see the opening photo). Be it a road or river leading from the foreground into the distance, this curve will draw the viewer's eye along the path where your main subject can be placed.

The intersection points on the horizontal and vertical lines are the spots where you should place your subject or point of visual interest.

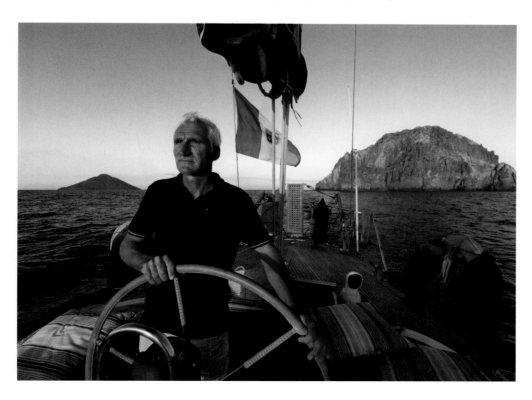

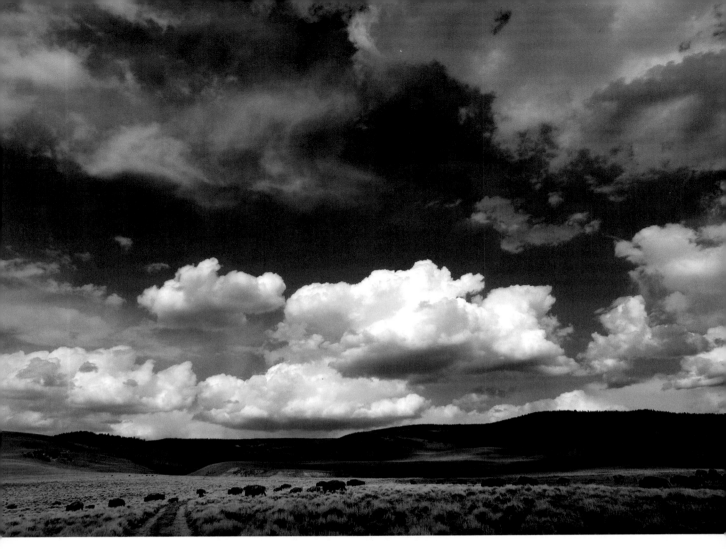

A horizon line placed low in the frame creates a more interesting photo of a buffalo herd in northern Colorado. If the horizon line were across the center of the photo, it would have been too symmetric to be interesting. Here, the "big sky" is emphasized. 14–54mm lens, 1/250 second at f8

Rhythm and Repeating Patterns

As in the photo of the B-52 bombers, another compositional theme is repeating patterns or *rhythm*. Seen in the redundant pattern of the aircraft, this theme carries the eye from the foreground to the background of the photo.

Using Horizon Lines

Horizon lines are best not placed across the dead center of the photo. When centered, the photo is divided into two distinct frames in the viewer's mind. Both parts are given equal importance and no tension is introduced

into the frame. It's better to have the horizon line high in the frame, emphasizing the foreground, or, conversely, placing the horizon line low and emphasizing the sky.

Leading Lines

Leading lines, such as a fence running from foreground to background, draw the eye into the photo and along the course of those lines.

This is a powerful way of using an element in the environment to pull the eye along a given path.

Layering

Look at the classic documentary work of Larry Frank, Danny Lyons, and Henri Cartier-Bresson to see how these photographers use the different layers of the photo to create entire dialogues within each.

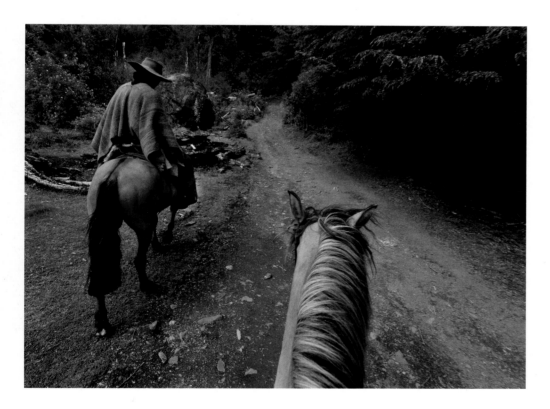

While photographing an assignment on the Futalefeu River in Chile, we were riding horses on a path adjoining this Class V river. I used layering in the composition of this photo of a gaucho leading our way. This creates different layers of interest: the trail forms the background layer, the rider on the left forms the middle layer, and my horse's neck creates the foreground layer. This forces the viewer to absorb the content of each layer and combine the information for the photo's message. Here I am using the trail to lead the viewer's eye into the distance.
11–22mm lens at 11mm, 1/125 second at f5.5, 100 ISO

Scale

By simply adding a familiar element to the photograph, such as a human, car, or animal, we create an instant indicator of the size of the landscape or subject. This is a great way to inform the viewer of the scale of the photo.

Tension

This is what we take aspirin for, right? In our real lives, perhaps. But in the world of graphic arts, tension is a tool we can use in our photography to convey a feeling in the photo. Two-time Pulitzer Prize–winning photographer (and friend) Larry Price provides this definition of tension:

> The idea of "tension" in a photograph or other two-dimensional image—as in a painting or collage, for instance—can be interpreted as a manner of composition that excites the visual senses apart from the generally accepted "rules" of composition. For instance, classical composition such as the "rule of thirds" usually results in a pleasing arrangement regardless of the subject matter. But if the artist breaks all the rules and uses extreme compositional techniques, the resulting visual "tension" sometimes results in a more engaging image. For instance, if the photographer severely tilts the camera frame, visual tension is induced because the viewer isn't accustomed to viewing the real world from a skewed perspective. These techniques sometimes work because they stimulate the visual senses to accept the information as a new and different way of looking at the world. The best photographers and artists constantly challenge the basic rules of composition to find ways to infuse this tension. If successful, the results yield energetic and vibrant visual statements.

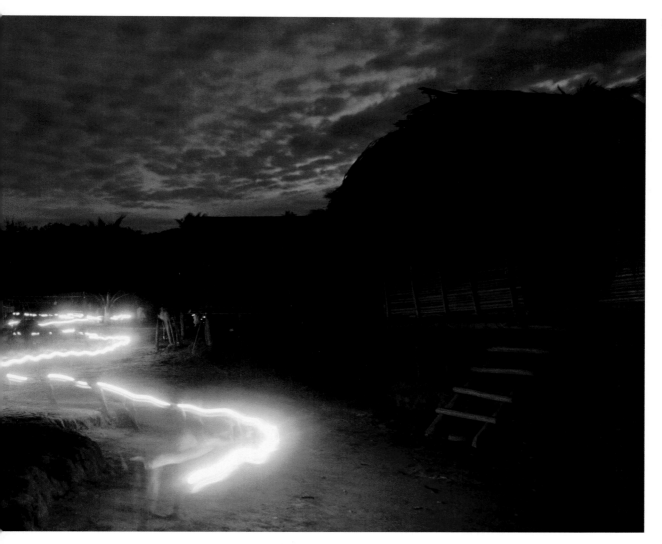

This photo of the village of Wagu in Papua New Guinea was shot on assignment for *National Geographic*, as part of "Return to Hunstein Forest," a story dealing with an unexplored area of the country. I wanted to illustrate what this village looked like in a visually interesting way. I had a villager walk through Wagu with a lantern, having taken an exposure reading of the light that the lantern cast on the huts, and waiting until that exposure matched the exposure of the light in the sky. The line created by the lantern's light, and the lines on the walls of the building, act as leading lines, pulling the viewer's eye into the photo. 20mm lens, 20 seconds at f5.6

KEEP IT SIMPLE

When my kids were younger, one of their favorite books was *Simple Pictures Are Best* (by Nancy Willard). That title is a good motto for photographic success. By eliminating distracting and unimportant material in the photo, we force the viewer to interact with the subject.

In our visually sophisticated society, I'm surprised that one of the common problems I see in many photographs is too much going on in the frame. The photographer is often so excited by what is happening in front of the lens that he doesn't remember that the camera is capturing everything in the field of focus. A frequent comment when viewing photos in print form or on the computer monitor is "I didn't realize that was going to be in the photo."

Move close and fill the frame, remembering that the viewfinder is your world, and everything in the frame should be relevant to the image. Don't hesitate to move closer or farther back physically to frame the subject. Many photographs suffer from the photographer allowing the eye to become the zoom lens, never changing physical perspective by moving closer to the subject.

Another often-prescribed rule in photography is this: Don't place your subject in the middle of the frame. This habit is like kids learning to kick soccer balls—the natural tendency is to kick to the center of the goal where the goalie is. The tendency for the new photographer is to center everything. Photographically, this can create boring images.

Here are a few thoughts on keeping your photos simple and graphically appealing:

- Use one center of attention in the image. Too many areas requiring the attention of the viewer will create a confusing image.
- Move in close to fill the frame or move farther back to capture more of the environment.
- Move high and low to change your perspective.
- Use fence lines or other leading lines to draw the viewer to the subject.
- Be aware of what's in the frame. Sounds simple, but too many photos suffer from being way too busy.
- Use the viewfinder as a painter uses a canvas, making certain that everything in the frame is relevant to what the photo is saying.

BREAKING THE RULES

Now we'll go in the other direction and discuss breaking the rules I've described. Photography is an art form—and a subjective art form at that. Our criteria for what makes a great photo is personal. The photo I love, someone else might find uninspiring. I enjoy looking at some of the photography found in many publications such as *Condé Nast Traveler*. The out-of-focus, weirdly cropped, strangely composed pictures may succeed because they

By using implied subjects in this image—the tracks of animal, the shadow of a desert plant, and the ripples of the sand dune—the viewer is provided enough information to create a feeling of the desert. 7—14mm lens, 1/60 second at f8

draw the viewer into the image and create a sense of place.

These images work on a different level, speaking to emotion instead of a literal translation of the subject. Many photographers are flaunting the rules of focus and composition and are succeeding in producing powerful images. The point once again: does the photo work or not?

What Makes Your Photo Work

A photo can work on several levels. Compositionally, the photo can be well constructed, following the rules of composition, and it may not work. Bert Fox, former *National Geographic* photo editor, now director of photography at the *Charlotte Observer*, sits in front of a computer monitor all day, looking through hundreds of photos and deciding during the edit which images to keep. Bert has to make a very fast, instinctual decision on what photos are "working." What is it that makes the photo succeed?

One of the greatest powers of photography is the ability to capture reality. We are photographing moments in our lives, and these images can become a testament to that time. Is it art? If the photo is strictly a document of a moment with no intent of composing or using elements to convey a message, that photo probably does not qualify as art.

But if the photo creates an emotion in the viewer, whether it's nostalgia, melancholy, outrage, or humor, and if it also has craftsmanship, then perhaps it becomes art. The photographer has the ability to use compositional elements to construct at least a visually interesting photo. But to take that photo to the next level requires the photographer to combine composition, the sense of the moment, and historical or emotional content.

We're taught from early on that first impressions are important. This is true in photography as well. How well the viewer reacts initially is how that photo may be remembered. The reader of a magazine will linger on a photo for less than a second. The photographer has to create a first impression that will force the viewer to linger. The photograph has to succeed on deeper layers of meaning.

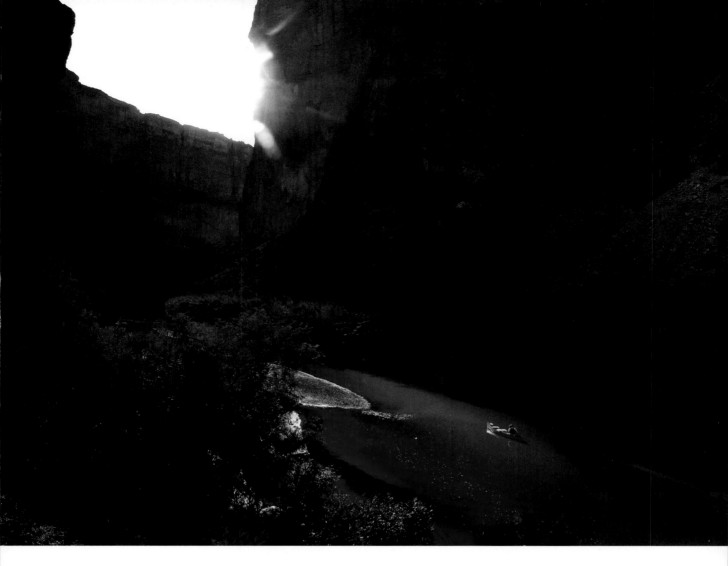

Paddling the Santa Elena Canyon in Texas's Big Bend National Park is a pretty long haul. A couple of hard days' paddle within the walls of this remote area, I wanted to provide the feeling of size of this natural wonder. I pulled my canoe up on some rocks and yelled at my paddling partner and guide, Rich McCaffery, to paddle on downriver. I used a Singh-Ray 2 f-stop, "hard edge" graduated filter to reduce the exposure on the upper-left sky, allowing the canoe to be isolated in the vastness of the landscape. 7–14mm lens, 1/60 second at f8, Singh-Ray 2 f-Stop Graduated Neutral Density Filter

How To: Using a Multitude of Tools in Your Composition

As you've seen in this chapter, the photographer has a number of tools at hand to empower a photographic composition.

Use your wide-angle lens to create a sense of space and emphasize the vastness of an area. In many workshops I teach, I find many amateurs are hesitant to use a wide lens, thinking that the only purpose of this lens is to get more in the photo when space is limited. The wide lens is a common and irreplaceable tool in almost every pro's bag. Dynamic structure and leading lines are a couple of the strengths of this tool. In addition to shooting wide, I also used the Live View monitor of my camera, which allowed me to hang over the railing of the crow's nest aboard the National Geograhic *Endeavour*, while holding the camera at arm's length below me, composing from afar of the running lights on the ship as it maneuvered the Corinth Canal in the Aegean Sea. 7–14mm lens, 1/60 second at f8

When using a wide lens, try using something in the foreground to frame the subject. This will establish more interest in the photo by creating a layered effect of foreground to background.

The Kulala Lodge in Namibia is shown in the beautiful light of a full moon. Don't stop shooting after the sun goes down—this can often produce stellar results as the mix of light sources— ambient, moon, flash—can provide the photographer with an unimagined palette. 11–22mm lens, 5 minutes at f3.4

Using leading lines with a wide angle pulls the viewer's eye along that line and can help make an interesting composition. When shooting wide, use roads, fences, and architectural features—any strong vertical or diagonal lines—to draw the eye through the photo. Including a person in this photo in Olympia, Greece, adds scale. 7–14mm lens at 8mm, 1/250 second at f8

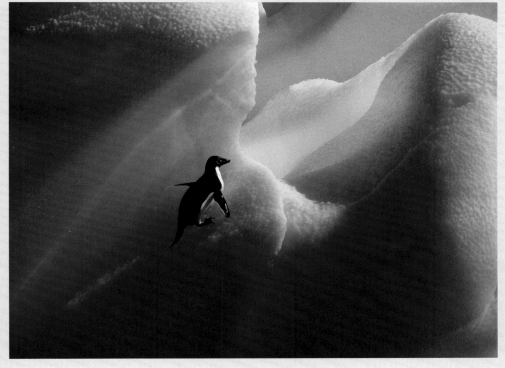

Using a long lens allowed me to not only compress the depth of this iceberg, it gave this Adelie penguin enough room so it would act in a natural way, leaping up from the water to the ice. Filling the frame with the iceberg provides the background, the penguin is that "moment." 50–200mm lens at 200mm, 1/500 second at f5.6

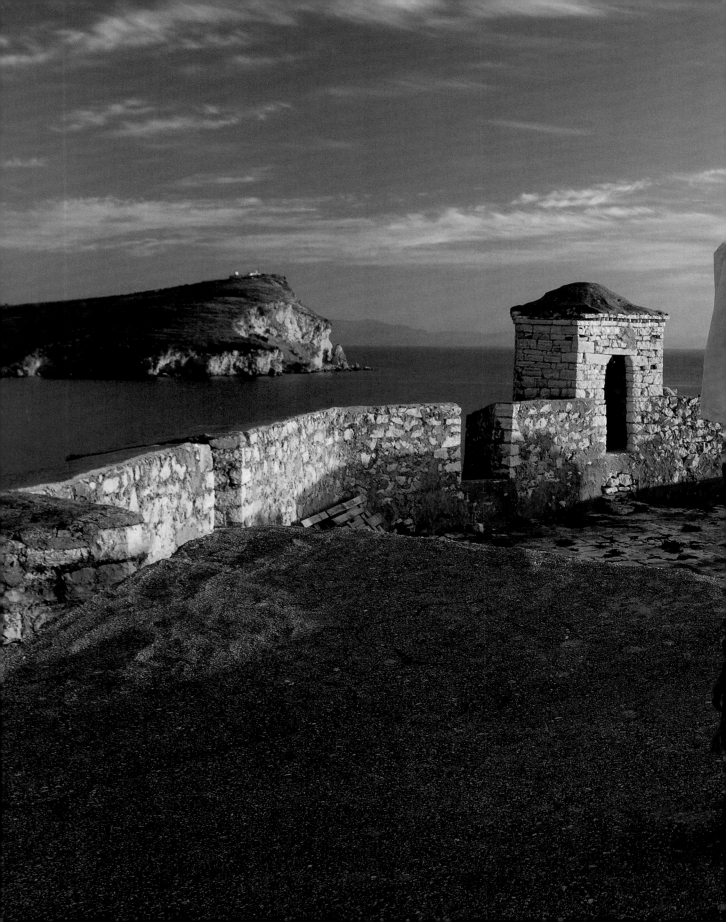

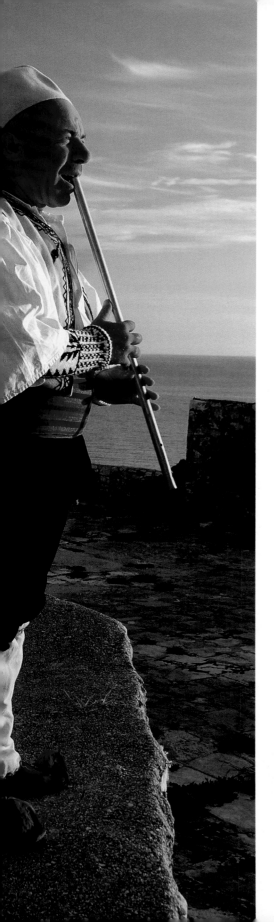

TELLING THE STORY

Photography is a way of feeling, of touching, of loving. What you have caught on film is captured forever…it remembers little things, long after you have forgotten everything.

—Aaron Siskind

We all love a good story. From John Steinbeck's *Cannery Row* to Mark Helprin's *A Soldier of the Great War*, these works form powerful mental images. As a kid in school, I remember reading *Cannery Row*. Steinbeck's ability to create imagery in my mind while telling a great story has always stayed with me. I think the role of a photographer as storyteller is fairly similar: we pull the viewer into the story and use our photography to create a narrative for the viewer. This chapter will deal with the process of telling a story in photos.

Albania, locked behind the Iron Curtain for decades, opened up to the world with the changing millennium. While aboard the National Geographic *Endeavour*, we stopped at Porto Palermo for the afternoon. My job aboard the *Endeavour* was to be the National Geographic Expert on all things photographic. At the Castle of Ali Pasha Tepelena in the late afternoon light, a traditional Albanian flutist was serenading the crowds. I photographed him with the Dalmatian Coast in the background, using the late afternoon light as it painted both flutist and the background. 12–60mm lens at 14mm, 1/60 second at f8

Whether you're shooting for the family album or for *National Geographic*, constructing a story and providing the viewer with key elements gives the photo story life and generates interest in the viewer. A story should have several key components: an establishing shot, a close-up to explain what is going on, a photo or photos with a key moment that creates an interest, an image that can finalize the story, and a visual style that ties these together.

Part of the process of shooting a story for *National Geographic* entails a story conference involving the writer and photographer team working on the particular story. This conference occurs at the outset of a project to make certain everyone is on the same page. The photographer and writer each bring a unique narrative to the story. In this chapter, we explore that process of finding and weaving a story together.

THE COMPONENTS OF A STORY

Many aspiring photographers want to know how to find a story to shoot. They are thinking that the story needs to be some grand work, instead of finding what is important to them. But what could be better to photograph and construct as a photo piece than a subject near to you? Too often, the photographer is thinking on too large a scale, ignoring what is in his or her own backyard or neighborhood. Look at the people around you. Try photographing your son or daughter during a soccer or swim practice. Try shooting a story on a local Fourth of July celebration or on your family vacation. These are naturals and are easy to work with because we immediately

eliminate the intimidation factor that so many find a very large hurdle.

To see how today's photographers are using web technology, visit http://mediastorm .org/.

A photographer assembles a story much the same way a writer does, with an introduction that includes an overview of the subject, a main body of work addressing details, and a closer. A successful photo story contains its own narrative that carries the viewer through the different parts of the piece.

Set the Scene

As the photojournalist—and this is truly what you've become, since you will be creating a visual narrative—you need to create an image to establish where you are and how the subject fits into that environment. This opening shot will bring the viewer into the world of the subject and provide a sense of place.

Back in the days when I was a newspaper photographer, an unwritten rule of covering a news story was to shoot an initial overview of the scene as you approached the story. This still holds true in magazine photography or in sharing your vacation photos with relatives: open the story with a *scene-setter*.

What is a scene-setter? It's a photo that visually describes the location in which you are shooting. Whether it's Dubrovnik or Disneyland, this establishing photo can be very simple in its construction. A well-composed image of the gates of Disneyland or an overview of the city of Dubrovnik shows why this place is different from home. It introduces the location to the viewer.

The Magic Can Be in the Details

Once you have an initial opening photo, you can work on several photos to create the story of the trip to Disneyland or Dubrovnik. Shooting the entrance tickets clutched in a tiny hand says a lot about where you are. A close-up of the lavender iris flowers for which Croatia is famous introduces that fact to the viewer. These detail photos can provide much information about your location and can be a way of creating a more personal interaction with the story. Moving in close for detail forces the viewer into a more intimate relationship with the photo story.

Here is where research on your subject really pays off, as it allows you to capture what you find interesting about this subject or place. The photographer's personal perspective is unique and should be considered central to the telling of the story (somewhat like the three blind guys describing the elephant).

The photographer's job is to stop the viewer and draw her into the story, bringing her information that she may not have been aware of or conveying a fresh sense of place.

Bring Life into the Story with Portraits

Effective portraiture can bring life to a story because it obviously conveys a sense of whom we are photographing. People love seeing and understanding other people, and a strong portrait is a very inviting way to draw someone into your story.

A Day in the Life of Africa was one in a long line of the best selling "Day in the Life" series. One of my assignments on this huge, all-digital project was to photograph park rangers in South Africa inoculating water buffalo. Part of the job of the photojournalist is to move in to the subject, thereby taking the viewer by the "eyeballs" and making her feel as if she is within that circle of activity occurring in the photo. A little fill-flash helped on this by brightening the shadows. 9mm lens, 1/30 second at f4

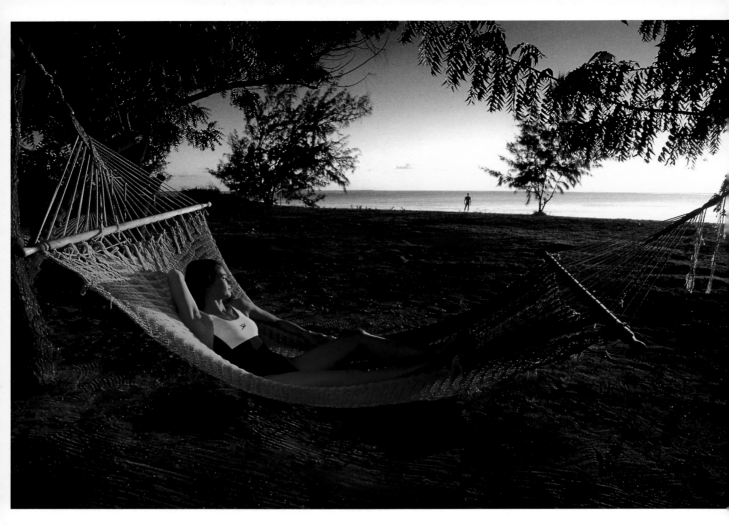

An opening photo often will be one that conveys a sense of place, providing the viewer with a feeling of the area he or she is seeing. On the Caribbean islands of Turks and Caicos, I was photographing a story on the luxurious and idyllic lifestyle a tourist can lead in these beautiful islands. We used this photo as the "sense of place" image to create that feeling of "I want to be there" to the viewer. 17–35mm lens, 1/125 second at f8, Singh Ray Graduated Neutral Density Filter

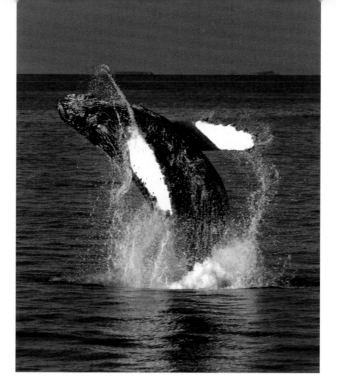

Sometimes composition takes the back seat to the immediacy of the image. This whale leaped immediately off the starboard side of the *National Geographic Sea Lion* during a recent trip to Mexico's Baja California, where I was photographing the huge density of wildlife. 90–250mm lens, second 1/500 at f8

A visual opposite of the image of the whale leaping, here a whale quietly breaks the surface of the Sea of Cortez. This photo tells a totally different story from the explosive energy of the other image. 12–60mm lens at 39mm, 1/500 second at f6.3, 100 ISO

An area that aspiring photographers may have difficulty with is shooting close portraits of strangers. This is discussed in detail in Chapter 8, but here are a few important points regarding portraits in a photo story.

- Approaching a stranger on the street can be intimidating at first. However, a bit of confidence along with a compelling reason why you want to photograph that person can go a long way. You're shooting a series of portraits on the craftsmen in the flea market or fishermen in a small village. Most potential photographic subjects will comply with your request if it sounds legitimate. The first few times are the toughest, and it does get easier.

- Show an interest in what that person is doing. That's what appealed to you photographically in the first place, right? I've found that if I am sincere in my interest, more often than not I am allowed to photograph that individual. Here's where asking some questions about what the person is doing can be of some value as it allows the would-be subject to be the expert. Genuine interest is often a ticket to making a good photograph. When you take the time to be interested, you're an interesting person to the subject.

- Photographing that person doing what attracted you in the first place is essential. This takes time as the first few minutes he probably will be staring at your camera waiting for you to take the photo. Explain that you would like him to do what he

was doing when you approached, and then give it time. I'll often spend an hour or so (if it feels like I'm not intruding) watching and waiting for that one moment.

- This bears repeating: Photography takes time. This makes budgeting your time important, especially if you're not at home.

- Last, but certainly not least, use that benefit of the digital technology—the monitor on the camera—to show your subject the images you've captured of him. This can be a tremendous ice-breaker, drawing the person's interest further into this process of making his image as powerful as you can.

Key Moments Are Essential

This is a natural extension of my last point, as working the situation for key moments also takes time. A key moment is, as Henri Cartier-Bresson described, existent in every situation in life. The dynamics of two people conversing on the street will build to a "decisive moment," where the gestures of the individuals reflect the peak of energy in their discussion. It doesn't have to be a dramatic over-the-top photo to be powerful. An example of a key moment could be the second a woman touches her new grandchild's face, how her face lights up as her hand is extended to touch the baby. Or when the Little Leaguer leaps in the air after touching home base with his team around him—now, *that* is a loud key moment.

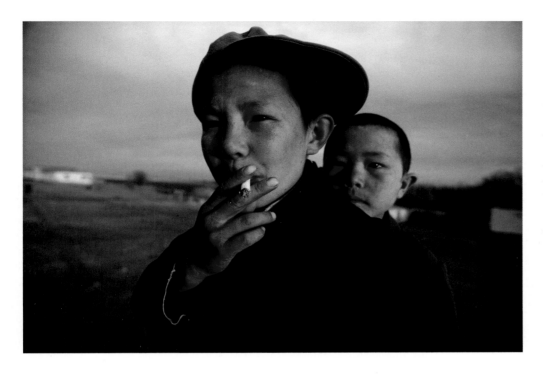

Stories involving people usually benefit from a tight, close-up portrait. This makes the photos much more personal by forcing the viewer to confront the subject visually. This photo of a couple of kids was shot for *A Day in the Life of China*. Typical of any son anywhere in the world, the 12-year-old on the left was scared his mother would see him smoking. 35–70mm lens, 1/125 second at f4

These key-moment photos will bring life and energy to your story, and they can be the fabric that not only connects the images, but also helps the viewer understand how those moments felt as they occurred.

A key moment does not always have to be a super-dramatic, wide receiver flying through the air with the ball on fingertips photo. Good key moments can be much more gentle.

Anticipating human response allows the shooter to be ready when the decisive moment arrives. This is a skill that will develop the more you shoot. Knowing when to shoot is made easier by staying focused, literally and figuratively, on your subject.

Bringing Closure to the Story

You've got a good opener, a photo that introduces the viewer to your subject and explains a bit of the character of the place or people. Your story then contains a detail or portrait, or both, that makes the story more intimate. You've introduced the viewer to a specific person or aspect of the story. You've worked the situation for those wonderful explosive or quiet moments that bring energy to the story.

Bill Allen, retired editor of *National Geographic*, says that each reader is coming into the story through *his or her* own door, and you want the reader to leave through *your* door. That door is the closing photo.

The closer can be as obvious as the sun setting over the kids walking down the beach on the last day of the vacation. It can be as gentle as a flower lying in the church aisle as the bridal couple is walking away in the background. The closer wraps up the story and

can direct the emotional feeling the viewer will be left with.

Looking at photo essays—not just any old photo essays, but really good ones—is of definite benefit to anyone aspiring to shoot one. W. Eugene Smith's famous 1948 photo essay on the "Country Doctor" for *LIFE* magazine is one such essay, and scores of others can help guide the aspiring shooter.

Less Can Be More

In your vacation story presentation or in a *National Geographic* layout session, one rule holds true: less is more. Six photos of kids kicking soccer balls will be good for the season-end dinner presentation, but in a story those redundant images will bore the viewer. One really strong action photo will speak volumes compared to several weak photos.

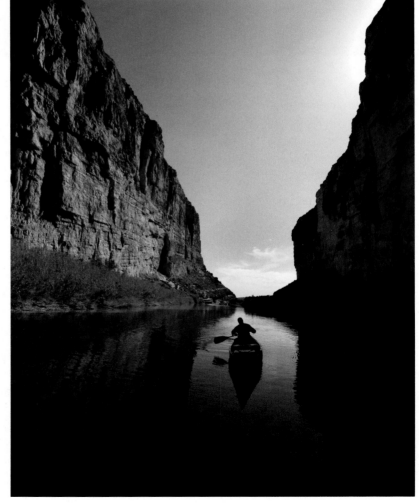

On assignment for *Texas Highways* magazine, I spent a few days canoeing Santa Elena Canyon, which forms the southern boundary of Big Bend National Park. Rich McCaffery was my guide and paddling partner—this is Rich as he is just about to exit the canyon. A quiet scene, the paddle in the air is that subtle decisive moment that brings a bit of visual interest to the photo. This photo ended up on the cover of the magazine. 12–60mm lens at 14mm, 1/250 second at f8

When shooting a story, the photographer has to produce an image that will close the visual narrative. On an assignment for *TIME* magazine, my subject was the Canadian Rockies. As a closing image, this photo of the highway between Banff and Jasper National Parks creates that ending; the taillights streaking by provides that visual element of interest, pulling the viewer into the photo. 11–22mm lens at 14mm, 2 seconds at f4, 400 ISO

How To: Creating a Photo Story

As a contributing editor for *American Way*, the in-flight magazine of American Airlines, I was asked to come up with story ideas. I would research story ideas in or near cities to which the airlines flew. One story I proposed to the editors was on the Palio di Siena, in Siena, Italy. This twice-annual horse race has been run since the 11th century and was an event I'd always wanted to see. A race track is created in the village square, the Piazza del Campo, with tons of dirt being trucked in to cover the ancient brickwork. The 17 *contrade*—neighborhoods or city wards—are each represented by a horse and rider who will tear around the piazza at breakneck speed. The winning horse can even be riderless. It is utter and wonderful mayhem.

I'd contacted the tourist office in Siena and arranged a meeting with the director. He in turn put me in contact with a few *contrade* directors, and I made sure I at least introduced myself to them prior to the weeklong events leading up to the July race.

This is an overview of how I shot the story and how it was constructed as a finished piece.

Step 1
Needing an opening photo that introduces the Palio to the reader, we wanted to use a strong dynamic photo with enough photographic tension (see Chapter 6 for a discussion of tension) to stop and draw the viewer into the image.

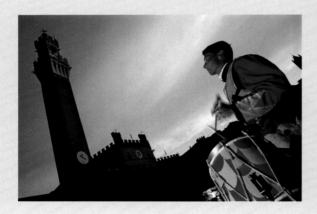

Step 2
Having made a graphic entrance into the story with the opening photo, I then immediately brought in the main element—the horse and the flag theme continued from the first photo—that is also carried to the next image. This created a visual narrative by establishing a palette of colors and shapes.

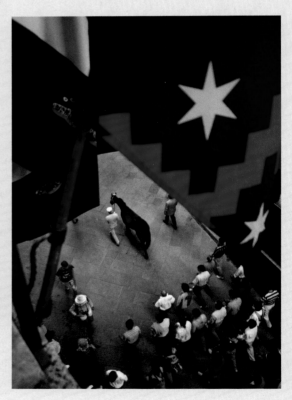

Step 3

With this photo, the visual narrative of the palette continues, but it brings the human element into the story. I like the idea of the *contrade* colors being common to the first three photos.

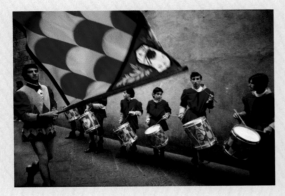

Step 4

A photographer friend, Jeffrey Aaronson, told me once that if something makes us laugh or go "Oh, wow!" we should be photographing that subject. Historically in the Palio, each *contrada's* horse is taken into the neighborhood church to be blessed. You don't see that every day in Topeka. It's always nice to be able to introduce humor into the piece.

Step 5

I've teased the viewer with some very nice images of specific events happening in Siena; now I wanted to bring a view of the town, the track, the race, and the crowd. There's a lot going on in this photo, but it actually is quite simple—and necessary to show the reader where I was. That detail does not always have to be up front in the story.

Step 6

Providing more continuity, as I did with the palette theme, I use the crowd from the previous photo in this image. But I bring the human element into it with the beautiful young lady.

Step 7

As with the opening three photos, I use three crowd photos, but each has a totally different feeling and place in the narrative. The main focus of this photo is the two kids watching the race; the crowd is the supporting cast.

Step 8

Another repeating theme, and this is what the event is all about: the race itself. In the magazine layout, we actually used these four photos as a series. This corner of the track is notorious for horrendous crashes, and it happened during this race. I had to purchase a very, very narrow seat with an overview of this spot—it was not cheap, but, as you can see, it was well worth it.

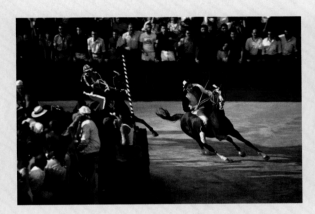

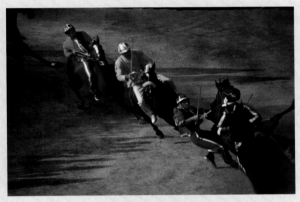

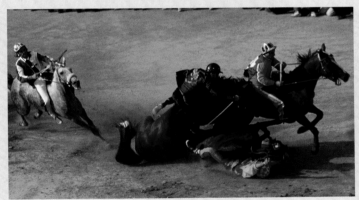

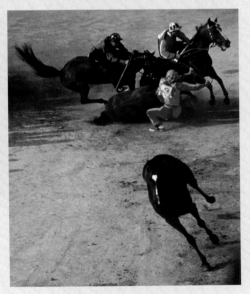

Step 9

This *contrada* had not won the Palio for a number of years, so it was an emotional event for the neighborhood members. Following them back to their church where the winners have historically gone, I found this woman emotionally celebrating the win.

Step 10

After giving thanks in the church, the *contrada* carries the winning jockey through the streets of Siena. This is purposely shot at a slow shutter speed with a flash to get the movement, while freezing the jockey's face.

Step 11

This is our closing photograph. Small fires are lit atop a few buildings to celebrate the race, and I talked my way atop a hotel nearby to get this important overview. Is working on a story tiring? Yes. Is it exhausting? Yes. Is it worth it? Yes!

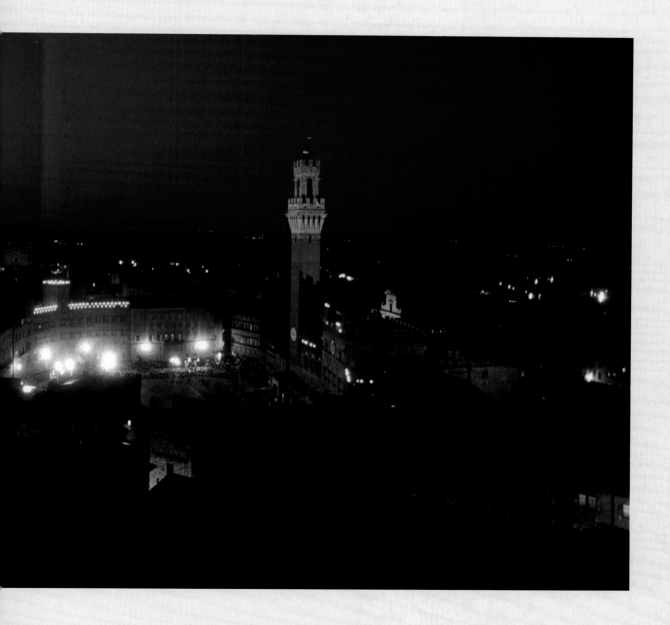

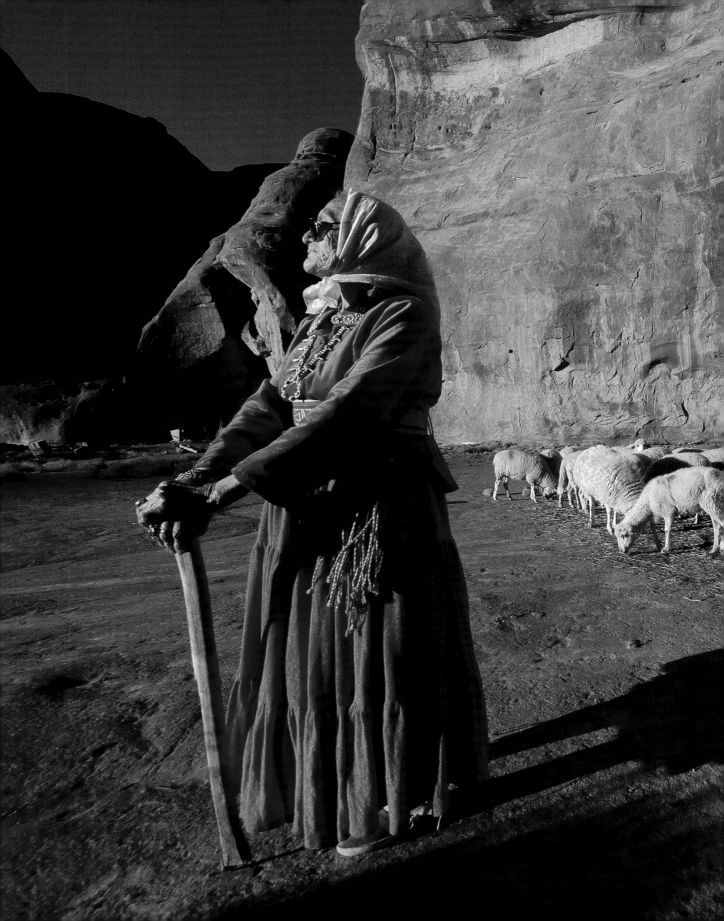

PHOTOGRAPHING PEOPLE

Like the people you shoot and let them know it.

—Robert Capa

Above all, I know that life for a photographer cannot be a matter of indifference.

—Robert Frank

We love photographing each other—it is part of the fabric of being human. Becoming comfortable with this task takes a little time and initially a little nerve. But the power of being able to photograph people well is one of the most satisfying areas of photography.

Monument Valley in Arizona is the home of Suzie Yazzie, 80-plus years old and a lifetime resident of the Navajo Nation and the amazing valley. I had the opportunity to photograph Suzie during a shoot in the valley, where she still works her sheep and was gracious enough to give me more than an hour of her time. Talk about intimidating—she was there when John Ford shot *Stagecoach* back in 1939. I placed her off center, balancing her sheep in the background to create a slightly asymmetrical image. 7–14mm lens, 1/125 second at f8

Perhaps you've turned to this chapter first, as people are one of the most intimidating and frustrating areas of photography. How the heck does a *National Geographic*, *Condé Nast Traveler*, or *TIME* photographer go into those situations where he or she may not speak a word of the language and come out with those magical and involved photos?

In many ways, it really is a simple combination of confidence and interest. The confidence is gained by having approached strangers many times, as well as knowing your equipment. Taking real interest in another person and who he is, is the other part of the equation. This is the heart of what we'll talk about in this chapter.

IS THERE AN EASY FORMULA TO PHOTOGRAPHING PEOPLE?

Yes, there is! I've mentored on several American Photo Mentor treks, and one of the most-asked questions is how to approach people on the street. I've found the best answer to this question is a demonstration. I'll be with a group of trekkers and we'll find someone on the streets we want to photograph. Eye contact with a friendly look is the starter, followed by an explanation of what I'm doing. And here's a major hint: give yourself an assignment so your photographic mission has a reason to exist.

Your photographic mission can be as simple as "I'm shooting portraits for a photographic series I'm assembling" or "I'm shooting a photo project on the streets of your town." What you'll often find is an interest

and a willingness of the subject to help you in your endeavor. Also, on your camera's monitor, show your subject one of the photos you've taken of him or her—this may be the ultimate ice-breaker, and it can get your subject more interested in allowing you to continue shooting.

A Few Lessons on Approaching Subjects

- *Don't travel in a group.* This can seem to your intended subject as though you're part of a gang of camera-wielding attackers. Work solo or with as small a group as you can. If you're out shooting with a spouse or friend, that person can help hold reflectors and carry equipment.

- *Make eye contact* with your potential subject. We're all humans here, and the small task of looking someone in the eye shows that you acknowledge him. A smile can go a long way.

- *Show interest* in what the subject is doing. We all like to feel that what we do is of interest or has a degree of importance to someone else. Spend a few minutes watching or listening to your intended subject, and talk about her craft or work. Even if you don't speak the language, you can visually interpret quite a bit by watching.

- *Ask permission* to take his photo. Believe me, after 35 years of creating relationships, however brief, with intended subjects, the times I've been turned down for photos is a tiny

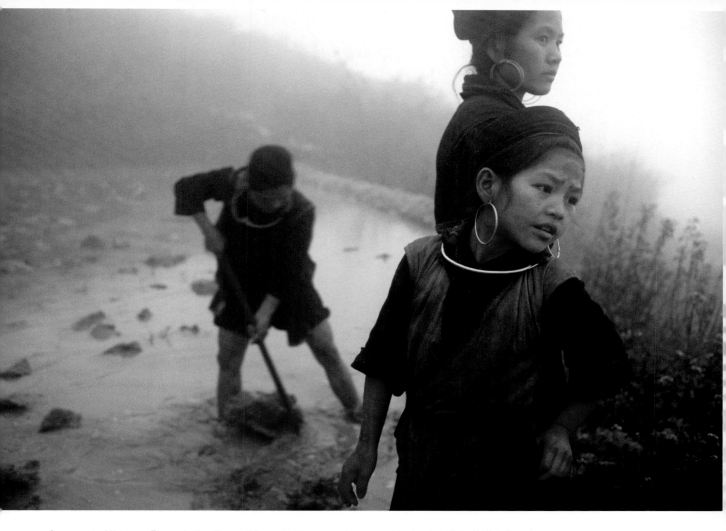

Passage to Vietnam: Through the Eyes of Seventy Photographers was the brainchild of Rick Smolan, who assembled a group of photographers to enter the country in 1994. I'd taken a train on a ten-hour trip from Hanoi to Lao Cai, where a four-wheel-drive Soviet-era jeep drove us on the four-hour, bone-jarring trip to the H'Mong village of Sapa. I was wandering the mountain trails around Sapa when I found this family working on one of thousands of rice paddies dug into the mountainside. 35mm lens, 1/60 second at f4

percentage of the times I've received willing permission to photograph total strangers.

■ *Above all, show the subject respect.*

Throughout this chapter, I'll share some examples of photographs I've taken around the world and also share the stories of how I got permission.

Revisiting a Memory and Movie Location, Salina, Italy

This is what I love about this business and how a simple piece of gear, the camera, can be an entrée into someone's life. I have a standing invitation to return to the farm in Salina with my family, and I have new friends in another part of the world. In return, the family had the

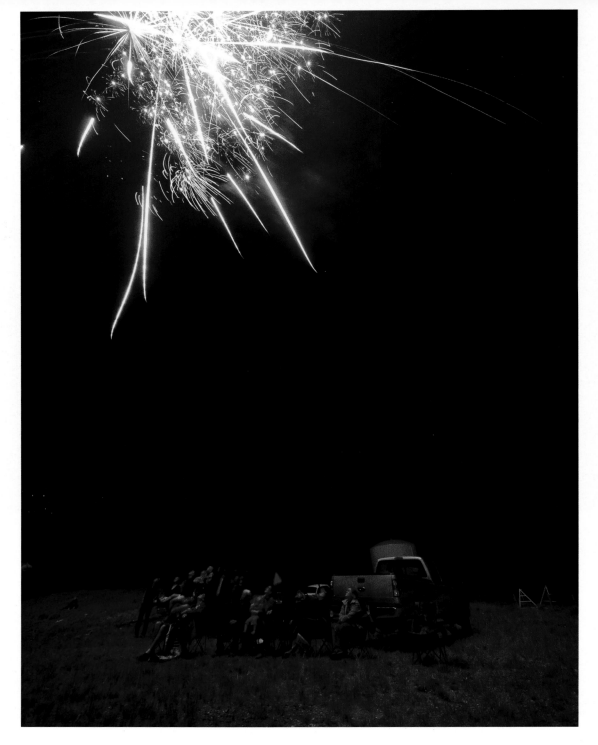

During one of my FirstLight Workshops, I photographed this group of locals watching the official as well as the impromptu firework displays. Teenaged kids of these folks were setting off the pyrotechnics just a few feet away, sending some of the rockets directly over the small crowd. 7–14mm lens, 4 seconds at f4

opportunity to share with a foreigner a bit of their history, and they, too, have a new friend in the United States.

Breaking the Language Barrier

What if language is a barrier to communicating with your intended subject? It's likely that those three years of high school Spanish are a foggy memory, or perhaps your next trip is to a country whose residents speak a language you've never had the opportunity to learn. If you have the luxury of a couple of months before you leave on your adventure, try your local community college for a crash-course in the language of your destination. Or go online and buy a Berlitz (www.berlitz.us) or Pimsleur (www.languagetapes.com) short course in the language. Your standard travel guidebook will help you learn at least a few words of the language: Thanks! May I take your photo? Has anyone told you your eyes are the color of liquid? (Well, the last one may not go over.)

The point is, if you show the locals of the place you're visiting that you've at least attempted to learn a few phrases, it will go a long way toward making that essential connection.

Once You're on Location, Now What?

You've found your subject and you've made the approach. You've spent a few minutes talking with her to convey your legitimate interest in photographing her. Now what? How do you get the best photograph possible?

Some years ago I spent nearly six weeks in the Aeolian Islands of Italy, seven islands just above Sicily, and about as remote as one can get in Europe. Recently I was back in the Aeolians on a shoot for Steve Connatser's *Traveler Overseas* magazine. On the island of Salina, we were visiting the home and location where the 1995 movie *Il Postino (The Postman)* was shot. The owners happened to be there, so I asked if we could photograph their son. As typical, during the first few minutes, his gaze was on me. After a while, I became pretty boring and he went back to blowing bubbles. Late afternoon light and the gaze of his eyes makes this simple picture work in a gentle way. 14–54mm lens, 1/60 second at f8

Second-nature familiarity with your equipment is crucial. Part of being successful in photographing people is the comfort range and knowledge of your equipment that you

In a small church on the island of Sardinia, my assignment was to photograph a centuries-old festival to bless the fishermen against cruel weather. This group of kids was awaiting the procession, so I ducked in and hung out a while and found this scene of youngsters sharing secrets. 17–35mm lens at 17mm, 1/15 second at f2.8, ISO 200

display as you work. If someone has allowed you into her world to share who she is with you, it is your responsibility to know your craft so well that the process of taking photos does not get in the way of the relationship you've created. The camera should not be an intrusion in this process.

Understanding exposure, what you want, what your camera is capable of, and what the situation can accommodate must also be second nature. When the camera is raised to take the picture, all should be ready.

Anticipate the Decisive Moment of Your Scene

Give a situation time to develop. Henri Cartier-Bresson, the great French photo-journalist, said that every situation has its "decisive moment." That is the moment when everything comes together in the photo. Whether it's a guy hanging fish or kids on the soccer field, the responsibility of the photographer is to capture that peak moment.

I was explaining to one of my students in a photo workshop this theory of the decisive

moment and that we have to take the time to allow a situation to develop. I pointed out that the photographer has to "work" the scene, exploring it from every angle, seeing both wide and tight, trying to find that unique look and the perfect moment. The next day, the student brought his CompactFlash card in for review. Instead of working the subject by photographing the many ways we'd discussed, this person shot two frames and called it a day, never getting the decisive photo.

This is a common problem with new photographers—not working a situation.

You've spent the time searching for the subject material and you've made the approach and created a relationship of trust; now stay with it until you feel you've really gotten the moment. This may take 3 frames, or it may take 75 frames. This is irrelevant. The bottom line is this: Does this image work? Does it capture that decisive moment?

So how *do* you capture the decisive moment?

- First, find subject material that interests you. Do a little research if necessary and figure out why this is a good subject.

Okay, I'm not a wedding photographer. I'd photographed a wedding in the late 1960s and swore I'd never do it again. However, in the past couple of years, I've judged photos for the Wedding Photo Journalist Association (WPJA) and I was pretty blown away with the documentary style that is so popular, as well as the really high level of photography. While on the Aeolian island of Lipari, I chased around this wedding procession as they visited traditional sights where they would stop to be photographed. I liked the setting sun, the light gently painting the bride's train, and the islands of Salina and Filicudi in the background. 7–14mm lens, 1/30 second at f5.6

- Next, create a story line for your assignment. This could be portraits of Spain or a day at the soccer match.

- Then approach the situation, identify the potential subjects, and repeat the process described previously: make eye contact, state your mission, and express interest in what the subject is doing.

- Give it time. Stay with the subject and really watch for the small gesture he makes or the laugh between two friends sharing a story. That will be the moment that produces a nice image. Stay with it until your presence is no longer alien. You want to disappear like a wallflower so the camera's presence is not driving the situation.

- Don't be hesitant to shoot multiple frames of a situation or person. One or two frames may not get that moment, and by working on getting that moment you'll become more proficient in the craft.

- I can't emphasize enough that you must be technically proficient and know your equipment like the back of your hand. Also, stay with your subject material until you've exhausted every possible way to see it. I don't want to sound like a broken record, but the last sentence bears repeating. Pushing yourself here is what will make you grow as a photographer.

Don't Overstay Your Welcome

Remember that you need to know when it is time to back out or leave. Many situations call for sensitivity. In some countries, women do not want attention called to themselves. That street vendor you are photographing may not want you in his face for too long. Learn how to read signals from your subjects, and make a graceful exit.

PHOTOGRAPHING CHILDREN

Children are an easy subject and such great material. Kids are naturals when it comes to posing, and without much exception they love having their photos taken. Rarely do you find a kid who is self-conscious in front of a photographer, and most will willingly strut, mug, and perform for the camera. However, some hard-and-fast rules must be addressed.

First and foremost, *always* ask permission from a parent or guardian before you shoot. This is not always easy, as the parents may not be around, but if a parent isn't around, you have to weigh whether the photo is worth possible police involvement. This is an unfortunate truth that must be adhered to.

Once you have obtained permission, and you've explained why you'd like to photograph this person's child, the kids will usually go back to doing what drew your eye to them in the first place. Again, give this situation time to develop.

I've always found with children that the first few minutes of the process involves their mugging and acting for the camera. The trick here is either to put your camera down when they fight/mug/act up for the camera or turn it in other directions. This will quickly get the

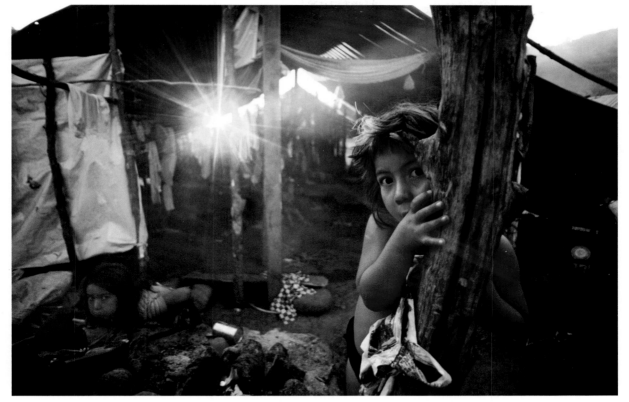

While covering the war in El Salvador in the early 1980s, I photographed this young girl in a Honduran refugee camp. This photo was part of a 13-picture series for which I won the Pulitzer Prize. The story was very somber and dark, and I wanted to end the series on an upbeat note. I'd seen this shy little girl when we first arrived in the camp the previous evening. The next morning I made my way through the camp until I found her family's tent. I sat for a while without shooting, so she'd become used to my presence. Speaking in the little Spanish I knew, I talked to her as I moved closer, kneeling down to her level, and took just a couple of frames. I wanted the explosion of the sun's rays, so I moved the camera up and down until I found the effect that looked best. 24mm lens, 1/60 second at f2.8

idea across that this silliness is not what you are trying to shoot. Again, give the situation time to become natural.

Be prepared to walk away from the scene you're trying to capture, a short distance or altogether, if it gets out of hand. Like a news event, you do not want your presence and camera to be what drives the situation.

The best photos will happen when the kids have gotten bored with your presence and go back to doing what attracted you in the first place. This takes time and patience on your part and can be worth the extra effort.

A Few Rules and Tips Regarding Photographing Children

- Get permission. In parts of Europe, it is actually illegal to photograph kids in a school, so be aware of local regulations. Look for the chamber of commerce in the area you're visiting and see if it can help with this important aspect. You can also check with the local school.

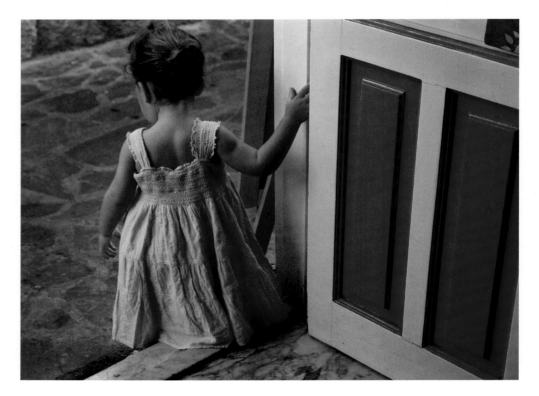

Often the photographer does not have to include the face to create a meaningful image. I photographed this little girl as she was leaving an ice cream store on the Italian island of Panarea. I think this is a simple and successful image, her hand on the doorsill being that critical moment from which many photos will benefit. 12–60mm lens, 1/60 second at f4

- Get down to the kids' level. Too many pictures of children are shot from the adult eye level, which creates a superior feeling. When you kneel down to shoot your photo, you are creating a feeling of being on the children's level. You'll also find that kids react to you more readily if you're willing to kneel down and shoot from that level.

- The beauty of digital is being able to show the child (and the parents) his own photo. This will also help him understand what you are trying to photograph.

- If a person has gone out of her way for you, be sure to send a print to her. Too often, photographers walk away from a session and never send prints, even when someone has gone to extra effort.

- Above all, remember to give it time and work the situation. Don't be content with taking a couple of frames and departing. This is a craft that requires time.

- Some of you sharp-eyed readers will have noticed that many of my people photos were shot at a relatively slow shutter speed, the lens near wide open. I do this, as I really like to work a subject in late-day light, and at lower ISOs. Why? Softer light and controlling the depth of field (wider open allows the photographer to select the "zone of focus," allowing the background to gently drop out of focus).

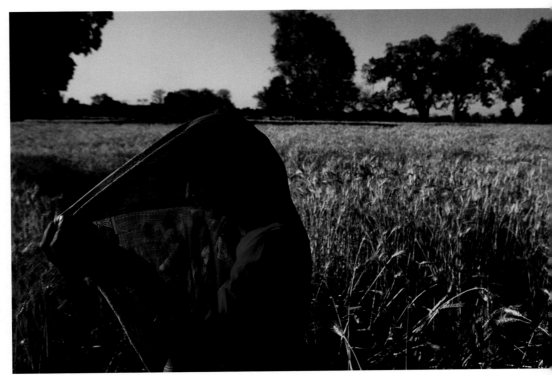

Along the same line of the photo of the little girl in the doorway, often by *not* including the face of the subject, the photographer can create a sense of mystery and intrigue that would not exist if the subject were facing the camera. In a small village outside of Agra in India, I photographed this young woman who had been picking corn in this field as she shielded her face from the sun. 17–35mm lens, 1/125 second at f5.6

POSING YOUR SUBJECT

Posing is an issue in all photos of people. Do you want the photo to look natural or staged? One is not better than the other and both can work beautifully.

I wanted the Custer image to look as though it was really the general at Last Stand Hill and decided on a late afternoon session so we could use the beautiful light on the gently rolling hills of Little Bighorn. I had Steve stand in the grassland and had my assistant (this time, my wife) hold a gold and silver reflector (more about these in the equipment and lighting chapters, Chapters 2 and 4) to fill in some of the shadows on the shadowed side of Steve's body. This is a simple trick used by photographers, but it can enhance a photo by eliminating some of the hard light caused by direct sunlight.

A postscript: When I called Steve to obtain a release to use his photo in this book, I hadn't spoken to him since the picture was made several years ago. I tracked him down in Monroe, Michigan, where he had bought the house George Custer once lived in. His wife, Sandy, answered the phone and I explained that I needed Steve to sign a release. She said there should be no problem and asked if she could tell me a story. When she was single, Sandy had been flying home from a vacation. Prior to the flight, she had said a little prayer that a sign be given to her as to who her life mate might be. She opened up the *American Way* magazine during her flight to the page where this photo of Steve appeared. There and then she knew he was that person. Kinda nice, huh?

Whether you're photographing on assignment or for friends, start thinking of

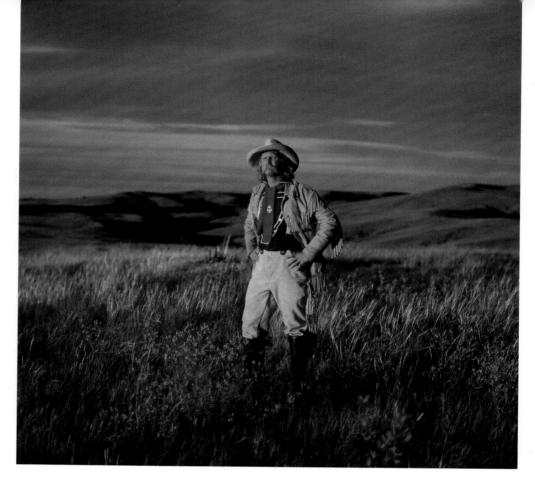

The re-creation of the battle of Little Bighorn occurs twice a year—once by the Hardin, Montana, Chamber of Commerce and again by the Crow Nation. They tell a slightly different story, but both feature General George Armstrong Custer as one of the key figures. As a contributing editor for *American Way*, I was assigned a story to photograph both these events. An obvious necessity for the story was a photo of General Custer, who was admirably and believably portrayed by actor Steve Alexander. I'd contacted Steve and asked if we could take his photo out on the hill where Custer had died. 80mm lens, 1/30 second at f2.8, 50 ISO

different ways of posing your subjects even while you're shooting the initial photos. Think of these as warm-ups. The subject may be a bit nervous at first, and this is a great opportunity for her to become comfortable and for you to have the time to think of other ways to pose her.

Don't be static—move in and step back. Fill the viewfinder with the person, and then move back so the environment is incorporated. Don't only center the person in the viewfinder; try placing her off to one side in some frames. The viewfinder is your canvas, so make certain that everything going on in the frame is relevant to the image.

The entire time you're shooting, try talking to the subject—even stupid jokes can help relax the situation. Or you could

impersonate the actor David Hemmings from *Blow-Up* or Austin Powers and get into the "Yeah baby…" talk. (Probably better not to, though—she may confuse you with Austin Powers.)

Maintaining eye contact is important as well. This will make your subject more comfortable and create a feeling of confidence. And the confidence you exude will be reflected in the trust the subject will give you, resulting in better photos.

CHOOSING EQUIPMENT TO GET THE BEST SHOT

Within our camera bags we carry various lenses for different looks and effects. Wide (short) lenses and telephoto (long) have their own look, wide lenses exaggerating perspectives and telephoto lenses compressing the field of view. Photographing people can call on all the tools in your bag.

Head-and-shoulder portraits are extremely direct and force the viewer to look directly at the subject. A medium to long telephoto is often the lens of choice, ranging from 85mm to 200mm. This medium length does not compress the subject too much, which would have the tendency to flatten someone's face out of proportion.

Photographing for the book *A Day in the Life of the United States Armed Forces*, I was on a mountain in the rainforest to the east of Hanoi, in Vietnam. I was photographing Joint Task Force–Full Accounting, a long-term project involving all branches of the US

military to collect the remains of US service people lost in World War II, the Korean War, the Cold War, the Vietnam War, and the Gulf War. A former North Vietnamese soldier had discovered the remains of a US Navy A-6 Intruder aircraft on the hillside where it had crashed in 1972. The carrier-based plane had been on a mission near Hanoi and was heading back to the Gulf of Tonkin.

The photo I took of this soldier was shot with an 85mm f1.4 lens, wide open. I wanted the background to be out of focus as well as the sides of his head. The desired effect was to build the photo around his eyes, with the very select focus created by the extremely shallow depth of field of this fast, short telephoto lens.

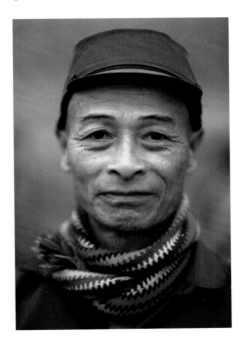

Ly Thien fought with the Viet Cong. I shot this with an 85mm f1.4 lens, wide open, to create a plane of interest of the very shallow depth of field this lens produces when shot at maximum aperture.

Sometimes a photo of a person does not have to be literal—that is, we do not always have to see the face of the person or people in the photo to get a feeling for their character. Also, by *not* including the face, the photographer can create an air of mystery about the photo.

You can also use different types of light to emphasize specific components of an image you're trying to capture.

Using Strobe Lighting with the Ambient Light

Colorado had been through several continuous years of a drought, and the assignment for *TIME for Kids* magazine was to shoot a cover using this youngster as my subject. Shooting in the harsh midday light in the drought-stricken eastern plains of Colorado, I wanted to create a fairly stark lighting effect. I used a single "soft box" with a strobe inside it as my main light. This is fairly common, mixing

available light (the sunlight) and artificial light. As you can see, the effect is one of a balanced and even light across the subject, making the viewer respond to the photo and not the lighting.

ENVIRONMENTAL PORTRAITS

Many assignments for *TIME* call for an *environmental portrait*. This is a photo that will capture the essence of the subject as well as telling the viewer something about that person's environment or world.

Environmental portraits are generally shot with the subject in the near foreground, while the background contains elements relating to the subject. Often shot with a wide-angle lens, these added elements in the background can contain a powerful narrative about the person.

The nice thing about environmental photos is that they can be accomplished with a minimum amount of equipment and hassle.

Not a person, but this dog in the back of an ATV was waiting for his Canadian cowboy owner to return from gathering horses on the Ya Ha Tinda Ranch in the Canadian Rockies. I really liked the softness of the light, the ears askew on the dog, and the two cowboys riding up in the background. My old friend, former *National Geographic* photo editor Bert Fox, has always said that everything in the frame either works for the image, or against it—there is no middle ground. 7–14mm lens at 9mm, 1/4 second at f4, ISO 200

I'll really date myself here. I used to photograph rock and roll, ranging from Jimi Hendrix to Janis Joplin, Led Zeppelin to Willie Nelson—the files are deep. In 1969 I photographed Led Zeppelin at the Texas International Pop Festival, during the band's first American tour. 85mm lens, 1/125 second at f1.8

Try using a wide to normal length lens and a strobe and/or reflector to add a slight amount of light on the subject, helping to create a little more visual interest. Place your photo subject thoughtfully—for example, your neighbor in the foreground with his Harley-Davidson in the near background. The strobe will work on-camera for this, or you can use an extension cord for the strobe so the light it casts will not be so flat. Moving the light slightly out and above the camera will create more interesting shadows. For the next step up in complexity, try using a photographic umbrella or your own bumbershoot with white paper or aluminum foil placed inside the dome. Pointing the strobe into the umbrella will create a softer and less obtrusive light.

A reflector can also work nicely in an environmental scenario, but it can cause a subject to squint if the light is too bright. I've almost fried eggs with the amount of energy bounced off of a silver reflector on a bright day, so be kind to your subject! A combination of the two works very well, placing the strobe as the key light—lighting the main part of the subject's face—and using the light bounced off the reflector to fill shadows on the side of the head.

Exposure in this scenario would be for the general scene in the background. Make the exposure using no additional lighting to ascertain the correct exposure for the background, and then introduce the lighting in

TIME for Kids was doing a story on the drought in the American West and gave me the assignment to photograph this young man and his dad and brother on some of their sun-parched acreage. I shot this with a strobe bounced in an umbrella, along with a reflector just off to the side to fill in the shadows on the side of his face. 80mm lens, 1/250 second at f8.5

the foreground. This really is building a photo, the monitor on the digital camera being the perfect place to check the accuracy of each step.

PHOTOGRAPHING PEOPLE IN ACTION

Combining available light and on-camera flash on the Futaleufú River in Patagonian Chile made this image work. The assignment was for Steve Connatser's *Traveler Overseas* magazine as part of a story on this world-class whitewater river.

With the shutter speed set to 1/15 of a second, I set the aperture to the correct exposure to get movement in the background and to create a sense of speed. I had the camera and on-camera flash in an ewa-marine bag, which made it waterproof. The strobe was set on TTL exposure, about two-thirds of a stop underexposed. This is personal preference: I like the flash fill slightly understated. I think this makes for a more believable photo.

Light is what this business is all about, and the photographer decides what form of light he or she will use in creating a portrait. As simple as a light ray pouring through a window creating a feeling of mystery, to a fully controlled environment with multiple lights, the choices are as great as the potential.

Photographing people is such a natural and wonderful part of photography, and using some of the simple tricks discussed here will give your photographs more power and visual interest. A comfort level with your approach and with your equipment skill will give you that much more control over the finished photo.

Lighting a Portrait

Find your willing subject, someone who is ready to put up with a bit of an extended shooting session. Find a location that has an interesting background, perhaps a flowerbed in your backyard or a neighborhood park.

Have a portable flash handy and something to bounce the light into—this could be a white piece of art board, say a minimum of 20 inches square, or a photographic umbrella. You can create a

makeshift photo umbrella with a normal umbrella lined with some aluminum or gold-colored foil. A reflector is a great tool to have in your bag; these are discussed in some detail in Chapter 4.

Bring your subject close to the camera with his back to the sunlight and frame the photo so it makes a simple composition, such as the person in the foreground off to one side of the frame and the garden in the background. Take a meter reading on the background; this will be your main exposure. I usually underexpose the background one-third to two-thirds of a stop.

The flash can be set to TTL, Auto, or Manual—your choice. Manual exposure will give you the most consistent results and the output can be controlled exactly in this mode. But the accuracy of today's TTL exposure systems is so good, you can depend on it.

Shoot a test exposure with the strobe pointed and bounced into the umbrella or card. The light bouncing off of the reflective surface is dispersed over a greater area, creating a softer effect. Using the flash pointed directly at the subject will create a very harsh light.

When the exposure looks good, have your assistant hold the reflector just out of the frame so it reflects some of the light from the strobe onto the side of the face that is most heavily shadowed. Generally, I like to have the reflector just out of range of the viewfinder as it is more efficient in bouncing light in to soften the shadows the closer it is to the subject.

In this process, the flash is your key light and the reflector is providing fill light, which is not as powerful as the main light, but just enough to bring up the light levels in the shadowed area.

Riding backward in the bow of a raft through Class 5 whitewater provided the "point-of-view" photo of this paddler being doused by a wave. Facing the back of the raft, I at least didn't have to worry about what was coming! Camera: Olympus 8080 in an Olympus waterproof housing. 1/15 second at f11 with a fill flash set to two-thirds of a stop underexposure

How To: Photographing People with the Light You Have—A Sometime Minimalist's Guide

The very nature of a photojournalist/traveling photographer dictates that equipment be kept to a minimum. Most of my lighting is in response to the needs of the moment; rarely do I go out with a specific lighting scheme in mind. Adding light when photographing people can bring life as well as attention to your subject, especially if not overdone.

I will use whatever is at hand to accomplish my lighting needs, with the overriding idea of creating a strong image that works on the merits of a good photograph, not a photo that the viewer looks at thinking, "Is that photo overlit?" Keeping it natural and understated works for me.

With that in mind, this How To will be an overview of several methods I've used in the past, with a brief description of how to use these styles of lighting in your own work.

One tool I always carry is a flashlight—not only for seeing where I'm going so I don't crash and drop expensive equipment, but as a subtle way to add light in exact areas to make the photo more interesting. (See the section "Sometimes the Simplest Light Is the Best" in Chapter 4 for the photo of Tom Prince, lit with a flashlight.)

Using available light can literally mean using the only light available at that moment. This photo of a couple of square dancers was shot in Dubois, Wyoming. Walking out of the event, I spotted Kevin Christopher and thought he'd look great for a photo, so I asked him if I could photograph him. My wife then saw Gretchen, Kevin's wife, and grabbed her to add to the photo. The only available light was the neon window sign for the bar, so I placed both of them with the light coming slightly from the side. Balanced with the deep purple sky and the neon light, it makes a nice portrait of some Dubois cowpersons!

I was shooting a story on the Yukon River for *National Geographic* and my subject here was the *Ruby*, one of the barges that deliver goods on the 2000-mile-long river. I wanted to illustrate the barge making the last trip of the year, so I positioned myself on about 3000

cases of beer that were being delivered on the bow of the barge. I exposed my camera (tripod-mounted) at 1/2 second at f5.6, while "painting" the truck in the lower foreground with a pretty strong spotlight. I was moving the light constantly and lit or painted this area so the light would be smoother than if I were to have held it steady. This brought up the light value (the brightness) on the side of the truck, which would have been totally dark otherwise. The captain in the cabin of the barge is lit with a flash that I taped up in the upper-right corner of the cabin and is actually being fired by the captain of the *Ruby*. I had the flash connected to a camera by a remote cord, and the camera was placed within reach of the captain. I asked him to press the shutter of the camera when I signaled him with a small penlight I held in my teeth. The interior of the cabin is lit, the side of the truck is lit, and the overall scene is correctly exposed—three lighting sources for a multiple-light situation: flashlight, flash, and ambient.

This photo took a bit of work, but it was shot with equipment that is common to a lot of photographers: a couple of flashes connected to a single camera used to fire these that were placed in the police car, with the sheriff triggering the shutter on that camera. The flashes were taped above the car's visors, the remote cords stretched along the side of the window. The tricky part? I was riding in the open trunk of an old Cadillac that was immediately in front of the sheriff's vehicle. It did turn a few heads of drivers passing us on this photo shot for *LIFE* magazine—a police car in slow-speed pursuit of an old Caddie with a guy standing in the trunk taking photos. The only way this photo would work was to shoot at a slow shutter speed, here 1/2 second at f5.6, so the sheriff could trip the shutter on my command and I could capture the flash during the exposure. This situation works when you can shoot several images, since coordinating flash and shutter is an inexact science.

TRAVEL AND DOCUMENTARY PHOTOGRAPHY

The world is a book, and those who do not travel read only one page.

—Sant'Agostino

The first time I set foot outside of the United States was as a child growing up in Texas. For our annual family vacation, my mom and dad opted for south Texas, and Mexico was close enough for a day trip. I remember the moment we crossed into a foreign country, and the feeling of adventure and excitement in finally moving out of my comfortable realm. I still vaguely recall the sights and sounds of that initial foray, but I don't have a single photo from that trip.

2400 miles off the west coast of Chile is Easter Island, the most isolated inhabited island in the world. Also known as Rapa Nui, it is home to the gigantic stone moai (statues). On a National Geographic "Around the World by Private Jet" trip (I know, it's a tough job, but someone has to do it), this was our second stop. A good friend, National Geographic photographer Jim Richardson, had completed this same trip a couple of months before, and he was a great source of information on this location. He'd suggested we go to this site late at night to do a "light-painting" session with these amazing structures. We were incredibly fortunate in our timing as we had a moonless night and an absolutely clear sky. The best images were captured in the first hour of shooting, as the Milky Way was directly behind the moai, offering a stunning background.

 For a tutorial on light painting, visit www.perfectdigitalphotography .com. 14–35mm lens at 14mm, 30 second at f2.2, 2000 ISO

Now, many years and many visa stamps later, my travels are well documented with photographs. When I look through those photos I am instantly brought back to the sights, smells, and experiences from the trip. This is one of the huge benefits of photography—the ability to record our travels and experiences for our future, both personally and for our family's history.

The baby boom generation has come of age and along with it is a longing to travel to the far-flung corners of the Earth. Rarely do you see a traveler without a camera and the desire to gather more than simple snapshots from a trip. We want to document our travels and times. This chapter will explore the dynamics of photography in the extended world and how digital is a perfect medium for that. You'll find tips for traveling as a photographer, photographing safely in foreign lands, protecting camera gear on the road, and respecting local customs.

Go Light! Minimize Equipment for Travel Photography

Late one night in Haines, Alaska, I watched a group of photographers unloading their equipment from their bus, one individual moving case upon case of gear. The next morning I ran into the same group at the Chilkat Bald Eagle Preserve, and I watched that same individual struggling with his mountain of equipment, all while missing images of the hundreds of bald eagles in the beautiful morning light. The group leader,

on the other hand, was moving quickly from vantage point to vantage point, using one camera with a long lens and a second camera with a shorter lens. His streamlined approach meant that he got the shots the less experienced photographer missed while wrestling with his gear.

Traveling light is traveling smart. We travel to immerse ourselves in another culture and to have new experiences, not to feel like globe-trotting baggage handlers. I prefer to keep my focus on shooting, not on thinking about what particular piece of equipment I need to use to justify the hassle of bringing that gear along.

Tips for Traveling Light

- Stick with one brand of equipment. I often see photographers traveling with two entirely different brands of cameras, necessitating specific lenses for each body. I always carry two cameras—a wide zoom on one body and a medium telephoto zoom on the other. This way, I'm ready to shoot most anything that appears, and if I manage to fill one of my CompactFlash (CF) cards on one body, I still have the other I can use any of my lenses on. Also, one brand of camera uses the same type of battery; no need to carry different chargers and batteries.

- The amount of gear you carry when shooting should be what you need and little more. Nothing is more daunting than digging frantically through a heavy camera bag hanging from your shoulder

while a "moment" is occurring. Further along in this chapter you'll find a list of what I carry.

■ Be familiar with your gear so operating the camera is second nature. What's important to you is the image, not fumbling with the camera. The camera is the tool to capture the photo.

■ Decide whether you prefer a camera bag or a photo vest. Each offers benefits, as well as problems. The bag is bulky, but it can be put down quickly. The vest is a bit more noticeable, but it's more fluid to work from. This is a matter of personal choice.

Sometimes the photo gods are shining on you—literally. I was photographing in Etosha National Park in Namibia. The afternoon was overcast, the animals were few and far between. Knowing that sunset was approaching in about 20 minutes, we headed the Land Rover toward the compound, figuring the day was over. Rounding a corner in this incredible landscape, we came upon a herd of giraffe just as the sun broke out under a low shelf of clouds. 90–250mm lens, 1/500 second at f2.8, ISO 100

THE ADVANTAGE OF DIGITAL IN TRAVEL PHOTOGRAPHY

Digital is the perfect photography medium for travel. You'll not only eliminate the hassles of traveling with film (carrying it to and from, protecting it, changing it, processing on site if needed), but you can also instantly share your photos with your subjects. I used to carry a Polaroid so that I could show my subject an image of himself, which obviously required extra space for the camera as well as packs of Polaroid film. Now, by using the monitor on the camera, I can instantly share the actual image I shot with the subject.

Say "So long" to the shoulder bag containing the required rolls of film to get the shoot done—this can number in the hundreds on long shoots—and "Hello" to the 4×4 inch media wallet containing several CF cards.

The photographer also has the ability to *geotag* images using an external device or enabled memory card to write information to the photo about the exact location, both longitude and latitude, where the photo was made.

Usually I take my laptop, which allows me the opportunity of editing and cataloging my photos. For peace of mind, I *always* copy the files to a second, independent location. (Two small WiebeTech pocket hard drives that I have RAIDed—see the How To at the end of the chapter for a bit more on RAID—so the two hard drives appear as one on my desktop. When I drop my images into that one location, it is actually copying to both hard drives.) I

also burn a DVD of my images. This allows me to reformat my CF cards after download so I always have fresh cards at the start of the day.

Since the events of September 11, 2001, traveling has become more of a hassle for everyone, and the photographer is no exception. More often than not, a camera bag will be marked at the security gates for further screening, primarily because an X-ray of the camera's electronics can look suspicious. Eliminating film from your camera bag makes the trip through security less stressful. No longer do we panic when approaching security at the airport, frantically trying to remember the number of times our film has been through the X-ray; multiple passes through airport X-rays can negatively impact the film.

The number one reason in the growing list of advantages of digital over film: the ability to confirm the image. Content, composition, and exposure can be judged in a heartbeat.

HOW TO FIND PHOTO POSSIBILITIES

If you actually look like your passport photo, you aren't well enough to travel.

—Sir Vivian Fuchs

One of the most common questions I hear from dedicated amateurs is, "What is there to shoot?" We all love putting the camera to eye and capturing that moment, but how do we find that event that will create our moment?

Becky, my wife, CFO, and office manager, is also co-founder of our FirstLight Workshops, a series of international photography work-

We hosted our inaugural FirstLight Workshop in Auvillar, France, in 2003. Very unique, as we are the only workshop that publishes a magazine of our students' work. I believe this is an important "week in the life" of these communities, documenting the fabric of each community. We always send additional copies to the city center, town hall, or mayor's office for their archives.

A significant part of the time spent on a *National Geographic* assignment is used for research. The photographer is right there in the middle of the mix, researching a story and gathering information on what to photograph. What does the photographer look for while doing this research that sets off the "Photo Opportunity" buzzers?

Check the local calendar of events for the times you are traveling, and don't hesitate to call the local tourist board for any ideas or hints. Often an event that the locals consider mundane may be that sparkling photo op you were looking for. An event might be noted with no particulars, and a phone call can provide exact dates and times, in addition to the "Oh, yeah, you may want to check this out…" ideas that will surface during a conversation. Festivals, celebrations, annual events commemorating special holidays—all these are potentially ripe for photographic opportunities. I will plan an entire trip around a festival, as such an event can provide wonderful photos. And for the shy photographer, it is an ideal situation since many people involved in the celebration may enjoy being photographed.

shops held in locations ranging from France, Spain, and Scotland, to Dubois, Wyoming, Chesapeake Bay, and Colorado. We provide the assignments for our participants, prearranged and checked out by myself prior to the workshop. These workshops are unique in that we actually publish a magazine of our participants' work.

Traveling Abroad Contact Information

What if you don't have the grandeur of the Yukon or the access that *National Geographic* may give you? Do some reading and research about the country or area in which you are planning on traveling. Google is a powerful tool for speeding up this research process. Chambers of commerce offer calendars of events for US locations. Tourist offices are helpful for international locations.

Here's a list of some popular destinations and interesting websites:

Africa www.travelafricamag.com (a very interesting magazine about Africa)

Australia www.sydney.australia.com

Caribbean www.caribbeanconsulting.com/ touristboards.htm

China www.cnto.org

France www.franceguide.com

Germany www.germany-tourism.de

India www.tourisminindia.com

Ireland www.discoverireland.ie

Italy www.italiantourism.com

New Zealand www.newzealand.com/travel

Spain www.spain.info

United Kingdom www.visitbritain.com

A great all-around website with information on many countries' tourist offices www.intltravelnews .com/tourismdirectory

Here are a few other websites that can provide valuable information.

Lonely Planet (www.lonelyplanet.com worldguide) Lonely Planet is an excellent publisher of guide books and provides a great website chockful of international travel information.

Centers for Disease Control and Prevention (http://wwwn.cdc.gov/travel) This well-built site provides important, sometimes critical, health information about traveling to third world and remote areas. Required vaccinations, health warnings, and travelers notices are examples of the more important pages on the CDC site.

SeatGuru (www.seatguru.com) I love this site. Once you have your airline ticket in hand, find out the type of aircraft you'll be flying on and then visit SeatGuru. Select the airline and the type of plane you'll be flying on, and SeatGuru will provide seat maps of the aircraft that show which seats you should avoid as well as those you should try to grab.

FlightAware (http://flightaware.com) Along the same lines as SeatGuru, this site provides real-time information on the estimated time of arrival (ETA) of your (or your loved one's) scheduled flight.

The Internet can also provide access to local newspapers that can offer information on events in the area. Many search engines even provide a translation option, though the translation is often very rudimentary.

The idea of "self-assigning" works very well in the world of travel photography. As

you head out for a day's shooting, assign yourself certain images to obtain that day—portraits of the locals, kids in parks, sporting events, the wedding of the day. The beauty of shooting specifics is that it allows you to focus on the photos within those ideas. Portraits can reveal so much about the people and world

you are visiting. Try to create *environmental portraits*, positioning the subject in the foreground, and possibly putting him or her slightly to the side of the frame and layering the photo so the background contains a feeling for what that person is about.

In many countries, you'll find that Saturdays are a good day for weddings. Shooting an assignment for *Travelocity Magazine*, I was in the beautiful city of Dubrovnik, along the Dalmatian Coast.

Walking the walled city on a Saturday afternoon, I came upon a wedding party jubilantly parading down the main cobbled street. Not able to speak Croatian, I used sign language to ask permission of the family to shoot photos as they sang and danced along their way. Instead of a tourist on the outside, I was quickly assimilated into the group and accompanied the bride and groom as they were married; I was even invited to the wedding party afterward. Isn't this why we travel?

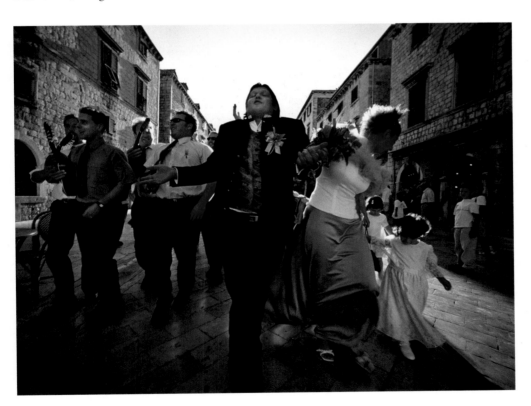

In Dubrovnik, I was wandering the town on a Saturday when I came upon a wedding party making its way down the street, or I should say, they came upon me. It didn't take long until I was accepted as part of the group! 17–35mm lens at 17mm, 1/125 second at f4, ISO 100

So You've Arrived, Now What?

Late day into evening is a great time to mix flash with slower exposure. Using 1/4 of a second exposure slower than the normal shutter speed used with flash (which can be 1/125 or 1/250) allows the image to show motion, while the high-speed flash will "freeze" the subject near the camera. This will give a feeling of motion and energy.

Shooting a story on the rebirth of the Dalmatian Coast, previously part of Yugoslavia, I had walked up a path I'd scouted years before on a trip, to an overview of the beautiful city of Split. I had planned my foray toward dusk, wanting to utilize the evening light, as the port city faced west. Having headed out hours earlier, I took along a tripod since I knew I was going to shoot into early evening, when the city lights had come on but there was still enough ambient light in the sky to give it some definition. Mixing these two light sources can produce a beautiful palette in the photo—the warm glow of tungsten light fixtures and the increasingly blue-purple of the twilight sky. Being prepared and doing my research translated into a beautiful photograph.

I will often go out wearing a photo vest with many pockets. This allows me to carry one or two lenses, a strobe, and filters, as well as an umbrella and a very compressible jacket, such as a waterproof windbreaker. Vests come in all styles and colors. I've found that if I keep the color low-key, my presence is less obvious. The nice thing about a vest compared to a bag

is that the photographer has less stuff hanging off his shoulders, and a vest is more difficult for someone to snatch gear from.

Where to Find Inspiration

Here are a few resources I use to get inspired before embarking on a journey:

- **Photography magazines** The myriad of photo magazines on the newsstand can and should be a source of inspiration to all of us. In summer, look for the *Communication Arts Photography Annual*. It's unbelievably inspiring (and a bit intimidating!) and includes very current work. I look forward to each month's *National Geographic*, not to steal the ideas of the artists, but to add to my own visual database information about how each photographer approached his or her subject. The inspiration includes not only examining how each photographer worked the subject aesthetically, but perhaps how that person approached an event that at first glance was not visually rich. Every situation has its best picture.

- **Books** In the early 1980s, Rick Smolan and David Cohen started publishing their iconic and famous series, *A Day in the Life of…*, which included America, Australia, Japan, Hawaii, Spain, Italy, Ireland, the USSR, China, and Africa. As a photographer, I was privileged to work on this series; as someone who loves to look at great photography, I believe these books can be a source of inspiration for ideas for future travels.

- **Photographic websites** There are so many terrific websites out there…. A great site that illustrates the direction photography is headed today is www .MediaStorm.com. Also, check out Paul Nicklen's website at www.paulnicklen .com—he is a *National Geographic* photographer doing great underwater photography.

Learn Something About the Area You're Visiting

In the pre-Internet days, a *National Geographic* article required a huge amount of research on the part of the photographer. I would spend hours on the phone in the initial stages of setting up the story, in addition to hours spent in a library poring over tomes and text. Now, Google, Yahoo!, and other search engines make the research stage easier. The Internet puts so much more power in the hands of the photographer. One fact can lead to an avenue of discovery that eventually leads to a great photo. While you're searching, try enabling or clicking the Images link, which will bring up many cross-referenced images applicable to your search term. This can give you photographic ideas as to what is available in the particular area you'll visit on your trip.

For photographers shooting for themselves, this power is equally important. In the past, trying to figure out a location demanded on-the-ground time and research, often not easy or possible with a limited amount of time in a place. The Internet provides information and direction that can

take you to an area of rich photographic possibility. For example, do a web search on the *Palio di Siena*, the biannual horse race in Italy, and you will find not only the dates of the race but also information on the best shooting locations.

TAKING THOSE FIRST FEW TRAVEL SHOTS

Your research is done, your airline tickets are in hand, and you have several photo ops lined up. You know a bit about the place to which you are traveling. Now what?

An area that concerns many aspiring photographers is "How do I approach a subject I've never met before, especially if I don't speak the language?" On a shoot in India, I watched a tour bus disgorge its load of camera-toting travelers. In the field of fire was an old beggar squatting by a red door. The pack of tourists moved as one, kicking up a trail of dust as they marched in lockstep toward the old guy. All cameras came up as if by signal, and the shooting began. The poor guy never had a chance. Never once did I see one of the visitors approach him to ask permission or even make eye contact—he was simply an involuntary photo op. The photo most of the 10 or so tourists took home was of the old guy, hands up to deflect their invasion of his privacy. Nice photo.

A few days earlier, on a similar tour bus event, I watched several of the traveling photographers move out on their own. I followed one woman to watch how she

Islands Lost in Time was a National Geographic book I worked on several years ago. Spending nearly six weeks in the Aeolian Islands of Italy, I had fallen in love with the place and always wanted to go back. In the fall of 2007, I had an assignment for *Traveler Overseas* magazine, after convincing the publisher, Steve Connatser, that the islands were absolutely worth a story (after visiting, he agreed). Previously, I'd photographed the Blue Grotto, a sea cave on the western side of Filicudi, one of the seven islands of the chain. On this recent assignment, we knew a seaborne festival built around this cave was planned, and the locals were going to place a figure to represent the spirit of the place. I had a small boat drop me off inside the cave and scrambled up the volcanic cliff to an overview so I could photograph the boats assembling for the event. 12–60mm lens at 12mm, 1/250 second at f2.8, ISO 100

worked. She walked down a small street off of the main drag, where merchants were selling psychedelically colored spices in baskets. She moved slowly, making eye contact with the storeowners until a particular scene stood out. Instead of firing away from a distance, she approached the merchant and gestured toward her camera. She smiled, he smiled, and a tacit okay was given. The photographer stayed for probably 15 minutes, waiting for that nice photo to materialize. She went home with a beautiful photograph from her efforts.

This is a great case study on how to work in a foreign country: As a traveling photographer, the "foreign" part is you. We are guests in these people's lives. Treat them with respect. See Chapter 8 for information on simple tricks and hints for shooting in a new place.

How to Deal with People and Your Own Shyness

One of the most difficult subjects to photograph is people. Shyness and hesitation in approaching perfect strangers is a natural obstacle to making good photos. Often I will literally take a breath and a step toward someone I'd like to photograph. Most of the time that person will be okay with having his photo taken. You'll find the curmudgeon every now and then, but you'll also find them in your neighborhood. Let it roll off your back and try again.

I was shooting in Spain in a small village and asked in broken Spanish if I could photograph an old cobbler working in front of his shop. A curt dismissal sent me on my way, and within a few shops I spotted a baker hanging out his breads. He was quite friendly and I photographed him for probably an hour. Finished shooting, I was walking away from his shop with a loaf of bread under my arm. I immediately ran into the cobbler, who had seen me photographing the baker and wanted to know if I'd shoot his photo now.

Showing interest in the person you want to photograph is a great icebreaker. Everyone wants to feel that what he or she does is

On a train from Hanoi to Lao Cai, Vietnam, I spent a couple of hours of the nearly 11-hour trip sitting across from this older gentleman. He saw my cameras, I gestured a question of permission, he smiled, and a short while later I photographed him as he sat engrossed in his paper. 12–60mm lens at 35mm, 1/60 second at f3.5, ISO 200

important, and the camera can be a perfect validator of that importance.

Another door opener is to take along a small portfolio of your work. This, too, can work wonders and adds to the idea that photographers are not always taking, taking, taking. An inkjet printer is perfect for

producing these images, and your local office supply store can add an inexpensive spiral binding to keep it together. Sharing your work will also show the potential subject what you have in mind photographically. Or, consider putting together a hard-bound or soft-bound version of your work through an online service such as Mpix or one of numerous similar companies.

I always try to follow through with sending images back to subjects who have allowed me to enter their lives. Sending photos to your subjects means that you not only are doing what's right, but you are acting as a goodwill ambassador for the next photographer who enters his or her life. Be forewarned, however, that once you give a photo to one person, everyone is going to want his photo taken.

PHOTOGRAPHY AS A PASSPORT, THE PHOTOGRAPHER AS AMBASSADOR

Photography forms a common language in the world. Everyone loves seeing images of him- or herself. This "passport" to the world should be seen as an introduction between people, not a barrier.

What caught your eye in the first place? If something made you stop and smile, or feel awe, or created an emotion, it very well may be worth a photograph. These often gentle moments, or rambunctious celebrations, will create images that your friends and family, and perhaps editors, will enthuse over.

In addition to being travelers and tourists, we are ambassadors with our cameras. Many people in other countries will form their impressions of Americans by their interactions with you. Understanding the cultural mores of the country you visit is invaluable.

The ability to speak a few words of the local language, as much a no-brainer as it seems, can work wonders. I'll learn the basics—Thanks, No thanks, Yes, May I take your photo?—for every country I visit. I've found that my clumsy attempts at the local language usually elicit friendly smiles and makes it easier for me to take their pictures.

DOCUMENTARY PHOTOGRAPHY

Photojournalism and documentary photography are often viewed as overlapping fields of art. The term *photojournalism* came into existence during the Great Depression, when President Franklin Roosevelt appointed Rexford Guy Tugwell, a Columbia University economics professor, as Assistant Secretary of Agriculture. Tugwell instituted controversial and expensive reforms that included low-interest loans and interest-free subsidies to America's struggling farmers. This was a potentially volatile act in those economically depressed times. Tugwell had the foresight to realize that photographs documenting the farmers' conditions could be a tool for change: documenting both the problem and the cure. He brought Roy Stryker into the department to direct the photographic mission.

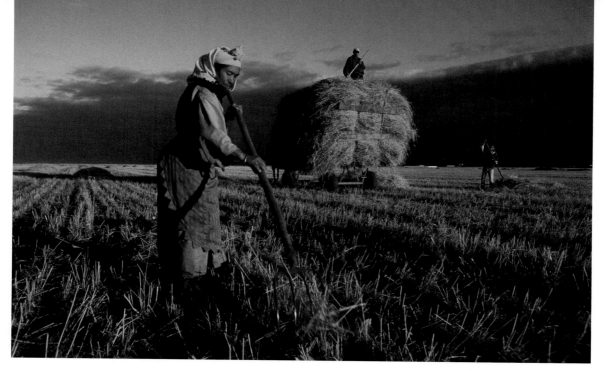

On a shoot in Morocco, I came upon this family as they harvested the last vestiges of their wheat. I was with a driver who spoke their language, and after asking and obtaining permission, they allowed me to make a few frames...just a few.... The photographer has to be aware of when the camera becomes an intrusion. 17–35mm lens at18mm, 1/125 second at f4.8, ISO 100

Stryker, another former Columbia economics professor, had used photography in his lectures to illustrate the economic plight of farmers. He brought this photographic documentary approach to his new job with the Farm Securities Administration (FSA). Stryker appointed a small group of highly talented photographers, including Walker Evans, Carl Mydans, Dorothea Lange, and others, to travel and photograph the plight of America's farmers and the heartland. These artists were not only photographers, but anthropologists and historians. Documentary photography was defined by this project.

My wife's father, Harris Skelton, was a bombardier in World War II. Sitting in the nose cone of a B-17, his moment came over the bomb site, where he would take control of the aircraft. In the seconds leading up to this moment, Harris shot this photo out the canopy of the bomber, a perfect illustration of a photo becoming a document versus a simple snapshot: the bomb "sticks" dropping from the aircraft, the diagonal line of smoke from a direct hit, and the explosion of one of the bombers.

Castellers in Spain are famous for the gigantic human towers they build. Standing as high as 40 feet or more above the crowd at the La Mercè festival in Barcelona, this tower hovered over a sea of people. 12–60mm lens, 1/320 second at f7.1, 200 ISO

The body of work produced by the FSA stands today as not only a remarkable group of photographs, but as a set of images that had a profound effect on society. An earlier example of the power of documentary photography—even before this style of photography had a name—was the work of Danish immigrant Jacob Riis, a reporter for the *New York Tribune*, whose main beat focused on the immigrant-jammed slums of New York in the late 1880s. Riis had complained to city health officials about the horrible overcrowding and high death rates in this area, but nothing was done. Riis decided to use the newly invented flashlight powder that allowed photographs to be taken indoors. The resulting book he produced from this work, *How the Other Half Lives*, shocked everyone who saw the photos, including a rising young politician, Teddy Roosevelt, who sent Riis a note saying, "I have read your book and I have come to help." Roosevelt soon became New York Police Commissioner, and help he did. *How the Other Half Lives* resulted in a reform movement that improved conditions in the slums of New York. Riis's work proved what documentary photography could do.

By capturing closer detail during the Castellers event, I forced more intimacy between the viewer of the image and the participants in the photo. The face of the guy looking up is where the eye drifts to in this crowded photo of the group's preparation for building a human tower. 12–60mm lens, 1/400 second at f4, ISO 200

The documentary photograph, upon first viewing, may be little more than a snapshot. But interlaced in the image are psychological layers of meaning and importance to the photographer. The camera shows things as they are, and this is the power of a good documentary photograph.

The family photographer is a documentary photographer in his or her own right. The photos we take of our families contain visual hints of that time, and the successful photograph will elicit a reaction of recognition, joy, or many emotions all at once. Photographs are one of the most powerful records of history.

How To: Choosing What's Inside the Camera Bag

Since the invention of photography, two constants in the world of the photographer have been shutter and aperture. The equipment may become more and more technically sophisticated, but these two compatriots of the camera are still the core of the mechanical side of the camera. Here are a few ideas on using the shutter as your creative tool.

Photographic equipment is the hammer and wrench of the photographer's toolbox. The lighter and more efficient the toolbox, the easier it is for us to work. Plan ahead for your photo outing, whether it is a Little League game down the block or a month-long trip to Nepal. Take only what is necessary to get the job done. Don't load yourself down with so much gear that it gets in the way of making photos.

My camera bag is pretty well defined by years of travel and getting caught with too much or not having brought the correct equipment. On the plane or in the car, one medium-sized Domke camera bag, with two camera bodies and three or four lenses—depending on the shoot—will usually suffice for almost all conditions.

I carry two Olympus E-3 bodies, along with an Olympus E520 as a backup. I'll often carry a small point-and-shoot Olympus. The 5060 can go in a pocket and works in some situations where the larger bodies and lenses would broadcast "Photographer!" There are areas where someone shooting seriously may not be well received, and for those times, the 5060 looks more like a tourist's camera. But the quality from a camera like this is excellent and provides good quality files for printing. Another camera that resides in my pocket at all times, the Olympus 1030 is good to 33 feet underwater—and it's very small and compact.

Your camera choice may be a Nikon D300 with a second body, a D80, or a Canon 50D and a Canon 1Ds

In my Lightware wheeled carry-on case, I carry two Olympus E-3 bodies, three to four lenses ranging from 7mm to 200mm (equivalent to a 14mm up to a 400mm), a flash and cord—along with a LumiQuest 80-20 diffuser, and battery chargers (two with one cord that has been adapted to using one plug for both chargers). Also, two Singh-Ray graduated neutral density filters, a warming polarizer, remote release cord, card readers and cords, extra batteries, extra CF cards, and my tripod: a Gitzo Carbon Fiber with an Acratech ballhead. With this equipment, which will all go onboard a plane, I can pretty much get any job done that doesn't require exotic lenses or gear.

Mark III. Having two bodies really makes the shooting process easier. I'll carry a wide zoom on one body, a medium-long zoom on the other. This way, I'm ready to shoot anything almost instantly. In many if not almost all situations, this camera setup can cover all your bases.

Lens choice is specific to the type of photography you are doing. In my "basic" bag I'll carry a 7–14mm (which, in the 35mm film world, is equivalent to a 14–28mm), a 12–60mm (24–120mm equivalent), and a 50–200mm (100–400mm equivalent). On shoots that require high-speed lenses, a 14–35mm f2 (28–70mm equivalent) and a 35–100mm f2 (70–200mm equivalent). If photographing sports or wildlife, a 150mm f2 (equivalent to a 300mm f2, extremely fast), and for wildlife or sports photography, a 90–250mm f2.8 (180–500mm equivalent) and/or a 300 f2.8 (a 600mm f2.8 equivalent). These lenses, along with a 1.4 or 2 power converter, which multiplies the focal length of lenses by a 1.4 or 2x factor, give me just about all the lens power I need.

Always found in my bag is a TTL (through the lens) flash and a remote cord for that strobe so I can shoot off-camera with the flash. The cord allows me to hold the flash away from the camera so I can bounce or reflect the flash off of a ceiling or wall for a softer and more natural light. Today's flashes often use infrared or radio control, allowing the photographer to set up several wireless lights that are controlled from the camera. This is the official "Next Best Thing Since Canned Beer."

A Lexar wallet carries my assortment of Lexar CF cards, usually a couple of 8GB cards that reside in-camera, a few 4GB cards, and a 1GB card in the wallet.

In a second bag, I carry two 160GB WiebeTech pocket drives. These are configured, in my computer's operating system, to act as a RAID (Redundant Array of Independent Disks) device. When plugged in to my laptop, the two drives appear as one on my desktop. When I drop images onto the drive icon, the images are copied to both drives, which mirror each other. Packed in that bag are enough CDs or

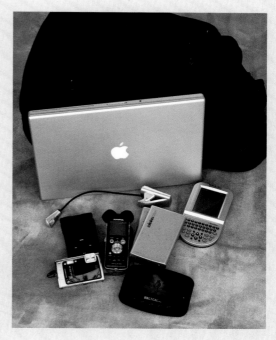

In a backpack, as my second carryon, I carry a MacBook Pro (maxed out with 4GB of RAM), two WiebeTech hard drives, my JOBO GIGA Vu PRO (as my third backup, this allows me to run a slideshow), a reading light, a high-end voice/sound recorder, my iPod with a great music selection, and my *New York Times* crossword puzzles.

DVDs to burn the number of images I think I may shoot on the particular assignment. *Before I erase/reformat a card, I make sure the files are in a minimum of two independent places.* This is a cardinal rule.

If you don't want to lug a laptop to Lithuania, several manufacturers make small and very portable hard drive viewing units. JOBO makes a beautiful unit, the GIGA Vu PRO evolution, which provides up to 160GB of space. Epson makes the P7000, and Apple offers the photo-capable iPod, iPod Touch, and photo-capable iPhone, now found in many photographers' bags. These units will hold a huge number of images and allow the photographer to

view and share them. The one downside to using *only one* of these two units: will this be the only backup for your photos? This could be reason enough to carry a laptop or a portable CD or DVD burner.

In the bits and pieces category, I carry a Sharpie black marker wrapped with about 1 feet of gaffer's tape (gaffer's tape differs from duct tape as it can be used on lights and other hot items without leaving behind a sticky residue), a small headlamp (a very lightweight model made by Petzl), a pen, and my ubiquitous reflector, discussed in Chapter 4.

Power Management and the Traveling Photographer

One of the great benefits of shooting digital is the elimination of film and the problems of transporting the number of rolls needed for a trip. Now we carry a few CF cards that equal many rolls of film. One of the big issues with digital is power. We now have a technology that is 100-percent power dependent. Gone are the days of carrying a fully mechanical 35mm body as a backup. When I turn the lights off in my hotel room, it looks like the approach of the mother ship in *Close Encounters of the Third Kind* due to all the power chargers running.

Here are some power necessities for the road:

- As I mentioned earlier, use a camera system that uses the same batteries and charger.

- Always carry extra batteries. This includes rechargeable and non-rechargeable types. In addition to two or three extra camera batteries, I also carry a small bag with extra AA and AAA batteries. Nothing, and I mean *nothing*, is worse than running out of power with no backup in the middle of a great photo event.

- I always carry an extra charger, well worth the minimal weight increase since this provides 100-percent faster battery charging because you are charging two at once. It also provides a backup if one breaks. Not likely, but don't tempt Murphy's Law!

- I carry a small 12-volt power inverter (NexxTech Power Inverter model 2218075), which can be found

at Radio Shack. It's a 75-watt model that is small and light and provides charging time while on the road, plugged into your cigarette lighter.

- Keep appropriate adaptor plugs for the area in which you are traveling. I'll stop for lunch and ask to sit at a table by an outlet, so I can use my charger to top off the batteries. Steve Kropla's website (www.kropla.com/electric2.htm) not only lists the voltage availability worldwide, but it tells you the type of adaptor plug you'll need for that country. Take at least three adaptors.

- Brunton released the Solaris series of portable solar panels and Solo series of portable battery units that solves a *lot* of problems unique to digital—that need for power. I've been using the Solaris 26 solar panel, and with the Solo 15 battery pack, I've been able to charge several of my E-3 camera batteries. This is an invaluable tool for today's traveling photographer. This gives you the ability to charge not only your camera battery, but your laptop battery, and your databank (JOBO, Epson, iPhone, whatever) in those powerless areas, as long as you have direct or indirect exposure to the sun for the charging process. These pack nicely, the battery being about the size of thick pocketbook and the panel folding up to similar size.

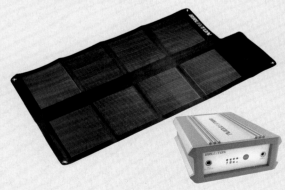

The Brunton solar panel and battery pack—finally the photographer can charge necessary batteries in remote or powerless areas.

Travel and digital photography are natural and necessary partners, as we love to document our world and our travels. Taking that step and moving from shooting passable images to memorable showstoppers is our aim, and creating a moment that defines our memory is our task. We photographers can reap the benefit of our exposure to the world. Isn't this what travel is about, experiencing a moment in time that transcends our daily routines?

On the Web

Geotagging allows the photographer to capture the exact map coordinates of where a picture was taken by using an external device, such as the JOBO Photo GPS. Adobe Photoshop Lightroom has a really cool feature that uses this information along with Google maps to create a map of exactly where your photo was made. Go to www .perfectdigitalphotography.com online for a further discussion of this process.

We travel to find the mystery and intrigue of foreign lands. On a National Geographic expedition in the Antarctic, I found this colony of penguins at Port Lockroy, a sheltered anchorage used by early whalers and later established by the British as their first Antarctic "Base A" in 1944 as part of a secret wartime initiative to monitor German shipping operations. I sat on some rocks, waiting for the curious critters to come closer to investigate. The mountain in the distance forms the background, providing a lot of information about this rugged and remote location. The penguins in the mid-left of the frame provide a nice moment, while the fellow in the foreground is the initial layer to which the eye goes to initially. 12–60mm lens, 1/250 second at f8, ISO 100

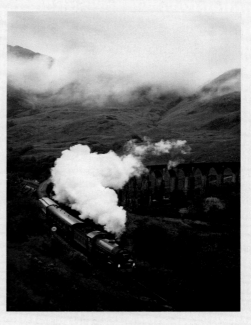

Scouting ahead can pay off handsomely. My assignment was to photograph the posh Royal Scotsman train on the six-day route around Scotland. I had read that at one point, the diesel engine is exchanged for a traditional steam engine when the train goes from Fort William to Mallaigh in the Western Highlands, crossing this amazing trestle bridge, as seen in the *Harry Potter* movies. I'd gotten off the train in Fort William and hired a taxi to take me to the trestle bridge, clambering through the heather to this overlook of the tracks. 35–70mm lens, 1/60 second at f4

SHARING YOUR VISION
by Jack and Rikki Swenson

Jack and Rikki Swenson lead Photo Expeditions for Lindblad Expeditions, in alliance with the National Geographic Society, guiding photographers to many of the world's wildest places. Jack, a professional photographer and wildlife biologist, has co-authored two books, and his images have been widely published in wildlife and nature publications worldwide. Rikki is an inspiring instructor of digital photography, photo imaging techniques, and her own unique programs of creative ideas for photographers. Their travels regularly take them to Africa, Baja California, Galapagos, Antarctica, Alaska, Costa Rica and Panama, and the high Arctic. Their image collections can be viewed at www.ExpeditionGallery.com.

Photographs are rich visual descriptions of our world as it was in the brief moment the shutter was clicked. In that fraction of a second, a photographer creates a tangible artifact that has the power to inform, to educate, and even to move hearts. Although many images may never reach quite this far, you give them this possibility when you share them with others.

We've been fortunate, spending years leading other photographers on photo expeditions and safaris around the world, having amazing opportunities to photograph wildlife in a great variety of locations. Some of these remote places have been preserved within parks or refuges, while others remain potentially threatened by development or other causes. Through the years, we've seen how our images have helped to create awareness back home as they are viewed by others, building further appreciation for the natural world we hope to see conserved for future generations.

You don't need to be able to travel to the far reaches of the earth to reveal the magic of our planet through photographs. This can be true regardless of your subject matter. You might have spent your time photographing an aging building in your hometown, traveled to a distant country, or found hidden beauty in a nearby swamp. For people who weren't there with you, their understanding and awareness of this other place will be shaped by the images you share with them. Through viewing photographs, people create associations with a place. These associations can be strong or weak depending on the structure and power of your images. By this simple process—arcing through you and your images—a place name on the map evolves into other people's increased understanding and perhaps a meaningful connection to a place. By this elemental process, the roots of deeper values begin to grow.

It was this fundamental step that photographer William Henry Jackson made in 1871, joining the now famous Hayden Expedition to document the marvels of the little known Yellowstone region of Wyoming. After this expedition, it was Jackson's photographs and Thomas Moran's paintings—depicting incredible landscapes and strange geothermic formations—that are largely credited with helping to convince the U.S. Congress of the stunning beauty of the Yellowstone

region. Within a year it was designated as the nation's first national park.

In terms of conserving the places we love, it is a sad reality that people seldom protect something just for the sake of preserving it. People only want to save the things, or places, that have a perceived value or intrinsic charm. Few people have the opportunity to watch a polar bear leaping across a gap in the arctic ice pack, yet photographs and films have opened a window into those remote places, showing us the magnificence of these creatures and the tenuous nature of their frozen world. That is part of the power of photography. In our contemporary world, many renown wildlife photographers, like Frans Lanting, David Doubilet, Tom Mangelsen, and Kevin Schafer (to name only a few) use the power of their images as a means of encouraging awareness of the natural world they hope to help preserve. Their work will reach millions through the pages of National Geographic, conservation organization's annual calendars, fine art prints, and well-distributed books. Most all of these photographers began small, exploring the world around their home with a simple camera.

One doesn't have to be a professional photographer with publishing contracts to have a role in this process.

Sharing your own images from your experiences can help build awareness in very meaningful ways. We make individual photographic books, ordered online, and it's amazing how they move like wildfire through a room of people, sparking interest and discussion on the places we've traveled.

Today, more than at any other time in the history of the photographic image, there is an amazing array of creative tools for any photographer—amateur to expert—to share and display photographs. For many people, their photographs often remain essentially unseen in shoeboxes or tucked away on a hard drive. The advances of digital technologies have spawned ever simpler means to re-create your images in different forms. Like ripples radiating outwards from a little splash in a pond, your images can now easily reach more and more people. Don't underestimate the power of one—whether it be one photo, one book, or one person's inspiration—and what might be generated from there.

Use your imagination to find new creative ways to let your images speak to others. You will find that you, too, can have an influential voice for helping others to care about the treasures of our world.

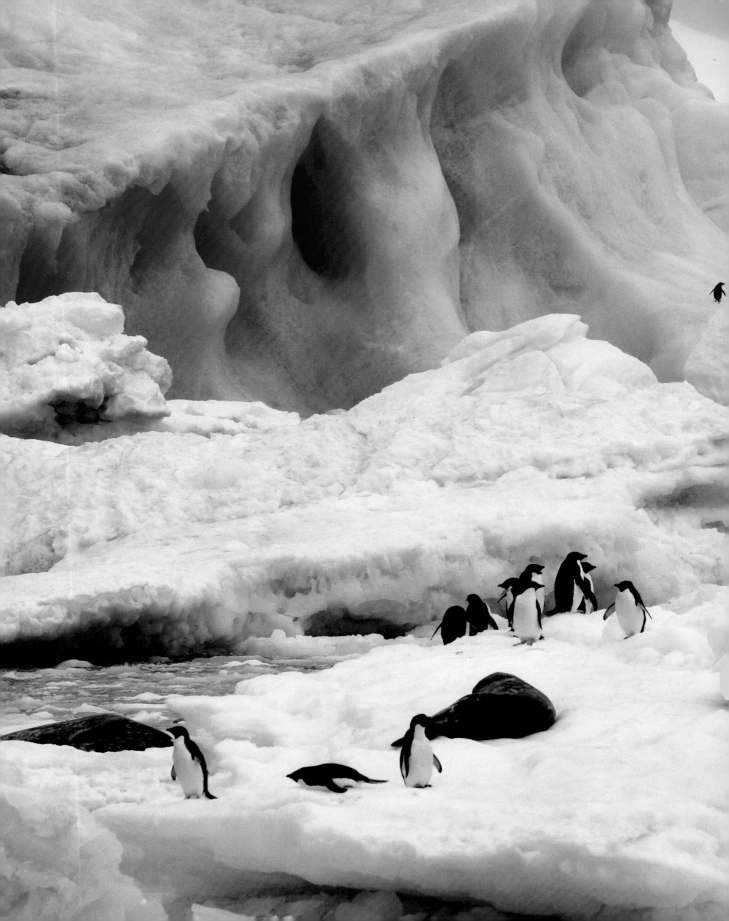

PHOTOGRAPHING THE NATURAL WORLD

Twenty years from now you will be more disappointed by the things you didn't do than by the ones you did do.... Explore. Dream. Discover.

—Mark Twain

As evidenced by the explosion in popularity of *Outside* magazine, *National Geographic Adventure*, and the ubiquitousness of Patagonia outdoor clothing, more and more people are exploring the great outdoors. As long as photography has been in existence, the natural landscape has been a prominent subject in photographs. The subtle contours of rolling hillsides, the grandeur of precipitous and craggy cliffs, and the ever-changing sky provide an infinite array of photographic potential. This

At Point Wild in the Antarctic, Weddell seals and penguins lounge on ice floes in this remote part of the world. I love the name of the place, as those words re-create the essence of what this felt like to me. In the background, a lone penguin on its own journey is the one extra "dimension" providing depth and a feeling of discovery in that layer of the photo. 50–200mm lens at 169mm, 1/320 second at f8, 100 ISO

chapter will help you improve your outdoor photographs and give you invaluable tips on photographing wildlife and protecting your camera equipment in unpredictable environs.

WE ALL WANT TO BE ANSEL ADAMS

It was early in the morning when we set the helicopter down on Roraima-tepui in southeast Venezuela. These giant and ancient granite monoliths rise straight from the surrounding rainforest floor to heights of 5000 to 6000 feet. Roraima-tepui, the largest, is almost 15 miles long and several miles wide. The tepuis are protected by the Venezuelan government as part of the country's national park system. *National Geographic* had obtained permission for me and a writer, Tom Melham, to escort a mountain rescue team as they practiced for a month on several of the nearly 100 tepuis.

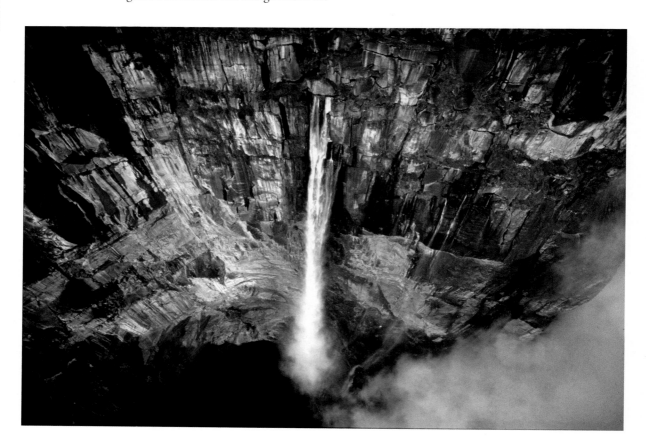

Angel Falls, the world's tallest waterfall, shot from a bird's-eye view while I was on assignment for a National Geographic book, *Beyond the Horizon*. I spent several weeks photographing the tepuis in southern Venezuela. 20mm lens, 1/500 second at f3.5

We had the luxury of air support (two helicopters) on this assignment, which allowed us to visit Roraima-, Auyan- (the home of Angel Falls, the tallest waterfall in the world), and Cuquenan-tepuis. Normally this is a hike of several days from small villages, themselves very remote. Wandering about the vast geological wonderland of Roraima's surface, I saw a couple of people standing perilously close to the near-vertical edge of the 4000-foot drop. I thought perhaps they were two locals from a nearby village. Two local tribes had recently been warring, and I didn't want to be mistaken for an adversary, so I moved with as much noise as I could to give them plenty of warning that I was in the vicinity. I cautiously approached the people, and as I drew closer I realized that their huge size was due to their backpacks and camera bags. They were photographing the amazing view of the jungle canopy afforded them by days of hiking. I'd found the local Ansel Adamses.

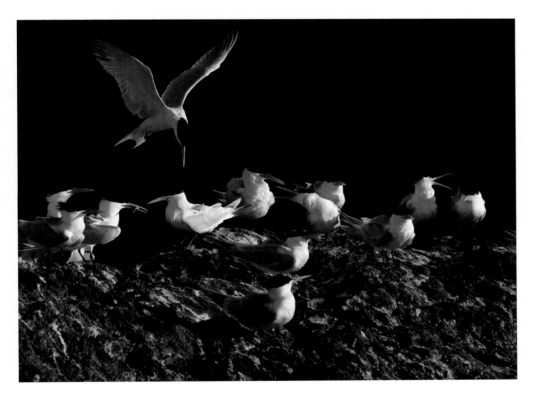

Isla Rasa in the Sea of Cortez is a protected bird sanctuary with huge, huge numbers of Heermann's Gulls, Elegant Terns, and other unique ornithological species (birds, in other words). Late afternoon, in a Zodiac raft, a group from the National Geographic *Endeavour* was watching as these Elegant Terns *(Sterna elegans)* gathered on rocks along the littoral zone of the island. I love the one tern hanging above the others and the lineup of other birds, each part of the composition of this image. 50–200mm lens at 158mm, 1/500 second at f5.6, 100 ISO

On Isla Rasa, this group of Heermann's Gulls had been frightened into an explosion of flight by another more fearsome resident of this densely packed isle sanctuary—a falcon had flown overhead. 50–200mm lens at 200mm, 1/500 second at f3.5, 100 ISO

Cameras have given us glimpses into the most remote and untraveled corners of the Earth. When we can see and share the images of the rainforests in Brazil or the tepuis of Venezuela, it gives us a greater understanding of the importance of these areas instead of what we gain by just reading a description. Through photographers such as Eliot Porter and Frans Lanting, the photograph has helped generate support for the preservation of wild places.

Photographers and travelers (almost synonymous) want to record their travels into the natural world. Let's talk about the various components of photography in the outdoor world and what a perfect fit digital is with the great outdoors.

The Components of Outdoor Photography

Successful landscape and outdoor photography uses several components that are key in making it successful. A powerful photograph provides the viewer with a sense of scale, place, or magic.

Creating a Sense of Scale

Who isn't overwhelmed by the scale of the Grand Canyon or the size of the redwoods in northern California? If you've seen Yosemite, the view from Glacier Point can hold you for hours. Unfortunately, most aspiring photographers are underwhelmed when they view their photos of these places. One of the reasons this happens is that they fail to convey a sense of scale in their images. This is critical, as you have to translate an immense physical location into a 4 × 6 or 8 × 10 print.

One of the simplest solutions is to add a person to your landscape. This creates an instant sense of scale if that person can be used to gauge the size of the cliff, waterfall, or whatever natural feature you're photographing.

Here are a couple of tips for effectively communicating a sense of scale:

- *Don't place the subject too close to the camera.* This does not put the person in a place that creates scale. Place her back in an area where the size of the natural feature can be judged against the size of the person.

- *Use a clean background.* If the person in the photo is lost in the trees, the sense of scale will not exist. Place her against a solid bar of color or against the sky. This will make your photo stronger by making the subject stand out and uses scale as another dimension of the photo.

- *Incorporate subject elements that are familiar to the viewer.* A barn, a lone house, a fence post, or a windmill can also help tell the story of the area and provide a tangible point of reference for the landscape.

- *You don't always have to use a person for sense of scale.* The interior of Iceland is one of the most phenomenal places I've had the fortune to visit. Equally portioned between stunning and breathtaking, these four photos shown on the following page convey my sense of this amazing place.

Finding Your Subject

Within those "Big Places," your subject can be the focal point of the photo, whether that subject is a person, bird, or bear. What your subject is doing helps create a more interesting photo. When the subject is centered in the frame staring into the camera, our eyes gravitate toward the center and little else. Conversely, when your subject interacts in the scene, the overall photo becomes the message.

Adding a subject to your photographs of Big Places not only adds a sense of scale, but it heightens your personal interest in the photo. Photographs are most successful when the subject interacts with the environment, as the interaction tells a story and engages the viewer.

During a late afternoon snowmobile foray to the middle of Vatnajökull Glacier in Iceland, the largest glacier in Europe, I looked back to see another member of our party rushing to catch up with us, under the rising moon. 180mm lens, 1/30 second at f2.8

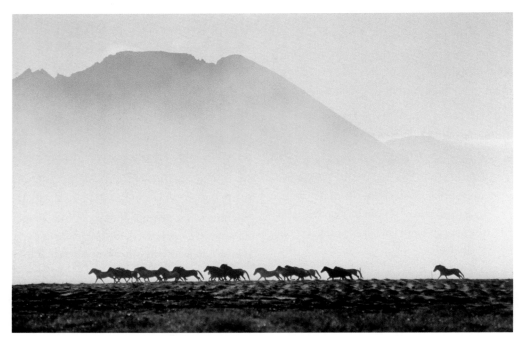

Part of the assignment was a three-day, 100-mile horseback ride in the mountains of southeast Iceland. This photo was shot the morning our farmers were gathering the Icelandic ponies for the trek. 300mm lens, 1/500 second at f5.6

Iceland gets the majority of its power from geothermal sources; I saw this natural geothermal vent one late afternoon as the sun was setting. 180mm lens, 1/125 second at f2.8

A pair of white swans perform a mating ritual in the volcanic fissure lakes in the interior of Iceland. 80–200mm lens, 1/125 second at f4

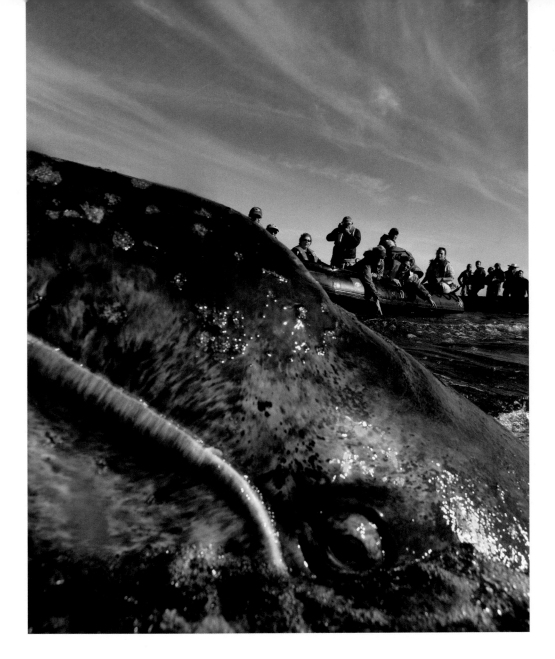

The photographer has to be ready—when that camera strap goes over your head, a switch should be turned on in your mind so you are "on," thinking photographically. Magdalena Bay on the Pacific side of Mexico's Baja California peninsula is a breeding ground for the gray whale. Hundreds of these magnificent creatures return to this fairly remote bay to give birth to their calves. This event also attracts viewers, arriving by boat. As I was photographing the whales, the mothers almost pushed their babies to the surface to encounter humans (whales must have short memories, considering how humans nearly wiped them off the face of the Earth), bumping against as well as under our Zodiac rafts. I wanted to capture a slightly different look at this event, so I used my camera's Live View, holding it at arms' length, just above the water's surface, to capture this young whale just as it surfaced, while it eyed my camera with curiosity. 12–60mm lens at 12mm, 1/500 second at f4.5, 100 ISO

Creating Interest: Make Your Audience Want More

Flipping through a stack of prints from your latest vacation can be an exhilarating experience or an exercise in frustration, depending on the content of those photos. How do you make your photos command the attention of the viewer and make your audience want more? Here are a few tips:

- Keep things simple in the frame. One common mistake is having too much going on in the frame. Strive for simple, elegant compositions.

- Have your subject interact with the scene, not stare into the camera. Stay with the subject until something interesting happens. If you are photographing prairie dogs in a field, wait until two dogs interact or one stretches its head toward the sky. Often a simple gesture creates a spark of interest in what could have been a boring photo.

- Use contrasting colors to create interest. An expanse of blue sky with a strategically placed person in a red sweater creates a contrast in palette that draws the attention of the viewer.

- Shoot during a time of day when you can utilize the light. Good afternoon or morning light against the wall of a cliff may not only produce a nicer quality light, but it can also create a more even light that helps the photograph succeed.

- Even in the natural world, the idea of "moment" still exists—the photo of the young gray whale is an example of this. If

the photo had been shot a moment before or after, the eye might have been closed or underwater. This is our job—to wait for that moment when everything comes together.

Creating a Sense of Place

One of the old rules of thumb when covering a story as a newspaper photographer was to shoot wide as you started your coverage. This anchors the story within the environment. It could be the zoo, the middle of the Sahara, or a village in Scotland. Next time you pick up a photo-driven magazine such as *National Geographic*, look for the establishing photo that shows the viewer where you are. A photo that works well in this sense works on several layers. The first and most obvious is to introduce the viewer to what the subject's world looks like. Second, it gives clues to the character of the subject as we are heavily influenced by where we live.

You've traveled far and wide to get to the place of your dreams, and you want your photos to convey that feeling of being there. You want the viewer to understand the magic of what attracted you to the locale. Remember that if something makes you say "Wow!" it's worth a photograph. What is the single element in the environment that compels you to pick up your camera? Isolate it and make that element the subject of your photograph. It's easy for landscape images to become cluttered. By composing your photo around a central element, your landscapes will be easier to "read" and will convey the essence of the environment.

Creating a Sense of Magic

Veteran photographers have the uncanny ability to be at the right place at the right time, consistently—almost like a sixth sense. Your "spider" sense may not tingle when a stunning opportunity is near, but your pictures can benefit by using some of the tricks employed by professional landscape photographers.

The photographer is constantly struggling with glare, scattered light, and reflections that degrade the quality of the photograph. These can dilute the light or obscure subjects in the photograph. The extended dynamic range of a scene may be beyond the ability for the sensor to capture the full range of bright to dark in the image. A polarizer, when used correctly, can assist in mitigating these problems.

A polarizing filter is one of the most essential filters to reside in your camera bag. What makes it indispensable is its ability to control glare, deepen colors, and eliminate reflections. All photographers should have a basic understanding of how the polarizer works to take full advantage of this uber-filter.

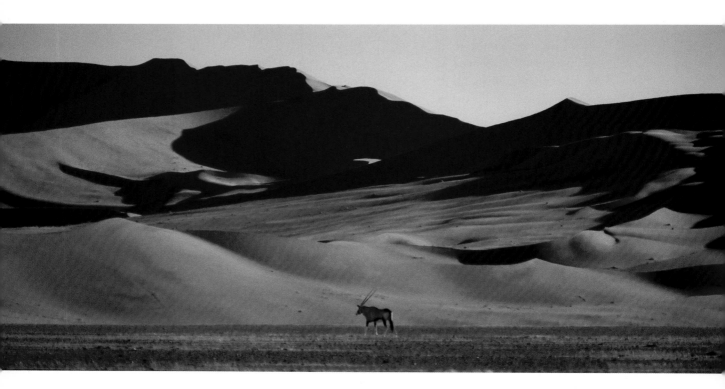

The Namib Desert in Namibia, Africa, is one of the oldest deserts on Earth, and *Traveler Overseas* magazine sent me there on assignment. Our job as a photographer is to make sense of the "visual chaos" that is always in front of us. As an oryx was passing the dunes in the background, I shot this image with a "super-telephoto," allowing the compression created by a long lens to place foreground and background on the same plane of focus. 20–250mm lens, 1.4 converter, at 320mm, 1/500 second at f5.6, 100 ISO

Some shooters leave polarizers on their cameras permanently, which can result in images that look obviously polarized. Also, be wary of wearing polarized sunglasses—you might miss a good picture because you couldn't see a reflectance that the polarized glasses absorbed.

A Quick Polarizer Tutorial

Almost all outdoor photography is accomplished with primary light sources such as the sun or moon. The light from these sources can be described, very simply, as a flow of particles moving perpendicular from the source. These light sources are *unpolarized*, and the job of the polarizer is to allow passage of the light rays that are directed in the polarizing direction, effectively "selecting" which light rays may enter your camera's lens.

Polarizers work when the lens is pointed at a 90-degree angle to the light source (sometimes you may want to polarize a source or reflectance that isn't related to the sun). One easy trick: Use your hand to make an "L" with thumb and index finger. With your index finger, point at the sun and extend your thumb at a 90-degree angle to your index finger. That will be the direction you'll want to point your lens for maximum polarizer effect.

The bezel, or rotating front glass element of the polarizer, is turned while you're looking through the camera. You watch through the viewfinder or the monitor to ascertain when the desired effect is reached. Wide-angle lenses can create problems with landscapes that include a lot of sky. Since the wide lens takes in such a large expanse of horizon, the ideal 90-degree positioning of the camera to the sun is changed on the extreme sides of the wide-angle image. The lens takes in so much of the horizon that the effective angle of the edges of the frame to the sun will not be 90 degrees, but closer to 45 to 75 degrees. This causes the polarizer not to darken the sky equally in the corners, but proportionally as to the relative angle. You will notice a darkening of the sky in the middle of the frame and lighter sky at the edges. One way to deal with this is to use a graduated filter. (See the section "Another Necessity: The Graduated Filter" a bit later in the chapter.) This filter will provide an even darkening of the sky. Polarizing filters also affect the exposure as they are essentially a neutral density filter that absorbs about 2 f-stops of light. Your camera's TTL metering will adjust for this, but if you are using an external meter, adjust the camera's aperture by opening it 2 f-stops. If the external meter reads 1/250 second at f8, the correct exposure with the polarizer would be 1/250 second at f4.

Two types of polarizing filters are available:

- **Linear polarizers** are considered standard and can actually cause problems with auto-focus and/or auto-exposure, contributing to inaccurate exposure and focus problems. Also, they may play havoc with your TTL light meter.

- **Circular polarizers** can be used on all cameras without any of the problems associated with the linear polarizer. A circular polarizer is preferred for digital photography as it will provide the best results with auto-focus lenses.

Using a polarizer for this photo of the volcano on the Aeolian island of Vulcano allowed the sky to darken, balancing out the density of foreground and sky, and having a human in the scene provide a sense of scale. 12–60mm lens at 12mm, 1/125 second at f8

Polarizers in Action

Saturation of colors is a natural and often desired component of using a polarizer…an almost other-world scene is enhanced by the use of this filter.

Another Necessity: The Graduated Filter

We photographers use many tools in our business. Some deal with the natural inability of digital to capture the dynamic range of the scene as our eyes can see it. The human eye can look at a scene and readily capture the full range of light, while the camera is limited by its ability to capture only a slice of that full brightness range.

Another lifesaver that is a close second to the polarizer is the graduated neutral density filter. This filter helps to compress a scene's brightness range into a range that can be captured by film or digital. This rectangular filter is half neutral density, half clear, with a split in the middle. Used for situations where the sky is significantly brighter than the rest of the image, the filter is placed over the lens so that the split section of the lens aligns with the horizon and the neutral density portion of the filter covers the sky. This balances the brightness values so you can correctly expose for both the sky and the foreground.

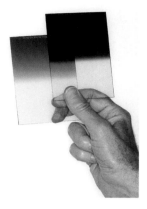

Two Singh-Ray graduated filters are *always* in my bag. The version at left is a 2 f-stop filter, the version at right a 3 f-stop graduated filter.

The sole purpose of this filter is to evenly reduce light passing through the lens. This can be used when the ambient exposure requires too high a shutter speed. These filters come in 1 f-stop, 2 f-stop, or 3 f-stop levels of reduction. Say you want to shoot a blurred image of runners to accentuate the movement, and the slowest exposure you can achieve is 1/60 of a second at f16. Pop on a 2 f-stop neutral density filter and you immediately alter the exposure to 1/15 second by the 2 f-stop light loss the filter creates.

Skylight/UV/81A Filters

These are the filters to leave on the lens at all times. With no light loss and a very minimal amount of impact on the image, these filters will be a cheap insurance policy against having to replace an unprotected front element if something whacks the front of your lens. And believe me, after replacing a few front elements over the years, I have learned that keeping a filter on the lens is a lot cheaper way to go. I use B+W or Heliopan as my filters of choice, as I've seen the results a cheap filter can create on optical benches in measuring the distortion.

As a photographer who grew up shooting film, I always kept an 81A filter on the lens for protection and for the slight warming effect the filter imposed. The 81 filters come in three strengths: 81A, 81B, and 81C. I have all the filters listed on the back of a Minolta color meter, which includes 81D and 81EF. The A filter has a very slight warming effect, just enough to add a warm (gold-orange) feeling to the photo. The B filter goes further, as does the C, both being too strong for everyday

When we look at a beach scene, our eyes capture the deep blue sky, the aquamarine of the water, and the soft umber color of the sand—all in the full blaze of the midday sunlight. The camera's sensor does not have the dynamic range of the eye and thus the unfiltered photo of that scene will suffer. If the exposure for the sky is correct, more than likely the sand will be blown out. Or if we expose for the sand, the sky will be almost black. The graduated neutral density filters let you more nearly capture the scene as you see it. Filters are the method by which we control the light and the exposure range.

The Neutral Density Filter

A graduated neutral density filter, as used in the photo of Oban, has half the filter darkened to enable the photographer to reduce half the image's exposure. A neutral density filter is 100-percent darkened.

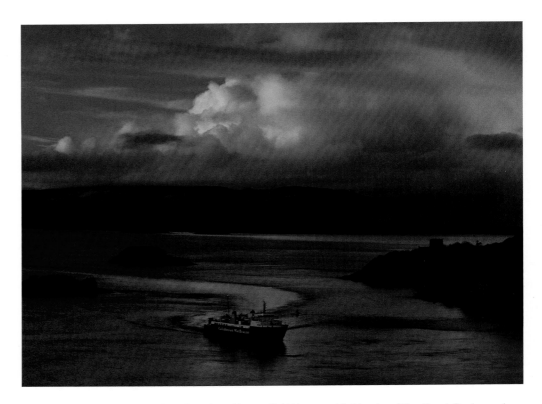

Oban is a resort town in the rugged and beautiful Western Highlands of Scotland. Becky and I were there scouting a location for a FirstLight Workshop. It was late afternoon, and the day had been rainy and cold, but we decided to venture to an overlook of the port city. The early evening skies broke open, providing a stunning scene as one of the ferries that ply the outer isles came into port. The use of a graduated neutral density filter and a Singh-Ray warming polarizer allowed me to darken the sky so that the foreground could be exposed properly. 50–200mm lens at 100mm, 1/20 second at f4, 100 ISO

shooting. Digital does present a bit of a problem with the 81A, B, and C filters. The white balance setting on your camera will see that warmer light that has been enhanced by the filter and will pump up the blue channel in the camera's software, thereby neutralizing the filter's effect. The problem here is that the blue channel is where the main body of noise comes from. A skylight or UV filter is the best choice for a permanent filter on your lens.

Software Filter Packages

In the not-so-long-ago past, all filtration was done in the obvious place, in front of the lens. Understanding filter packs, light loss, and mixed light sources all were part of that knowledge you gained through years in school or in the business. With the advent of digital, the photographer now has some filtration options that can be introduced in the computer.

Unfortunately, the most common uses of photographic filters can't be introduced in the digital darkroom. Filtering a scattered light source with a polarizer or compressing the brightness range of the scene can't be done on the computer. Digital filters are nice tools for slightly enhancing or modifying photographs, but they are not a substitute for filtration done on the lens.

The photographer can use warming and cooling filters that can be applied to the image with ultimate control as Photo Filter adjustment layers in Photoshop and Lightroom.

PHOTOGRAPHING WILDLIFE

Animals, animals, animals require patience, patience, patience. Wildlife photography is a wildly popular area of photography that does not necessarily demand that you travel to the four corners of the Earth. I'll discuss where you can go to obtain great wildlife photographs without breaking the bank. I'll also include some ideas regarding photographing critters.

I spent some time in the Dry Bay Area of the enormous Glacier Bay National Park, a very remote section accessible only by bush plane or boat via the Gulf of Alaska. I was photographing a story for *National Geographic* on the Tatshenshini-Alsek River and needed to photograph grizzlies for the story. Greg Dudgeon, a National Park Service ranger for the northern extremes of the park, had suggested the area, which has one of the highest densities of the bears in the world. Access to Greg's location had required an all-terrain vehicle (a four-wheeled motorcycle) trek followed by a short hike to the banks of the East Alsek River. We took off early and made it to the river before dawn. A shallow rapid was a natural ladder for the salmon swimming upstream to spawn, and we were right in the middle of the spawning season. Moving as quietly as we could so we would not scare off any bears, we tiptoed past dozens of bear-mauled salmon carcasses.

Greg chose a spot on the riverbank, thinking that we could make our presence known to the grizzlies and not surprise them, which could initiate an attack. We sat that first morning for two or three hours, with several predators moving past in the distance. A gray wolf and a grizzly were out that morning, but not close enough to photograph. We decided to try again the next morning and headed back to the same place. A super-telephoto 600mm lens was mounted on my tripod with a second camera carrying an 80–200mm zoom. I hoped I would be ready for anything.

Within a few minutes a large coastal grizzly (so named because these bears stay close to the ocean for the abundance of fish) appeared out of the willow brush along the far shore, about 200 yards away, thus a little too far to photograph. Still, the grizzly's arrival caused an immediate increase in my pulse rate and focused my attention—these bears are generally larger than their mountain brethren and this one was no exception. Greg, armed with a shotgun, was talking softly so the bear would not be alarmed by our presence.

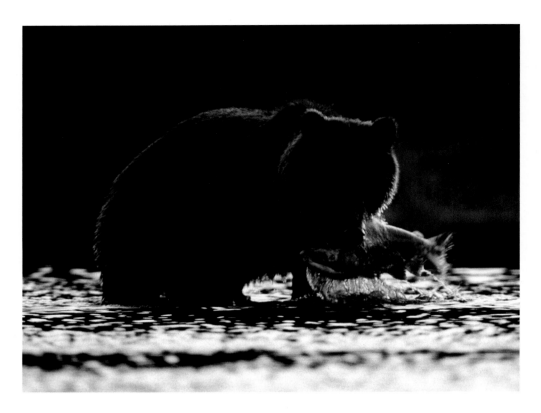

The grizzly stopped just short of us, deciding to feast on this salmon instead. 80–200mm lens at 100mm, 1/125 second at f2.8, 200 ISO

The initial rush of seeing this huge critter so close soon gave way to our relaxing a bit as the bear moved around in a small area. Twenty minutes passed and my attention was starting to drift. Something, a sound or motion, triggered the bear's next reaction. Turning toward us, he lit out in a full sprint directly at our exposed position. I started shooting with my camera and Greg brought his weapon up. The charging bear stopped in the water immediately in front of us. Sizing us up, he looked at us, and then looked into the water, back at us, and back at the water. He then dunked his enormous head into the rapids, bringing up a large salmon. I've always thought he was deciding, "Hmmm, surf or turf?"

Animal Encounters Close to Home

The Serengeti, the Arctic Circle, the rainforest…. Traveling to these exotic locales will provide amazing photo opportunities. However, it will also expose you to hungry lions, ornery polar bears, and a host of creepy crawlers that you'd probably rather not have scurrying around your camera bag. Practicing your techniques at your local zoo provides access to animals from around the world, but without the risk of becoming lunch for a hungry carnivore.

Encounters like my grizzly adventure are rare and require time—a lot of time. I've always hugely admired the wildlife photography of

Frans Lanting, Paul Nicklen, and John Shaw and wished I had the same patience their craft requires. If you are short on time or don't want an unexpected encounter with a giant bear, the zoo can provide a wonderful environment for capturing wildlife. In your bag, be sure and carry a long lens for close-up portraits of the animals and to help compress the photo enough that the distracting background is a blur.

- A 300mm lens is a great choice for shooting in a zoo—long enough to reach out but not so long that any tiny bit of motion is amplified because of the long reach. This long lens will also help to blur the bars of the cage between you and the animal you're photographing.

- Find out when feeding takes place. This is a time when you'll get action from the animals instead of a series of portraits of sleeping bears.

- Take your time. Hang out at a cage or pen that has an interesting animal and give it time for something to develop. Remember that wildlife photographers may be hunkered down in a cold blind for hours waiting for the moment the eagle swoops down for a fish. This is good training for the time you are in the field and have to practice patience.

- Think early and late when deciding when to visit. Often, these are the times when the zoo is least crowded and the animals may be up and moving.

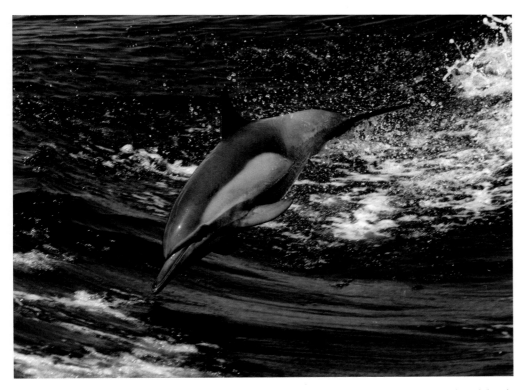

In the Sea of Cortez, a porpoise breaks the surface of the ocean. Steady tracking and anticipation was the formula for this image. 50–200mm lens at 158mm, 1/500 second at f5.6, 100 ISO

- Approach a zoo administrator and ask if they ever need photos for possible publicity, archiving, and so on. Most larger zoos have their own photographic staff, but smaller zoos may be quite interested in working out an arrangement. This relationship may pay off by them contacting you the next time they have an animal birth or special event happening.

- Bring a flash so you can fill in the shadows on a harshly lit or backlit photo.

- Zoos are more than pleased to have amateur photographers on the premises as long as they are not shooting for commercial gain. This means no selling the images, for publication or for any monetary gain. This is a strict policy with large zoos, and you should ask for a copy of the zoo's policy on commercial photography if that is your intent.

SPECIALIZED EQUIPMENT

The world of outdoor photography can demand a lot of photographers and their equipment. Weather conditions are not always ideal, traveling to and from a location can be arduous if not hazardous, and trying to combine good light with the perfect moment can be frustrating. In this section, I'll talk about how to improve your odds and make life a bit easier.

Camera Equipment and Such

We'd hiked across the tundra in the eskers country of the Northwest Territories for hours, trying to find the den of arctic wolves that Terry had seen earlier. I was on assignment for *Condé Nast Traveler* to photograph this unspoiled and largely uninhabited area of Canada. Terry was not only a guide; he was an accomplished photographer as well. He'd whittled his equipment down to two bodies—one in a LowePro TLZ Pro AW chest case and the other a body with a long (400mm) lens attached to a monopod. (Imagine using one leg of a tripod with a ballhead attached and you get the picture: fast and stable.) This was no country for a camera bag. I had my vest loaded with the minimum amount of gear to get the job done: a total of two cameras and three lenses. I used a wide zoom on one body, a medium-length zoom (80–200mm) in my vest pocket, and a 600mm on the other body, also on a monopod.

The outdoors will teach you quickly what works and what doesn't. What does work well are cases such as the LowePro bag that attach firmly to your torso so there is no bouncing of the camera against your chest. Providing a snug fit for a camera with up to an 80–200mm lens attached, the bag also affords weatherproofing and is well padded against shock and accidental knocks.

 On the Web When you don't need them, tripods are a pain to carry, but when the conditions require the use of a tripod, they are utterly invaluable. Those conditions include long exposures, and when shooting with longer lenses and holding 15 pounds of lens and camera would be unrealistic. I carry a Gitzo GT2540 6X carbon fiber base with an Acratech GV2 ballhead. This light combination works extremely well for me in the outdoors and has taken and shaken off quite a bit of abuse. For further information, please visit www.perfectdigitalphotography.com.

Another piece of equipment that is always in my outdoors bag is a macro lens. This extreme close-up lens opens worlds to the outdoor photographer. I've spent hours in a 10-square-yard area working on shooting close-ups. It is another world that some photographers even specialize in. Here are a few tips for macro work:

- A small flash can be helpful, or try a ring light. Ring lights are flash units designed in a circular pattern to fit around the lens. The light produced by a ring light is very even across the photo.

- A reflector is a must for the macro photographer, often to reflect a bit of light to fill in the shadow caused by the camera and photographer or to warm up the image. To improvise, I'll carry small pieces of paper and aluminum foil to create mini-reflectors that can be fitted into very small spaces yet reflect just enough light to fill in shadowed areas of a flower or insect. The foil that wraps Wratten filters can sometimes be the right size.

- A small tripod is a necessity as the zone of focus of a macro lens can be very shallow, and working close in lower light amplifies any movement of the camera.

- On that small tripod is a ballhead, and my brand of choice is the Acratech head, which is beautifully machined, ultra-light, and very stable. Ballheads are great because they give you almost unlimited positioning and lock down quickly once you have found that perfect angle.

- A shutter release cord should also be in your macro kit. When you are working with extreme close-ups in low light, any movement of the camera can affect the sharpness, and the shutter release cord removes your shaky hands from the camera. If you've forgotten your shutter release cord, try using the self-timer on the camera. Set it for a couple of seconds, compose your photo, and then remove your hands as soon as you press the shutter. This allows any movement of the camera to settle out, ensuring a very stable platform. Mirror lockup can be used to help steady the camera further when shooting long exposures, but focusing must be done pre-lockup as this trick eliminates the ability to see through the camera.

- A small spray bottle of water can be used to moisten leaves, petals, flowers, and other parts to give them a bit more life.

- If shooting insects, bugs, birds, and such for possible sales, decipher the scientific name. Any serious biological journal will want to know that you've photographed an *Euchromus giganteus* and not a "funky kinda green and gold huge critter."

Various and Sundry Other Gear to Contemplate

In my years of working as a photographer, I've accumulated my own set of specialized outdoor gear as well as stuff I find helps me in my photographic mission. Keep a list of what you take, and at the end of the shoot note

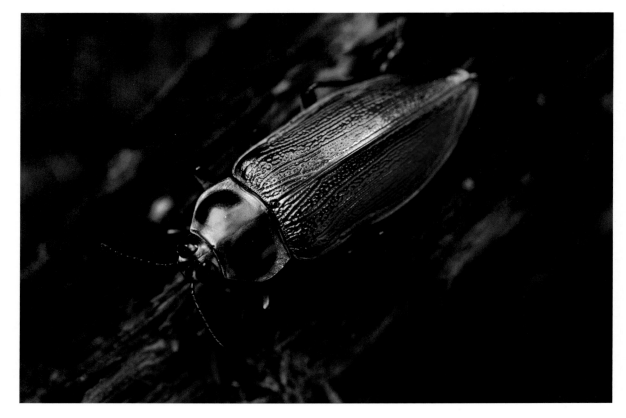

The Amazon basin has a dizzyingly large array of insects. On assignment for *Condé Nast Traveler*, my photographic subjects, who happened to be biologists, found this beautiful beetle, *Euchromus giganteus*, about 2.5 inches long. I used a reflector to fill in the light on the insect's wings, producing a visual "pop" to heighten the attention on the colorful creature. 60mm macro lens, 1/60 second at f5.6

what was used and what wasn't. Over time you will have your own list addressing your shooting style and needs.

Here are a few other bits of specialized gear I'll take on outdoor shoots:

- I always carry one or two chamois cloths in my bag/vest. These are invaluable as camera wipes and rain covers. Check your local auto parts store or grocery store for a chamois.

- A camera raincoat is a rain cover made specifically for the camera and lens. Several different brands are available, including Photo-Fax Camera Raincoat, which is one of the most serious looking covers, and rain covers made by FotoSharp (www.fotosharp.com) and Think Tank (www.thinktankphoto.com/ttp_products .html). If you're serious about shooting in the great outdoors, a good rain cover is an absolute necessity.

- I always take an umbrella—either a small, portable one that fits in a pocket of my vest or a golf umbrella. It's cumbersome, but it provides great protection as long as the wind is not blowing!

- Desiccants and zippered baggies are also permanent residents of my travel/outdoor kit. At the end of a day shooting in a rainforest or other high-humidity situation, the camera and lens go in a baggie along with a small container of desiccant. Desiccants are the little bags of moisture-absorbing silica gel we're not supposed to eat that are included in almost every bit of electronic/photographic gear that we purchase. The Camping Survival website (www.campingsurvival.com) offers good silica gel desiccants in containers that make them realistic to carry and reuse, as they are able to be "baked" back to new.

- One unfortunate byproduct of the Golden Hour, that perfect time near sunset when the light is ethereal, is that it is also the time mosquitoes call lunch hour. To deal with these little devils, I always wear a long-sleeved, light-colored shirt, sprayed with Permethrin. When sprayed on clothing, this product repels ticks, mosquitoes, chiggers, and mites. I've never had a reaction of any sort to this product and it works wonderfully. Find it online at www.sawyerproducts.com. Several clothing manufacturers now offer clothing that is pretreated with Permethrin, such as Exofficio's Buzz Off line of clothing.

- I keep a lens pen and batteries specific to my camera in my vest.

The Benefits of Digital in Nature Photography

On a three-month assignment in Papua New Guinea, I was so remote I did not have the opportunity to ship my ever-growing pile of film to *National Geographic* for processing. Every day I'd check the case where the rolls resided and worry about exposure, camera problems, if the moment was captured, and so on. Beyond frustrated, I found myself shooting more than normal with different cameras on the same situation. I wanted to cover my tail and protect against losing an important image due to camera malfunction.

Fast-forward to the digital era. I shoot, I confirm, I move on. At night, I back up my cards to my laptop and external RAID system (two WiebeTech pocket drives configured in my Disk Utility to appear as one icon on my laptop) and burn them to DVD. The advantages of digital in this particular area of photography are legion. The ability to check out the image immediately for composition and exposure actually empowers the photographer in this craft. (And, don't forget, it also allows you to spend countless hours poring over your laptop when you could be sleeping!) Instead of covering your tail by shooting and shooting, you can move on to the next image when you see the fruition of the moment or situation on the monitor. If possible, I shoot test exposures based on my metering and make adjustment prior to the real deal. Then I know I don't have to bracket, shooting additional exposures a third of a stop or so on either side of the correct exposure to cover myself—and I can work on the moment.

How To: Creating a Sense of Place in Your Outdoor Photography

When photographing on assignment for an outdoor publication, the photographer is responsible for capturing a sense of place. The viewer has to feel that photo resonate. Here are some tips for effectively conveying that sense of place:

- It may take more than one photo. Start with a wide shot to create an overall scene. Again, use your light as a key factor by shooting at good times of the day. Supporting photos can be details and moments that help create that sense of grandeur.

- What attracted you to this area? This could be the key element to your photos. If it's Yellowstone National Park's Old Faithful, then use it as an element in your photo, even if it is only in part of the frame—perhaps with your child in the foreground taking a photo of the geyser.

- The preceding tip goes hand in hand with this one: Don't be literal. A photo of Old Faithful by itself will not be as interesting as a photo that includes a human. Try shooting from different levels—up high, down low. Look around. An image of Old Faithful reflected in a tourist's sunglasses tells a lot about the crowds that eagerly await its eruptions.

- Include scale if the scene is grand. This will give the viewer a sense of the majesty of the place.

- Don't stop working the scene after the sun sets. This can be a wonderful time to bring out the tripod for long exposures, which open up another world of photography and a fresh look and palette.

- As an aside, here's a website that I recommend to students: www.artphotogallery.org. This website has a Masters section with important images from some of the most legendary photographers ever: Ansel Adams, Edward Weston, Arnold Newman, Joel Meyerowitz, Walker Evans, Yosuf Karsh, Irving Penn, Richard Avedon—62 artists are catalogued here. This is a nice, free access photo library for anyone interested in seeing accomplished work.

Stromboli volcano, the Aeolian Islands of Italy. A long hike in late afternoon with a guide landed us at the constantly changing overlook of this active volcano. Explosive eruptions were absolutely startling, and first instinct is to run for cover. Looking down into the crater resulted in this late-day photo. 12–60mm lens at 36mm, 3/10 second at f5.6, 100 ISO

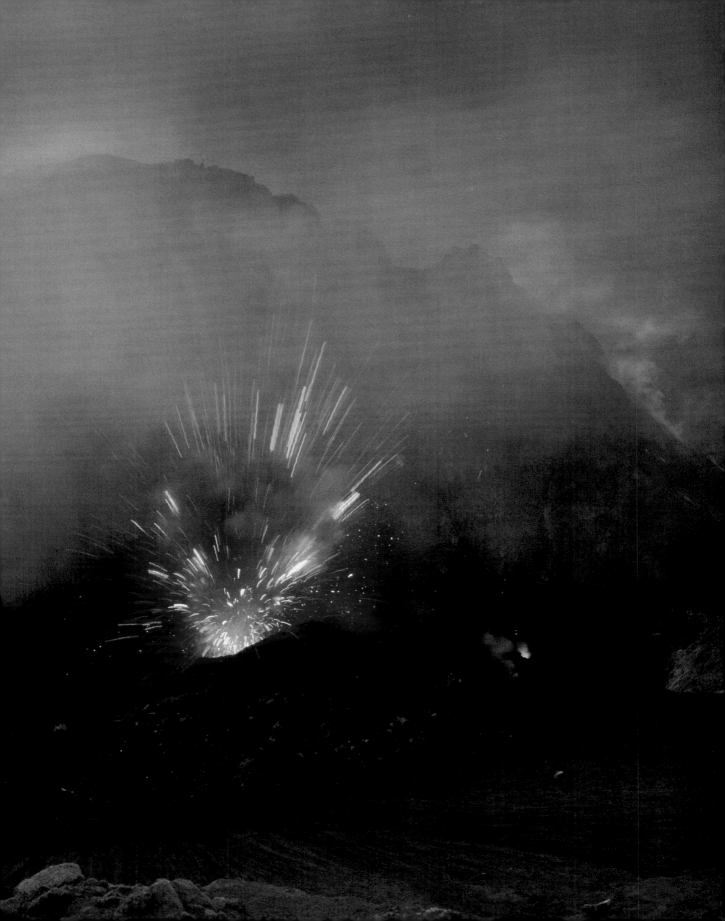

THE
DIGITAL
DARKROOM

Photographed and written by Jay Kinghorn

WELCOME TO THE DIGITAL DARKROOM

Photography has always been a technical art. Shutter speeds, apertures, development times, darkroom chemistry, and print contrast ratios have always challenged traditional photographers. Digital photography is no different. The tools found in Adobe Photoshop, Adobe Photoshop Lightroom, and Apple Aperture help a skilled photographer guide a viewer's eye through a photo, establishing resting areas for the viewer's gaze to linger and infusing a photo with depth and vibrancy.

As is true with all technologies, digital photography will continue to grow and change. New tools will emerge, making digital photography easier and more powerful. To get the most out of your digital photography, you should learn how to use these new tools to capture your vision, organize your work, and create compelling prints to share with others.

Car Trails on Trail Ridge Road. Olympus E-500, 7–14mm lens, 1/10 second at f18, ISO 100

Until this point, this book has concentrated on capturing a brilliant digital negative. Now let's turn our attention to distilling the content in that digital image through a series of adjustments, then preparing it for print or the Web, and finally archiving the image for posterity.

New Tools, Same Challenges

Since we wrote the first edition of this book, tools for processing, managing, sharing, refining, and printing your digital photos have become both more powerful and easier to use. Although the essential tool for photographers working in the digital darkroom continues to be Adobe Photoshop, it is no longer the only tool at your disposal. New image processing programs such as Apple Aperture and Adobe Photoshop Lightroom provide a unique suite of tools to help photographers organize, correct, and print digital photos. These applications complement Photoshop's specialty in exercising complete control over specific areas in a photo with tools designed to help photographers work faster and more efficiently.

In this chapter, I'll discuss the differences between applications such as Photoshop, Aperture, and Lightroom to help you decide which programs are right for you. In addition, I'll discuss the differences between shooting in the camera raw and JPEG formats and why this decision, made before you even shoot your pictures, has a profound impact on the quality of your photos.

This chapter is designed to be an introduction to the digital darkroom and provides an overview to the components that help you download, store, correct, print, and archive your photos. These steps, from image capture to print, can be summarized in a single word: workflow.

Building Your Workflow

For most of Photoshop's life, the application was designed to give you complete control over editing pixels, the basic building blocks of digital photos, in a single digital file, traditionally a scan of a film negative or slide. This system served photographers well because only a small percentage of the hundreds or thousands of photos in a photographer's collection were ever scanned into a digital format.

The invention of digital cameras changed everything. Instead of having a handful of digital photos to manage and correct, a photographer now has thousands or tens of thousands of digital photos to cull through, correct, and store. This change requires an entirely new approach to the process of handling digital photographs, one that focuses less on the individual photo and more on the processes involved in taking large numbers of photos from the camera to final print. These processes are your digital workflow. While your workflow will differ slightly from that of another photographer, several workflow stages are common to all photographers. In this book we'll address each stage of the process in detail to help you tailor your workflow for the best

image quality and greatest efficiency. To begin this journey, let's take a bird's-eye view of each stage of a digital photography workflow to see how they fit together.

Stages of a Photography Workflow

Your workflow is unique to you. Like a fingerprint or signature, no two workflows are exactly alike. Because we all approach challenges such as organization, backup, and even image correction in slightly different ways, one specific workflow does not fit everyone. For that reason, this book is designed to help you develop a workflow that best suits your individual needs, instead of prescribing a workflow for you to copy exactly.

As unique as workflows are, they all share at least five major stages in the process:

1. **Input** The process of copying photos from your camera's memory card to your computer. As simple as this seems, several important steps are often overlooked in this process. We'll cover the input stage in greater detail in Chapter 12.

2. **Editing** How do you select the best photos in a shoot? What do you do with the rest of the images that aren't necessarily bad photos, but don't represent your best work? Strategies for quickly editing your photo shoot along with answers to these questions and more are covered in Chapter 13.

3. **Global corrections** Refers to a change applied to the entire image. For example, a correction to a photo's overall color balance is a global correction. Global corrections form the bulk of your image processing duties and are covered in detail in Chapter 14.

4. **Local corrections** Adjustments applied to specific areas of a photograph—brightening a person's face, for example. Most local corrections emulate advanced techniques from the wet darkroom and combine them with the power and control that Photoshop offers. Learning how to master local corrections gives you a high degree of nuanced control over how your photos appear onscreen and in print. These intermediate to advanced techniques are covered in Chapters 15 and 16.

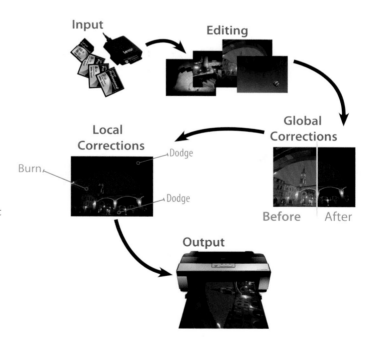

The five stages of a digital photography workflow

5. **Output** While the print is still the gold standard for photographic reproduction, it is by no means the only game in town. Websites, mobile devices, and multimedia hybrids offer exciting new avenues for displaying and sharing your photos. With any output medium, it is essential that your photos meet the technical requirements of the output device; otherwise, the results will be disappointing. The output-based Chapters 17, 18, and 19 all focus on helping you achieve the best results, whether you're printing to a wide-format inkjet printer or preparing a photo for inclusion in a multimedia production.

These five stages are built around maximizing quality while minimizing time spent organizing, correcting, and managing your photos. A cornerstone of an effective digital workflow is shooting in your camera's raw format.

THE IMPORTANCE OF SHOOTING RAW

The most significant change that has occurred in digital photography in recent years is the rapid adoption of a camera raw workflow. Whether you are new to camera raw or an experienced veteran, it is beneficial to understand just how fundamentally different raw files are from their JPEG counterparts.

What Is a Raw File?

A camera raw file, or raw file as it is commonly called, is the unprocessed information stored by your camera immediately after the light reaching your camera's sensor is converted to a digital signal. All digital photographs begin their lives as raw files, but depending on your camera model and your on-camera settings, this raw information may be processed in-camera and stored on your camera's memory card as a JPEG. If you are photographing in raw mode, your camera will not perform any processing on the photo; instead, it will store all of the digitized information to your memory card in its raw state.

Why Is Raw Important?

Shooting in raw is important for three major reasons:

Once the light is digitized by the camera's sensor, your photo is stored in either a raw or JPEG format depending on the camera's settings.

- It provides the full range of unprocessed information, just as your camera's sensor captured it. This gives you more latitude to fine-tune highlights and shadows, contrast, and color. JPEG files are processed in-camera with preset color, contrast, and sharpness settings. This limits the range of corrections you can perform in Lightroom and Photoshop.

- It is easier to batch-correct multiple raw files at once, greatly improving the speed of your workflow.

- And here's the clincher: When you make corrections to a raw file, your adjustments are completely nondestructive. Short of moving your photo to the trash bin, you cannot ruin a raw file. Changes made to a JPEG file can be permanent, and a JPEG photo can lose quality by being saved repeatedly.

These three points illustrate why shooting in raw gives you a better experience in the digital darkroom—but perhaps the most important reason for *Perfect Digital Photography* readers is that processing raw files is easier and more intuitive than processing JPEG files. The adjustment controls are simpler and more logically arranged, and, to reiterate a point, the changes you make to a raw file are never permanent, making it easy to experiment with tools available in the raw processing software without fear that you will damage or lessen photo quality.

What If My Camera Doesn't Shoot Raw Files?

Most digital SLR cameras, and an increasing number of point-and-shoot cameras, can shoot in raw. If you don't see the option in your camera's menu, you can check to determine whether your camera offers a raw option by reading your owner's manual or viewing the technical specifications.

If your camera isn't set up to create raw files, don't worry. Photoshop CS3 and CS4, Lightroom, and Aperture all allow you to adjust JPEG photos as though they were raw. Since JPEG photos are already processed, you won't have the same degree of flexibility you would have with raw files, but you will still be able to perform common corrections and make beautiful prints from your photos.

For the tutorials in this book, we're assuming you are shooting in raw mode. For a refresher on setting up your camera to shoot in raw, please visit Chapter 3. As we go deeper into the correction process, the differences between raw and JPEG will become clearer. You'll see why raw is the format of choice for an effective digital photography workflow.

WHAT TOOLS DO I NEED? BUILDING YOUR DIGITAL DARKROOM

In a traditional wet darkroom, you would expect to find enlargers, chemicals for development, wash and rinse basins, and an array of papers for printing. Since pixels have replaced negatives, you might find the following items in the digital darkroom.

Hardware

Camera

Digital images are most often captured with a digital camera or created by scanning a piece of film. Photographers wanting the most control over their images will use a digital SLR (DSLR) with interchangeable lenses. For the tutorials in this book, you can use a DSLR, point-and-shoot, or film camera.

Image courtesy Olympus Imaging America

Memory Cards

Most digital photos are temporarily stored on CompactFlash (CF), Extreme Digital (XD), or Secure Digital (SD) cards until they are transferred to your computer. Photographers working in a studio environment will often shoot in tethered mode, where the camera is connected directly to the computer and photos are automatically stored on the computer's hard drive instead of the camera's CF card.

Tip When downloading photos from your camera, it is easier and safer to use a card reader instead of connecting your camera directly to the computer.

Computer

Technology evolves at a blistering pace. Many pros suggest buying the fastest processor you can afford and loading up the computer with as much RAM as it can hold. This is sage advice.

Both the Windows and Macintosh operating systems are appropriate for digital photographers. Each system offers slight advantages and disadvantages when compared to the other, but the core applications such as Photoshop and Lightroom are virtually identical when running on Windows and Mac computers. I recommend that you use whatever platform you are most comfortable with.

Hard Drives

Your photo library will take up more space than you can imagine. Although I don't recommend buying a bunch of hard drives now, you should consider your future storage needs before purchasing any new hard drive. Most important, you need to have enough space on a separate hard drive to back up your entire image library. I'll help you develop a bombproof backup strategy in the next chapter.

Image courtesy WiebeTech

Monitor

Your monitor is your primary means of judging your photos. Because of this, you should get the best one you can afford. Otherwise, you could find yourself limited by a poor-quality monitor when it comes to fine corrections and printmaking. I strongly recommend that you spend as much money as you possibly can on your monitor. It is an investment that pays for itself quickly when you begin making prints. The better quality your monitor, the fewer prints will be ruined by inaccurate color. In fact, it is more important that you have a high-quality monitor than a fast computer.

Monitor image courtesy
EIZO Nanao Corporation

Shopping for a monitor can be daunting. Few reviews specifically address the needs of serious photographers. Of all the product specifications, only a few impact a monitor's effectiveness in the digital darkroom. The rapid pace of development makes it impossible to offer concrete recommendations; however, the higher end Dell and Samsung monitors are

both good values, Apple and LaCie monitors are a step up in both price and performance, while EIZO and the top-of-the-line HP DreamColor displays are currently leading the pack. The following information may help you in reading reviews and product specifications to sort through the jargon and find a monitor that is right for you.

On the Web For a current list of monitor recommendations for digital photography visit www .perfectdigitalphotography.com/monitors.php.

Monitor Type

Photographers are likely to encounter three types of monitors: CRT, LCD, and LED. You can think of these monitor types as the past, the present, and the future.

CRT (cathode ray tube) monitors are virtually extinct, having been surpassed by the LCD monitors in common use today. While CRT offered a few advantages for viewing photographs, few, if any, manufacturers continue to produce CRT monitors. The last remaining CRTs are approaching the end of their usable life and will give way to new LCD and LED monitors.

Odds are the monitor with which you perform most of your photographic corrections is an LCD (liquid crystal display). While LCD monitors are widespread and used in all types of professional workflows, some inherent limitations in the technology will make the LCD's dominance short-lived. First, an LCD display is illuminated from a single light source, making it difficult to maintain consistent

brightness and color in all areas of the monitor. Second, LCD monitors cannot be calibrated as accurately as CRT or LED monitors because they have only a single light source instead of separate light sources controlling the intensity of red, green, and blue information, as is found with CRT and LED.

LED (light-emitting diode) monitors hold great promise for digital photographers. These monitors deliver accurate color more evenly across the screen and can be calibrated to tighter tolerances than LCD monitors. For these reasons, LED monitors, which are already beginning to appear in laptops and professional-level displays, will quickly overtake LCD as the technology of choice for high-quality monitors.

Making the Most of Your Monitor

Unfortunately, with monitors, you tend to get what you pay for. Spending the extra money to get a professional-quality monitor will usually pay dividends over the life of the display. That said, if you're suffering from sticker shock, here are a few tips to make the most of your investment.

First, buy small. Big monitors are in vogue right now, but the quality of a large monitor is often inferior to that of a smaller one. For most of my career, I've worked on a single 19-inch monitor and it has served me well. When I upgraded from my original system, I invested in a professional-quality 19-inch and purchased an inexpensive 19-inch to store my palettes and other documents. Buying the highest quality display will more

than pay for itself over the display's life—in saved ink and paper, not to mention the hair pulling you avoid when prints actually match your monitor.

Second, lower the brightness. Most monitors have an expected life of around three years. Keeping your monitor at full brightness often cuts the life of a monitor in half and causes problems when you're trying to match color in photos between your monitor and your prints. Lowering the brightness of the monitor not only saves you money in print costs by improving screen-to-print accuracy, but it will extend the life of your monitor.

Finally, carefully weigh your needs before you buy. If you're a photography enthusiast who predominantly shares photos online, you don't need a super high-quality monitor. If you are a fine-art photographer who does a lot of printing and is very discerning of tone and color, you will save money in the long run by investing in the highest quality monitor you can afford. I've spent a lot of time consoling frustrated photographers who keep striving for better print quality but are limited by their monitors.

> **What About Laptops?**
>
> While laptops can, and often are, used for digital photography, the displays used in laptops aren't as accurate as their desktop brethren. If you are currently using your laptop for performing corrections, and it's working for you, I encourage you to continue to do so. If, however, you get to a point where you can't seem to get the color right in your prints, you may be asking for more than your laptop can deliver, and it may be time to add a desktop monitor to the mix.

Monitor Calibration Package

No serious digital photographer should be without a software and hardware package dedicated to calibrating and profiling your monitor. A well-calibrated monitor is an accurate monitor that will save you a tremendous amount of ink, paper, and frustration when making prints. My favorite monitor calibration packages come from X-Rite, basICColor, and ColorEyes.

A detailed tutorial on calibrating and proofing monitors is included in Chapter 18.

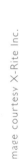

Image courtesy X-Rite Inc.

Output

Viewing images on the screen is nice, but it is difficult to hang a monitor on the wall or send your laptop to a friend as a gift. The output stage of the workflow is still commonly geared toward printmaking, but multimedia uses of

photography are increasing by the day. We'll cover printing in great detail in Chapter 18 and will explore multimedia in Chapter 19. For now, it's worth looking at two common printing methods available to help you round out your digital darkroom.

Inkjet Printers

You probably have a photo-quality inkjet printer sitting on your desk or stationed in your studio. Printers that print only letter-sized photos are fine for general photo printing duties, but serious photographers will want to take advantage of the superior archive life, print quality, and variety of paper types supported in 13×19-inch and larger format printers.

Image courtesy Epson America, Inc.

Digital Photo Lab

The digital darkroom extends well beyond the walls of your home or office. Professional photo labs offer medium- to high-quality prints made on photographic paper from digital files. Printers such as the Fuji Frontier, a common printer found in minilabs, or the Océ

LightJet use lasers to expose photosensitive paper to light. Because they do not require the same chemistry used for traditional color printing, these prints have a good archival life and a brilliant color palette, and they make high-quality prints. Many online printing services use a photographic printer such as the Fuji Frontier to make inexpensive prints from photos you've uploaded to their website.

Lighting

Believe it or not, the lighting and the color of the walls in your workroom has a profound impact on your ability to perform color and tone corrections accurately and match your prints to your monitor. We'll go into greater detail on room lighting in Chapter 18, but suffice it to say if your print colors don't look right, try moving the print to a north-facing window to see if the color improves.

Software

The computer, monitor, and printer all serve as a support system for your software, which performs most of the actual work involved in image correction. As digital photography has grown in sophistication, specialized programs have been developed to address specific needs. Considering the myriad applications geared toward digital photographers can be a bit overwhelming. To help clarify your choices, in this section, we'll discuss the different types of digital photo applications and how they are used in a photo workflow.

Adobe Photoshop is synonymous with correcting, processing, and adjusting images. While Photoshop is still the best pixel editor on the planet, several other software applications can help you edit and manage files or quickly process a shoot. These applications typically fall into one of four main categories: file browsers, asset managers, raw processing applications, or all-in-one workflow solutions.

File Browsers

File browsing software allows you to view the contents of a single folder very quickly. This makes file browsers an excellent choice for your initial edit or for managing a small image library. File browsers offer only limited help in managing a large image library as they can only view the contents of one folder at a time. The most popular file browsers are Adobe Bridge and Photo Mechanic.

Adobe Bridge (Included with Adobe Photoshop CS and Later)

Adobe Bridge has evolved into a central file management application for all of the applications in the Adobe Creative Suite. Within Adobe Bridge, you can sort, keyword, and edit your photos, or preview a folder of project files including page layouts, Flash animations, HTML documents, and video clips. This versatility is advantageous for working across applications, but it can become

cumbersome for photographers who need only the ability to download, edit, and organize photos quickly.

Photo Mechanic

Photo Mechanic has long been the file browser of choice for newspaper photographers and photojournalists who measure deadlines in minutes instead of hours or days. Photo Mechanic is a specialized tool for downloading images, applying descriptive metadata to photos, and selecting the best images from the shoot. While not as versatile as Adobe Bridge, Photo Mechanic is the tool of choice when speed is an absolute necessity.

Asset Management

Asset managers help you create a visual database of your photo library, allowing you to view all your photos in one location, even if they reside in different folders or hard drives. The searching capabilities within asset management applications are superior to those found in file browsers. For example, a quick keyword search for "beach" might bring up photos from your trip to Hawaii in 2005, plus a visit to Big Sur, California, last year, plus a host of individual photos from your trip to Ireland this year. Asset management software is essential for managing a large image library, because it helps you catalog, search, and find photos very quickly. Two of the most popular asset management applications are Microsoft Expression Media and Extensis Portfolio.

Extensis Portfolio

The most robust of the file-management options described here, Extensis Portfolio is best suited for smaller stock or advertising agencies needing to store and access files on a network. The single-user version of Extensis Portfolio contains most of the key features found in the server-based package at a much lower cost, making it an excellent choice for photographers who need to catalog 50,000 to 100,000 photos.

Microsoft Expression Media

Called iView MediaPro before Microsoft purchased iView Multimedia, Expression Media is a longtime favorite of photographers for managing medium-sized image libraries and sharing photo catalogs with multiple users in a network environment. Expression Media has the shortest learning curve of the asset management applications.

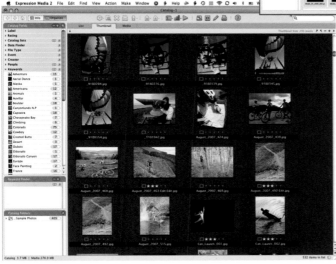

Raw Processing Software

Before you can share or print your camera raw files, they are decoded through a process called *demosaicing*, which is done by raw processing software that turns your original raw files into more versatile file formats such as JPEGs and TIFFs. Before you buy, be sure that the

raw processing software can read the raw file formats generated by your camera.

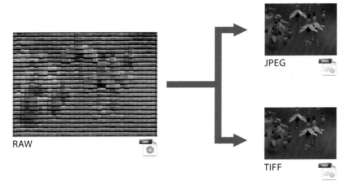

Raw processing software is used to create JPEG and TIFF versions of your camera raw files.

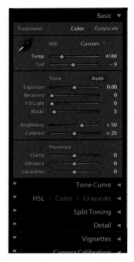

The user interface of Adobe Camera Raw in Lightroom

Adobe Camera Raw (Included in Adobe Photoshop and Lightroom)

Far and away the most popular raw processing application, Adobe Camera Raw is used by more than 90 percent of professionals at the time of this writing. This dominance is well deserved: Adobe Camera Raw provides a high degree of control over the color, contrast, and tone in your photos while its integration with Photoshop and Lightroom makes for an effective, efficient workflow.

Adobe Camera Raw can be used with both Adobe Photoshop and Lightroom. While the display of the interface's controls differs slightly between the two programs, the underlying programming and functionality is identical, making it easy to transfer photos between Lightroom and Photoshop.

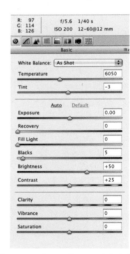

The user interface of Adobe Camera Raw in Photoshop

Capture One

Although Adobe Camera Raw is the 800-pound gorilla in the photography world, Capture One from Phase One is an excellent

program and provides a superb suite of tools for correcting and processing raw files. Some photographers prefer the look they get from Capture One over other raw processing applications.

All-In-One Workflow Solutions

All-in-one workflow applications such as Adobe Photoshop Lightroom and Apple Aperture are the future of the digital workflow. They dramatically streamline the process of editing a shoot, selecting your favorite images for processing, performing tone and color corrections, printing, and managing your image archives. Sounds like a lot to ask of a single application, doesn't it? Fortunately, these applications have been designed with your needs in mind. They focus on fulfilling the core needs of digital photographers, leaving the specific, selective corrections to Photoshop.

Apple Aperture

Aperture (Mac OS X only) is Apple's all-in-one workflow solution that offers a compelling set of tools for editing, optimizing, and sharing photos. Aperture excels in its flexibility in editing and selecting photos with a Light Table interface that is reminiscent of editing slides on a traditional light table, but improved for the digital age. Aperture also provides excellent built-in image backup features and a wide variety of different output options, from calendars to linen-bound books and slideshows to sophisticated web galleries.

Adobe Photoshop Lightroom

With every new release, Adobe Photoshop adds more features that meet the needs of professional videographers, web designers,

graphic designers, illustrators, and scientists. While these features offer tremendous benefits to those users, it makes the application more complex and more difficult to learn for digital photographers.

Lightroom is designed to be the bread-and-butter application for digital photographers who need to process a whole shoot of images very quickly. Perhaps the best way to think of Lightroom is as a "hybrid application." Adobe took the very best features found in file browsers and asset managers, combined them with Adobe Camera Raw for image processing, and added printing and web gallery creation to round out the tool set.

While you still need to jump into Photoshop to perform intensive compositing or image adjustments, Lightroom makes this an infrequent occurrence instead of the norm.

Software Featured in This Book

Since it is impossible to cover all of these applications in a single volume, I'll be demonstrating the workflow I believe is most effective for those of you reading this book. After extensive testing and development of my own workflow and my client's workflows, I believe the best solution right now for digital photographers is to use Adobe Lightroom as their primary image management, editing, and image correction software, combined with Adobe Photoshop for specific, localized image adjustments and refinements. This is the software that is featured in this book.

Whether you are using Lightroom, Bridge/ Photoshop, Aperture, or other software applications, you should understand the underlying concepts behind the tools you use. This helps you become more agile and adaptable in your workflow, because the only thing certain in digital photography is change.

ORGANIZING YOUR PHOTO LIBRARY

Before you begin performing image corrections, making prints, and creating dazzling web galleries, you should take some time to organize your photos into a centralized image library. Why? First, to make photos easier to find when you need them. Second, and perhaps more important, to make it easier to safely back up and protect your photos in case of a hard drive failure, system upgrade, or catastrophe.

Separate your image library from the rest of the files on your computer. If you're working on a desktop computer, this means

purchasing and installing a second internal hard drive in your computer. If a laptop is your primary editing computer, I recommend buying a second external hard drive to serve as your photo storage location.

Primary hard drive	Secondary hard drive

- Operating system
- Applications

- Documents
- Photos
- Custom settings

This separation makes it easier to perform normal system maintenance or upgrade to a new computer with a minimal amount of hassle. Of course, you will need to have an effective backup strategy in case the hard drive containing your images fails. After all, the question is not if a hard drive will fail, but when. For this reason, it's critically important that you have a backup plan that accounts for many different contingencies—from the more common challenges such as a hard drive crash, to the more catastrophic crises such as the theft of computer equipment, a fire, or a flood. Various backup strategies are covered next.

First, you need to continue creating your image library. After you've configured your computer for optimal results, you need to begin building a system of folders and subfolders to contain all the photos in your image library. Most photographers create

a folder on their hard drive titled "Image Library," and then create a new folder for each photo shoot. Adding the date and a descriptive title makes it easier to find a specific folder of files quickly. The folder structure also creates manageable file sizes for backing up to CD/DVD, supplemental hard drive, or online sites, which, conveniently enough, is the subject of the very next section.

Backup Strategies

Effective backup strategies can range from simple and inexpensive, such as burning a DVD of your shoot and storing it at a friend's house, all the way to a complex, expensive, and automated system that automatically backs up your photos to an offsite server. You'll want to select a system that meets your budget, matches the size and value of your image library, and is easy to use. Here I'll begin with simple, inexpensive methods and progress to more expensive backup strategies, highlighting the pros and cons of each.

You can find more information on backup strategies, software, and hardware products at www .perfectdigitalphotography.com/backup-archiving.php.

CD/DVD

Backing up to optical media, such as CDs and DVDs, is inexpensive, reliable, and effective. These small discs can easily be stored in an archival box at a friend's house or another offsite location, making them great options for storing backups of your most valuable photos.

Tips for making the most reliable CD/DVD backups can be found at www.perfectdigitalphotography .com.

The biggest disadvantage of using CD/DVDs is that they are relatively slow to read from and even slower to write to, and they aren't very flexible—you can't add a file to an already burned disc.

Hard Drives

Because of the disadvantages associated with burning files to CD/DVD, most photographers have switched to storing photo collections entirely on hard drives. Hard drives are becoming significantly less expensive, while increasing in capacity. However, the primary disadvantage of hard drives is that they fail. And when they fail, they often fail spectacularly, taking all of the photos with them. For that reason, you should never, ever, store your photo collection on only one hard drive.

It is essential that you have some system of copying files between multiple hard drives. This can be done manually, which is the most cumbersome, or automatically using a software backup system or by using a RAID system.

RAID

A RAID (Redundant Array of Inexpensive Disks) system is a series of separate hard drives connected to one another through a software system or hardware enclosure to appear as and function like a single drive on your computer.

Desktop RAID Solutions

Several manufacturers offer inexpensive desktop RAID solutions. The initial cost of purchasing a RAID system is higher than purchasing external hard drives, but the overall cost of ownership combined with the peace of mind and ease of use makes these desktop RAID systems very attractive to photographers with medium- to large-size image libraries.

Image courtesy WiebeTech

Web Storage

While external hard drives and desktop RAID solutions offer inexpensive, redundant backups of your image library, they don't provide protection against a catastrophic loss

such as fire, flood, or theft. For these reasons, you may want to store your prized photos in a web-based storage system. By renting space on someone else's server system, you are well protected against hard drive failure or the loss of your computer system. Web-based storage is the most secure, but it is also the most difficult to use and the most expensive option. For that reason, I recommend storing a limited subset of your best photos online.

Following are a few of the most common web-based storage systems:

- **Jungle Disk** www.jungledisk.com
- **Box.net** www.box.net
- **.Mac** www.apple.com/mobileme
- **Window's Live SkyDrive** http://skydrive.live.com/
- **Mozy** www.Mozy.com

Backup Software

Whether you plan to back up to a CD/DVD, hard drive, or web-based system, it helps to let a software program take care of the details; it can remind you when a backup needs to be made and back up only the files that have recently changed.

Eric Ullman, Director of Product Management for EMC Retrospect, is an expert in backup strategies and amateur photographer. He offers three "Laws of Backup" that you can use to test the efficacy of your backup systems:

- *Back up everything. Sooner or later you'll wish you had.* "Hard drives are so

inexpensive right now that it makes sense to back up everything on your computer. If you back up only bits and pieces, when it comes time to restore your data you'll often find that you're missing key settings, color profiles, or other files you need to work effectively. These missing pieces are often very time-consuming to re-create from scratch."

- *Automate your backups.* "It's too easy to forget to manually back up your files. Instead, let the software take care of remembering to begin your backup. The computer never forgets."

- *Get a copy out of the building.* "This is the most important of the three. Getting some backup of any kind offsite and updating it regularly protects against a catastrophic loss."

The most popular professional-level backup software for both Mac and Windows is Retrospect, though dozens of products on the market will suit almost any budget or backup need. For more information on Retrospect for the Mac and Windows, check out www.emcinsignia.com/products/smb/retroformac/.

Every art form has a handful of simple rules that create the fundamental essence of the craft. Visual artists, photographers, painters, and illustrators strike a balance between light and dark. In music, the quiet passages allow the listener's ear to relax, giving more force to the louder passages.

With so many options available to photographers to adjust, refine, and manipulate photos, often the most difficult artistic decision is to know when to stop. It helps to think of your photos as a combination of separate elements that are blended in just the right amounts to bring out the best qualities in your photos. What are the elements in a digital photo?

- **Tone** Our eyes are accustomed to seeing snow as white, not gray. The tires on our cars are dark, not light. A photograph should generally reflect how we see the world. The tone of an image is like a picture's skeleton, giving shape and form to the picture. Tone also sets the mood of a photograph. Dark tones are somber, mysterious, and sinister, while lighter tones are open, airy, and pure.

- **Color** Our perception and emotional reaction to color is a fascinating subject encompassing physiology, evolution, psychology, and even culture. The complex relationship humans have with colors gives photographers great power to infuse photos with emotion by manipulating the appearance of colors. Warm colors such as orange and red make a photo inviting and comfortable, while cool colors such as blues and cyans make viewers feel cold and distant. Heavily saturated colors feel saccharine or sticky-sweet. Desaturated colors provide a sense of melancholy or longing.

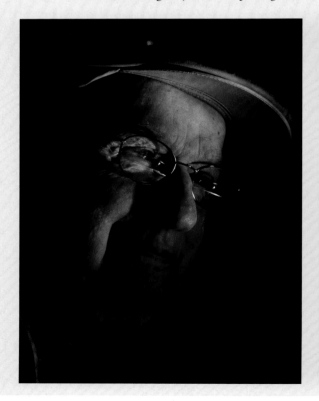

- **Contrast** The difference between tones, the contrast, makes details appear sharper and images more vibrant. In Lightroom and Photoshop, you can add contrast globally to all parts in the image to add extra presence to a photo. Or you can add contrast locally to key areas in the photo, causing the viewer's gaze to linger a little longer in a specific spot. Understanding the effect contrast has in a photo is key to successful imagemaking.

- **Focus** Imagine two photographs: The first is an expansive landscape taken from a high point in the desert. As you look at it, your eye roams from the scraggly sage in the foreground across the rolling mesas and sandstone buttes and travels across the horizon along a bank of puffy, white clouds. The second image is an intimate portrait of a pair of emerald eyes taken with a long lens. Your gaze is riveted on those captivating eyes. Focus is a powerful ingredient in a digital photograph. As you learned earlier, you can control the depth of field in a photograph by your choice of lenses and your aperture setting. In Photoshop, you can refine the depth of field even further by selectively sharpening and blurring key elements in your composition.

GETTING STARTED WITH LIGHTROOM

Adobe Photoshop Lightroom is a hybrid application—part asset manager, part raw file converter, and part multimedia and print generator. I like to think of Lightroom as having the best features from Photo Mechanic for image editing, Photoshop for camera raw processing, and Expression Media for organizing and cataloging photos. Because using Lightroom is different from using programs such as Photoshop or Photoshop Elements, we'll take a tour of Lightroom in this chapter to help ease the transition. We'll look at how Lightroom is structured, dive into the concept of catalogs, and get started importing photos from your hard drive or memory card.

Mountain bikers, Slickrock Trail, Moab, Utah. Olympus E-3, 35–100mm lens, 1/50 sescond at f2, ISO 320

HOW LIGHTROOM IS ORGANIZED

One of the core concepts behind Lightroom's software design is that you should see and access only those features you need to accomplish the task at hand. Everything else should be hidden from view. While this simplifies the process of working in Lightroom, it is a departure from Photoshop and other applications. Initially, this approach may seem a little foreign to you, but it will quickly become familiar the more you work with it.

- **Library** Designed for organizing and arranging the images in your catalogs and for editing and selecting images from your photo shoots.

- **Develop** The central location for performing all your image corrections, from adjusting white balance, to tweaking exposure, to increasing contrast.

- **Slideshow** The location for tools for creating professional-quality slideshows of your best photos.

- **Print** Used for making individual prints as well as contact sheets of an entire shoot.

- **Web** Makes it easy to create web photo galleries and publish them to a website using the built-in FTP server.

Lightroom's tools are organized into five separate sections, or *modules*, shown in the upper-right corner of the workspace. Each module is designed to help you perform a specific set of tasks in your workflow. Think of the five modules as waypoints for your workflow. The uses for each of Lightroom's modules are as follows:

On either side of the Lightroom workspace are panels containing the tools used in each of the modules in your workflow. For example, the **Library** module has panels for adding keywords and captions, while the **Develop** module contains panels adjusting saturation, sharpness, and vibrance.

pointers to your original photos on your hard drive. The best analogy for Lightroom's catalog is a public library's catalog. The library catalog is used to search for a specific book, find information about the books on the shelf, and get directions to find the physical book on the shelf. The Lightroom catalog works in a similar way. It remembers where your photos are stored, gives you information about your photos, and, even better than the library's catalog, retrieves your photos for you when you need them.

The panels, along with the contents of the menu along the top of the screen, change depending on the currently active module. For example, you can't access the panels for building websites when you're working in the **Library** module. While this is simple enough to understand, it can take awhile to become accustomed to the menu items changing. Shown at right are examples of the options available in the Photo menu from the **Library** and **Develop** modules.

Fortunately, the menus are sensibly arranged so that you will be able to find an option when you most need it.

Understanding the Catalog System

Another conceptual difference between Lightroom and other imaging applications is the catalog system used by Lightroom to help you organize and track your photos. A Lightroom catalog contains references and

Lightroom varies the menu options according to the active module. Differences in the menu options between the **Library** (left) and **Develop** (right) modules are highlighted.

This is a departure from other applications such as Apple iPhoto, which stores *copies* of your photos within a database. Lightroom doesn't store photos or copies in its database; instead, it references the actual photos on your hard drive. This lets you easily migrate your image library to another application if you decide that Lightroom isn't to your liking.

Lightroom doesn't store your photos; instead it references your photos in their original location on your hard drive.

Note This may sound redundant, but I think it's worth reinforcing: Lightroom doesn't store your photos. It merely references the photos stored on your hard drive. The number one Lightroom tech support call is from customers who import photos into a Lightroom catalog and then delete the originals from their hard drive. This is like entering the books into the library's card catalog and then throwing away the books. Be sure to keep your originals!

Catalog Management

You'll perform most of your photo file management in the **Library** module, and you can view the physical locations of your photos in the **Folders** panel on the left side of the workspace.

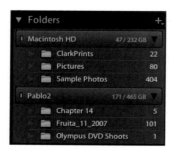

The **Folders** panel displays a list of hard drives that currently house the photos in your Lightroom catalog and lists their total drive size and space available. This makes it easy to see when your drive is beginning to fill up. A green light next to the drive's name indicates that it is currently connected to the computer. The drive's listing in the **Folders** panel will be grayed out if the drive is not available, and image thumbnails will show a question mark indicating that the original file is not currently accessible. These may be files stored on a hard drive that isn't currently connected to your computer, or images that may have been moved or deleted through your operating system instead of through Lightroom.

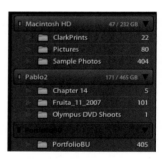

How Many Catalogs Should I Make?

With Lightroom 2, you can create as many catalogs as you need. You might, for example, create one large catalog that contains your entire image collection and additional catalogs that you use to organize, edit, and correct a single photo shoot. I recommend beginning with a single catalog, and then branching out into multiple catalogs as needed.

Create a new catalog by choosing **File > New Catalog**. Name your catalog and specify the location you'd like it saved to. Since Lightroom will work with only one catalog at a time, Lightroom will temporarily close and then relaunch with your newly created catalog.

To return to a previous catalog, simply choose **File > Open Recent**, or choose **File > Open** and navigate to the saved Lightroom catalog.

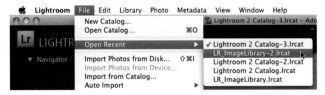

Now that you understand how Lightroom is organized and how catalogs work, it's time to begin adding images to your own Lightroom catalog.

Downloading Images from Your Memory Card

After returning from a shoot, the first thing you want to do is download the images to your computer to view the fruits of your labor. As part of the process of copying photos from your memory card to your computer,

Camera or Card Reader?

It is preferable to download photos to your hard drive with a card reader instead of connecting your camera directly to your computer for two reasons: First, if your camera's battery dies during the download process, you run the risk of losing all the photos on your memory card. Second, using a stacking card reader like this one from Lexar allows you to download the contents of several cards simultaneously.

you'll want to take advantage of Lightroom's features for adding a descriptive filename and your copyright information to each photo during the download process.

Lightroom makes it easy to download and import photos directly into your Lightroom catalog. After inserting your memory card into a card reader, Lightroom's **Import Photos**

dialog box should open automatically. If it doesn't, choose **File > Import Photos from Device** to open the **Import Photos** dialog manually.

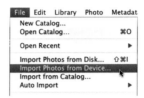

The **Import Photos** dialog box allows you to do more than simply copy photos to your

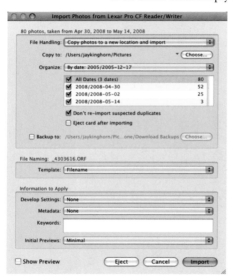

hard drive. Here, you can automatically rename photos, add descriptive metadata to assist you in finding photos later, embed your copyright notice, and even apply preset image corrections. All of these features minimize the amount of work required later in the process and save you time processing every shoot, so it makes sense to explore each of the features and create presets you can use for every subsequent download.

A listing of the number of photos on your camera's memory card with the dates the photos were taken appears at the top of the **Import Photos** dialog box. Lightroom reads this information from the time/date stamp embedded in each photo by your camera. If the dates listed are incorrect, you'll want to update the time/date stamp on your camera. Consult your owner's manual for specific instruction on how to adjust this feature on your camera.

Under the **File Handling** pull-down menu are two similar options. Both copy photos from your memory card to your hard drive, but the **Copy photos as Digital Negative (DNG) and add to catalog** option adds one important step to the process: instead of simply copying your camera raw files, this option first converts your raw photos to Adobe Digital Negative (DNG) format, a nonproprietary raw format, and then saves the converted images to your hard drive. If you are shooting raw files, you may want to read the sidebar "DNG: A New Standard?" before deciding whether DNG is right for you. If you're shooting JPEG, choose the **Copy photos to a new location and add to catalog** option.

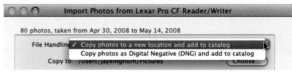

I typically keep my photos in their native ORF format, so I'll select **Copy photos to a new location and add to catalog** from the **File Handling** pull-down menu.

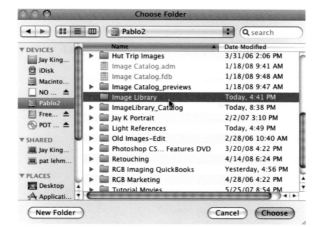

Next, in the **Copy to** section of the **Import Photos** dialog box, specify the location where you'd like the photos saved. By default, Lightroom will save photos to your Pictures folder. Since you've already configured your image library as outlined in Chapter 11, I recommend creating a new folder in your image library, giving it a descriptive name to help you remember the contents of the shoot. Click the **Choose** button in the **Copy to** section to target your newly created folder.

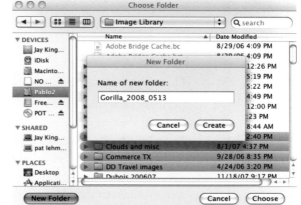

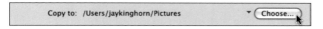

For a set of images of my friend's cats, Gorilla and Pumpkin, who live in Salt Lake City, I'm giving my folder the name of the main cat in my photos, Gorilla, along with the year and date the photos were taken. I'll discuss file and folder naming strategies later this chapter. For now, give the folder a name describing the contents in a single word. Then click **Create**.

The **Organize** pull-down menu in the **Import Photos** dialog box determines the structure in which photos will be saved. Since you've already created a unique folder for the shoot, I recommend setting this to **Into one folder**, leaving the **Put In Subfolder** option unchecked.

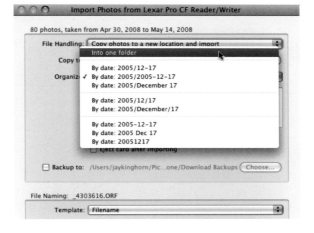

The **Don't re-import suspected duplicates** checkbox is a real benefit for those times you forget to erase your card before you go back out to shoot. With this option checked, Lightroom will compare the time/date stamp and camera serial number against the photos that exist in your hard drive and will not import images that are duplicates of images already in the library. I suggest leaving this checked along with **Eject card after importing**. This allows you to remove the card from the card reader safely after the download is complete.

☑ Don't re-import suspected duplicates
☑ Eject card after importing

Creating a Backup Copy

Lightroom offers several ways to create backup copies of your digital photos. The first is in the **Import Photos** dialog's **Backup to** section. Click **Choose** and select a folder on a second hard drive in which to copy photos. This backup method is best when you are in the field or on an extended trip and need to download photos, erase the card, and continue shooting without copying the photos to your regular backup system. This should not be your primary backup method, however, because the labels and ratings aren't copied to the second location. Should your primary hard drive crash, you will still have a copy of the photos from your shoot, but the edits, labels, and corrections will be lost.

What's an ORF?

Every manufacturer has its own proprietary file format. Following is a listing of the most popular file formats:

- **CR2, CRW** Canon
- **NEF** Nikon
- **ORF** Olympus
- **ARW** Sony

In the How To at the end of this chapter, you'll learn about methods for performing a more complete backup that will protect all the work you've added to your image library. For now, if you're working in the field and want a second copy of the photos as a short-term backup, go ahead and add a check mark to the **Backup to** checkbox and specify a folder where you'd like the images copied. If you don't need the option, leave it unchecked.

File Naming

Photographers over the years have spent untold hours designing, testing, and developing an ideal naming structure to help identify and track their photos. A good file naming structure will help you identify and find photos quickly. Fortunately, digital tools have made the job of naming photos much easier.

A filename such as Knoxville_2007 _0125_035.orf is a lot more descriptive than _W083949572.orf. When I glance at the first name, I know I took this photo in Knoxville, Tennessee, on January 25, 2007. This is

sufficient information to remind me that I took a series of night photos in downtown Knoxville on that trip, and this photo is one of them.

A Preset and a Naming Structure are not the same thing. They differ in subtle ways. A Preset is a saved setting in Lightroom. In this book we have Presets for file naming, metadata, image corrections, printing, and so forth.

For simplicity, let's eliminate the word "template" since it doesn't appear in any of the menu options. A file naming structure can exist independent of Lightroom and should be referred to separately.

Best of all, creating a simple file naming *preset*, or template, in Lightroom makes it easy to create, and stick to, a naming convention for all your photos. Your goal is to create a naming structure that can be applied to all of your photos. I'll demonstrate first how to create the preset, and then, in the sidebar "Developing a File and Folder Naming Convention," I'll offer some background on why you should create a naming convention that makes sense to you.

Step 1 In Lightroom's **Import Photos** dialog, click the **Template** pull-down menu and select **Edit** to open the **Filename Template Editor**. While Lightroom ships with a number of predefined naming structures, I'll show you how easy it is to create your own.

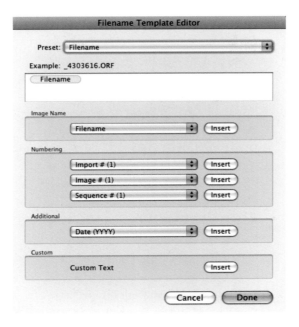

Step 2 In the **Image Name** window below the Example filename, you will see at least one light blue badge displaying one of the elements included in your filename. You can modify, rearrange, or add elements within this window. You can delete any of the elements by clicking to the right of the last badge and pressing DELETE to remove all the badges currently displayed.

For my naming structure, I insert a descriptive name for my photos, followed by the year, month, and date the photos were taken, plus a unique sequence number followed by the file extension. For example, photos I shot in Rocky Mountain National Park on June 10, 2008, would be renamed like so: RMNP_20080610_0001.orf. To use this structure as a template in Lightroom, you would add the following elements to the filename template: *Custom Text_ Date(YYYYMMDD)_Sequence(#0001)*

Step 3 Add the first badge, **Custom Text**, by clicking the **Insert** button to the right of the **Custom** window. Then click in the **Image Name** window to the right of the blue **Custom Text** badge and type an underscore.

The underscore character helps make your filename easier to read without you needing to add spaces. Spaces in a filename can cause problems on some older operating systems and creates extra characters in the filename when it's posted to the Web. For that reason, it is preferable to use a name like RMNP_20080610 instead of one like RMNP 20080610.

Step 4 From the **Additional** pull-down menu, choose the format used to display the date and click **Insert**. For my preset, I'm using the Date (YYYYMMDD) format. After inserting the date element to the **Image Name** window, add another underscore to separate the date element from the next element in the filename. Alternatively, if you'd prefer to have an underscore separating each part of the date, you can add separate elements for the Year, Month, and Date. Some people find this easier to read in a filename.

Step 5 Add a sequence number to your photos: select a three- or four-digit number from the **Sequence** pull-down menu in the Numbering window, and then click Insert. The new element will appear in the Image Name window.

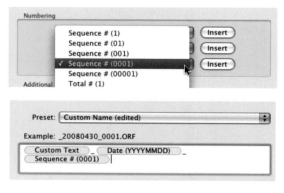

Step 6 Saving this filename structure as a template allows you to apply this naming structure to your photos quickly in subsequent downloads. Open the **Preset** pull-down menu and select **Save Current Settings as New Preset**. Then, in the **New Preset** dialog, give your preset a descriptive name that is easy to remember. Then click Create.

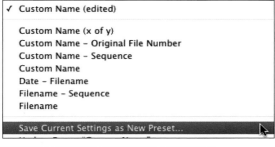

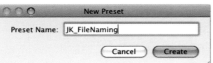

Step 7 Click **Done** to exit the **Filename Template Editor** and return to the **Import Photos** dialog. Here, you'll see your newly created template listed in the **Template** pull-down menu. At this point, go ahead and enter your descriptive text in the **Custom Text** field and verify that the **Start number** is set to **1**.

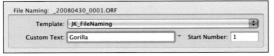

Developing a File and Folder Naming Convention

Photographers take many approaches to naming their photos, and it is essential that you develop a system that works for you. One simple system is to add a descriptive name comprising the primary subject of the photo shoot, followed by the date, and then a sequential number. The descriptive name can be a person, place, or thing that best describes the contents of the shoot. Most often, I default to the place the photos were taken, but you can use whatever seems appropriate. If you are a flower photographer, for example, it might make sense to include the types of flowers featured in the images instead of the location where the photos were taken. My recommendation is to look at your photos and ask yourself, What is the first word that comes to mind to describe all the images in the shoot? Use that word as your descriptive name.

Some photographers prefer to place the date before the descriptive name. While there is no critical factor to the order, I place the date after the descriptive name because it makes it easier for me to identify images in e-mail attachments and file structures, where the complete filenames are often truncated or obscured.

The important thing is to have some naming system in place—it doesn't need to be a perfect system, but it should be used consistently.

To learn more about file naming and view alternative approaches to file naming, visit UPDIG's Naming Files guidelines at www.updig.org/guidelines/naming.php or Controlled Vocabulary at www.controlledvocabulary.com/imagedatabases/filename_limits.html.

Creating a file naming template takes a little time up front, but taking the time to set it up saves you time on every shoot thereafter. The options in the **Information to Apply** section of the **Import Photos**

dialog work the same way. A little work up front saves a lot of time in the long run.

The **Develop Settings** pull-down menu allows you to select a saved group of image corrections and apply them to all photos during the download process. For example, if you know that you want to convert all the images in a shoot to black and white, you can select your favorite black and white preset from this menu and Lightroom will automatically correct all your photos using that preset. We'll cover the creation and use of develop presets in Chapter 14. For now, leave the **Develop Settings** pull-down set to **None**.

Creating a Metadata Preset

Metadata presets allow you to apply your copyright and contact information automatically to all of the photos in your shoot by selecting a *metadata template*. This helps to identify you as the creator and copyright owner of all your photos, which is essential if you enter photo contests, post photos online, or license your photos to clients. You work hard to create your photos, so it makes sense to add this information to ensure that you are credited and compensated fairly for your efforts.

Like your file naming preset, you need to create a metadata template only once. Then you can select it from the **Metadata** pull-down menu in the **Import Photos** dialog to apply it to your photos. To create a custom metadata preset, select **New** from the **Metadata** pull-down menu.

In the **New Metadata Preset** dialog box, your goal is to create a baseline set of information that can be applied to each of your photos, regardless of the photo's content. You'll have the opportunity to add specific captions and keywords to your photos later, during the editing process. For now, add your information to the **IPTC Copyright** fields in the dialog box:

- Copyright
- Copyright Status
- Rights Usage Terms (optional)
- Copyright Info URL (optional)

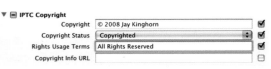

Then add your information to the **IPTC Creator** fields:

- Creator
- Creator Address
- Creator City
- Creator State / Province
- Creator Postal Code
- Creator Country
- Creator Phone
- Creator E-Mail
- Creator Website
- Creator Job Title

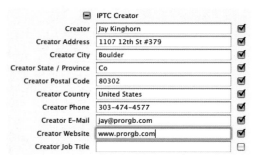

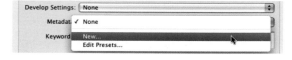

Tip If you choose not to include your home phone number and address in photos that might be posted to the Web, be sure that you include at least a contact e-mail and website URL to provide a potential photo buyer with a way to contact you.

Finally, enter your name, along with the year, in the **Preset Name** field. Adding the year provides a reminder to update the template next year to ensure your copyright notice is always up to date. Click **Create** to create your new metadata template and store it for future access.

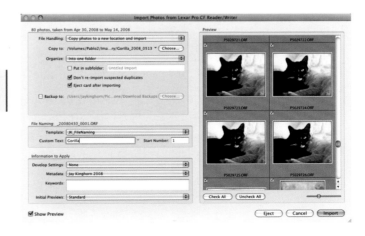

Tip To add the copyright symbol on the Mac, press OPTION-G. On Windows (XP and Vista) open the **Start** menu and choose **All Programs > Accessories > System Tools > Character Map**. Select the copyright symbol "©" from the Character Map, and then copy and paste it into the **Copyright** field in Lightroom.

After creating your metadata preset, you will automatically return to the **Import Photos** dialog. Your new preset should be displayed in the **Metadata** pull-down menu.

In the **Keywords** field of the **Import Photos** dialog, you can enter descriptive

keywords that can be used later for finding photos within your image library. We will discuss the creation of a keyword list and how to apply keywords within Lightroom in the next chapter. For now, you can leave the **Keywords** field blank.

Lightroom provides four different options for generating the initial preview thumbnail that is displayed in the catalog. For most users, the differences among the four are not significant. For that reason, I recommend using the default setting of **Minimal** for the **Initial Previews** field. If you are working on a very large monitor, or you find that you are waiting too long for the thumbnails to generate during your second round of editing, select the **1:1** option.

The final option in Lightroom's **Import Photos** dialog is the **Show Preview** checkbox in the lower-left corner. Clicking this checkbox will display a small thumbnail for each of the photos on the card, allowing you to preview the card's contents. This can be very helpful if you are applying descriptive keywords to your images in the **Import Photos** dialog.

You are now ready to click the **Import** button to begin importing your photos from the memory card to your hard drive. Lightroom will automatically rename and add your metadata to each of the photos in your shoot and will safely eject the memory card from the computer when the download is finished.

You can track the progress of the download with the progress bar in the upper-left corner of the Lightroom workspace, which will always display the progress of any currently active tasks.

Importing Photos from Your Collection

Lightroom allows you to import images from your existing folder structure into the Lightroom catalog. Lightroom can either collect the images into one central location or reference the photos in their original location. In this section, we'll import photos already on your hard drive into the Lightroom catalog and tell Lightroom to reference the photos in their original location.

Step 1 Begin by launching the **Import** dialog: Choose **File > Import Photos from Disk** or click the **Import** button in the lower-left corner of the **Catalog** panel.

Step 2 A dialog containing the contents of your computer's hard drives will appear. Select a folder of images you want to import into the catalog and click **Choose**.

Note for Windows Users Navigate to the folder of images you want to import, click the folder, and then click **Import All** to import the contents of the selected folder.

This brings up the **Import Photos** dialog box, which is virtually identical to the **Import Photos** dialog box used to download photos from your memory card.

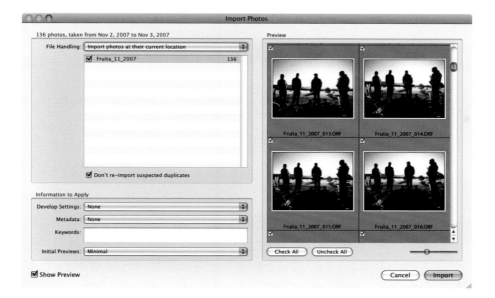

(Note that in the examples that follow, I've unchecked the **Show Preview** option to save space and focus attention on the import options.)

In the **File Handling** pull-down menu, you can choose from among several options: **Add photos to catalog without moving**, **Copy photos to a new location and add to catalog**, or **Copy photos to a new location and add to catalog**. Since you've already organized the photos on your hard drive, you'll want to choose the first option and import the photos from the current location. Since you are not changing the location of the files, you are not able to rename photos during the import process, but you can rename photos after they have been imported into the catalog.

Step 3 In the **Information to Apply** section, leave the **Develop Settings** setting at None, select the metadata template you created earlier, and leave your **Initial Previews** set to **Standard**.

Step 4 Click **Import** to add your photos to the catalog.

Organizing Photos in Lightroom

After your photos are imported into Lightroom, they can be searched, sorted, and organized in many different ways according to the task you are trying to accomplish. For example, you could sort images by a colored label to select the best images in your portfolio, by descriptive keyword to create a web gallery of similar images, or by folder to edit and correct photos from your most recent shoot.

All of these tasks are accomplished in Lightroom's **Library** module.

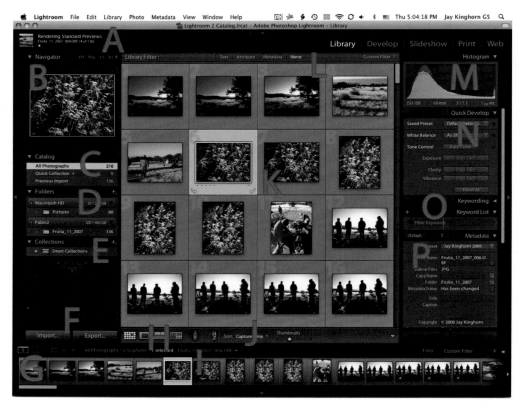

A Progress bar

B Navigator panel

C Catalog panel

D Folders panel

E Collections panel

F Import and Export buttons

G Primary and secondary monitor control

H Tool strip

I Filmstrip

J Sort by

K Grid view (or Loupe view: Hidden)

L Library Filter bar

M Histogram panel

N Quick Develop panel

O Keywording panel

P Metadata panel

In this section, we explore the features available in Lightroom's **Library** module in the order you are likely to encounter them during the photo-editing process.

You can monitor every task in Lightroom in the progress bar at the top-left corner of the workspace. If Lightroom is sluggish, check the progress bar to see if Lightroom is busy performing another task. While you don't have to wait for Lightroom to finish importing images from your card to begin editing the shoot, it may be a bit slow in generating thumbnails when you're trying to complete two tasks at once.

Whenever you add images to a Lightroom catalog, they can be immediately accessed under the **Previous Import** heading in the **Catalog** panel. This makes it easy to distinguish the photos you've just downloaded from your memory card from the rest of the images in your image library. To preview photos from the current import only, click **Previous Import** and the rest of the images in the catalog will immediately be hidden from view.

Choose **All Photographs** to display the contents of your catalog in the **Library** module. This is the first of several different methods used to control the display of photos in your Lightroom catalogs. We'll explore these different methods throughout the editing process.

Lightroom's organizational systems will become even easier to understand once you begin using them to edit your images and perform image corrections. Now that you've begun adding your photos to your Lightroom catalog, it's time to graduate to the next step in the workflow process: editing.

Now that you've begun adding photos to your Lightroom catalog, you should protect your work by designing a strategy for copying your image library and Lightroom catalog to a backup hard drive. While Lightroom contains an automated backup system, it copies only the catalog, not your original photos, making it an inadequate solution for a true backup system.

Fortunately, you can create an effective and hassle-free backup routine with relative ease. To follow the steps in this How To, you'll need *file synchronization software*. Dozens of capable file synchronization applications are on the market. Two of my favorites are Synchronize! Pro X for Mac (www.qdea.com) and SyncBackSE for Windows (www.2brightsparks.com).

Most of the heavy lifting for the backup process happens at the beginning. First, you need to ensure that the photos in your image library are all stored on a single hard drive and housed in a hierarchical folder structure, as recommended in Chapter 11. Having all your photos in one place makes the backup process go *much* smoother.

your active photo library, containing all the photos, catalog files, and settings. The second is a mirror image of the first that serves as your backup. This image library lives on a backup drive that you would access only in the event of an emergency—that is, if your hard drive dies. I recommend purchasing a separate, external hard drive to serve this purpose so that you can take the hard drive offsite and store it at another location, and because it's just silly to keep your backup hard drive on the same system as your primary hard drive.

Two important elements of your image library need to be backed up on a regular basis: your photographs and your Lightroom catalog that contains image corrections and organizational elements such as keywords, captions, and collections. While your Lightroom catalog is replaceable, it would take a lot of time to redo all this work. For that reason, it's worth making sure that it is backed up regularly.

To back up your Lightroom image and catalog files, you will create two parallel image libraries: The first is

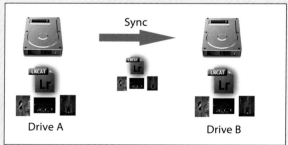

To back up your image library and Lightroom catalog, you'll need to create two parallel systems: the first is a working library and the second is a backup copy.

Step 1

Deselect all photos by pressing CMD-D (Mac) or CTRL-D (Windows). This ensures that you'll back up the full contents of your image library.

Step 2

Create your backup image library by exporting your current image library as a new catalog: choose **File > Export as Catalog**.

Step 3

Assign a location for your backup library on your backup hard drive. Save this backup catalog with the name LR_BackupCatalog to ensure that you don't accidentally begin working off this backup copy in the future.

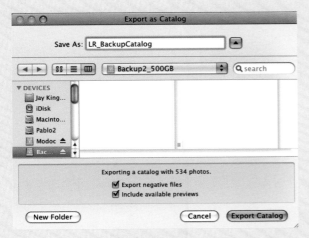

Lightroom will make a copy of your images along with the Lightroom catalog. If you've already added a large number of photos to your Lightroom catalog, this will take a long time to complete.

Once your backup image library has been established, your file synchronization software will apply changes you make to your original Lightroom images or catalog to the corresponding elements in the backup hard drive.

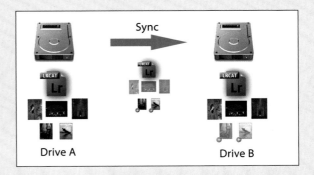

Once your backup library is created, your file synchronization program will copy your changes from your working image library to your backup, ensuring that your backup is always up-to-date.

Most file synchronization applications can be preset to run at a specific time of day or day of the week, making backups automatic and painless.

For the greatest protection, I strongly recommend storing this backup copy in a physical location separate from where your original image library is stored. This affords you greater protection in case your computer equipment is stolen or damaged by fire, flood, or other disaster. While I hope that you never need to put your backup system to the test, knowing you have a backup system in place helps you sleep a little better at night: whatever happens, your photos and the rest of your work will be safe.

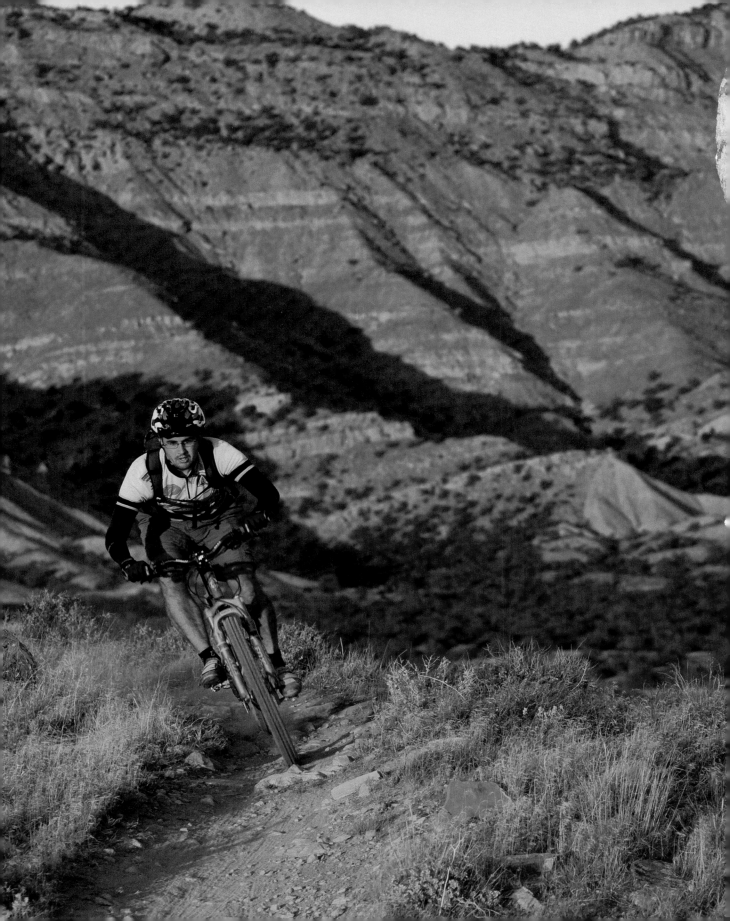

EDITING YOUR PHOTOS

The purpose of editing is to distill your photo shoot to the very best images. During the course of a shoot, we all make images that don't reflect our best work. It is important that you remove or separate these outtakes from your best quality work before you begin the photo correction process. Otherwise, you will spend a lot of time correcting images that won't ever be used.

Mountain biker, Fruita, Colorado. Olympus E-3, 35–100mm lens, 1/200 second at f4, ISO 250

Why Not Keep Everything?

As your photo library grows, the amount of upkeep and work it takes to store and manage it grows exponentially. If a photo is out of focus, your subject blinked during the shot, or you forgot to take the lens cap off, delete the image! There is no need to manage and sort through photos that you'll never print, display online, or e-mail to a friend. If you are uneasy about deleting photos, burn a DVD of each shoot before you perform your edits; that way, you'll have a full archive of every photo you've taken.

Reviewing Images in Lightroom

Begin by isolating your recently imported shoot from the rest of the images in your catalog in one of two ways:

- If the shoot you want to edit comprised the last items imported into the catalog, clicking the **Previous Import** heading in the **Catalog** panel will display only those images, provided they were all imported in a single session.

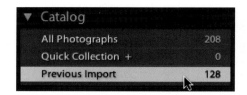

- If these photos weren't the last ones you imported, or your photo shoot spanned multiple cards and imports, navigate to the **Folders** panel, click the disclosure triangle next to the hard drive where your images are stored, and navigate to the specific folder containing your photo shoot. You created a separate folder for each photo shoot, didn't you?

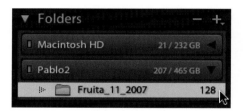

Once you've isolated the recently imported photos from the rest of the collection, you'll want to begin viewing the photos using the two most common methods for viewing them: the Grid view and Loupe view.

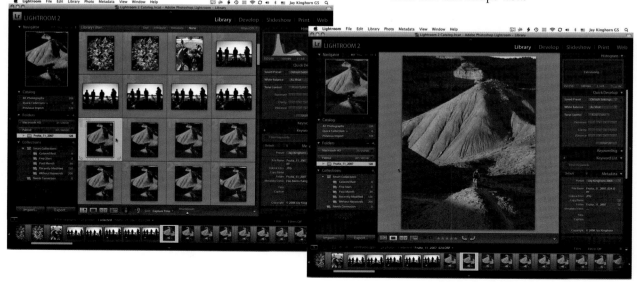

The Grid view is Lightroom's default method of displaying photos and is often referred to as the thumbnail view, because your images are all displayed as small thumbnails in the main content window. The size of the image thumbnails can be adjusted by moving the thumbnail slider to the right for larger thumbnails or to the left for smaller thumbnails. The Grid view is useful for sorting and organizing your image library.

Tip To add filenames to the display of images in Grid view, CONTROL-click (Mac) or right-click (Windows) and choose **View Options** from the context menu. In the View Options dialog box, choose **Expanded Cells** from the Show Grid Extras pull-down menu.

You can switch to the Loupe view by clicking the **Loupe View** icon below the thumbnail grid or by pressing E on your keyboard.

The Loupe view is best for editing images, checking focus, and comparing images side by side. As you perform your image edits and image corrections, you'll need to zoom in to check the details or focus in your photos. This is easy to do in Lightroom's Loupe view: Click the image to zoom immediately into 1:1 view, the best option for checking critical areas of your photos, since every pixel in your photo is displayed as one pixel on your monitor. The 1:1 view is the only way to really see onscreen all the detail that's present in your photos. Therefore, 1:1 view should be used for checking focus.

Tip To return to the Grid view, click the **Grid View** icon to the left of the Loupe View icon, or press G on your keyboard.

You can scroll and pan through your photo by dragging the light gray rectangle in the Navigator panel to reposition the portion of the image displayed on screen.

Alternatively, clicking and dragging the image itself will allow you to reposition the field of view quickly.

While in the Loupe view, use the LEFT ARROW and RIGHT ARROW keys on your keyboard to move to the previous or next image, respectively, stacked in the Filmstrip at the bottom of the screen. Or use Lightroom Filmstrip's scroll bar to jump quickly to any image in the shoot.

Tip If you'd like to cycle through a limited number of images, first select them in the Filmstrip. Use the LEFT ARROW and RIGHT ARROW keys to toggle through the selected images. The image surrounded by the lightest gray highlight is the image currently being displayed.

If you are working on a laptop or smaller monitor, hiding the side panels provides more screen space for previewing photos. Along all four sides of the Lightroom window are small, outward pointing triangles. Clicking one of these triangles will hide the user interface elements along that edge of the screen. When working on my laptop, I often hide the left and right panels so that I can concentrate on the editing process.

To reaccess the left and right panels, hover your cursor over the side of the screen and the panels will temporarily appear to allow you to perform your adjustments.

When you want to concentrate on the photos without any distractions, Lightroom provides a feature called Lights Out, which dims all the user interface elements. You can cycle through all three of the Lights Out modes by pressing L on your keyboard or by choosing **Window > Lights Out** and then choosing the appropriate option: **Lights On**, **Lights Dim**, or **Lights Off**.

Tip You can adjust the Lights Dim mode by accessing Lightroom's Preferences window (**Lightroom > Preferences** on Mac, **Edit > Preferences** in Windows), and then selecting an alternative Dim Level or Screen Color.

Now that you're comfortable navigating through your photos in the Lightroom catalog, it's time you began the editing process. Lightroom provides three separate methods of "rating" photos: color labels, star ranking, and flagging. All three methods serve as tools for labeling some photos as superior. While there

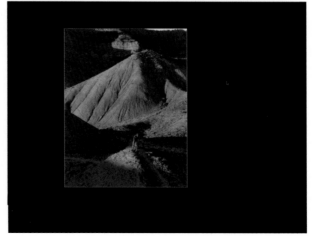

is no "right way" of using these three rating methods, I'll go through each type of rating system before demonstrating the system I use for rating and editing my photos.

Applying Color Labels

The colored label system is the most popular of the three rating systems, because it provides the easiest method of visually distinguishing between different ratings. Colored labels are popular in most image editing programs including Adobe Bridge, Expression Media, and Photo Mechanic.

You can add colored labels to your photos by choosing **Photo > Set Color Label** and then selecting a color of your choice.

To apply colored labels quickly, you can use these keyboard shortcuts:

- **Red** 6
- **Yellow** 7
- **Green** 8
- **Blue** 9

To remove a label altogether, press the keyboard shortcut a second time or choose **Photo > Set Color Label > None**.

Adding Star Ratings

The star rating system works along the same principles as the color labeling system. Star ratings can be applied by choosing **Photo > Set Rating**, and then choosing the appropriate number of stars.

For faster rating, press keys 1 to 5 to assign the corresponding number of stars. Some photographers think that because the rating system offers a higher degree of objectivity (a photo with four stars is better than one with only two stars), this system works more effectively when collaborating with others.

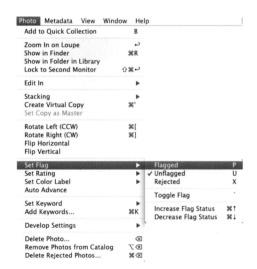

the icons for rotating an image or toggling between the Grid and Loupe views.

To adjust the star rating of a photo, you can either type in the new rating (1 to 5), or use the bracket keys—left bracket ([) or right bracket (]) to decrease or increase a photo's rating, respectively. To remove a rating entirely, press 0 (zero).

Star ratings are displayed in different places on the photo, depending on whether you are working in the Grid or Loupe view.

In the Grid view, a rating is displayed in the lower-left corner of the thumbnail.

In the Loupe view, the star rating is displayed below the image preview along with

Using Flagging

While both the color labels and star rating systems allow for a high degree of flexibility, the flag system offers only three choices: Flagged, Unflagged, or Rejected. Flagged photos you want to keep are called *picks*, photos destined for the trash are *rejects*, and the rest are unflagged.

You can apply the flag rating to photos in three different ways:

- Choose **Photo > Set Flag**, and then choose the appropriate flag rating (Flagged, Unflagged, or Rejected).

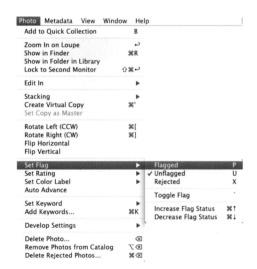

- Press the keyboard shortcut P for pick (flagged) or x for rejected.

- In the Loupe view, click the pick (the light colored flag) or reject (the flag with an X) flag icon.

To remove a flag rating, press U for unflagged.

Tip While the flag system may be the simplest and most logical method to use, it can be a bit limiting because there are often several degrees of photo quality within a shoot. For example, a photo can be above average, very good, or portfolio-worthy. For that reason, it is often beneficial to use a colored label or star rating as your primary method for ranking photos.

Edit Like a Pro with Editing Shortcuts

When using all three ranking methods, pressing the SHIFT key while pressing a keyboard shortcut (such as 6 for a red label) applies the red label *and* advances to the next photo. To advance to the next photo in the series without playing finger twister, you can enable the Auto Advance feature from the Photo menu (choose **Photo > Auto Advance**). This will automatically advance to the next photo as soon as a color label, star rating, or flag is applied to an image.

Rating Strategies

With all these options, deciding where to begin might be a little overwhelming. Should you use color labels, star ratings, or flags? If you have a smaller image library, your initial choice doesn't matter, so you should use the system that makes the most sense to you. When you start working with a larger number of images, it pays to put some thought into developing a system that uses the ranking system to describe both the quality of the photos for editing purposes and the status of the photos (what corrections need to be applied next).

The following table shows a sample rating system that uses both star ratings and color labels to define the photos that are preserved and employs the reject flag to send photos to the trash.

While this may be a more detailed system than you currently need, it is one example of how you can begin organizing photos within your library by quality and workflow status. Of course, Lightroom can store your photos with or without labels. Using a system like this one makes it easier to see the status of a photo at a quick glance in Lightroom.

Rating	Description
Send to trash	Missed photos, out of focus, poorly exposed, and so on
One star	Above average images from a first round of editing
Two star	Very good images, typically the best two or three images from a single shoot
Three star	Unassigned
Four star	Among the best images in your photo collection
Five star	Highest quality and most treasured images—select photos for a portfolio or fine-art gallery
Red	Images that need captioning and keywording
Yellow	Images that need image corrections
Green	Layered Photoshop document
Blue	Part of a series (image sequence, panorama, or high-dynamic range image)

PERFORMING THE FIRST ROUND OF EDITING

Some editors have an uncanny ability to select the very best image in a shoot from across the room while speeding through images in the Grid view. The rest of us will want to take a more methodical approach to editing, typically making multiple passes to narrow down the photo shoot into a few superlative images. As we progress through the editing process, I'll discuss the practical uses of the label and rating systems and introduce Lightroom's filters.

Here is a step-by-step method you can use quickly to find the best images from the shoot:

Step 1 Enter the Loupe view by double-clicking an image thumbnail or pressing E. Using the Loupe view makes it easier to judge overall composition, expression, and focus than using the Grid view.

Step 2 Hide the panels on the left and right sides of the photo by clicking the gray triangles at the right and left sides of the screen or by pressing TAB. This gives you the

maximum amount of screen real estate in which to view your photos.

Step 3 Choose **Photo > Auto Advance.**

Step 4 Advance through the images quickly, looking for images that stand out from the bulk of the images in the shoot. Don't worry about whether picture A or picture B is better. You can narrow your choices in the second round of editing. For now, concentrate on picking any photo that elicits a positive, emotional response. Press 1 to apply a single star rating. Remember that Auto Advance will move you to the next image as soon as you apply a rating. If you're indifferent to the image, use the ARROW key to advance to the next photo.

Step 5 If you encounter a poorly composed or out-of-focus photo, press x to flag it as a reject. Notice that the photo's thumbnail is grayed out in the Filmstrip, indicating it is a reject.

Using Lightroom's Filters

After you've completed your initial round of editing, you'll have three groups of photos: the one-star photos that are the above average images from the shoot; the unlabeled photos that didn't elicit any reaction from you; and the rejects that are destined for the great pixel bin in the sky.

To help you isolate the photos you want to view from the multitude of images in your collection, Lightroom provides a series of filters that let you show and hide photos based on any number of image criteria. After your first round of editing, you'll want to filter the photos to display only the rejected images so you can send them to the trash, and then restrict the one-star photos so you can perform a second, more refined edit on these images.

To eliminate your reject photos, you'll need to filter the images based on their flag rating using two different methods:

▪ Choose **Library > Enable Filters** (or press CMD [Mac] or CRTL-L [Windows]), and then choose **Library > Filter by Flag > Rejected Photos Only**. This will display only the photos containing the reject flag in the Filmstrip, Grid view, or Loupe view.

Or

■ In the Grid view, near the top of the screen, is the Library Filter bar. Click the **Attribute** heading. Next, click the **Reject** flag (the rightmost of the three icons) to display only the reject icons.

Create a Filter Preset

Whenever you use a Lightroom filter on a regular basis, it's worth creating a custom preset to make these filters even quicker to access and easier to use. For example, if you use the second filter method mentioned in the preceding section in the Grid view, you can click the **Custom Filter** pull-down menu at the far right of the screen and choose **Save Current Settings as New Preset**. In the New Preset dialog box, name this new preset **Rejects Only** and then click **Create**.

Filter presets are saved in all three of the commonly accessed filter locations:

■ Choose **Library > Filter by Preset** and then choose the preset name.

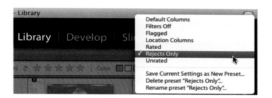

■ Choose the preset from the Library Filter bar at the top of the thumbnail in the Grid view.

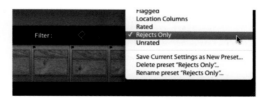

■ Choose the preset from the Filter menu located immediately above the Filmstrip in both the Grid and Loupe views.

These are but a few of the ways you can use filters to limit the display of images in your catalog. Images can be filtered by virtually any image attribute, from labels and ratings, to

keywords and captions, to the camera or lens used. The more familiar you are with filters, the more quickly you will be able to access and work with photos in the Lightroom catalog. As we continue the discussions on editing and correcting images, I will provide additional examples of how you can use filters in your workflow.

Once you've filtered your reject images from the rest of the shoot, I recommend giving these thumbnails a quick review to ensure that

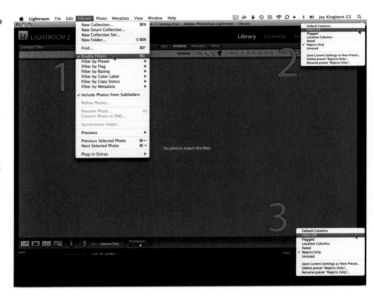

1 Choose **Library** > **Enable Filters**.

2 From the Library Filter bar, choose **Filters Off**.

3 From the tool strip Filter menu, choose **Filters Off**.

these are the images you want to delete. Once you've confirmed that these are all rejects, you can delete the photos by choosing **Edit > Select All** or by pressing CMD-A (Mac) or CTRL-A (Windows) and then pressing DELETE. Lightroom will show a dialog asking whether you would like to remove the images from the catalog or delete them from disk. Selecting **Delete from Disk** removes the images from the catalog and sends them to your trash or recycle bin.

Isolating the First Round Selects

After deleting the outtakes, you'll be presented with an empty-looking catalog because you've deleted all of the images matching the reject

filter. You'll need to clear the filter to return to all the images in your catalog. You can do this via any of the three filter menus.

Tip Forgetting which filters are active is one of the most common mistakes Lightroom beginners make. If you ever have difficulty finding photos in your library, always disable all filters, check to make sure you're viewing All Photographs in the Catalog panel, and then start the filtering process over again.

Now that you've disabled the Rejects Only filter, you're able to again see all the images remaining in your shoot. You won't necessarily see all of the images in the catalog because you still have Previous Import selected

in the Catalog panel, which is limiting the images displayed to those included in the last import session.

At this point, you'll want to isolate the one-star images to perform a second round of editing. Although you can use any of the three filter locations to accomplish this step, I prefer to use the Filter menu from the tool strip above the Filmstrip. Clicking the **Filter** text to the left of the pull-down menu causes a special filtering strip to appear.

In this new Filter menu, click the one-star icon.

Using this menu gives you the ability to refine the search further by including greater than, less than, or equal to ratings. This allows you to filter images with only one star (equal to) or one or more stars (greater than). For the second edit, you'll find this kind of control to be very helpful. To start, set the filter to

display images with ratings of greater than or equal to one star.

PERFORMING THE SECOND EDIT

During the second edit, you are taking a more critical pass through the images to get to the best photos from the shoot. At this stage, you'll perform comparisons to find the best image from a series and to check expression and focus more carefully, so you can leave the session having identified your very best work.

Comparing Images

Frequently, you'll have multiple photos of the same scene or composition and you must select between images taken a fraction of a second apart that contain only the slightest differences in expression, gesture, or focus. In many applications, narrowing a large group of images is a daunting task because you can view only one photo at a time. In Lightroom, however, editing a large group of images is easy with the Survey and Compare editing modes.

For this shoot, I asked the mountain bikers to take multiple passes across a large hill to improve my odds of getting a great picture.

Using a Second Monitor

When performing the second edit, I find a second monitor very helpful for comparison purposes. One of the significant improvements in Lightroom 2 is support for multiple monitors. If you have a second monitor, click the second monitor icon at the far left side of the tool strip to launch a Lightroom window on the second monitor.

Lightroom uses the second window to provide an alternative editing view. While my tutorial and screenshots will concentrate on working with a single monitor, you can access any of these views on a second monitor, giving you multiple views of the editing process.

After my first round of editing, twenty images received one star. Obviously, I need to reduce the amount of photos to find the one or two best out of twenty similar frames. Here's how I'll do it:

Step 1 I select all the similar images from the shoot in the filmstrip by selecting the first in the series and then SHIFT-clicking the last image in the series to select all the images in between.

Step 2 I enter Survey view by clicking the **Survey View** icon in the tool strip, or by pressing N.

Step 3 In Survey view, Lightroom fills the screen with my selected images. Each photo displays its star rating, and the currently selected image shows a white highlight to separate it visually from the rest of the images. Hovering the mouse over an image causes the pick and reject flags to appear along with a white X in the lower-right corner of the thumbnail. Since the reject flag has already been used to designate photos destined for the trash, I won't use it in this context to avoid throwing images away inadvertently.

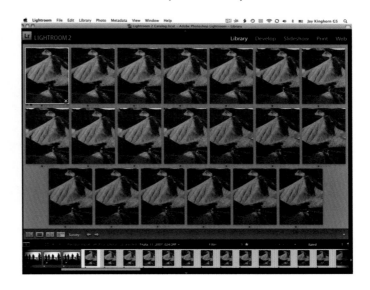

Step 4 Instead, I visually move across the images, removing those in which the expression or body position is obviously inferior to other images in the sequence by clicking the X at the bottom of the thumbnail. This removes the images only from the survey and deselects them in the Filmstrip; it does not delete them or change their rating.

Step 5 Using the Survey view, I cull the initial selection of 20 images down to 12 images that require a closer look than I'm able to achieve in the Survey view, but that I can easily accomplish in Compare view.

Step 6 The Compare view is used for comparing two images simultaneously. The first image is called the *select* and the second image is referred to as the *candidate*. I like to think of editing in the Compare view as a game of "King of the Hill." The select is on top of the hill and the candidate is trying to knock the select off its throne. In this way, I can narrow the remainder of the similar images very quickly by comparing the candidates to the select.

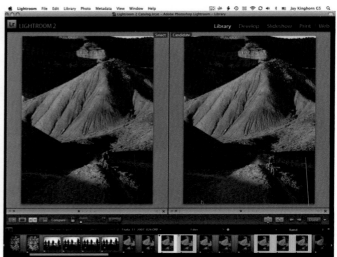

Step 7 I enter Compare view by clicking the **Compare View** icon in the tool strip or by pressing C on the keyboard.

Step 8 In Compare view, labels at the top of the screen designate the select and candidate, and subtle icons in the Filmstrip connote the same designation. A black diamond indicates the select and a white diamond indicates a candidate.

A thin, white outline is used to designate the active image that will receive any ratings that I apply using keyboard shortcuts.

I can use arrow keys to advance the candidate images or use the Compare icons located on the right side of the tool strip.

Step 9 I click the **Swap** icon to replace the select with the candidate. I don't use this icon as often as I use the next item in the list, the Make Select icon.

The Make Select icon replaces the current select with the candidate. I use this when the candidate knocks the select king off the top of the hill.

The Left and Right arrow icons are used to advance the candidate image.

Step 10 I click **Done** to exit Compare mode and return to Loupe mode.

When working in Compare mode, you will most often be comparing the fine details in the image. Zoom in to the image by clicking inside either photo. I use the Hand tool to scroll through the image. Both windows scroll simultaneously.

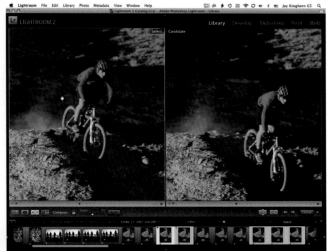

I usually want both images to scroll simultaneously. If you've changed camera position or if the subject has moved to a different area of the photo, you can unlink the scrolling by CONTROL-clicking (Mac) or right-clicking (Windows) and choosing **Unlink Focus** from the context menu.

Step 11 Next, I continue through the images in the series comparing the candidates against the select image until I find one or two shots that are, by all accounts, the best images from the series. For my sequence, I'm able to select the single best image from each of my two models very quickly. I give each image two stars to set each apart from the other images in the sequence.

Step 12 Finally, I click **Done** to exit the Compare view and move on to the next sequence of images, repeating the above steps until I've performed a second pass through all of the one-star images in the shoot.

Quick Develop

From time to time during the editing process, you'll encounter an image that needs minor image corrections before it can be critiqued effectively. This may be an incorrect white balance setting, slight over- or underexposure, or a predominant color cast. The Quick Develop panel gives you a limited set of image correction tools designed to help you make a quick adjustment to your image so that you can judge the image more effectively. More extensive image correction tools are contained in the Develop module and are covered in great detail in Chapter 14. For now, make sure you are objectively selecting the very best images in the shoot for further refinement.

To give you an example, two images show the sun rising up over the horizon to create a brilliant backlit field of grasses. In the first image of the series, I forgot to change my white balance from the Tungsten setting I used for the previous shoot indoors.

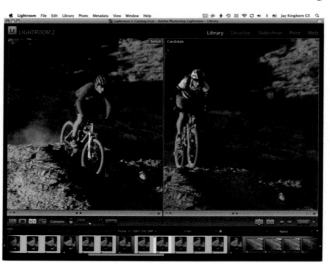

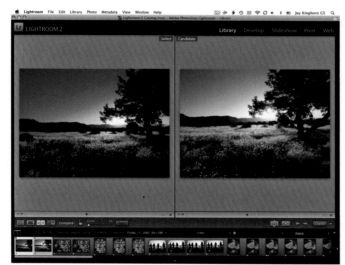

The image correction options available in the Quick Develop panel are stripped-down versions of those found in the Develop module. Detailed instructions on using the tools in Quick Develop are referenced by corresponding tools in Chapter 14.

After all images in the shoot are edited, you can adjust the filter to display only the two-star and higher images by clicking the second star in the Filter menu of the tool strip.

This narrows the shoot down to the very best images to which you'll want to add a descriptive caption and several keywords that can help you to find these images easily as your image library grows. Before you do that, however, add a colored label to indicate that these photos are ready to proceed to the next stage in your workflow and have metadata added. This allows you to come back to these images quickly in case you are

Since both images are camera raw files, I can perform a nondestructive change to quickly alter the white balance to the image on the left using Quick Develop.

By hovering my cursor over the right side of the Lightroom window, the Quick Develop, Keywording, and Metadata panels appear. Changing the White Balance setting from As Shot to **Cloudy** corrects the white balance problem, allowing me to compare these two photos accurately.

interrupted or go on another photo shoot. To recap from earlier, we're using the red color label to indicate images that are ready for captions and keywords.

To apply the red label to all your two-star images, return to the Grid view (G), choose **Edit > Select All**, or press CMD-A (Mac) or CRTL-A (Windows), and then press 6 to apply the red label to all images.

Adding Metadata

Metadata is information used to describe the contents of the photo and to provide information on the technical attributes of a photo (lens used, shutter speed, aperture, ISO sensitivity, and so on). Lightroom uses metadata for filtering images based on user-selected parameters and for finding images based on content. Metadata is critical to the success of managing a large image library, because text is the only method by which we can search. Lightroom cannot help you find your photos of mountains unless you include metadata labeling them as such.

To ensure that you will always find the photo you're looking for, learn to leverage metadata for finding and organizing images quickly. When used correctly, metadata adds richness and depth to your image library. The current tools available now are just the beginning. In the very near future, you can expect to see intelligent image corrections that read image metadata to "know" what type of corrections to make.

Before we get ahead of ourselves, though, let's first look at metadata today: how it is created, how it is used by Lightroom, and how you can get the most out of your photos, with a minimal time investment. None of us wants to spend our days cataloging photos. It's a bit like flossing—we all know that we should to it, but we often find better things to do. In this section, I'll give you some helpful tips that you can use to make your images easier to find today so you can spend your time taking photos, not searching for them on your computer.

Where Metadata Comes From

The term *metadata* is used in a number of different contexts depending upon the user, but most would agree that metadata is information that describes an asset. This asset can be a CD, DVD, photograph, video clip, or web page, and the metadata can describe technical information about the asset or descriptive information that provides context. For example, if you look at a track on a music download service, you'll see that the digital file containing the music has a number of different attributes: artist, album, track listing, track duration, genre, rating, and so forth. These are all examples of technical metadata. This allows you to find the track by searching for the genre "rock" or the artist's name.

Like the music data analogy, the more descriptive metadata you apply to your images, the richer your image collection becomes. Using a combination of the star rating system

and a descriptive keyword, you can find the 15 best travel photos you've taken from a library of 20,000 images. Or perhaps you want to find all the snowboarding photos you took in 2008. You can do that all by adding just a little bit of descriptive metadata.

By now, I hope that I've convinced you of the need to begin adding captions and keywords to your images. Next, I'll show you how to begin adding metadata and provide strategies on making the most of the information you add.

Types of Metadata

As mentioned, two distinct types of metadata can be used: *technical* metadata, which provides information about the size of the file,

the file type, and the camera and lens used, and *content* metadata, or caption.

In Lightroom, you can view this information in the Metadata panel on the right side of the Library module. If the Metadata panel is still hidden from your editing session, pressing TAB will bring back the panels on the left and right sides of the window.

As you'll notice, the copyright and creator information entered during the import process is displayed in this panel along with

the aperture, shutter speed, focal length, and ISO sensitivity for the photo.

Tip You can learn a great deal about the creative aspects of photography by looking at the metadata for your photos. Metadata makes it easy to understand how adjusting your aperture and shutter speed affects your finished photos and helps you take creative control of your camera.

The Metadata panel's pull-down menu offers a range of metadata display options. These presets show or hide specific metadata fields, allowing you to work more efficiently by displaying only the information you need. For example, the Large Caption preset is particularly helpful for performing the next step in the workflow: captioning.

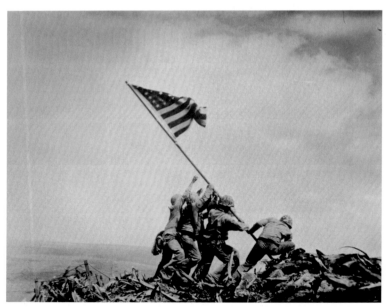

Photo Credit: National Archives and Records Administration

Adding Captions

Let's face it, adding captions is probably the least exciting aspect of digital photography. As photographers, we like to think of ourselves as artists, not archivists or librarians. Yet if you think about the greatest photographs of all time, the level of contextual detail the photographers retained is incredible. Take, for example, the famous photo of the flag raising on Iwo Jima taken by Joe Rosenthal. In the government archive, the registry provides the following caption:

Photograph of Flag Raising On Iwo Jima 02/23/1945

On February 23, 1945, during the battle for Iwo Jima, U.S. Marines raised a flag atop Mount Suribachi. It was taken down and a second flag was raised. Associated Press photographer Joe Rosenthal captured this second flag-raising. Now part of U.S. Navy records, it is one of the most famous war photographs in U.S. history.

While that caption may have been written well after the photograph was taken, the level of detail included helps provide the contextual information that adds significantly to our appreciation of the photograph.

Think about how this level of caption information would enliven your family photos. Unfortunately, most family photos are like this one from my family's collection. It's a great photo, but we don't know when it was taken or who, exactly, is in the photo.

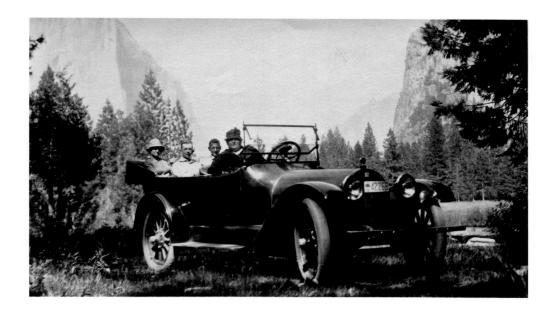

If you are a professional, or would like to turn pro, descriptive captions become essential for finding photos that meet a specific photo request from a magazine or catalog and they ensure that you have the correct names of the people in the photo.

To limit the amount of time you spend captioning your photos, I recommend adding captions only to the best photos from each shoot. This is another reason for adding a star rating and a colored label, because these ratings and labels can help you quickly see which images from the shoot deserve a caption. It's much less intimidating to write a caption for six images than for hundreds of images.

Going back to your Lightroom catalog, you should have a collection of images from the most recent shoot that contain both two stars and a red label, indicating they need captions. If need be, refilter your catalog to display only images that meet these requirements.

In the Metadata panel's Metadata options pull-down menu, choose **Large Caption**.

Beginning with the first red-labeled image, enter a descriptive caption in the text field below the Caption heading.

The caption doesn't have to be long-winded or overly detailed. Include just enough information to address who, what, and where the photo was taken. The time and date the photo was taken is automatically embedded within the photo by the camera, so most photographers don't manually enter this information.

After writing the caption, move on to the next image in the series, but don't change the colored label just yet. You'll still want to apply keywords before moving on to image corrections.

Keywords

Descriptive keywords are the most commonly used tool to search for information within a library of any kind. Think of the last time you made a purchase in an online bookstore. You probably typed "photography books" into the search field and found this book's title and dozens of others.

An effective keywording system distills the essence of the photo into a few short, descriptive words or phrases. Possible keywords for this image might include Fruita, Colorado, Mountain Biking, Adventure, Outdoors, Desert, and Adrenaline.

You'll notice that keywords include both descriptive terms about what's actually happening in the photo along with ideas or emotions the photo connotes. These are more conceptual in nature and are very valuable if you intend to license your photos for stock sales.

Tip If you are interested in developing a stock library for sale, be sure to visit several popular stock photography websites and look at the way keywords are used. Often, a photo will have dozens of keywords describing its content and the possible connotations. Here are a few of the most popular sites:
www.istockphoto.com
www.gettyimages.com
www.photos.com

There is no perfect keyword list that works equally well for all people in all situations. Begin adding keywords as you need them, and eventually you'll hone in on the keywords you use most often. Lightroom is structured to allow you to build on a keyword list over time, making it easy to adapt your keywording strategy as your photo library evolves.

The simplest way to begin adding keywords to your photos is through the Enter Keywords field found in the Keywording panel. All you need to do is select one or more images in Lightroom's Grid view, and then type in a descriptive keyword. Lightroom will automatically apply that keyword to the photo and add it to the Keyword List panel, if the keyword isn't already present.

Once a keyword is added to the Keyword List panel, it is easy to add the keyword to other photos by clicking the image thumbnail and dragging the thumbnail on top of the keyword. Select multiple photos by SHIFT-clicking to select contiguous images, or CMD-click (Mac) or CTRL-click (Windows) to select noncontiguous photos and drag them onto the keyword in the Keyword List panel to apply keywords to multiple photos simultaneously.

On the Web

For more information on working with Keywords in Lightroom, visit www.perfectdigitalphotography .com/workflow.php.

Searching with Keywords When you need to search for an image with a particular keyword, you can go through any of the filtering methods described so far or single-click any of the keywords in the Keyword List panel. This performs an instant search for the keyword of your choosing.

**Alert! Syncing Keywords
Back into Original Files**

The keywords and metadata you apply in Lightroom aren't automatically written back into the original files. Instead, the information is stored within the Lightroom catalog and is embedded within the photo when you export photos using Lightroom's Export module. This is a sound approach and shouldn't cause concern for most users. The only time this arrangement could cause a problem is if you use another application to access the original files instead of exporting photos from Lightroom. In this case, your metadata would be separated from your photos.

The moral of the story: If you're using Lightroom to edit your photos, be sure to export your photos in Lightroom before opening them in other applications. We'll cover the Lightroom Export module in Chapter 17.

If you'd like, you can manually sync Lightroom's metadata back into the original files by first selecting the images, and then choosing **Metadata > Save Metadata to File**, or by using the keyboard shortcut CMD-S (Mac) or CTRL-S (Windows). Lightroom will then write the metadata back into JPEG, TIFF, and PSD files and will create a separate metadata file called a *sidecar* XMP file for storing metadata in raw files.

Metadata	View	Window	Help	
Set Keyword Shortcut...				⌥⇧⌘K
Add Shortcut Keyword				⇧K
Enable Painting				⌥⌘K
Keyword Set				▶
Color Label Set				▶
Show Metadata for Target Photo Only				
Copy Metadata...				⌥⇧⌘C
Paste Metadata				⌥⇧⌘V
Sync Metadata...				
Edit Metadata Presets...				
Edit Capture Time...				
Revert Capture Time to Original				
Save Metadata to File				⌘S
Read Metadata from File				
Update DNG Preview & Metadata				
Import Keywords...				
Export Keywords				

After you've applied your captions and keywords, select all the images within the shoot currently containing the red label and apply the yellow label by pressing 7. You're now ready to move on to the next phase in the workflow.

COLLECTIONS

Before moving onto the next chapter, I'd like to show you one last feature in Lightroom that will help streamline the editing process. *Collections* are, as the name implies, groupings of images that you've determined belong together. You can build collections of your best images to serve as an impromptu portfolio,

images that need to be printed, or images that fit a certain theme. For instance, in gathering photos for this book, I created a collection of images called "Perfect Digital Photography." Collections serve an important role in filling in the gaps between other filtering or sorting methods.

Four types of collections are used in Lightroom:

- Quick Collection
- Collections
- Collection sets
- Smart collections

Quick Collection

I like to think of the Quick Collection as a means of quickly gathering images together. For example, if I'm looking to put together a slideshow, I'll search through my image library and add to the Quick Collection the photos I believe will best fit the theme and tone of the slideshow. You can use the Quick Collection to make similar, informal groupings of photos quickly and easily.

To add photos to your Quick Collection, drag a photo's thumbnail onto the Quick Collection label in the Catalog panel, or press the B key.

Tip Pressing the B key both adds and removes images from Quick Collection, making it easy to accidentally remove an image from Quick Collection. There are three ways to check your work and prevent any accidental removals:

- In the thumbnail view (Grid view), a small gray circle in the upper-right corner of the thumbnail (shown at right) indicates that the photo is part of the Quick Collection.

- Whenever you change the status of the image, a textual overlay appears in the lower third of the main Lightroom window. This unobtrusive reminder can help you keep tabs on whether the photo

has been added or removed from the Quick Collection.

- Click **Quick Collection** in the Catalog panel to view the photos currently stored in your Quick Collection.

Collections

You are limited to one Quick Collection at a time, because a Quick Collection is meant to be a temporary holding place for photos that will later be moved. When you need a more permanent solution, look to collections. You can create as many collections as you need. Like the Quick Collection, collections are great for grouping photos for any number of different purposes.

To create a collection, click the fly-out menu on the right side of the Collections

panel. From this menu, choose **Create Collection**.

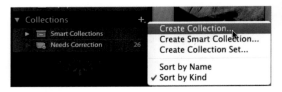

In the Create Collection dialog, name your Collection, and then click **Create**.

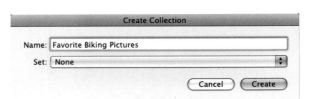

Add to your collection by dragging photos onto the collection name. Clicking the collection name displays only the photos contained in your collection.

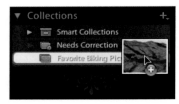

Collection Sets

If you build a large number of collections, you may find it easiest to store your collections in collection sets. Think of collection sets as file folders for your collections, designed to help you organize and limit the number of collections visible in the Collections panel.

To create a collection set, click the fly-out menu on the right side of the Collections panel and choose **Create Collection Set**.

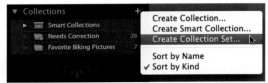

In the Create Collection Set dialog, name your new collection set and click **Create**. Then drag your existing collections onto the collection set to nest them inside the set.

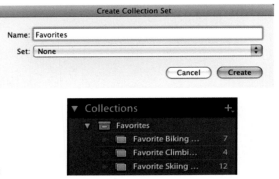

Smart Collections

The most powerful of all the collection tools, smart collections are like active filters that automatically gather images meeting a predefined set of parameters. For example, to make it even easier to see which photos need captioning, create a smart collection that looks for images with the red label. The smart collection will automatically add any photo containing a red label to the collection.

Create smart collections by choosing **Create Smart Collection** from the Collections panel fly-out menu. Next, specify the rules the smart collection will use when gathering images. Here, for example, you can specify that all photos in this collection must have

Make a Collection from Your Quick Collection

Say you've made a Quick Collection of photos for a presentation, and after the presentation you decide that you like the way those photos go together and you want to save the presentation for future use. You can convert your Quick Collection to a collection by CONTROL-clicking (Mac) or right-clicking (Windows) Quick Collection in the Catalog panel and choosing **Save Quick Collection**. In the Save Quick Collection dialog,

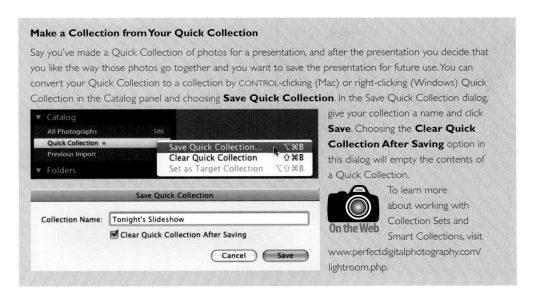

give your collection a name and click **Save**. Choosing the **Clear Quick Collection After Saving** option in this dialog will empty the contents of a Quick Collection.

To learn more about working with Collection Sets and Smart Collections, visit www.perfectdigitalphotography.com/lightroom.php.

been taken with a specific lens, must contain a specific rank, or must have been shot at a designated ISO setting. Lightroom will read your photo's metadata to determine whether or not an image belongs in the smart collection.

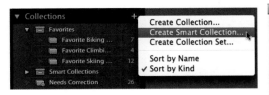

For this example, I'll create a smart collection that searches for images with a yellow label, which indicates they are ready for image corrections. After titling the smart collection, I'll create a rule allowing only images with a yellow label into the collection.

You can group your Collections and Smart Collections into Collection Sets, which are organizational tools for grouping together your Collections. Click on the **Create**

New Collection icon, then choose **Create Collection Set** and give it a name. You can drag your Collections or Smart Collections onto the Collection Set listing to group collections within the collection set.

As you've seen in this chapter, Lightroom provides a number of tools you can use for editing, organizing, and sorting photos and the ability to create presets for your most commonly used tasks. Lightroom brings this level of attention to your image corrections as well. In the next chapter, you'll learn how to make your camera raw files shine with the tools found in the Develop module.

How To: The Philosophy of Editing

by Bert Fox

As a former photo editor for *National Geographic* and now Director of Photography for the *Charlotte Observer*, my most important role is to help develop my photographers' eyes and abilities to tell a story through pictures.

Often, photographers get mired in the process of taking a photo. They remember struggling through the harrowing windstorm or chasing the light, but they lose focus of the original story they meant to tell. This colors a photographer's opinion of that photo, often adding more weight to the picture during the editing process. As an editor, I bring the approach of someone who wasn't there. This allows me to find "moments" that speak to me, without being jaded by the ease or difficulty of taking that photo.

The role of an editor is as important for serious amateur photographers as it is for my staff photographers. By cultivating an objective eye, like an editor, and having others edit your work, you will gain a deeper understanding of the photographic process and become a stronger photographer.

In honing your editorial eye, look for pictures that move you because they speak about love, or hate, or revenge, or terror, or about virtues like honesty or generosity. I look for the human nature or the personality that comes out of the scene. I'm looking for the subtleties in the environment, the drama of the human condition, or the elegance of form, structure, and line.

I look for images lacking "visual noise," annoying light or color, or objects that take away from a picture's impact by cluttering its visual message. Pictures, like good writing, need clarity to tell their stories. The photograph's center of interest should grab the eye while the remainder of the frame supports it. If numerous parts of the picture compete for the viewer's attention, the picture fails.

Great photographers don't just "grab" moments. They lead the viewer through their pictures by orchestrating the scene. No, I don't mean arranging the people, but rather arranging scenes through your choice of lens and point of view to carefully create a backdrop driving the viewer's eye to the most important part of the picture. As a supportive background emerges, photograph emotive moments between your subjects. If I can read your subject's feelings hours or weeks later on my monitor, you have succeeded.

Remember that the camera is an objective viewer of the scene, while the photographer's view is highly subjective. Think like a camera when you make pictures. Take control of the entire frame. Make it support the moment. And stay with a scene. Don't take

a few frames and walk away. You should be filling up cards with pictures as moments emerge.

Don't settle for simplistic pictures, because simple pictures won't hold a viewer's interest. As an editor, I seek complex pictures with compositional order and layering of elements that capture a moment. *National Geographic* photographer David Alan Harvey is a master of the layered picture. He brings disparate moments together within different corners and layers of the frame. From their enjoinment, a meaning emerges that is more than the sum of its parts. Look closely at the subtle and nuanced pictures in his book *Cuba*. Their meaning transcends their moments.

If I find two dozen great pictures from a magazine assignment, we have the beginnings of a successful story. For a newspaper, I may need only one photo, but that photo needs to highlight the subtle and often complex aspects of a story. Wonderful pictures alone are not enough. Together, these images must create a narrative. The photographer must lead the viewer through a story by creating pictures that set the scene, introduce a crisis or dilemma, and end with resolution. It is analogous to writing a novel. No one wants to read a story that repeats its fourth chapter again and again. Picture stories are no different. If 10 of the best pictures from an assignment say the same thing, all but the strongest frame are gone.

Whether you're on assignment or holiday, think about variety. Think about varying your shooting perspective from tight, to medium, to loose. Bring the viewer into the scene with ever-tighter frames that eschew the surroundings for the moment. Plan to photograph different subjects that together give the viewer a broad perspective. Look for different qualities of light. Midday sun may be dreadful for landscapes but ideal for details and moments.

Seek out rituals—birthdays, baptisms, and burials. Rituals present the symbols of culture, manifested not only in ceremony, but also in its trappings, such as clothing and song. From rituals emerge the fabric of the human condition. Dig into the event by going beyond obvious snapshots and finding interpersonal and memorable moments. Ask yourself how a *National Geographic* photographer would shoot this scene.

Capturing moments like these, perfect in every way, is a difficult thing. It's almost as if the demons of disorder are in charge when you look through the viewfinder. You have to wrestle them into submission by making the unimportant elements of the image recede and the important parts of the picture jump to the forefront.

You have the ability to photograph in all the ways I've described. It takes time, patience, and humility to listen thoughtfully to critical comments others make about your work. So it is important for you to choose an editor you respect. These can be amateur or professional photographers, artists, or even a family member. But they need to identify great photos and also articulate why a given picture wasn't as successful as intended.

So get out there and build a network of friend-editors who provide constructive criticism about your photography. They can be as close as a family member or a distant as someone in an online social network. But they should be able to describe why pictures are successful or why they fail. They should provide you with constructive criticism. By working with and listening to this group, you can use their feedback to shape the pictures you make and guide you toward a successful style.

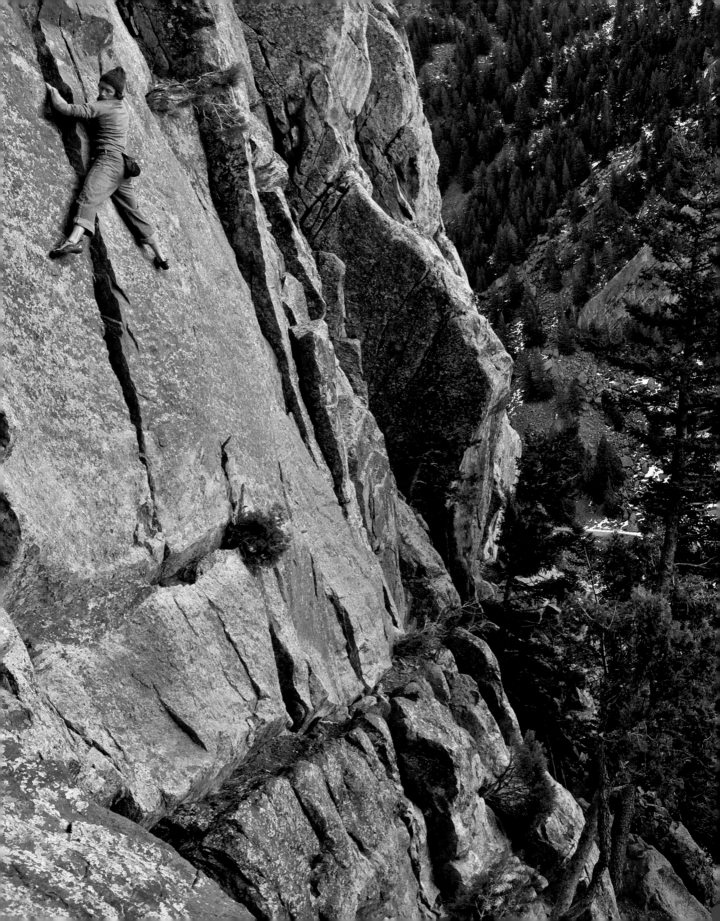

CORRECTING TONE
AND COLOR

Every time you pick up the camera and take a picture, you're telling a story. It may be a simple story of your nephew's birthday party as told through a snapshot, or it may be a soaring call for the protection of wild lands as told through a series of vivid color fine art prints.

Just as certain words add color, texture, and depth to your writing, image brightness, contrast, and color affect the message your viewer receives from your photos. In the next two chapters, we'll look at how you can use Lightroom and Photoshop to influence your viewer by supporting the story you've captured when pressing the shutter.

Climber, Eldorado Canyon State Park, Colorado. Olympus E-3, 12–16mm lens, 1/60 second at f4.5, ISO 200

This chapter focuses on making adjustments to the entire image. Chapter 15 builds upon these global adjustments and gives you tools for making selective adjustments to specific areas within your photos. Understanding how to use these tools to enhance your photos is to truly unlock the power of the digital darkroom.

Compare these two photos (*see* Before). The image on the left is open, airy, and warm. The bright blue skies and vivid sandstone work to tell a story of the desert at sunset. You can almost feel the warm breeze on your skin just by looking at the picture. Contrast these emotions with your perception of the photo on the right. The heavy shadows create an atmosphere of apprehension and uncertainty. The elderly couple walking arm-in-arm together and the appearance of a cane suggests a pair marching together toward the end of their lives, out of the light and into the darkness.

How would the couple photo look without the shadows? How evocative would the canyon photo be without the color? Both are shown here (*see* After) directly from the camera for comparison to underscore the importance of carrying your creative vision all the way through to your finished print or web gallery.

The first step in learning to take this kind of control over your photos is learning how to adjust the brightness levels, or tones, in an image. The histogram is one essential tool to help gauge the distribution of tones in your image.

Before

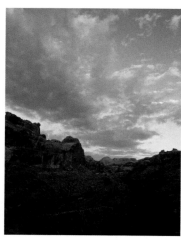

After

Histograms

The Histogram panel provides a visual representation of the tonal value for each pixel in your photo. The horizontal axis of the histogram corresponds to a gradient of increasing lightness from black to white (left to right).

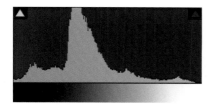

The height of the histogram represents the number of pixels with a given lightness value. The higher the peak, the more pixels with that tone are in your photo.

Black and white photos are great for helping you understand how a histogram relates to a photo, because they show only the tone, unaffected by the colors in the image. The following illustration shows a black and white image demonstrating the correlation between a histogram, a grayscale ramp, and a

photograph. Specific areas within the photo are represented with their lightness values and their locations on the histogram.

Most images should show a distribution of tones across the full range of the histogram, from shadows to highlights. The locations of the peaks and troughs will vary depending on whether the image contains predominantly light tones or dark tones. This particular image has peaks on either side of middle gray.

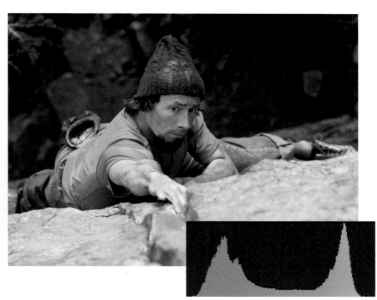

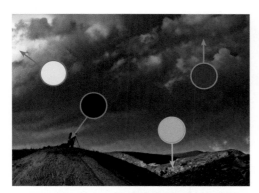

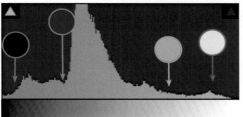

Here, specific tones within a photograph are drawn out from the image and their location is displayed on the histogram.

An image with a large number of darker shadows will show a histogram with high peaks on the shadow side.

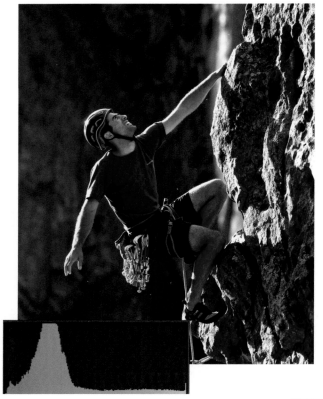

The snow in this image (at bottom) makes for lots of highlights, which appear toward the right side of the histogram.

You may have noticed that the histograms for your photos are displayed differently than those shown in these examples. Typically, Lightroom displays the tonal histogram in gray, along with the histograms for the color channels in red, cyan, green, magenta, blue, and yellow. To simplify the display of the histogram for the sample images, I chose to present only the tonal histogram. As you're working, you'll want to pay attention to both the tonal and the color histograms, as both provide valuable feedback on your image corrections.

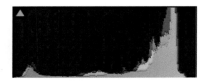

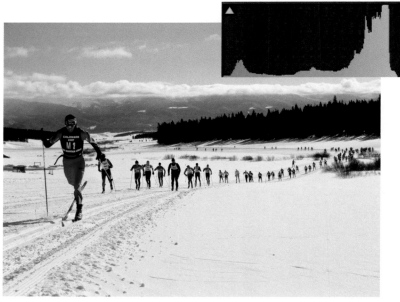

It is important to know how to read histograms both on the camera and in Lightroom. The on-camera histogram is the most accurate gauge of your exposure.

The first three images shown so far present "normal" histograms that vary based on the image content. While they initially appear very different, they share one important similarity: the peaks and troughs all stay within the left and right boundaries of the histogram.

Any peak or trough that appears within the left and right margins of the histogram contains detail that you can lighten or darken. If the histogram ends with a cliff on either side your photo, you've lost detail in either the highlights or the shadows. This information typically can't be recovered and can cause a major problem for you later in the workflow.

A histogram for a badly underexposed photo

A histogram for a badly overexposed photo

With histograms this bad, these exposure errors should have been caught in camera and the exposure corrected for subsequent shots.

When in Doubt, Overexpose Slightly

Photographers have long been trained to underexpose slightly to get better highlight detail and color saturation. This is a recipe for poor image quality when using a digital camera, however. Your camera's sensor doesn't "see" light the same way our eyes do. Our eyes have a natural response to the distribution of brightness in a scene that, more or less, pays equal weight to light colors and dark colors: bright tones and dark tones.

The camera's sensor does not give equal weight to all tones. In fact, your digital sensor is heavily weighted to the brightest areas in your photo. If you took a grayscale ramp like the one shown here and applied the camera's way of seeing it, you'd notice that instead of a smooth, gradual transition from light to dark, the camera lumps all the shadows on top of one another.

Taken another way, the camera has a fixed number of numeric values for describing the brightness of a pixel. Fifty percent of those numeric values are devoted to the brightest f-stop in your photo. Each successively darker f-stop receives one-half the number of the f-stop ahead of it, until the shadows receive only a small sliver of the total possible values.

This is important information, because all detail in your photos is a result of subtle differences in tone and color between adjacent pixels. In the shadows, where fewer values are available to describe these differences, it becomes more difficult to retain details. Underexposing photos drives more of the information contained within a photo deeper into the shadows, causing a loss of detail and an increase in *noise* (unwanted color impurities) in the photo.

Take, for example, these two photos shot by the same camera, only seconds apart. The first is correctly exposed, while the second was underexposed significantly and then lightened using raw processing software. At a small size, the two photos look very similar, yet when you look closely at the images you can see that smooth tones are blocky in the underexposed image and the shadows have lost details that are present in the correctly exposed image.

The key message is this: If you want the highest quality pictures, you have to pay close attention to your exposures. Your light meter and your on-camera histogram are terrific tools for gauging and adjusting for the correct exposure, but they aren't perfect. If you're uncertain and you think you have to hedge your bets toward over- or underexposure, it's better to err toward *slight* overexposure. It is important to emphasize the word *slight*. The image adjustment tools found in Lightroom and Photoshop's camera raw processing software are very good at bringing back up to

Correct exposure **Underexposed**

The image on the left is exposed correctly. The image on the right was underexposed by one f-stop, and then corrected in Adobe Camera Raw. Notice the difference in shadow detail and smoothness in the detail images.

½ f-stop of highlight detail on most images. Provided you don't see a radical spike on the right end of your histogram, you will probably be able to recover any highlight detail that may be temporarily lost.

At times the range of tones in the scene exceeds what the camera can capture in a single photograph. When this occurs, you have to make the artistic decision to expose for the highlights *or* the shadows, and you'll expect to see a cliff on one end of the histogram indicating you've lost detail in that portion of the tonal range.

This is a result of a series of differences between the way our eyes see light and the way the camera records it. Often, these differences are minor and form the backbone of the changes you'll make in the digital darkroom. These corrections are designed to bring the photo closer to the way you saw the original scene when you took the picture.

The first tool you'll use to perform these corrections is Adobe Camera Raw, found in both Lightroom and Photoshop.

OPTIMIZING YOUR PHOTOS IN LIGHTROOM

Thomas Knoll is one of the most influential people in photography today, yet you probably have never heard his name. Thomas and his brother John were the original inventors of Photoshop and led the software through its initial development and purchase by Adobe. While this accomplishment alone warrants mention in this book, Thomas has played an active role in the continued development of Photoshop and spearheaded the growth and development of camera raw files through the creation of Adobe Camera Raw (ACR), the raw processing engine inside Adobe Lightroom.

When we wrote the first edition of this book, some photographers were taking advantage of camera raw files using early versions of ACR and other raw processing software for development. While functional, those tools were crude by today's standards and didn't offer a

clear superiority for many photographers over shooting JPEG in camera.

Through the continued development of ACR, the vast majority of serious amateur and professional photographers now shoot exclusively in raw. More than 90 percent of all raw files today are processed through Adobe Camera Raw.

Camera raw processing is the cornerstone of an effective digital photography workflow for two primary reasons. First, the corrections you make to a raw file are nondestructive, and second, these corrections can be applied quickly to many other images in the shoot. While it is the first benefit that initially attracts photographers to camera raw, the second benefit provides the more profound, day-to-day workflow benefits.

In this section, I will help you learn to harness the power of the corrections in ACR from within Lightroom.

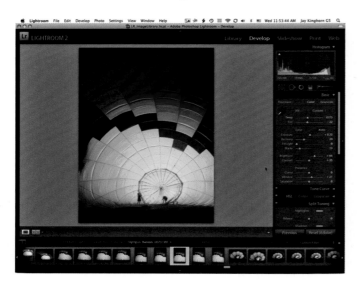

If you've been using ACR from within Photoshop, you'll find the controls in Lightroom very familiar. In fact, the ACR module that runs within Photoshop and Lightroom are identical. The layout is slightly different between the two applications, as Photoshop stacks the corrections horizontally in separate panels while Lightroom arranges corrections vertically, but the underlying code is the same.

When you open the Develop module in Lightroom, you activate the ACR module. When performing your corrections in ACR, you will typically follow the listed order of the tools from top to bottom in the Basic panel, beginning with White Balance (WB), then Tone, and finally Presence.

To help you better understand the use of the tools, I'll temporarily depart from this convention to discuss the tools for adjusting tone, followed by color-specific tools. The How To at the end of the chapter will follow the recommended workflow for performing image corrections.

Since we are postponing our initial color correction, I recommend that you select an image that has good color overall when following along with this chapter of the book.

Correcting Tone in ACR

While color may be the most visible element in a photo, the underlying tone provides the structure, support, contrast, and detail in an image. The six sliders under the Tone area of

the Basic panel in ACR give you fine control over the tonality and contrast in your pictures.

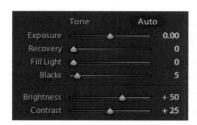

The first two sliders, Exposure and Recovery, both target the highlights in your photos. The Exposure slider is designed to increase the lightness of the photo and brighten the highlights, while the Recovery slider is used to darken the highlights without darkening the overall picture.

Begin your tonal adjustment with the Exposure slider used to set the lightest point that contains detail in the photo. This will push the highlights in the histogram to the right, brightening the highlights and improving overall image contrast.

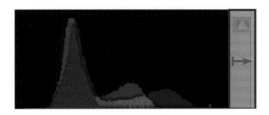

While this can be set by eye, you can use a trick to make this process even easier. Hold down the OPTION (Mac) or ALT (Windows) key on your keyboard while adjusting the Exposure slider. This activates the clipping display that shows areas in the photo that will

be *clipped*—that is, they will lose detail—at the current setting.

Increase the exposure amount until you begin to see important detail appear in the clipping display. Then back off your correction until the clipping display returns to black. If your image has *specular highlights*, the bright reflections off shiny surfaces such as chrome, water, or glass, it is okay for them to appear in the clipping display since they don't contain any important detail. Base your correction off the lightest point in the photo that should contain detail. For this particular image, the clipping display indicates that the right side of the rider's jersey is the lightest point in the photo, so I'll increase the Exposure slider amount until I see areas of the jersey appear in the clipping display; then I'll reduce my correction just past the point at which these areas disappear from the clipping display.

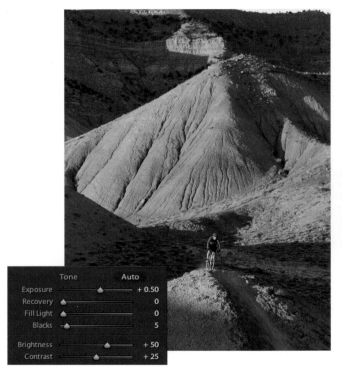

The Recovery slider is used for reclaiming detail in the highlight areas of your photos, effectively darkening the highlights at, or outside, the right margin of the histogram. Hold down the OPTION (Mac) or ALT (Windows) key to enable the clipping display, as described, or set the Recovery slider visually.

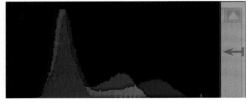

These images demonstrate the Recovery slider's ability to rescue detail in highlight areas.

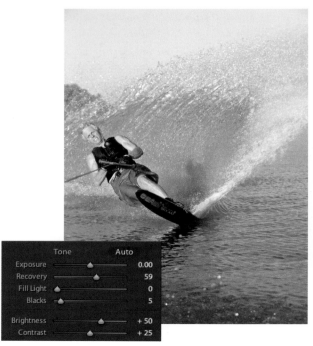

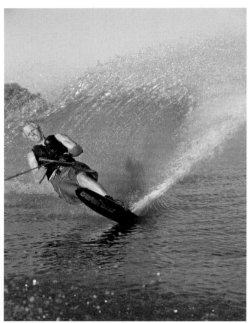

The Fill Light slider is a photographer's best friend, because it allows you to lighten the important shadows in your photo quickly to bring out detail in shaded faces and other essential details. It's like adding a fill flash or reflector to your photos after the picture has been taken.

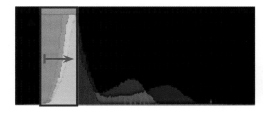

No clipping display is available for the Fill Light adjustment. Simply increase the Fill Light amount until you've lightened the shadows to your liking. With higher Fill

Light settings, it is natural for your image to lose contrast. Some of this contrast can be reclaimed with the Blacks slider, while additional contrast adjustments will be made with the Contrast slider (described shortly).

Returning to our original image, which didn't require any adjustment with either Recovery or Fill Light, we'll turn our attention to the Blacks slider, which is used for setting the darkest point in photos.

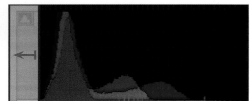

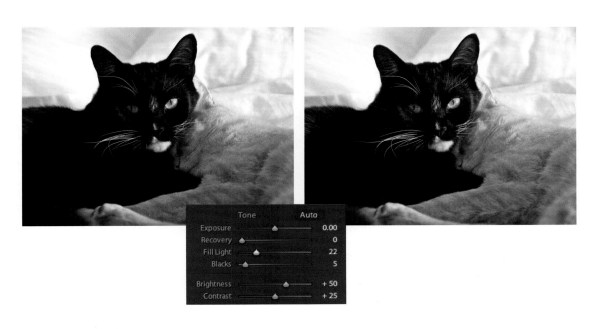

When adjusting the Blacks, hold down the OPTION (Mac) or ALT (Windows) key to enable the clipping display. In this case, the photo initially turns white, and black areas in the photo indicate areas in the photo that will lose details in the shadows.

For this image, I wanted to pay particular attention to preventing the shadows on the rider from turning completely black, so I slowly increased the Blacks slider setting until these shadows began to appear in the clipping display, and then I reduced my correction slightly to preserve detail in these dark shadows.

Setting the lightest and darkest points in the image using the Exposure and Blacks sliders increases the contrast in your photo by maximizing the dynamic range of the image. At this point, you will use the Brightness and Contrast sliders to adjust the midtones in your photo to dial in the overall appearance of the image.

The Brightness slider affects the midtones in the photo independently from the highlights or shadows.

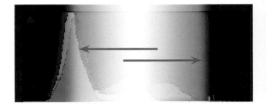

Increasing the Brightness slider tends to make a photo appear more open or expansive, while decreasing Brightness makes a photo feel more moody and mysterious. You'll have to judge what setting works best for your images. The more you experiment with different Brightness slider settings, the more intuitive your corrections will be.

For this image, I reduced the overall image brightness slightly to darken the shadows on the mountain and enforce the appearance of the late afternoon light raking across the hillsides.

Once the overall distribution of tone is established, you will often need to increase the contrast in the photo to improve the overall presence of the photo and improve the appearance of image details. The Contrast

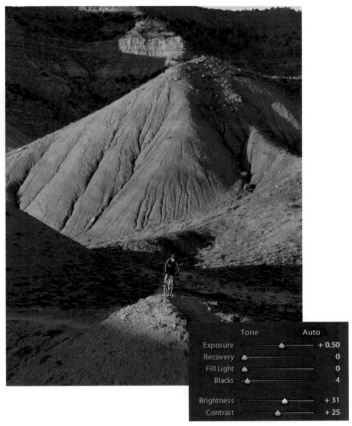

slider adds midtone contrast by pushing middle gray tones toward either the shadow or highlights.

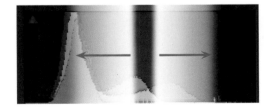

In this photo, adding contrast made the rider more prominent by lightening the rider and darkening the shadows behind him simultaneously. It also provided a subtle but important improvement to the overall feeling of depth and dimension in the photo.

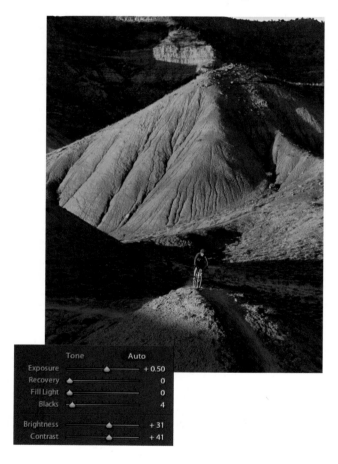

Once you've added contrast to the photo, you may need to go back and make subtle adjustments to your previous corrections, particularly Fill Light or Recovery corrections that you've made.

Note Be careful when using the Contrast slider. If your image contains predominantly highlight (high-key) or shadow (low-key) tones, increasing the amount of contrast in your photo will decrease the actual contrast in your photo. This happens because the highlight and shadows are compressed by the Contrast slider adjustment. If you have a high-key or low-key image, you'll be better served by performing contrast adjustments using the Tone Curve or a Curves adjustment in Photoshop. See "Adding Contrast" later in this chapter for information on using the Tone Curve in ACR.

Correcting Color in ACR

Now that you know how to adjust the tones in your photo, you're ready to graduate to the color adjustments. Like tone, color is a powerful tool for communicating your message. However, color takes a bit more practice to get right, as our color perception is often swayed by colors in our environment and even the amount of caffeine we've had today. While you can't always control variables such as room lighting and you don't want to give up your double latte, you *will* want to ensure your monitor is calibrated before embarking on a lengthy color-correction session. Monitor calibration is discussed in Chapter 18.

Correcting color in ACR is a multi-step process that addresses overall color, color intensity, and finally specific colors within the image. I'll address specific color adjustments later in this chapter.

Correcting White Balance

As you probably remember from Chapter 3, your camera offers a White Balance control to help match the colors in your photo to the way your eye perceives the colors in different light sources. For this reason, both your camera and ACR offer a series of presets matched to different lighting conditions, from tungsten and fluorescent, to shade and daylight.

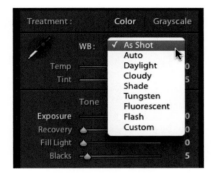

While these presets are helpful, you'll find it even easier and more accurate to use the White Balance tool. Located next to the White Balance sliders in Lightroom and along the top of the preview window in Photoshop, the White Balance tool allows you to neutralize the color cast in a photo with a single click.

In this image, the incorrect white balance setting was selected on the camera. To correct this problem, click the **White Balance** tool and select a portion of the image that should contain a neutral shade of white, gray, or black. When possible, select a light gray. This particular image doesn't contain any truly neutral colors, so I'll use the White Balance

tool to choose the best option available, which is a dark shadow on the trunk of the tree.

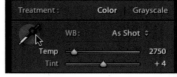

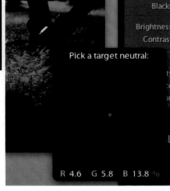

This improves the photo considerably. Although the correction isn't perfect, it is a significant improvement over the original image. If you aren't happy with the white balance correction, you can press CMD-Z (Mac) or CTRL-Z (Windows) to undo the correction, or select a new point with the White Balance tool. If you ever need to return to the original image, click **As Shot** from the **White Balance** preset menu.

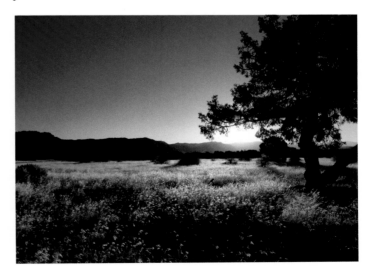

The White Balance tool is designed to help you quickly achieve an accurate color balance. Frequently, however, photographers prefer pleasing color over accurate color. After making a preliminary correction with the White Balance tool, you will often want to refine the colors further using the White Balance sliders, Temp and Tint.

Adjusting the overall color balance in your photos is an underappreciated art. While we all *see* color in slightly different ways, we tend to have similar emotional reactions to specific colors. Warm colors such as reds and oranges are inviting and approachable. Cool colors such as cyans, greens, and blues can feel distant, cold, and intimidating, particularly in skin tones. Movie and TV producers frequently play with the color balance to elicit an emotional effect in their audience. You can do the same with the Temp and Tint sliders in ACR.

The Temp slider controls the balance between blue (left) and yellow (right). The Tint slider controls the balance between green (left) and magenta (right).

The most common correction is to nudge both the Temp and Tint sliders slightly to the right to warm up the image. This adds a slight orange cast to your photo, similar to adding an 81A filter to your camera's lens.

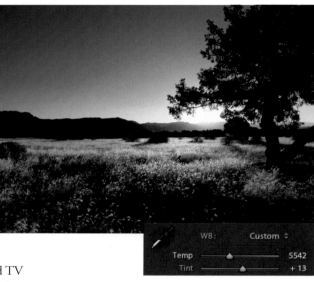

Conversely, if your goal is to communicate a cold, harsh reality, move both sliders to the left. Notice how changing the white balance creates a different emotional message for each image.

The tree and meadow image is typical in that adjusting the global white balance improves some areas of the photo, yet hinders others. For example, the correction we performed warmed up the landscape image, improving the color in the foreground, but it diminished the intensity of the blue sky. Fortunately, ACR provides very precise controls to help us adjust specific color ranges. I'll cover these later in this chapter. For now, select a white balance setting that provides the most pleasing overall color balance.

Next, let's turn our attention to the Clarity, Vibrance, and Saturation sliders located in the Presence area of the Basic panel of the ACR.

Clarity

Using the Clarity slider is a bit like adding chili powder to your cooking. A little bit is often exactly what you need, and it's easy to go too far and spoil the dish. The Clarity slider is similar to the Contrast slider, with extra intelligence built into it. While the Contrast slider adds contrast by making all the dark midtones darker and all the light midtones lighter, the Clarity slider analyzes whether to add contrast on a region-by-region basis. This process is a bit tricky to describe with words but easy to demonstrate with images.

Whenever you use the Clarity slider, be sure you're zoomed in to 100-percent view so you're looking at all the pixels in your image. Zoom in by clicking on the large image preview. Zoom back out by clicking a second time. The effect of the Clarity slider is most

dangerous on portraits, where you can age someone 20 years in only ten seconds.

This is a baseline view of the image without any Clarity added.

At a moderate Clarity setting of 15, the contours in the photo are better defined, making the picture look three-dimensional. This is the most that I would want to add to a portrait like this one.

A Clarity setting of 50 is really starting to cause problems with this image. Notice how pronounced the contrast is along the bridge of this gentleman's right cheekbone.

To see what happens when you really go too far, I've included a sample image with a Clarity setting of 90. The natural contours of the subject's face are heavily exaggerated and his skin looks blotchy and dark. As a point of reference, a Clarity setting of 90 looks pretty good in the primary preview window. It isn't until you zoom in and look at 100 percent that you can see the mess Clarity has caused. You can be sure that you'd see it in the finished print as well.

Tip Negative Clarity Selecting a negative setting for the Clarity slider softens a photo and decreases contrast. This can be useful for softening age lines or skin blemishes in a portrait or it can be used for creative effect in landscape or architecture shots.

While I rarely use the Clarity slider, the next two tools, Vibrance and Saturation, are essential for most image corrections. Both increase the *saturation*, or color purity, of a photo, but each does it in a different way.

Vibrance and Saturation

Vibrance increases desaturated colors more than saturated ones. A Vibrance correction will boost a pale blue more than a royal blue. Additionally, Vibrance is designed to protect skin tones so you can push the color further without making the people in your photo look artificial.

Saturation does a great job of making bright colors scream off the page. It needs to be used with greater care than Vibrance as it can make colors look false very quickly. The amount of Vibrance and Saturation you apply to each image will vary based on the content of the image and the effect you're looking for. Generally speaking, however, I find I add 2/3 Vibrance and 1/3 Saturation to give colors just enough pop without making them look fake.

For comparison, I've pushed the Vibrance and Saturation settings to 60 to show the different effect each slider has on the image. The final image uses a Vibrance setting of 21 and a Saturation setting of 10. The colors are vivid, but they don't yet look artificial.

After performing global corrections to the tone and color in your raw files, you'll often make smaller, more refined corrections using the advanced features in ACR.

Vibrance 60

Saturation 60

Vibrance 21, Saturation 10

ADVANCED CORRECTIONS

Many photographers never venture beyond the corrections found in the Basic panel. This is a shame, because several of my favorite tools for correcting images are found in the advanced panels of ACR. Don't worry, however, because although the corrections are more advanced and often less obvious than those listed here, they certainly aren't difficult to use and can result in big payoffs in your photos. In the next section, I'll show you how to perform two of the most common types of advanced image corrections in camera raw: adding contrast and correcting specific colors.

Adding Contrast

Before we get too far into the sections on adding contrast in ACR, it's worth considering the question, Why do I need to add contrast to my images?

The simple answer to this complex question is this: *contrast equals detail*. All of the detail you see in your digital photos is a result of differences in the lightness or color of the pixels in your photo. Adding contrast to your photos exaggerates these differences, enhancing the appearance of detail in your photographs. So if you want your photos to look their best, you need to become a master of intelligently adding contrast to your pictures.

I recommend the Contrast slider as a tool for adding contrast to the midtones in an image. While this is useful for a large number of images, it can be detrimental to images with important highlight or shadow detail. Take the upcoming fishing image, for example. Adding

contrast with the Contrast slider causes the fog rising off the river to become too bright and lose important detail. This occurs because the Contrast slider adds midtone contrast at the expense of the highlight and shadow areas. This is an unfortunate side effect of making corrections to digital photos. Adding contrast to one portion of the tonal range robs contrast from other areas. Since contrast equals detail, it is critical that you add contrast only to the most important areas in your photo. When you need this additional level of control, look to the Tone Curve for salvation.

The Tone Curve panel in ACR allows you to make more precise tone and contrast adjustments than you are able to make using only the sliders in the Basic panel. To orient yourself, think of the diagonal line of the curve as a histogram tilted up on a 45-degree angle.

Shadows are at the lower-left corner of the curve and highlights are at the upper-right portion of the curve. Bending the curve up and to the left lightens the photo. Pulling it down and to the right darkens the photo.

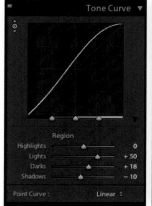 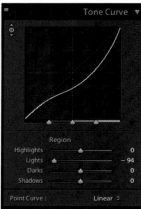

Now this is the most critical part for our discussion. Any areas of the curve steeper than the original 45-degree angle gain contrast, while any areas on the curve with an angle of less than 45 degrees lose contrast.

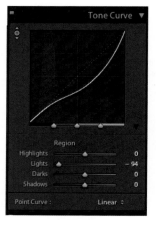

Our correction with the Contrast slider would result in a Tone Curve that looks like this:

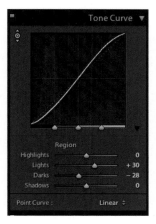

The midtones in the photo gain the most contrast, since that portion of the curve is the steepest. The highlight and shadow regions, however, suffer a loss of contrast. For many pictures, this is ideal and Adobe's rationale for making this the standard method of adding contrast. For this specific fishing picture, a simple midtone adjustment is less than ideal since the most important visual detail resides in the highlight areas and a different approach is required.

You can adjust the Tone Curve in Lightroom in three ways. All three will achieve the same results. Typically, photographers find one of the methods more intuitive than the others and use it more frequently.

■ *Use the sliders below the curve to adjust each of the tonal regions on the curve.* Hovering your cursor over the curve lists the tonal

region that will be adjusted and highlights the corresponding slider.

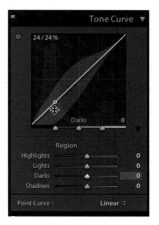

■ *Click and drag on the curve to perform tonal adjustments.* Although this is the most common method of adjusting the curve, it is the most difficult to use correctly because it requires the user to be able to look at the picture and guess correctly the corresponding location on the curve. You can use the histogram behind the curve as a guide to help you manipulate the curve correctly.

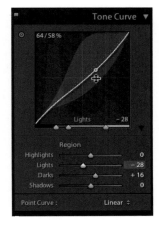

■ *Use the Targeted Adjustment tool (TAT) to make corrections on the image directly.* This is the most intuitive and certainly the coolest method of performing corrections, because it allows you to directly target a specific tonal region in your photo. Single-click the **TAT** icon in the upper-right corner of the Tone Curve panel, and then click and drag on the image to make adjustments to the curve. Clicking and dragging the cursor up toward the top of the photo lightens the corresponding tonal region on the curve, while dragging toward the bottom darkens it.

For adding contrast, you'll have the best success with the TAT, because it allows better control over your adjustments. For example, in this image of the fly fisherman, the TAT allows you to darken the water in the river and lighten the mist to increase the visual separation between them.

You can also increase the detail in the trees by lightening the highlight areas of the trees and darkening the deeply shaded bases of the trees.

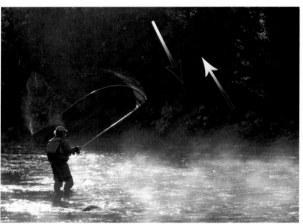

To follow up with our fly-fishing image, the top photo on the facing page is the result of adding heavy contrast using the Contrast slider. The image on the bottom-right is the result of using the TAT to add contrast to the highlights and the shadows, where contrast is needed most in this photo. Notice the difference in shadow detail in the background and the detail in the mist above the river.

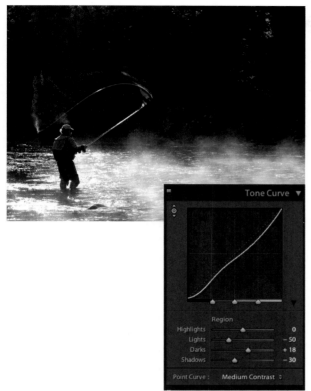

The most important thing to keep in mind while adding contrast to your photos is to think of adding the contrast through a *portion* of the tonal range, not a single point. If you want more contrast in the clouds, click the lightest portions of the clouds to make them lighter and darken the darker portions of the clouds to increase contrast throughout the clouds.

In the next chapter, we'll spend more time adding contrast to images; for now, instead of adding contrast throughout the picture, we'll focus on adding contrast to specific regions in a photo using a layer mask. This helps you enhance the contrast corrections you make at this stage.

Correcting Specific Colors

Until this point, all the image corrections have been applied *equally* throughout the picture. For example, adding yellow with the Temperature slider increased yellow in *all* areas of the photos. This can be problematic. Consider a landscape photo with a beautiful blue sky: adding yellow will make the grasses and trees in the photo more appealing while ruining the blue sky, since adding yellow to blue makes it grayer.

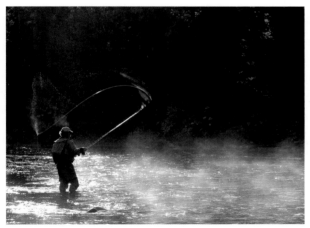

The Hue, Saturation, and Luminance (HSL) sliders allow you to adjust your blue skies separately from your green grass without the need to select or mask areas in the photos. You'll use HSL for three primary purposes:

- Correcting one set of color separately from another, as in the example of warming up green grasses without affecting skies.

- Correcting the differences in color between what your eye sees and the camera captures. This effect, called *camera metamerism*, is quite common and requires a custom set of corrections in Adobe Camera Raw to align the color in ACR with what your eye sees.

- Making your photos look more three-dimensional by lightening specific colors to "bring them to the front" visually and darken background colors to help them recede from view.

- I encourage you to dedicate some time to learning how to use the HSL sliders. Many of the corrections I once had to perform in Photoshop using masks and selections I can now do completely in Lightroom.

Introduction to HSL

You've probably already used the Hue, Saturation, and Luminance (HSL) color scheme without necessarily knowing it. Many computer applications use HSL standard when selecting colors for type and design. On the Macintosh, HSL is the standard color model used in Apple's Color Picker.

Even though HSL may be familiar, that doesn't necessarily help you use it for correcting images. For this, you need to have a basic understanding of how the HSL system is set up and why it makes difficult corrections easy and intuitive.

Several different models can be used to describe the full spectrum of colors. When working with digital cameras and digital images, we commonly use the RGB color mode, where all colors are created using varying amounts of red, green, and blue. HSL is similar in that you can describe any color using three variables; however, HSL is unique in that each of the three variables controls a different aspect of the color.

The best way to visualize the HSL color mode is to imagine a cylinder containing all the colors in the spectrum. Looking down on the cylinder's top surface we see the color wheel, familiar from art classes, paint stores, and software color pickers.

structure, open Photoshop and double-click the foreground or background colors at the bottom of the Toolbox on the left side of the screen to open the Color Picker.

Each of the 360 degrees around the circle corresponds to a different color hue. For example, a hue angle of 20 degrees corresponds to a reddish-orange. The vibrancy of the hue is determined by the Saturation amount. A Saturation of 0 is a shade of gray. A Saturation of 100 is a vivid, highly saturated color.

The third axis on the cylinder, Luminance, determines the lightness of the color. A low Brightness amount results in a dark color, and a high Brightness setting creates a light color.

Together, all three axes of HSL are combined to create all the colors in the visible spectrum. What makes this useful in ACR is the ability to adjust the axes independently. If you need to make a blue sky darker, you can decrease the lightness without making any change to the hue or saturation of the sky.

This is a powerful method of performing corrections to images. It is now time you learn how to make HSL work for you. If you want to become more familiar with the HSL

The Color Picker displays all of the possible color combinations for a single hue angle. You can think of the Color Picker as a vertical slice of the HSL cylinder. See what happens to the color when you adjust the H, S, or B (Brightness) values.

Using HSL Sliders Lightroom provides separate Hue, Saturation, and Luminance sliders for each of the primary colors: red, orange, yellow, green, aqua, blue, purple, and magenta. By default, these are organized as separate modes within the HSL/Color/ Grayscale panel. If you prefer, you can reorganize the controls to be viewed as one long list by clicking **All** to the right of the Luminance button or by color by clicking the **Color** heading in the panel's title. Changing

the controls' display will not affect their behavior.

When performing corrections, you'll use each of the three components for different types of corrections. The best use of Hue sliders is to affect more or less of a particular color: making the green grass less yellow or making the sky more blue, for example. The Saturation sliders increase or decrease the vibrancy of a color group. Desaturating skin tones (typically orange) helps to rein in overly saturated skin tones. The Luminance controls are commonly used for emphasizing specific areas within the photo based on the premise that your eye will always be drawn to the lightest and highest contrast area within a photo. Using the Luminance sliders to lighten your subject slightly will make it stand out more clearly from the background.

HSL slider use is very straightforward. However, it is not always obvious which slider is best for addressing a specific color problem. To adjust the salmon-colored panel on the hot air balloon, should you use the Red, Orange, or Magenta slider?

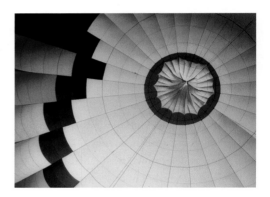

While you can experiment with the individual sliders, it is faster and more effective to use the TAT introduced earlier with the Tone Curve panel. Selecting the TAT allows you to click the image itself to perform your adjustments. Clicking and dragging up will move the Hue sliders to the right; dragging down will move the Hue sliders to the left. The brilliance of using the TAT in this case is that Lightroom will adjust multiple sliders simultaneously, if necessary, to perform your HSL adjustments. For the salmon-colored panel on the balloon, Lightroom adjusted the Red and Orange hues together.

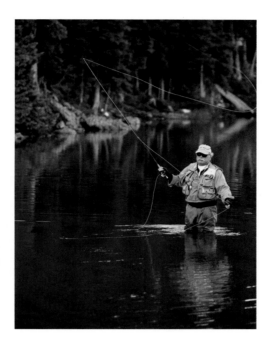

This subtle change created greater visual separation between the red, orange, and salmon-colored parts of the balloon, with the added benefit of making the red less yellow and more distinctive. Additional corrections to the Hue sliders cleaned up the balloon's green and purple colors, and deepened the blue in the sky at the center of the balloon. These types of corrections are perfectly suited to the HSL tools.

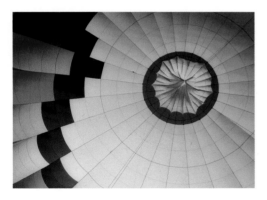

For a deeper understanding of HSL, let's look at another example that allows us to use HSL to fix problems with the photo and call attention to our main subject.

After correcting this image with the corrections in the Basic panel, we still need to make four corrections in HSL:

- Remove some yellow from the pine trees in the background.

- Darken and desaturate the greens in the pine trees and water.

- Lighten and saturate the blues of the fisherman's shirt to bring them to the front.

- Tone down the saturation from the fisherman's face.

Step 1 Use the TAT to push the greens from yellow toward green. This makes the color more natural, even though it is still too saturated.

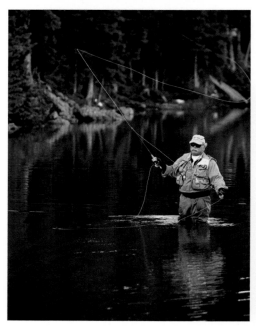

Step 2 Using both the TAT and the sliders directly, pull back the saturation in the greens and yellows to make the trees' color more accurate, increase the blues and aquas to add saturation to his shirt and fishing line, and decrease the saturation of the orange slightly to remove some color from his face.

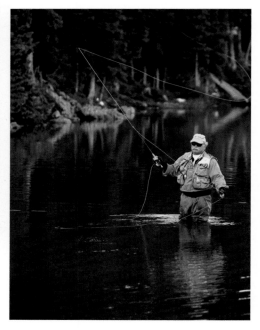

Step 3 Decrease the lightness of the greens significantly, and increase the lightness of the aqua to make the shirt stand out.

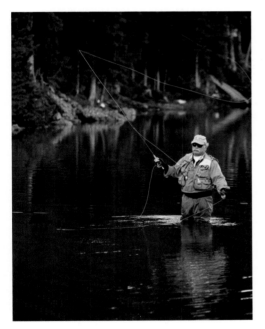

These are the types of corrections that used to require a high degree of Photoshop skill and a lot of time to correct but that can now be done in a matter of minutes using HSL sliders.

For information on correcting common lens problems and adding vignettes, visit www.perfectdigitalphotography.com/lightroom.php.

The next chapter will spend more time demonstrating tips you can use to guide your viewer's eyes through photos. In the meantime, I need to round out the discussion of the global image manipulation tools in Lightroom by discussing the Crop Overlay, Spot Removal, and Red Eye Correction tools.

Lightroom's Image Manipulation Tools

Photographers of all backgrounds and abilities need effective tools for cropping images. Although the ideal is always to crop your photos in-camera through careful composition, the reality is that most images need to be cropped either to match the dimensions of a given print size or to remove extraneous elements from a photo.

While there isn't enough space in this book for a thorough treatise on cropping, I will say that it is well worth your time to experiment with cropping your images in several different ways to see how much you can remove from your images while still maintaining the key stories within your photos.

Tip To learn more about cropping, try to track down a copy of *Visual Impact In Print*, by Gerald Hurley and Angus McDougall. Although the book is out of print, it is still readily available through used booksellers online.

The technical aspects of cropping are far more straightforward. Lightroom's Crop Overlay tool is very easy to use for free-form cropping and for cropping to a specific print size or aspect ratio.

The Crop Overlay tool is located immediately below the histogram in the Develop module on the left side of the row of icons, or you can access it by pressing R.

Once the cropping grid is activated, you can adjust the crop by dragging any of the anchor points on the corner or sides of the grid. To preserve the proportions of the original image, hold down the SHIFT key while dragging any of the four corner points.

When you are satisfied with your crop, press RETURN (Mac) or ENTER (Windows), press R, or click **Close** at the bottom of the **Crop & Straighten** panel.

Cropping Tips

- To reposition the cropping grid on the image, click inside the cropping grid and drag the photo into the new position. The trick here is to remember that the crop stays in the same position and you are relocating the photo within the anchored crop grid.

- To crop and straighten your image simultaneously, move your cursor outside the cropping grid at any of the four corners until the cursor changes from a

diagonal line with two arrows to a bent, double-headed arrow. Click and drag the image at a 45-degree angle down and left to rotate the image clockwise or up and to the right for counterclockwise rotation. A finer grid will temporarily appear to aid alignment.

- To crop to a specific proportion, choose your desired proportion from the Aspect pull-down menu in the Crop & Straighten panel. Select **Custom** to crop to sizes not included in the preset menu.

The crop applied in Lightroom is a *soft crop*—that is, you never throw away any of the pixels outside the cropped area of the photo. This allows you to return to the full image at any time. This is one of the many advantages of working in camera raw.

Spot Removal Tool

Dust is attracted to the sensors on digital SLRs, and many a photographer has lamented having to manually go through and removing dust spots from every image in a shoot. While Lightroom can't keep your camera's sensor clean, it does make the process of removing dust spots a little simpler with the Spot Removal tool.

The unique challenge of removing spots caused by dust on the camera's sensor is that spots appear in the same place on every file. While this makes the spots easy to correct one by one, it is a challenge from a workflow perspective, because the content of the picture around the dust spots will change from photo to photo. This requires an intelligent tool to remove spots from multiple photos quickly and effectively.

Located next to the Crop Overlay tool, the Spot Removal tool has two retouching modes, Clone and Heal.

For most of your retouching work, you'll want to work in the Heal mode, which automatically blends your correction with the surrounding tone, color, and detail to make your corrections invisible. For each spot you remove, you will have a source and a destination point. The source point contains the "good" pixels that will serve as the well from which Lightroom can draw its corrections. The destination point is the dust spot or area you want to remove. The destination point will receive the correction. For each correction you make with the Spot Removal tool, both points need to be specified.

To begin, find a spot in an image that needs to be removed. To make the demonstration clearer, I've added some nasty looking dust spots to an image in Photoshop and imported the image into Lightroom. You'll need to zoom in to your image to look for dust spots. Do this by clicking in the large image preview in the **Loupe** or **Compare** view.

Once you identify a dust spot you want to remove, look around for an area of the photo with similar detail and color that you can use for your source point. After you've found the most likely candidate, select the **Spot Removal** tool by pressing N or clicking the **Spot Removal** tool under the histogram. Next, position the brush over the dust spot and adjust the brush size by pressing the right bracket key (]) for a larger brush and the left bracket key ([) for a smaller brush. A brush that is slightly larger than the dust spot is ideal.

Click the dust spot, and then drag your cursor over to your clean source point in the image. Lightroom will draw an arrow from your source point to the destination point (dust spot). Ideally, the Spot Removal tool will blend your correction with the surrounding area so well that the only way you can identify the dust spot is by the arrow pointing toward it.

Repeat these steps for each of the dust spots in your image. Be sure to select a new source point for each dust spot. Otherwise, you might create a pattern of clean spots that is easily identified.

The Heal mode in Lightroom works remarkably well in smooth areas without lots of detail. When removing spots near edges the Heal mode tends to smudge the edge, leaving an obvious blotch on the photo. When this occurs, you'll need to take more control over the retouching by using the Clone mode. Switch from Heal to Clone mode by clicking the **Clone** heading at the top of the **Spot Edit** panel.

Unlike the Heal mode, which automatically blends the tone and color of the detail from the source point onto the destination point, the Clone mode copies pixels directly from the source point and places them over the destination point.

To demonstrate, I'll duplicate the photographer in this picture by creating a brush large enough to fully encompass the photographer, and then I'll move the cursor to my destination point, the blank area to the right of the photographer. Clicking and dragging from the destination point to the source point clones the photographer onto the ridge.

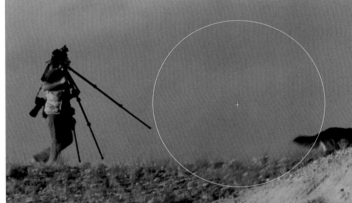

When cloning, click and drag from the destination point to the source point. This clones the pixels from the source onto the destination, and here it creates a second photographer on the ridge.

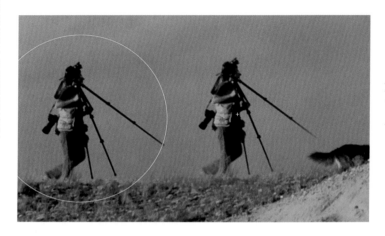

Red Eye Removal

This picture of my nephew, Finn, taken by his proud grandfather is a great snapshot; it's nicely composed and shows a great expression, but the red eyes make him look a bit devilish.

Red eye, caused by an on-camera flash bouncing directly off the back of your subject's eye and returning to the camera, can be quickly fixed using Lightroom's Red Eye Correction tool.

In the Develop module, select the **Red Eye Correction** tool from the middle of the row of icons below the histogram. As a preparatory step, I recommend zooming into your picture before selecting the Red Eye Correction tool to ensure that you remove the red eye entirely.

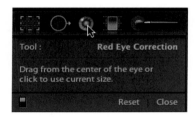

Center your cursor over the first red eye, and then click and drag from the center of the eye to just past the edge of the red. Lightroom will draw a target over the red area of the photo while you drag and then remove the red eye.

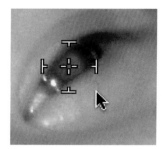

If you need to clean up Lightroom's correction, adjust the Pupil Size and Darken sliders to tailor your results.

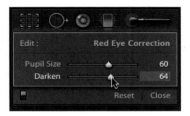

Repeat for the second eye. If one of your corrections is unsuccessful, delete the red-eye correction point by single-clicking inside the point's outline and then pressing DELETE. Changing the size or shape of the initial circle will often clear up even the most stubborn red eye. When you are finished, click the **Red Eye Correction** tool icon to close the **Red Eye Correction** panel.

Photo Credit: Steve Gleich

Context Is King

Instead of covering all tools in the Develop module in this chapter, I'll discuss tools for burning and dodging, sharpening, and noise reduction in later chapters. This will help arm you with background on these tools so you will have a comprehensive view of how to use them to make your images pop.

I'll cover the two remaining selective correction tools, Graduated Filter and Adjustment Brush, in the next chapter, where they fit within the broader context of making selective adjustments to optimize images. Additionally, the Sharpening and Noise Reduction controls are grouped with the Image Sharpening sections in Chapter 16 to teach you what image sharpening is, why it is important, and how to use a two-pass sharpening technique to tease out maximum detail in your photos.

This change allows us to focus our attention on batch processing multiple photos quickly and easily by synchronizing camera raw corrections and building presets to significantly cut the time you spend correcting images after a shoot.

Correcting Multiple Photos

While the correction techniques demonstrated in this chapter will help you process photos quickly, correcting the best images individually still amounts to a lot of time. Fortunately, using presets and batch adjusting photos will trim your image correction time tremendously. For the remainder of this chapter, we'll focus our efforts on applying the image correction

techniques to your photos in batches, which can help to expedite your workflow by leaps and bounds.

Synchronizing Corrections

ACR, both in Lightroom and Photoshop, stores your image corrections in a separate text file on your hard drive, typically in the same location as the original image. This text file, often called a *sidecar* file, is written in an XML-based language called Extensible Metadata Platform (XMP) and stored with the .xmp extension. This file tells ACR how to process your camera raw images. It also makes it easy for ACR to copy corrections from one file and apply them to another photo, since the text file takes up very little space on your hard drive and can be duplicated quickly.

Moab_04_2008_011.ORF Moab_04_2008_011.xmp Moab_04_2008_012.ORF Moab_04_2008_012.xmp

Moab_04_2008_013.ORF Moab_04_2008_013.xmp Moab_04_2008_014.ORF Moab_04_2008_014.xmp

In Lightroom, ACR seamlessly combines the original raw file with the sidecar file to generate the preview you see in Lightroom. That's why it sometimes takes a moment for your corrections to appear. Lightroom has to access the sidecar file to see what your photos should look like.

Copying these sidecar files and their corresponding corrections between multiple photos is easy. First, correct one image indicative of a group of images with the same white balance, exposure, saturation, and so on. Then select all the images in the group in the Filmstrip by SHIFT-clicking to select contiguous images or CMD-clicking (Mac) or CTRL-clicking (Windows) to select individual images. Then click the **Sync** button near the bottom of the rightmost panels in the Develop module.

A Synchronize Settings dialog appears, asking whether you want to copy all the attributes of the first photo in the series or only selected attributes such as White Balance or Spot Removal. For your shoot-specific corrections, you will want to leave most of these corrections checked. For scene-specific corrections, you'll want to tailor the list to adjust only a handful of corrections.

Using the Previous and Sync commands is useful when images are grouped close to one another, such as a series of formal pictures at a wedding. What happens when you need to match the settings between the cake picture you took before the bride and groom arrived with the cake-cutting picture you took several hours later?

In addition to being able to synchronize settings, you can copy and paste camera raw settings from one image to another. Correct a photo, and then in Lightroom click the **Settings** menu and click **Copy Settings**, or press SHIFT-CMD (Mac) or CTRL-C (Windows).

Settings	View	Window	Help		
Reset All Settings					⇧⌘R
Copy Settings...					⇧⌘C
Paste Settings					⇧⌘V
Paste Settings from Previous					⌥⌘V

Navigate to another image that needs the same correction and click the **Settings** menu and click **Paste Settings**, or press SHIFT-CMD (Mac) or CTRL-V (Windows).

Settings	View	Window	Help		
Reset All Settings					⇧⌘R
Copy Settings...					⇧⌘C
Paste Settings					⇧⌘V
Paste Settings from Previous					⌥⌘V

Click **Synchronize**, and after a moment, Lightroom updates the preview images to reflect the new changes. As you move on to your next batch of images, you can bypass the Synchronize Settings dialog by clicking the **Previous** button. This will apply all corrections from the last image to the current image.

Note The Previous button is available only when a single image is selected. The Sync button is available only when multiple images are selected.

Tip You can also access the Copy and Paste Settings options by right-clicking an image in the Filmstrip and then clicking **Develop Settings** and then **Copy Settings**.

By synching and copying camera raw settings, you can quickly perform your shoot-specific and scene-specific corrections. For corrections you perform even more frequently, such as camera-specific corrections, it's worth creating a preset that stores your changes and allows you to apply them to images with a single mouse click. A good rule of thumb for working efficiently in Lightroom is to build a preset any time you perform the same correction twice.

You've already learned how to create presets for file naming and adding your metadata. Now let's create a Develop preset that adds a baseline set of corrections for your camera.

Building Camera-Specific Presets

As you gain experience working with ACR, you'll find that you consistently perform a base set of corrections for all your images. To make your workflow more efficient, you'll want to save these corrections as a Develop preset that you can quickly apply in the Develop module or as a baseline set of corrections when importing images from your memory card.

Before creating a preset, I like to review a number of my previously corrected photos. In doing so, I find that I typically add Vibrance and Saturation, boost the Contrast slightly, and pull back from the default Blacks setting.

I wrote down the common corrections so I'll remember them when developing the preset. My new baseline set of corrections for this camera will be this:

Blacks:	0
Contrast:	37
Vibrance:	15
Saturation:	6

This isn't a strong correction, yet it is a step in the right direction. I expect to refine this as I continue to process images with the preset. I may find that the correction is too strong in some areas and not strong enough in others, so I may need to add HSL or Tone Curve corrections to make it more useful. Think of this first preset as a starting point for your custom camera defaults.

To create a preset, select an image that hasn't received any corrections. To be sure, click the **Reset** button at the bottom of the rightmost panels in the **Develop** module.

Next, apply your corrections to the photo. Once you've completed your baseline corrections, open the **Presets** panel on the left side of the **Develop** module and click the plus (+) sign in the upper-right corner to add a new preset. Title your preset ***CameraModel_Defaultsv1*** to indicate that this is the first set of baseline corrections. Be sure to check only the boxes in the New Develop Preset dialog for your baseline corrections. For my preset, this includes the Black Clipping, Contrast, Saturation, and Vibrance.

For subsequent refinements to this preset, title them *v2*, *v3*, and so forth. This helps you keep track of your changes. Versioning your corrections instead of choosing the same filename each time allows you to revert to an earlier version if you are dissatisfied with new additions to your preset and compare the same photo with different presets.

The goal of developing presets is to tailor Lightroom to match your aesthetic tastes. You can also create content-specific presets for black and white conversions, sepia toning, saturated landscape images, or neutral portraits. You can always perform additional corrections to supplement your preset or revert back to the original file if need be.

Set Your Preset as a Lightroom Default

Once you've developed your preset to the point at which you believe it can be safely applied to every photo from your camera, you can assign it as the default setting for your camera by applying the preset to an image and then holding down the OPTION (Mac) or ALT (Windows) key. The Reset button under the rightmost panel of the Develop module will change to Set Default. Clicking **Set Default** will establish these corrections as the baseline for all images brought into Lightroom from a specific camera. If you ever need to revert to Lightroom's original defaults, click the **Lightroom** menu and then click **Preferences** (Mac), or click the **Edit** menu and then click **Preferences** (Windows). Click the **Presets** tab and select **Reset All Default Develop Settings**.

Applying Your Preset

You can apply a new preset to photos in several ways:

■ For a single photo, click the preset name in the **Presets** panel in the **Develop** module.

■ To apply your preset to multiple photos outside of the Develop module or in the Filmstrip, select the images you wish to correct, right-click the images to open the context menu, click **Develop Settings**, and then click the preset name.

■ To apply your preset to an entire shoot upon import, select your preset from the **Develop Settings** pop-up menu in the **Import Photos** dialog.

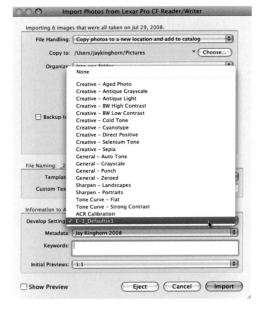

Working with presets makes your workflow more automated and efficient. It eliminates many of the tedious tasks in the digital darkroom and allows you to make your photos look the way *you* want them to, not the way the camera manufacturer or Adobe thinks they should look.

On the Web Adobe recently released the DNG Profile Editor for use in Lightroom 2 and Photoshop CS4 that allows you to create custom looks for your digital photos. These custom camera profiles allow greater control than the presets described here. While they are not difficult to create, Adobe recommends the DNG Profile Editor for intermediate/advanced users. To view a tutorial on using the DNG Profile Editor to create custom camera profiles, visit www .perfectdigitalphotography.com/lightroom.php.

This chapter introduced you to the controls in the Develop module; helped you adjust the tone, color, and contrast of your photos; and helped you develop efficient routines for batch correcting multiple files. In the next chapter, we'll go into even greater depth on optimizing a single photo in Adobe Photoshop. These corrections will build upon the work you've performed here and take your corrections even further to help your photos stand out from the crowd.

How To: Making the *New* Three-Minute Correction

The techniques presented in this chapter may initially appear to be complex and time consuming. Be assured, however, that once you become accustomed to using the tools, you can correct an image using the full suite of Lightroom's editing tools in *three minutes or less*. In this How To, I'll explain the thought processes behind the corrections I used to take a photo from bland to rich, vibrant, and full of interest. This How To is focused on helping you see the big picture and learn which tools to choose and why. Specific instructions on using each of these tools is contained throughout this chapter.

Overcast, drab days can be great for highlighting subtle colors in a scene, like the streaks of lichen on rocks and the bright green of a climber's sweater. Unfortunately, they don't always come out the way you'd like in-camera. Looking at this photo, I see several problems that need correcting:

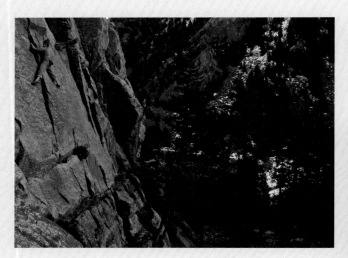

- **White balance** It was a cloudy overcast day, but I remember the orange of the rocks, the green of the trees, and the yellow-green streaks of lichen being far more prominent than the original suggests.

- **Shadows** The right side of the picture is a bit of a muddled mess. The trees in the foreground aren't visually distinct from the trees in the

background. This makes the picture feel flat and two-dimensional.

- **Climber** Since the climber is a small subject in a large scene, I need to bring him to the front by lightening and increasing the saturation in his shirt so he is the first thing you see in the photo.

With these goals in mind, let's get started with the corrections.

Step 1
The first step is to correct the photo's white balance using the White Balance tool, followed by a manual correction to the WB sliders.

Step 2

The overall exposure is good, but a small Recovery slider adjustment to eliminate clipping in the background, followed by a boost to the Fill Light and Blacks sliders, both lightens and increases contrast in the shadows, making the trees more distinct. I also increase the Brightness in the photo to make the picture appear more open.

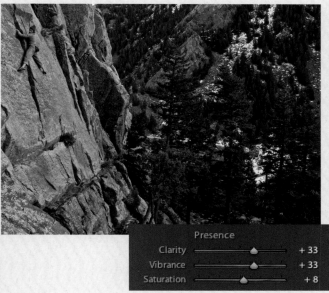

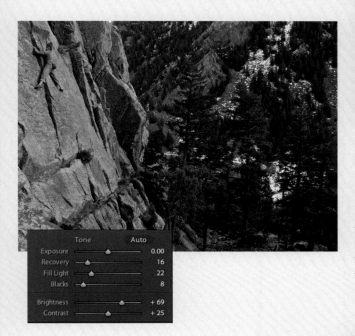

Step 4

Next, I set out to improve the visual separation between the trees in the background and the foreground by adding contrast to the shadows using the Tone Curve. Because the foreground and background trees are very close in tone, I modify the Split control in the shadow region to fine-tune the Darks and Shadows regions.

Step 3

After zooming in to 100 percent for a subtle Clarity correction to improve the contrast on the climber, I increase the color using the Vibrance and Saturation sliders. Once again, the ratio of three-parts Vibrance to one-part Saturation works well. I'll perform additional saturation adjustments with the HSL slider later. This correction is intended to set the photo's overall color.

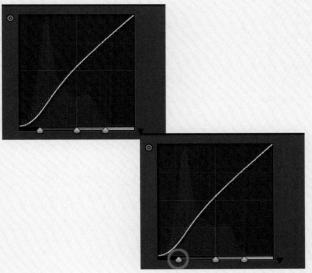

This adjustment allowed me to control the background trees with the Shadows slider and the foreground trees with the Darks slider. This Tone Curve adjustment is impossible to replicate using only the sliders in the Basic panel and is a part of why mastering the Tone Curve is so valuable.

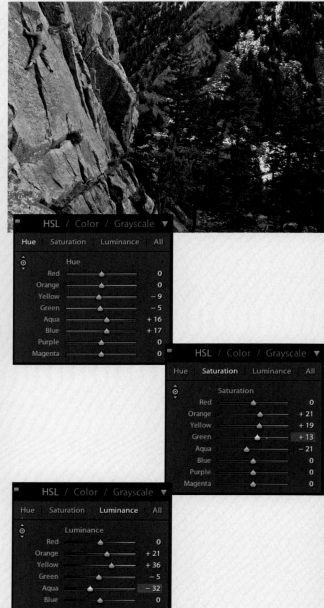

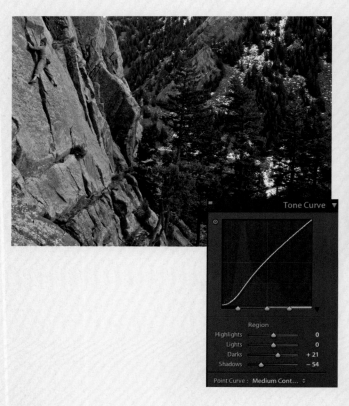

Step 5

To further increase the separation between foreground and background, I use the HSL sliders to make the background trees bluer and darker while boosting the lightness and saturation of the yellows, oranges, and reds, making the cliff, climber, and foreground trees more prominent in the photo. At this point, the photo feels a little too bright overall, so I go back to the Brightness slider and darken it three points—a subtle but noticeable improvement.

At this point, I've addressed my three goals and improved the appearance of the photo noticeably. There are a few minor, selective corrections I'd like to make before the photo is ready for print, but I'll save those for the next chapter.

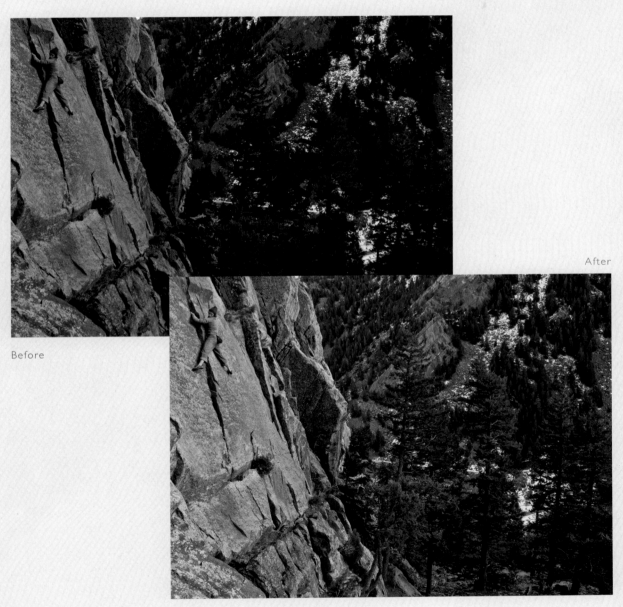

After

Before

Using only the tools discussed in this chapter, you can make changes like these in three-minutes or less.

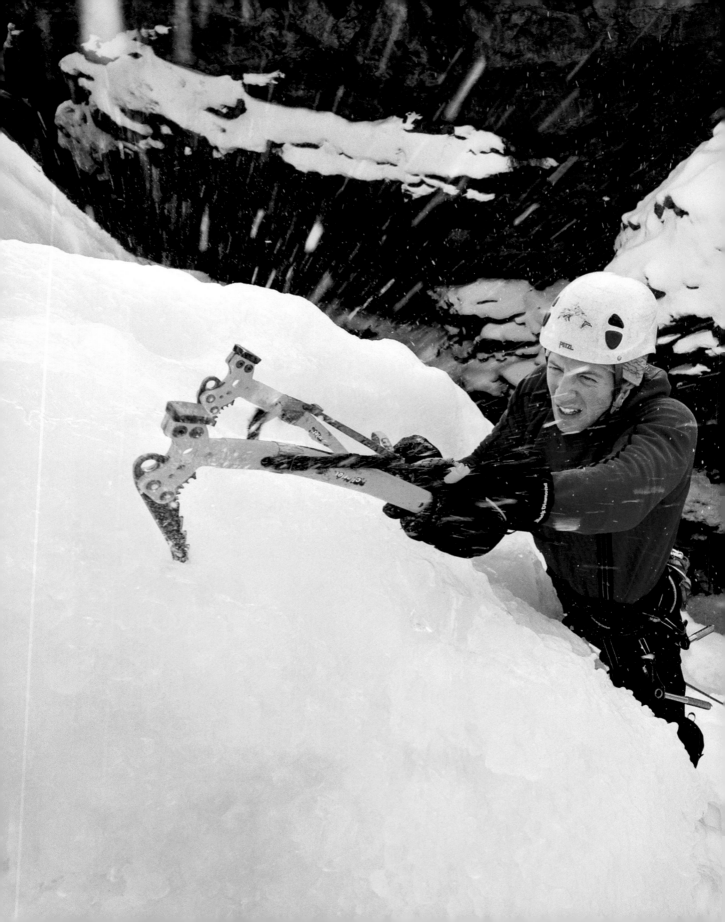

IMAGE REFINEMENTS

This chapter begins a journey that takes you beyond the basic image corrections to develop your skills in refining your images to enhance their core messages. We'll begin by working with the selective correction tools in Lightroom, and then we'll work with Photoshop for additional control over adjusting specific areas within your photos. In the next chapter, we'll go even deeper into the advanced correction options found in Photoshop.

Ice Climbing, Ouray Box Canyon, Colorado. Olympus E-500, 7–14mm lens, 1/200 second at f5, ISO 200

USING THE SELECTIVE CORRECTION TOOLS IN ADOBE PHOTOSHOP

I've already covered the Crop, Spot Removal, and Red Eye Correction tools in an earlier chapter, so I'll concentrate here on using the Graduated Filter and Adjustment Brush tools to correct specific areas within your photos.

Graduated Filter

The Graduated Filter tool is one of the most useful features in Lightroom 2. It mimics a traditional, graduated neutral-density filter that photographers place over the front of the lens to darken the sky.

To use the Graduated Filter, create a gradient by clicking and dragging your cursor across a portion of the image. Lightroom will fade the intensity of your correction from 100 percent at the start of the gradient to 0 percent at the end of the gradient. By fading your correction gradually, it blends with the image naturally.

Since the description sounds more difficult than it actually is in practice, I'll walk you through the process with a sample image (shown at right).

This image can be improved by darkening the sky and lightening the foreground sand to increase depth and feature the boats in front of the background.

Step 1 Click the **Graduated Filter** icon immediately below the histogram, or press M, to open the Graduated Filter panel and activate the Graduated Filter tool.

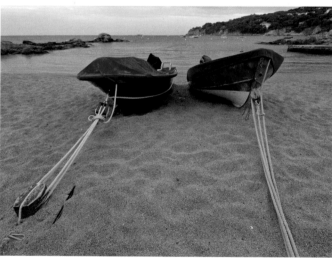

Step 2 Click and drag from above the horizon line to an equal distance below the horizon to draw a graduated filter across the image. This is the most difficult part of the process, as the length and position of the gradient will vary slightly depending on the content of the image and the intensity of your correction. If your gradient doesn't look quite right, don't worry, because you'll reposition it in the next step.

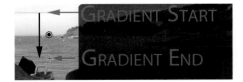

Step 3 The location midline of the gradient, indicated with a black and gray circle "pin" in the center, is key, because the midline indicates the area where the gradient transitions most sharply from corrected to unaffected. Ideally, this midpoint will land on a horizon or other natural transition in the photo to help disguise your corrections and make them appear more natural.

Adjust the gradient by clicking and dragging the portion of the gradient you want to change.

- If the midline isn't along the horizon, click the center pin in the center of the gradient and drag it to a new location.

- If you want to adjust the "throw," the length of the gradient, click and drag its start or end points.

- To rotate the gradient, hover your cursor over the center line until your cursor changes to the double-headed arrow, indicating the rotation tool. The closer the cursor is to the center of the gradient, the more wildly the gradient will rotate. Bringing your cursor out toward the margin of the picture will make subtle rotation of the gradient easier.

Step 4 Once your gradient is positioned correctly, you can begin applying corrections to the gradient using the Effect options. These corrections function exactly the same as those found in the Basic panel.

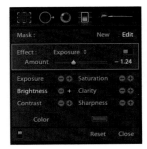

By default, Lightroom gives you control over only one attribute (such as Brightness *or* Saturation). Clicking the switch to the right of the Effect pull-down menu shows all the Effect sliders and allows you to adjust multiple attributes for each gradient (such as Brightness *and* Saturation).

Step 5 If you are happy with your adjustments, click **Close** in the lower-right corner of the Graduated Filter panel to close the panel and accept your corrections. If you're still not satisfied, you can continue to adjust the sliders to dial in your correction or adjust the positioning and throw of the gradient. If you'd like to discard the gradient and start over, bring your cursor over the center pin and press the DELETE key.

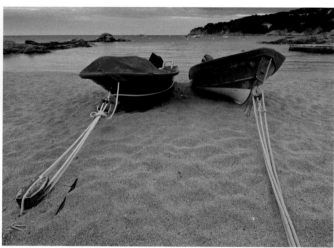

Use the Effect sliders to perform corrections along the gradient. Toggle the switch at the lower-left corner of the Graduated Filter panel to turn the Graduated Filter preview on and off.

The Graduated Filter darkens the sky, calling attention to the foreground. Settings: Exposure −0.97, Brightness −21, Contrast 13, Saturation 8

Applying Multiple Gradients

I often use two gradients in tandem to make my photos shine. The first, as in the preceding example, darkens the sky. The second lightens the foreground and boosts the color, helping my subjects stand out visually.

To create a second gradient, click **New**, immediately below the Adjustment Brush icon. This will preserve, but deactivate, your previous gradient, now indicated with a solid gray pin.

Drag your new gradient from the bottom of the image toward the top. Typically, I begin approximately a third of the way up from the bottom of the image and extend the gradient to near the top of the image. Using a longer gradient ensures that the changes between the foreground and the background corrections are subtle enough not to be noticed by the viewer.

Boost the presence of your subject by slightly increasing the Brightness, Contrast, Saturation, and Sharpness. These corrections help your subject stand out from the background and give your photos life.

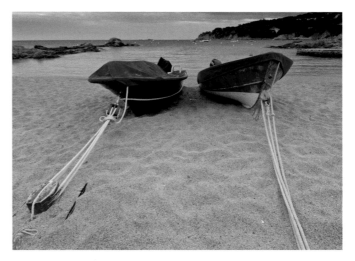

Lightening the foreground slightly makes the photo appear more three-dimensional and calls attention to the boats and their mooring lines. Settings: Exposure 0.32, Brightness 2, Contrast 26, Saturation 24, Clarity 10, Sharpness 10

Before we leave the Graduated Filter, here are two additional tips for working with gradients:

- **Adjust the length** Gradients with a short throw create a hard-edged correction, which is usually not very natural looking unless it's along a well-defined horizon, such as those at sea or along a flat horizon line. If your horizon line contains trees, buildings, people, or other variations, increase the length of the gradient. This spreads the transition across a larger distance, making the gradient more difficult to detect.

- **Hide your gradients** Whenever possible, hide the midpoint of your gradient in a portion of your image with natural transitions in tone or color.

Master Tip: Give Your Photos a Cinematic Look

If you enjoy the art of making movies, you've probably noticed that colored lighting is often used to heighten the emotional effect of a scene. Hyper-real color, particularly a nostalgic wash of orange, is often applied to scenes invoking romance, history, or freedom. You can achieve a similar, yet more subdued, effect by adding color to your gradients. I frequently add a slight tint of blue to my sky gradients and orange to my foreground gradients. Visually, this makes the photo more inviting and appealing.

After creating your gradient and performing your corrections, click the white rectangle to the right of the Color heading to open the Color Picker.

I recommend adding a blue/purple to dark or cloudy skies, particularly at dusk, and a yellow/orange to most foregrounds. I find it easiest to click first on the heavily saturated colors near the top of the Picker to select the correct hue, and then dial back the saturation using the slider at the bottom of the Color Picker.

When you are finished working with the Graduated Filter, click **Close** in the lower-right corner of the Graduated Filter panel or click the **Graduated Filter** icon.

After adding an orange tint with 30 percent saturation to the foreground and a blue tint at around 40 percent saturation to the sky gradient, the image is far more lively than it was originally.

Placing gradients along the horizon is successful because a natural gradient almost always appears along the horizon. Positioning your gradients along other transition points, such as shadow changes in subject or distance, will also make your corrections appear more natural.

Adjustment Brush

While the Graduated Filter is ideal for adjusting a large swath of an image, the Adjustment Brush is designed for quickly adjusting smaller areas with great precision. Performing corrections using the Adjustment

Brush is very similar to using the Graduated Filter, except you use a brush to apply your corrections instead of a gradient.

Activate the Adjustment Brush by clicking its icon or by pressing к. As with the Graduated Filter, be sure to show all the effects by clicking the switch to the right of the Effect pull-down menu.

Step 1 Select the appropriate brush size for your correction. Hover your cursor over the area you want to correct, and then use the left and right bracket keys ([and]) to make your cursor smaller or larger, respectively.

Step 2 To ensure that your corrections are subtly applied to the image, reduce the Density slider from 100 to between 60 and 80, depending on the intensity of your correction. If you're making a strong correction, it's often a good idea to select a lower density and build up your correction through multiple brush strokes. If your correction is subtle to begin with, you can select a higher Density setting to speed up the correction process.

Step 3 Click and drag over the areas you want to adjust to brush your corrections into these areas. Feel free to brush over all areas within the photo requiring the same correction. Or you can place a new adjustment pin in areas requiring a separate set of corrections.

For the sample image, I wanted to lighten the shadows on the hull of the boat slightly, so I created a pin near the bow of the boat and brushed across the hull in fluid, even strokes.

Step 4 Use your sliders to fine-tune the intensity of your correction.

The initial Brightness correction of +62 was too strong. Reducing the Brightness correction to +21 makes the hull of the boat look more natural.

Tip Click and drag the adjustment pin to adjust the intensity of your correction. Dragging toward the top of the image increases the correction (increases the adjusted sliders), while dragging down decreases the correction.

Step 5 Painting with a mouse or a laptop's trackpad is an imperfect art. If your brush strokes extend beyond the intended region, click **Erase**, located above and to the right of the Size slider.

Tip To see a red overlay of your corrected areas, hover your mouse over the Adjustment Brush pin (which you created at the start of your brush stroke).

The center of your cursor will change from a plus (+) symbol to a minus (–) symbol, indicating that you will subtract from your previous brush strokes. Brush along the errant brush strokes to remove them and clean up your correction.

Tip To temporarily transform your brush to an eraser, hold down OPTION (Mac) or ALT (Windows) while working with your initial brush. Release the key to return to normal painting mode.

To set the stage for discussing advanced techniques, I'll spend the rest of this chapter introducing you to Adobe Photoshop and its correction tools. In the next chapter, we'll perform selected adjustments similar to those we performed with the Graduated Filter tool, except we'll be working on compositing two images instead of correcting portions of a single image.

Should You Use Auto Mask?

The Auto Mask checkbox in the Brush portion of the Adjustment Brush panel (selected by default) restricts your brush strokes to areas of similar tone and color. The intention of the feature is to reduce the need to have to go back in and erase corrections that stray "outside the lines." In practice, I find that using this option slows down the correction process, and the masks it creates aren't precise. Unless you are performing your adjustments with a trackpad on your laptop, I recommend leaving Auto Mask unchecked and using the OPTION (Mac) or ALT (Windows) key to erase any unnecessary brush strokes quickly.

I'll reiterate a few key points about working with the Adjustment Brush or Graduated Filter:

- Delete brush strokes or gradients by hovering your cursor over the adjustment pin and pressing DELETE.

- Click the switch at the bottom of the Graduated Filter or Adjustment Brush panel to toggle the preview for all gradients or brushes on and off.

- Click **Reset** to remove all gradients/brushes.

- Click **Close** to close the panel and continue with additional corrections.

The new selective corrections tools are so good, you may never need to venture into Adobe Photoshop except to make the most advanced corrections. I suspect that in coming years, Photoshop will be used more as a program for specialized corrections, while Lightroom becomes the go-to program for the bulk of photographers' image processing.

Introduction to Photoshop

Until now, we've focused our discussion on making image corrections using Adobe Lightroom. While Lightroom has added tools for performing selective corrections to your camera raw images, it does not have the pixel-pushing power of its older sibling, Photoshop. When you begin making sophisticated selective corrections, you'll want the full complement of tools Photoshop provides you to take complete control over your photos.

The breadth and depth of Photoshop makes it impossible to provide a comprehensive tutorial on all that Photoshop has to offer. As Photoshop has grown in scope and complexity, photographers have concentrated their efforts on mastering the techniques they use daily. I will follow this strategy. After an introduction to Photoshop, I'll focus on those core techniques that you need to know to get the most out of your digital photos.

Lightroom with its versatility is like the Swiss Army knife of digital imaging tools that offers a variety of extremely useful tools for managing, editing, keywording, correcting, and printing digital photos. Photoshop, on the other hand, is like a scalpel, capable of dissecting your photos pixel-by-pixel with unmatched control.

Lightroom and Photoshop, a Symbiotic Relationship

Lightroom and Photoshop are designed so you can work quickly and easily between the two, using Lightroom for its file management capabilities and Photoshop for the selective correction possibilities available through layers. Most often you'll "round-trip" photos by performing preliminary corrections in Lightroom, performing selective corrections in Photoshop, and then saving a layered master file back into your Lightroom library. As you'll see, both Lightroom and Photoshop make this easy to do.

To make the round-trip as easy as possible, let's take a moment to configure Lightroom's export settings for the best results. You can access Lightroom's Edit in Adobe Photoshop settings from within Lightroom's Preferences dialog. For Apple computers, click the **Lightroom** menu and then click **Preferences**. In Windows, click the **Edit** menu and then click **Preferences**. Click the **External Editing** tab in Lightroom's Preferences dialog.

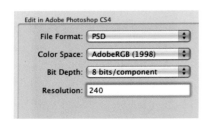

When Lightroom hands off your photo to Photoshop, it processes your raw file according to the Edit in Adobe Photoshop settings in your preferences. This makes for the most efficient workflow. Unfortunately, the default settings are designed for advanced users and will make image processing on older machines difficult.

To simplify your transition between Photoshop and Lightroom, change your Edit in Adobe Photoshop settings to the following:

- File Format: PSD
- Color Space: AdobeRGB (1998)
- Bit Depth: 8 bits/component
- Resolution: 240

These settings work well for 99 percent of all the images you will process between Lightroom and Photoshop. In Chapter 17, I'll discuss in detail the differences between file formats, color spaces, and image resolution. For now, you'll want to trust my recommendations and exit out of Lightroom's preferences. You can always alter my recommendations after reading Chapter 17.

After you've completed your preliminary corrections in Lightroom, bring your photo into Photoshop for further corrections by clicking the **Photo** menu, clicking **Edit In**, and then **Edit in Adobe Photoshop CS4**, or by pressing CMD-E (Mac) or CTRL-E (Windows).

Before Lightroom delivers your photo to Photoshop, you'll be presented with one final dialog box. At this point, Lightroom needs to know whether you want to deliver a copy of the original raw file with your Lightroom adjustments applied or the original raw file to be processed entirely within Photoshop. Click the top option, **Edit a Copy with Lightroom Adjustments**, which applies the corrections you've already made to the raw file, processes them, and opens the finished image into Photoshop. Be sure to check the **Stack with Original** checkbox to ensure that Lightroom includes your corrected file from Photoshop

in the Lightroom library. This option makes file management easy, as all of your edited versions will be accessible entirely from within Lightroom.

Navigating in Photoshop

Photoshop is a very different animal from Lightroom. If you've been spending a lot of time working in Lightroom, jumping into Photoshop can feel a little overwhelming. Fear not, because here I'll cover only a few palettes and tools that photographers use most often, and I'll introduce them in bite-sized segments to make it feel less daunting.

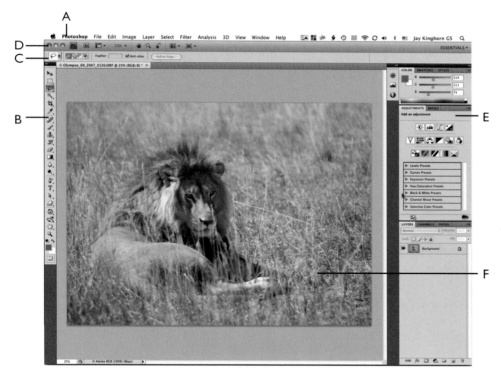

Photoshop's layout. A: Menu bar, B: Toolbox, C: Options bar, D: Application bar, E: Panels, F: Document window

Let's begin with a broad overview of Photoshop's layout. The menu commands sit at the top of the window. These menus help organize Photoshop's commands by topic. For example, the Image menu contains commands for resizing, rotating, and transforming images and converting between color modes. Don't worry if your menu bar differs slightly from the one shown here. Adobe now offers two versions of Photoshop, a Standard edition and an Extended edition, with additional tools for 3-D illustrators, video producers, and medical and scientific researchers. All of the techniques in this book, save a couple advanced options, use the tools found in the Standard edition.

The Toolbox, or toolbar, as it is commonly called, is on the left side of the window. Most photographers frequently need to use only the Selection, Retouching, and Brush tools, and you can safely ignore the rest for now.

Immediately below the menu bar at the top of the screen are the Options and Application bars. The Options bar contains additional options for the currently selected tool. For example, when the Brush tool is selected, the Options bar allows you to change the brush size, appearance, or opacity. When the Crop tool is selected, the Options bar allows you to enter your desired crop size.

The Application bar, a new addition to Photoshop CS4, makes many navigational and organizational commands much easier to use than in versions past. This eliminates the need to remember a long list of keyboard shortcuts or dive through a lengthy list of options.

Panels, the heart of Photoshop, are where you will spend most of your time. Photoshop CS4 contains 23 separate panels, each designed around accessing a specific portion of the application. For example, the Adjustments panel contains all of Photoshop's image-correction tools, from Vibrance to the Black and White correction. Frequently used panels are Adjustments, Layers, Masks, Channels, and Info. Docking or hiding your infrequently used panels will make your Photoshop experience more focused and enjoyable.

The document window, the central portion of the screen, displays your photo and hides the clutter on your desktop. If you have multiple photos open simultaneously, Photoshop creates a small tab for each one near the top of the document window (shown at right). This makes it easy to jump back and forth between multiple photos when you're compositing images.

Introduction to Layers in Photoshop

Central to compositing and essential to tone and color correction, layers give Photoshop a great deal of its flexibility and power. Once you learn to use layers effectively, you'll have a hard time imagining how you'd ever work in Photoshop without them.

The Layers panel is the starting point for accessing, creating, manipulating, and organizing layers. Layers are stacked from the bottom of the Layers panel toward the top, with layers higher in the stacking order obscuring those below. Imagine having two pictures on your desk: The picture on top covers the one below.

As shown next, a photo is seen from three different perspectives: first the finished photo, then the Layers panel displaying the layers used to create the photo, and finally an exploded view showing the stack of layers used to create the finished photo.

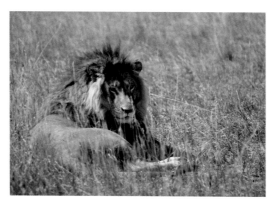

The finished photo

The Layers panel

An exploded view

This photo contains the two most frequently used layer types in Photoshop: pixel layers and adjustment layers.

Pixel layers contain the pixels created by your digital camera or scanner and are essentially what comes to mind when we think of a digital photo. Pixel layers are opaque and they obscure any layers below them in the Layers panel. For example, the topmost layer in the Layers panel, sharpen, is obscuring the four layers below it. Making changes to the Hue/Saturation or Black & White layer would have no visible effect, because the changes are hidden from view by the sharpen layer.

Adjustment layers store the color, tone, saturation, and contrast adjustments you make to your photos. Since adjustment layers are stored corrections, not actual pixels, they allow the underlying layers to show through. Think of adjustment layers as semitransparent sheets with various color tints and densities that alter the appearance of the underlying photo without actually changing the picture beneath. This image contains three adjustment layers: a Curves layer to add contrast to the image, a Black & White layer to remove the color, and a Hue/Saturation layer to add the sepia tint that is shown in the final image of the lion.

You'll become comfortable using adjustment layers as you practice the corrections demonstrated later in this chapter.

Other layer types available in Photoshop are less frequently used by photographers:

- **Text layers** Used for adding text to layouts, photos, web designs, or medical illustrations.

- **Shape layers** Used primarily in web design, graphic design, and illustration to draw standard geometric shapes such as squares and circles along with more esoteric shapes such as lightning bolts and arrows.

- **Video layers (Photoshop Extended only)** Recent support for editing and retouching video from within Photoshop was added in CS3. As a result, Adobe added video layers to allow users to manipulate and retouch videos.

A special type of layer called a *Smart Object* is in a class by itself and is used for advanced corrections. The primary advantage of Smart Objects is that changes such as sharpening or blurring are not permanently applied to the pixels on the layer, only to the Smart Object's metadata. This makes Smart Objects a powerful tool in your arsenal. We will cover their use in the next chapter.

You'll also want to be aware of two additional layer properties—namely opacity and the layer's blending mode, which affect the appearance of layers and the intensity of corrections in adjustment layers. Instead of giving you an academic discussion of these two topics, I'll revisit opacity and blending modes in context, demonstrating how to use these

features to perform specific image corrections. So without further delay, let's get started using adjustment layers to correct your photos.

If you've used Photoshop for any length of time, you already know that you can access the primary correction tools such as Levels, Curves, and Hue/Saturation in two ways. You can click the **Image** menu, then click **Adjustments**, and then click the tool name.

The second way to access these tools is by clicking the **New Fill or Adjustment Layer** button at the bottom of the Layers panel.

What you probably don't know is that a third method for performing corrections is new to Photoshop CS4: the Adjustments panel. This is a quicker method of creating adjustment layers than using the New Fill or Adjustment Layer button, though the net result is identical.

The real difference between the first method (clicking the **Image** menu and then clicking **Adjustments**) and the other two options, which create separate adjustment layers, is that corrections made by clicking menu items are immediately applied to the pixels in your photo, limiting your ability to make changes later in the editing process. We'll avoid this scenario by working exclusively with adjustment layers.

Performing corrections using adjustment layers offers three main advantages:

■ **Editability** What happens if you decide that the contrast you added three steps ago is too strong? With adjustment layers, you can quickly return to the adjustment and alter it while previewing the effect of subsequent corrections. This is particularly valuable as you develop your skills in the digital darkroom. You can revisit your early work with new skills and a new eye and fine-tune your earlier corrections. This isn't possible with other

correction methods. It is difficult to undo corrections without damaging your photo, particularly after you've saved the image.

- **Flexibility** Adjustment layers are quick to fine-tune at any stage of the image correction process. Often, it is not until you've performed several additional corrections that you realize a color correction was too strong or a saturation adjustment too severe. Correcting these minor, and inevitable, mistakes takes seconds instead of minutes or hours.

- **Selectivity** Every adjustment layer is accompanied by layer mask, the perfect tool for applying corrections to a selected area instead of the entire image. As you start using the advanced techniques described in this chapter, you will begin to appreciate the power layer masks provide over other selection methods.

Whether you decide to use the new Adjustments panel or the traditional New Fill or Adjustment Layer button to generate your adjustment layers is up to you. What's most important is that you use adjustment layers to ensure that you are taking full advantage of the tools Photoshop offers.

Introduction to the Adjustments Panel

Of all the interface changes to Photoshop CS4, the Adjustments panel will probably take the most time to get used to for longtime Photoshop users. For one thing, you can use Photoshop's tools while making corrections in the Adjustments panel, something you could never do before. This opens up some interesting possibilities, but the process can be frustrating when you're accustomed to using the old method. This also disables some keyboard tricks advanced users relied on for their work.

Working through any major change in the software is initially painful, yet it leads to greater productivity and performance in the long run.

To help you feel at home using adjustment layers, we'll get started with perhaps the most essential of Photoshop's image correction tools: Curves.

Curves

Ask any advanced Photoshop user what one tool he or she can't live without and the answer will be Curves. Most Photoshop users use Curves on virtually every image. Curves adjustments are used primarily for adding or adjusting contrast in images and performing color corrections. To get the best results from Curves, you'll need to know how the Curves settings are arranged in the Adjustments panel and how to control the curve effectively.

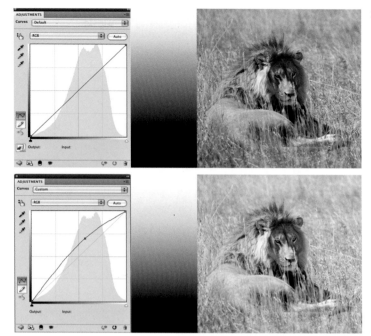

The curve graph is at the center of the Curves options and is arranged in increasing lightness, beginning with black at the lower-left point of the curve and finishing with white at the upper-right of the curve.

Control points can be placed at any area of the curve and are used to bend the curve and adjust a specific area of the tonal range. Bending the curve up and left lightens the corresponding area of the tonal range. The farther the curve moves from the center line, the more pronounced the adjustment's effects. In this case, the curve brightens the midtones and minimally adjusts the extreme shadows and highlights.

Bending the curve down and to the right darkens the image.

To make the effect of a Curves adjustment easier to see, we'll use the following example as a baseline to show an image and grayscale ramp with an unadjusted curve. Compare this graphic to the adjusted Curves image.

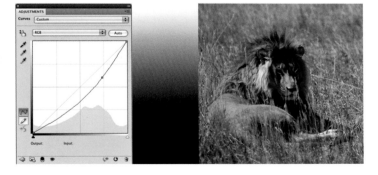

Adding multiple points to the curve gives you better control and is ideal for performing contrast adjustments.

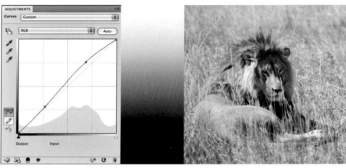

One of the most important things to remember when adding contrast with Curves is that any area of the curve steeper than the original 45-degree angle will gain contrast, while any sections of the curve flatter than 45 degrees will lose contrast. For every contrast move you make, you add contrast in some areas and remove it from others. This makes it critically important to add contrast in the *right* places.

The best way of accomplishing this is to click the On-image adjustment tool (the little hand icon) and drag your cursor, without clicking, over the key areas in the image. The circle on the curve displays the spot that corresponds to the lightness values of the pixels under your cursor. As you drag your cursor through the image, make a mental note of the range between the lightest and darkest areas of your subject.

For this particular image, I selected the on-curve adjustment and dragged my cursor over the areas of the rider's face, legs, and shoes, and then I quickly looked at the background and trail. Since I knew that I'd gain contrast in certain areas and would lose it in others, I wanted to gain contrast on the rider and background and was willing to sacrifice some contrast in the deep shadows of her jersey, shorts, and bike.

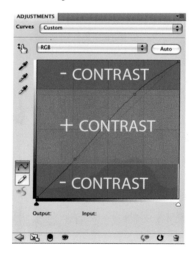

This next illustration displays the range of tonal values gathered by dragging my cursor over the key sections in the image. These points help me identify the range of values in the photo to be improved by adding contrast.

You can use the On-image adjustment tool to make adjustments directly on the image, just as you did with the Targeted Adjustment tool in Lightroom. Be careful not to add too many points to the curve, because doing so can create sharp bends and result in unnatural transitions, called *posterization*, in your image. I recommend trying to place only two points on any curve to preserve the image quality. If need be, you can create a second Curves adjustment layer to perform additional corrections.

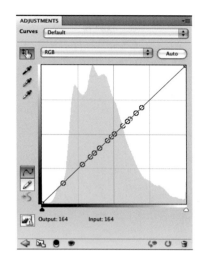

By making a mental note of the range, I can add two points to the curve, lightening the top point and darkening the lower point to create the S-curve typical for adding midtone contrast.

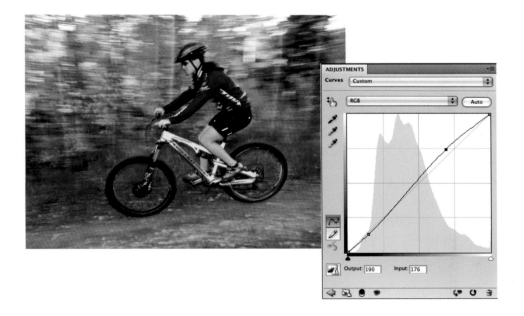

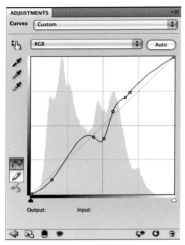

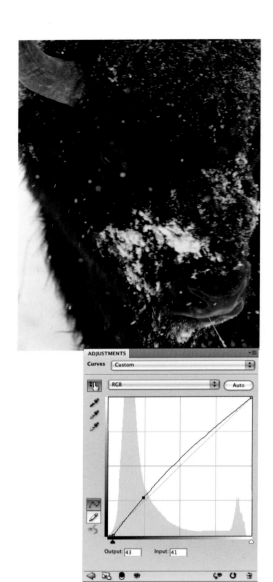

Sharp bends in a curve create unnatural and abrupt transitions, called *posterization*, in tone and color.

Most, but not all, images benefit from using this S-curve to add contrast to the midtones. Images with predominantly light or dark tones require special curves to add contrast to the correct areas of the tonal range. In the illustrations that follow, images are paired with their corresponding curve for adding contrast.

as well. You'll want to perform the majority of your color corrections in Lightroom on your raw files, but you'll often need to make slight color adjustments in Photoshop to warm up an image or balance a mixed-lighting situation by using Curves to apply color correction to a specific area.

Whenever you make color corrections in Curves, it is wise to use the Info panel to guide your corrections. The Info panel (**Window > Info**) provides a readout of the RGB color values in your photo that help you diagnose and remove color casts from your photos.

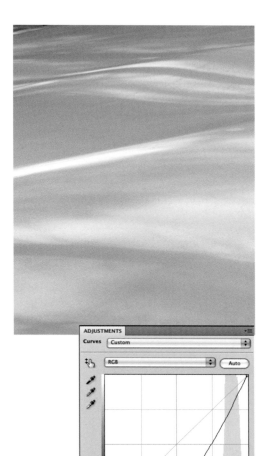

Here's how the process works:

Step 1 The photo on the next page was taken on a frozen waterfall in the deep shade, and as a result, I expect the color balance to be a little on the blue side. To verify such a hunch, you'd open the Info panel and drag your cursor over any areas of the photo that should be white, black, or gray, taking note of the RGB values listed in the RGB portion of the panel. When

Using Curves to Correct Color in Photoshop

You can use Curves adjustments for more than adding contrast or adjusting tone. Curves is a powerful tool for correcting or adjusting color

working in RGB mode, equal amounts of red, green, and blue create a neutral shade of gray. Uneven amounts of red, green, and blue indicate a color cast in the photo.

By examining the RGB values of the neutral areas in the photo (the top of the climber's helmet, the black gloves and black pants), you can see that all contain a higher blue value than either red or green, indicating a blue color cast throughout the photo.

For performing color corrections, you'll find it helpful to understand the relationships between red, green, and blue and the respective opposing colors of cyan, magenta, and yellow. Although the readout displays RGB, it is important that you know that a deficiency in red will create a cyan color cast and an increase in red and blue will make green deficient, causing a magenta color

cast. The following image illustrates the key color relationships between red, green, blue, and their opposing colors.

Step 2 Once you've determined that a color cast should be removed, place a series of sample points on the key neutral areas in the image to track your corrections, ensuring they are balanced throughout the tonal range.

The Color Sampler tool, hidden behind the Eyedropper in the Toolbox, is the perfect tool for adding color sampler points.

To select the Color Sampler tool, click the **Eyedropper Tool**, and then slide the cursor over and single-click **Color Sampler Tool**. You can add up to four sample points by clicking key neutral areas that should be black, white, or gray. The RGB values for each of your sample points appear in the lower half of the Info panel.

Here are a few guidelines for using sample points:

- In the Options bar, increase the Sample Size setting from the default Point Sample, which samples only 1 pixel, to a 5 by 5 Average, which averages the color values of 25 pixels for better accuracy.

- Set your sample points on the lit side of your subject or objects in the photo. The shaded side of an object will almost always be cooler (more blue) than the lit side and therefore will not accurately represent the overall color in the photo.

- Click and drag a sample point to reposition it. Or hover your cursor over a sample point and press DELETE to remove it.

- The primary reason for placing multiple sample points is to look for trends. You want to see the color values throughout the image, so distribute your points carefully. It's not uncommon to have one point out of line with the others (a black shirt with a slight reddish tint, for example). If multiple sample points indicate a particular color cast, you can feel confident in that assessment.

- For a photo with multiple light sources, such as a room primarily lit by fluorescent lights with daylight coming in through a window, correct the color in two steps using masks to isolate corrections to a specific light source. For your first round of color correction, place your sample points on neutral areas lit by the primary light source.

For this particular image, I placed sample points on the top of the helmet (1), on a sunlit section of the ice (2), on a point on the back of the climber's boot (3), and on the lit section of his glove (4).

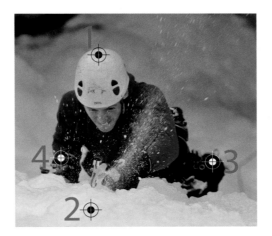

Looking at the Info panel, I can see that all four points have more blue than red or green, indicating a blue color cast. While I'm a little suspicious of point 2 since ice is often blue or a little cyan, having points 1, 3, and 4 indicating a blue color cast tells me that this photo requires color correction in Curves.

INFO			
R:	126	C:	57%
G:	143	M:	37%
B:	181	Y:	12%
		K:	0%
8-bit		8-bit	
X:	5.134	W:	
Y:	2.159	H:	
#1 R:	200	#2 R:	212
G:	200	G:	218
B:	210	B:	233
#3 R:	32	#4 R:	60
G:	31	G:	59
B:	43	B:	69
Doc: 14.1M/14.1M			

Click and drag to move layer or selection constrained to 45 degree increments.

Setting the sample points correctly is the most difficult part of color correcting. Once the points are set correctly, actually making the correction is easy—use the sample points in the Info panel to guide your corrections. You can use either Curves or Color Balance to perform your color corrections, but I prefer Curves because it gives me more precise controls and allows me to correct color in highlights, midtones, and shadows simultaneously. With Color Balance, I'm forced to correct these three regions independently.

Begin by creating a new Curves adjustment layer from the Adjustments panel or clicking the **New Fill or Adjustment Layer** button at the bottom of the Layers palette. Unlike your contrast corrections, you will adjust the red, green, and blue components independently. In Photoshop, these three color components are called *channels*. Photoshop automatically combines the red, green, and blue color channels to display your color image.

The pull-down menu near the top of the Curves settings allows you to select the channel you'd like to work with. I recommend beginning with the color that's creating the color cast. For this image, the blue channel is too high and needs adjustment.

Drag the end points of the curve up to add the channel's color or down to remove it. To remove a blue color cast, drag the highlight and shadow points in the blue channel down slightly. Use the Color Sampler points as your guide to gauge your corrections.

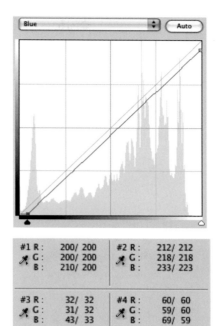

#1 R :	200/ 200	#2 R :	212/ 212
G :	200/ 200	G :	218/ 218
B :	210/ 200	B :	233/ 223

#3 R :	32/ 32	#4 R :	60/ 60
G :	31/ 32	G :	59/ 60
B :	43/ 33	B :	69/ 59

Tip When using a color or tone correction tool such as Curves, the Info panel will display two sets of numbers for each sample point: the left numbers show the original values, and the right numbers show the corrected values.

#1 R :	200/ 200	#2 R :	212/ 212
G :	200/ 200	G :	218/ 218
B :	210/ 198	B :	233/ 221

#3 R :	32/ 32	#4 R :	60/ 60
G :	31/ 31	G :	59/ 59
B :	43/ 33	B :	69/ 59

Adjust each color channel as needed until the RGB values for each sample point are equal or within a point or two of being equal.

You should be able to remove most color casts by adjusting the highlights and shadows. This corrects the color throughout the tonal range. Occasionally, you'll need to add an additional point somewhere in the midtones to correct a troublesome color cast.

Tip Use the On-image adjustment tool to set control points on the curve by single-clicking key points in your image. Photoshop will add a point to the active curve (RGB—red, green, or blue) that you can modify by dragging or by using the ARROW keys (up, down, left, right) to make subtle color adjustments.

When you're satisfied with your color correction, click the green arrow in the lower-left corner of the Adjustments panel, or click **OK** in earlier versions to close the dialog.

 You can reopen the Curves adjustment settings to make additional changes by double-clicking the **Curves** icon in the Layers palette.

After exiting the Curves settings, be sure to toggle the layer visibility on and off for a "before and after" preview. This is a helpful habit to get into with any correction to ensure that the correction you've made improves the photo's appearance.

Tip If you find your correction is too strong, you can quickly reduce the intensity of the correction by reducing the layer's opacity using the Opacity slider at the top of the Layers palette. This is faster than going back and adjusting the curve and achieves the same effect.

In a raw workflow, such as the one we're using in this book, you'll want to perform the bulk of your color correction using the tools found in Adobe Camera Raw (ACR) instead of using Curves. Using ACR allows you to make corrections to the unprocessed raw information, which will give you better image quality. You will most often perform color corrections using Curves when you need to color correct a portion of an image, which is relatively difficult to do in Lightroom. The principles for correcting a specific area are the same as those in place when you're performing global corrections such as those described here. I'll go deeply into correcting specific areas of your photo later in this chapter and in most of the next chapter. Whether you are working globally on the full image or locally on a specific portion of your image, you can use sample points whenever possible and let the Info panel guide your corrections.

While Curves is the most important adjustment tool, it is by no means the only tool available for you to use. Other adjustments, such as Hue/Saturation, Vibrance, and photo filters, are covered later in the book when we put the techniques into practice to solve real-world problems.

Before moving on, I'd like to add two final tips for you to keep in mind when working with adjustment layers:

- Create a new adjustment layer for each correction. This keeps your corrections separate from one another, allowing you to make changes more easily.

■ When creating a new adjustment layer, add your new layer at the top of the Layers palette. This way, your Layers palette always contains the newest corrections on top and the oldest at the bottom. This is important, because the stacking order of the layers affects their appearance, and it is an effective organizational tool to help you change layers quickly.

Photoshop will always insert the new adjustment layer above the currently active, or *targeted*, layer. The targeted layer is designated with a blue highlight in the Layers palette. Single-clicking the topmost layer in the Layers palette before adding a layer will ensure that your newly created layer is always on top.

Adjusting Specific Areas in Photoshop

The majority of your *global corrections*, corrections applied to the entire image, will be completed in Lightroom to your camera raw file. This will give you the best quality, because these changes are made to the unprocessed file, whereas corrections made in Photoshop are always made to a processed file and cause some degradation in image quality. The amount of quality loss is determined by the quality of the original and the severity of the correction.

Nevertheless, the key point to remember is that you want to perform as many of your corrections as possible within Lightroom, using Photoshop primarily for adjusting localized areas within the photo, compositing images, or performing other advanced multi-image techniques such as extending the dynamic range, creating a High Dynamic Range (HDR) image, or building a panorama. These are the areas in which Photoshop excels, and one of the fundamental skills common to Photoshop's advanced techniques requires the use of layer masks.

Masks and Selections

The key to isolating individual elements of your images is the effective use of selections and layer masks. These allow you to use any of Photoshop's adjustment tools including Curves, Hue/Saturation, and Vibrance with exacting precision to adjust the color of a flower, brighten a smile, or soften harsh shadows.

The traditional method of adjusting a specific area, such as lightening a foreground, was to use the Lasso tool or other selection tools to select the foreground, and then use the tools found by clicking the Image menu and clicking Adjustments to lighten the selected area. This workflow was simple and quick, but it left no room for error since these changes were difficult to undo without losing a lot of work. If the edge of the selection was visible in a finished print, the photographer would either repair the area or have to go back to the original image.

Fortunately, this workflow has given way to the use of nondestructive layer masks, allowing you more flexibility and "correctability" than selections alone. Masks are quicker to create, easier to apply to multiple layers, and, unlike selections, saved

with the document so you can go back to a mask again and again. In today's workflow, photographers rarely need to make selections, unless

- the selection forms the basis for an eventual layer mask, or
- you're removing an object from a background, a process called *clipping*.

For these reasons, we've elected to concentrate our discussion on layer masks, which you can use to create and use both simple and complex masks.

 Since selections still play a role from time to time in a photographer's workflow, we've posted a detailed article on Photoshop's selection tools and selection techniques online at www .perfectdigitalphotography.com/ selections-masks.php.

FROM SELECTIONS TO MASKS

Many Photoshop users never venture into the world of layer masks. This is unfortunate, because layer masks are key to unlocking the full potential Photoshop offers digital photographers. I encourage you not to be intimidated by layer masks. The fundamentals of layer masks are simple, and potential uses are endless.

Before we get too involved in the terminology associated with masks, let's take a look at what a mask is and what masks are used for.

Layer Masks 101

A layer mask is a means of limiting a correction or hiding a portion of a pixel layer. Layer masks are used to apply image corrections to a specific area within an image or for compositing multiple images together.

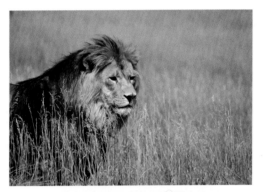

When an image (top) has a layer mask (center) applied, the black areas of the mask hide the pixels on the layer, resulting in the image at the bottom.

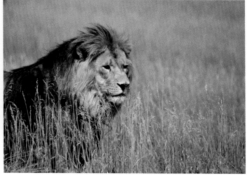

Layer masks are also applied to adjustment layers to restrict their corrections to specific areas within a photo. Here, a Hue/Saturation adjustment layer is used to desaturate a portion of the image. The layer mask (top) hides the correction, preserving the original color in the center of the photo (bottom).

Applying the gradient at top as a layer mask to a Hue/Saturation correction creates a smooth transition from color to black and white. The black areas of the gradient hide the desaturation applied by the Hue/Saturation layer, while the white area allows the correction to be applied fully. The gray areas in the transition allow a portion of the correction to be applied to the image.

Masks can contain not only black and white, but also shades of gray. This allows you to feather your mask to hide your corrections more effectively or make the transitions between composited images seamless.

Layer masks, by themselves, don't apply any particular effect to an image. Instead, they are an attribute of the layer to which they are connected and show or hide portions of that layer. This is the most difficult concept to grasp, and the best way to understand layer masks is to begin working with a few of your own.

352

On the Web

For more on layer masks, view the Layer Mask tutorial video online at www.perfectdigitalphotography.com/selections-masks.php.

Try following along with this example:

Step 1 Open a digital photo in Photoshop and create a Hue/Saturation adjustment through the Adjustments panel. Reduce the Saturation to −100 to pull all the color out of the image.

Step 2 Click the **Brush Tool** in the Toolbox and select the **Airbrush Soft Round 50% flow** preset from the Tool Preset picker in the Options bar.

Step 3 Press D on your keyboard to return to the default paint colors (white and black), and then press x to exchange the foreground for background color.

Step 4 Paint on the image to begin returning the color to your black and white image. Change the brush size as needed by using the Brush Preset picker located just to the right of your Tool Preset picker in the Options bar.

Step 5 If you make a mistake, you can brush out your corrections by pressing x to reverse your foreground and background colors and paint over your mistake.

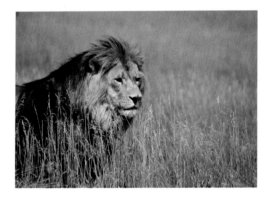

Congratulations! You've created your first layer mask. Pretty easy, isn't it? To learn more about layer masks, let's look at exactly what you did.

How Do Layer Masks Work?

When you create an adjustment layer in Photoshop, a layer mask is automatically added to your correction. The layer mask is the white rectangle icon to the right of the adjustment icon in the Layers palette.

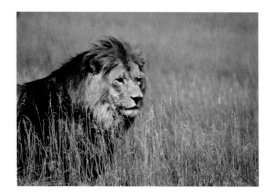

An important rule to remember with layer masks is *white reveals, black conceals*. Since the layer mask is white by default, it reveals the change created by the Hue/Saturation adjustment. In this case, it removed all the color from the image. When you began brushing with black on the layer mask, you began selectively removing the Hue/Saturation correction from the picture, causing the original color to return.

If you look at the layer mask separate from the image, you can see that any area on the mask that is black has returned to its original color. Areas on the mask in gray have returned a portion of the original color.

The purpose of this illustration is not to teach you how to hand-color all your photos, although that is one common use of layer masks. Instead, it is to reinforce the notion

that the black portions of the mask hide your corrections (or pixels) and white portions reveal your changes. Once you have this concept down, using layer masks is really easy. The difficulty arises when you want to apply layer masks to a complex or heavily detailed portion of the image. Don't worry, though, because we'll start simple and once you get the hang of using layer masks, I'll offer several tips for making complex masks in the next chapter.

For another example, we'll use a common scenario: You apply an S-curve to increase contrast in the midtones. While this change benefits the image as a whole, it negatively impacts a small portion of the photo, such as the foreground ice in this photo.

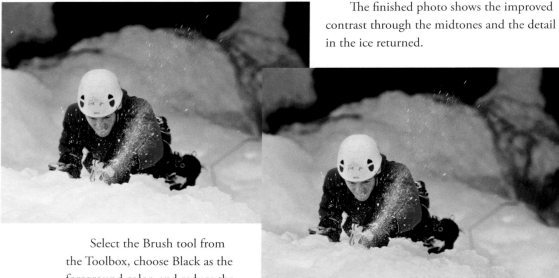

The finished photo shows the improved contrast through the midtones and the detail in the ice returned.

Select the Brush tool from the Toolbox, choose Black as the foreground color, and reduce the brush opacity to 40 to 60 percent; this allows you to paint out the contrast in the negatively impacted area. This image shows a black overlay on the painted areas of the mask.

Note When painting on the layer mask, you should not see the addition of black or white; you will see only the adjustment layer's change added or subtracted from the photo.

Tips for Working with the Brush Tool

Many of the layer masks you'll use are so crude, you won't need to create a selection before building your mask. For these masks, you'll use the Brush tool to target a specific region of your photo. Since you'll be spending a lot of time using the Brush tool, I'll arm you with several tips for using the tool when creating masks.

Although Photoshop comes with dozens of brushes in all shapes, sizes, and textures, you really need to use only two brushes for your work: a soft-edged brush for gently applying color and contrast corrections and a hard-edged brush for making changes along well-defined edges or lines.

The brush size, shape, and intensity are determined by three controls in the Brush Preset

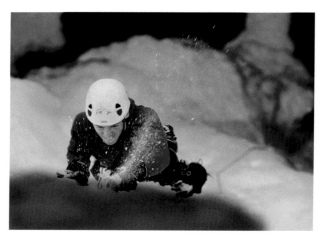

The image with a black overlay added to indicate the painted area of the layer mask

picker and Options bar: Brush size, Hardness, and Opacity. The Brush Preset picker is displayed only when the Brush tool is selected, so be sure you've selected the Brush tool.

The Master Diameter slider controls brush size (in pixels). It can be difficult to select an appropriately sized brush using the Master Diameter slider because the effective brush size is relative to the overall image size. This means a 100 px brush will appear tiny when working on a 3000-pixel–wide digital photo and will appear quite large when working on a small web graphic. Instead of setting your brush size in the Brush Preset picker, set your brush hardness and use keyboard shortcuts.

The Hardness slider setting determines how well defined the edges of a brush stroke are. A low Hardness setting creates a soft brush, ideal for making subtle changes to a mask. A high Hardness setting is often used in compositing, where a precise edge is essential.

The Hardness determines whether the paint strokes have soft or hard edges. Both brush strokes use a 60-pixel brush, but the top stroke uses a Hardness setting of 0 while the bottom uses a Hardness setting of 100.

Tip Use keyboard shortcuts. The easiest way to choose the correct brush size for all your painting needs is to hover your cursor over the image you'll be painting on and use the right bracket (]) and left bracket ([) keys to increase or decrease the brush size, respectively. This allows you to set your brush size visually relative to your photo.

The third important brush attribute is the brush Opacity, controlled by the Opacity slider in the Options bar.

Reducing the opacity helps your brush strokes blend in your changes more naturally. When applying subtle contrast or color changes, set your brush Opacity between 40 and 60 percent with a soft brush. This masks any imperfections in your brush strokes and allows you to build up your correction in several steps.

The topmost brush stroke uses a soft brush set to 100 percent Opacity. The remaining three strokes show the effect of painting using multiple passes at a decreased Opacity setting, from a single pass at 50 percent, to four passes at 50 percent.

Tip You can adjust the brush Opacity using the number keys on your keyboard when the Brush tool is active. Press 5 for 50 percent, 9 for 90 percent, and so on. Pressing 0 (zero) will return the brush to 100 percent.

Now that you feel comfortable using Photoshop's brushes, it's time to put your newfound skills to work modifying layer masks with the Brush tool.

Tips for Working with Masks

To review what we've covered so far, every Curves, Levels, or Hue/Saturation adjustment layer is accompanied by a white rectangle in the Layers palette. This rectangle is a layer mask for the adjustment layer. Since the layer mask is filled with white by default, any changes you make to the adjustment layer are applied to the entire image. Using the Brush tools on a layer mask, you can isolate your changes to a specific region of the image without affecting the rest of the image. Furthermore, you can adjust, scale, blur, and sharpen the layer mask to achieve very exacting results. Layer masks give you flexibility unmatched by traditional darkroom techniques.

To help you get up to speed quickly with layer masks, I've compiled a list of helpful tips. Use these to supplement the fundamental techniques discussed so far:

- When making a change adversely affecting one portion of an image, simply mask it out using the Brush tool and paint black on the layer mask.

- When you need to apply your correction to a small portion of the image, invert the layer mask from white to black by pressing CMD-I (Mac) or CTRL-I (Windows). Then brush in your correction by painting white on the layer mask.

- Use any of the selection tools to select a portion of the image, and then create your adjustment layer. Your selection will convert automatically to a mask and be applied to the new adjustment layer.

- Copy layer masks from one layer to another by holding down the OPTION (Mac) or ALT (Windows) key while clicking and dragging the layer mask to the new layer. When prompted, click **Yes** to replace the existing layer mask.

- Use the backslash (\) key to show your mask as a colored overlay on the image. The default color is red, but you can change this by double-clicking the layer mask thumbnail in the Layers palette.

Tip When using the backslash shortcut, be advised that Photoshop sometimes switches your foreground and background colors as it toggles between the mask preview and the original image.

Temporarily disable the layer mask by holding the SHIFT key and clicking the layer mask thumbnail in the Layers palette. I frequently use this to locate errant brush strokes or halos around the masked areas while zoomed in to a detailed section of the photo. (See the "Navigating in Photoshop" sidebar for additional information.)

Now that we've covered the basics for working with layer masks and adjustment layers, let's look at how you can apply a layer mask to your pixel layers to begin compositing multiple images. I'll address compositing along with many more advanced corrections in the next chapter.

Navigating in Photoshop

Unlike Lightroom, you can't zoom in while using Photoshop to check the detail of a section by clicking the main image. Instead, you'll need to use the Zoom tool, either directly by clicking the Zoom tool at the bottom of the Toolbar or indirectly by using a keyboard shortcut, which is much faster.

Two sets of keyboard shortcuts are available for zooming. Use the one that is most comfortable for you:

Set 1

Zoom in CMD-+ (Mac), CTRL-+ (Windows)

Zoom out CMD - − (Mac), CTRL - − (Windows)

Set 2

Zoom in CMD-SPACEBAR-click (Mac), CTRL-SPACEBAR-click (Windows)

Zoom out OPTION-SPACEBAR-click (Mac), ALT-SPACEBAR-click (Windows)

With either set, you don't immediately zoom in to 100 percent Actual Pixels view as you do in Lightroom. Instead you incrementally zoom through the zoom percentages, from 25 to 33, 50, 66, and then finally 100 percent.

If you want to jump to 100 percent view quickly, as you're accustomed to doing in Lightroom, press CMD-OPTION-0 (zero) (Mac) or CTRL-ALT-0 (Windows).

To see the full image in the document window, press CMD-0 (Mac) or CTRL-0 (Windows).

How To: Making Selective Adjustments in Lightroom and Photoshop

The more you work with Lightroom and Photoshop, the more you'll see opportunities to improve specific areas within your photos for maximum impact. The techniques covered in this chapter have shown you how to use the selected correction tools in Lightroom and create selections and layer masks in Photoshop for precise control. This How To will give you insight into the thought process behind assessing and executing these corrections.

This image has been corrected using the basic suite of tools found in Lightroom's Develop module. Overall, the color balance, exposure, and contrast are correct. Many photographers would be happy with the image as is.

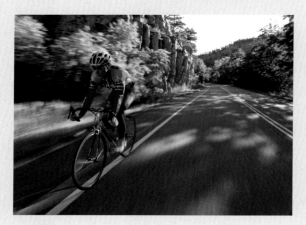

Given the selective correction tools, however, I think it can be made even better.

Looking at the image, the cyclist doesn't have enough contrast to stand out sufficiently from the background. Because the detail on the cyclist falls on the shadow end of the spectrum, adding contrast to these areas is best done in Photoshop using Curves instead of in Lightroom. While Lightroom's Adjustment Brush is an excellent tool, it doesn't provide the fine control over shadow detail and contrast that Curves provides.

Press CMD-E (Mac) or CTRL-E (Windows) to open the image into Photoshop CS4. If prompted, click **Edit**

a Copy with Lightroom Adjustments and check the **Stack with Original** checkbox. This will bring your corrected file back into the Lightroom library.

Once in Photoshop, I'll create a Curves adjustment layer. Using the On-image adjustment tool to assess the range of tonal values on the rider, I create a steep curve to lighten and add contrast to the shadows and dark midtones.

Pressing CMD-I (Mac) or CTRL-I (Windows) inverts the mask, filling it with black and hiding my correction.

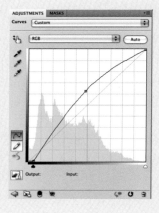

Using a soft brush with the Brush tool set to 50 percent opacity, I paint with white over the key lines in the rider's jersey, helmet, face, and bike. Instead of painting completely over the rider, I'm painting along key lines that I want to bring forward. For example, I'm painting over the rider's left arm, but not his torso, to create visual separation between the two elements.

Next, I switch to 30 percent opacity and paint with white over the bike tire, hub, fork, shoe, and highlight in the front wheel. These are all key portions of the bike and rider, and I want them to stand out.

Choosing a lower opacity ensures they do so, but it does not call attention from the rider.

I'm happy with the correction and can now turn my attention to secondary elements within the photo, namely the road. I feel the road could use more contrast to enhance the appearance of the motion blur in the foreground and emphasize the dappled highlights.

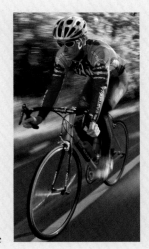

I create another curve and boost the shadows in this one as well. I'll also slide the shadow point slightly from left to right to deepen the shadows.

This improves the road but adds too much contrast in the rocks behind the rider, so I'll apply a quick gradient mask using the Gradient tool to remove this contrast adjustment from the top half of the image.

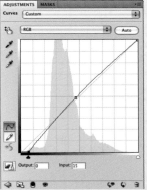

For a final touch, I'll add a bit of warmth to the shadows in the road by creating a Curves adjustment and adding 2 points of red and subtracting 4 points of blue.

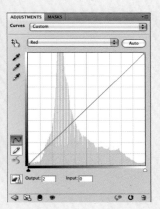
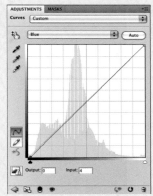

These three steps improve the quality of the picture significantly. Don't you agree?

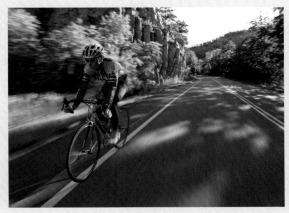

Before

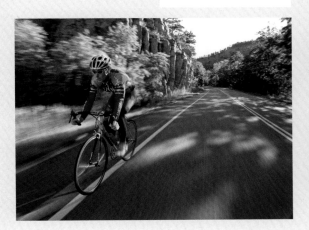

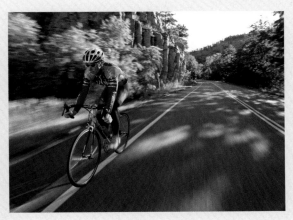

After

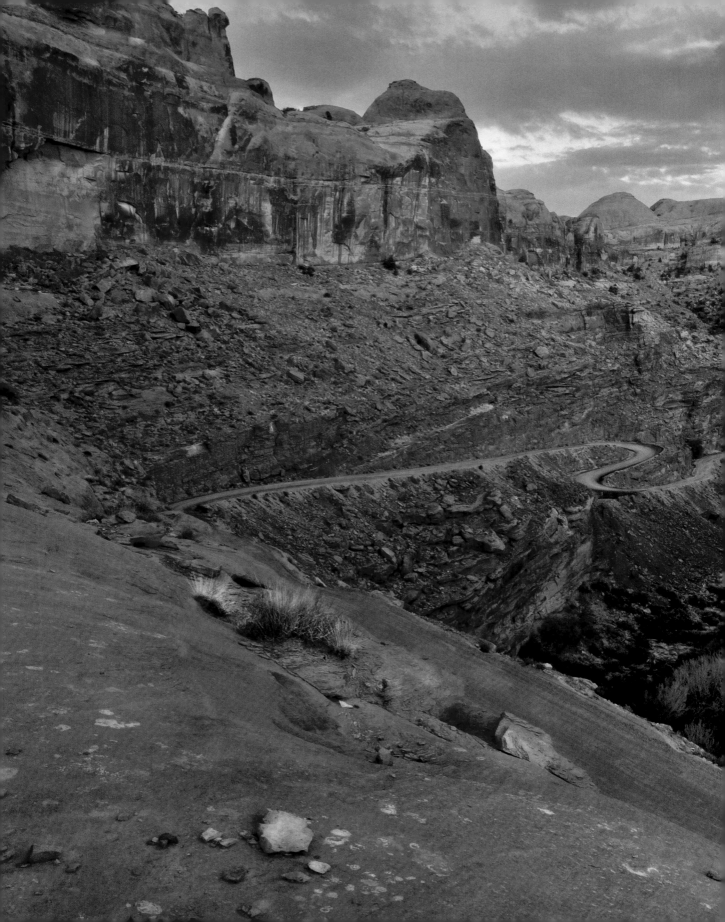

ADVANCED IMAGE CORRECTIONS

The true power of the digital darkroom lies in its ability to let you shape and sculpt photos for better interaction with viewers. This is a topic of such breadth and depth that it requires far more space than this book will allow. So in the interest of brevity, I've compiled a list of *Four Rules for the Digital Darkroom,* which form the basis for the techniques presented in this chapter.

Kane Creek Road, Moab, Utah. Olympus E-3, 12–60mm lens, 1/5 second at f11, ISO 100

Note The material presented here is designed for readers who already feel comfortable with the global corrections in Lightroom and the selective corrections demonstrated in Chapter 15. These techniques require a greater degree of skill and experimentation than those required in earlier chapters. If the digital darkroom is still new terrain to you, I'd suggest skimming this chapter and continuing on to Chapter 17. For those of you who want to attain a higher degree of dexterity and mastery in your photo corrections, this chapter may become your digital darkroom bible.

FOUR RULES FOR THE DIGITAL DARKROOM

In my small group training sessions, participants are often hungry for the "why" as well as the "how" of correcting photos. Learning techniques alone, while important, is insufficient. Understanding why a particular technique is effective, when to apply it, and how to modify it to adapt to changing circumstances are the most important skills you can develop and are the keys to developing your artistry in the digital darkroom.

While these concepts aren't necessarily simple, they can be described through a series of guidelines for refining digital photos for greater depth, presence, and emotion.

Rule 1: *Your eye is always drawn to the lightest and highest contrast area in a photograph.* Our brains are wired to scan a scene quickly, looking for edges, contrast, and shapes. When glancing at a photo, we're biologically programmed to look at the lightest and highest contrast areas first. Use careful composition and judicious burning and dodging to make sure your subject is the lightest and highest contrast area in a photo. This establishes a visual hierarchy in which the lightest elements are the most important and therefore demand the most attention.

Rule 2: *When looking at a photo, a viewer looks first at shapes and then attempts to interpret those shapes based on familiar patterns.* We have a visual database in our brains that allows us to identify common objects quickly. This is how we can identify a silhouetted tree as a tree, not as a dark blob on the horizon. Unfamiliar shapes take longer to read and require more careful attention. Well-conceived abstract photos are successful because they break this rule, creating a visual puzzle for us to solve. A key to making your photos engaging is to make sure all key elements in a photo "separate" visually from one another by selectively lightening and darkening the tones of elements within the photo.

Rule 3: *Contrast = Detail.* The human visual system has evolved to be highly attuned to movement and edge contrast. When looking at a photo, a viewer's eyes naturally travel along areas of high contrast and sharp detail. By controlling contrast and sharpness, you can, in effect, control exactly where the viewer's eyes travel in your photos. On a technical level, the appearance of detail in digital photos is due

to subtle differences in the lightness and color values between pixels. Enhancing contrast increases those differences and makes detail more apparent.

Rule 4: *Warm colors (orange, reds, and yellows) feel more comfortable and inviting than cool colors (cyan, blue, and green).* Cream is the most popular paint color for rooms because the subtle addition of a little orange makes the room feel more

cheery and inviting than a strictly neutral white. Adjusting saturation and hue to make colors warmer, cooler, or more vibrant is one way to enhance the mood created by your photo.

To demonstrate these four rules in action, compare the figure on the left to the one on the right. Do you react differently to the two photos? If so, what's different between the two? The answer is in the caption.

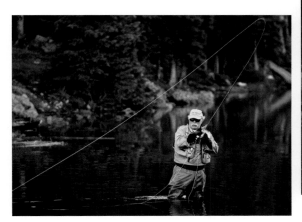

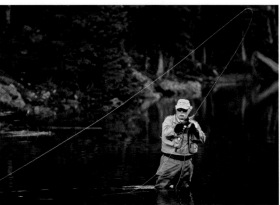

Several subtle, yet important, changes have enhanced this picture. First, the two patches of snow on the far bank were removed so as not to detract from the main subject. Second, contrast is enhanced throughout the photo to increase the visibility of details. Third, red and yellow have been added to warm the photo. Finally, key areas of the photo were burned and dodged to make the photo easier to "read" with a quick glance.

On the Web To learn more about the science of seeing and its relationship with the arts, visit www .perfectdigitalphotography.com/artistry.php. Also check out *Vision and Art: The Biology of Seeing* by Margaret Livingstone.

As you read about the concepts described in this chapter, think back to how they relate to the Four Rules and how you may begin applying the Four Rules in your images corrections.

One of the most important tools for applying the Four Rules to your photos is the layer mask. In Chapter 15, I covered several ways of using layer masks to apply a correction selectively. This chapter continues working with a variety of advanced image corrections.

BURNING AND DODGING

The concepts behind burning and dodging are simple; knowing *when* and *where* to burn and dodge is not. The terms *burning* and *dodging* are carryovers from the traditional wet darkroom, where photographers used all sorts of methods and techniques to modify the amount of light reaching the print from the enlarger. While those days are behind us, the need for burning (darkening specific areas of a photo) or dodging (lightening specific areas) is still critical to adding depth to a print, increasing the appearance of detail, or improving the separation between elements of a similar brightness level.

Unlike the corrections we've made up until now, burning and dodging is used to make precise corrections on very small areas—the petals of a flower or a tuft of grass, for example.

Typically, you'll burn and dodge near the end of your correction process after you've performed global tone and color corrections. A photographer uses burning and dodging in the same way that a chef tastes a sauce just before she adds it to the entrée, making slight adjustments to accent specific flavors.

Should You Burn and Dodge in Lightroom or Photoshop?

Lightroom 2 lets you perform simple burning and dodging within the Develop module using the Adjustment Brush. So, should you burn and dodge in Lightroom or in Photoshop? The answer is both.

As I've often said in this book, it is best to perform as many of your corrections as possible on the unprocessed raw file. That said, the burning and dodging controls are more sophisticated in Photoshop than they are in Lightroom. For most of your photos, you'll perform simple burning and dodging adjustments in Lightroom, and then you'll jump into Photoshop for specific edits requiring additional precision.

Tools for Burning and Dodging

The most commonly used tools for burning and dodging are the Brush tool and the Burn and Dodge tools. The Brush tool is, by this point, familiar from all the work you've done with masks. It is useful for burning and dodging broad areas within a photo. The Burn and Dodge tools are used similarly to the Brush tool; however, their effect on an image is quite different. They are better suited for very subtle burning and dodging changes to the photo.

The Burn and Dodge tools are located near the middle of the Toolbox below the Gradient and above the Pen tool.

Like the Brush tool, the Burn and Dodge tools have a Brush Preset picker in the Options bar for setting the Brush size and hardness. Unlike the Brush tool, the Burn and Dodge tools use an Exposure setting instead of Opacity and contain a Range pull-down menu that allows you to target your corrections to the shadows, midtones, or highlights. The Range setting is where the new, and greatly improved, Burn and Dodge tools in Photoshop CS4 really shine. By restricting your corrections to a specific tonal range, you have more control to lighten the contours of your subjects or subtly darken shadows to improve contrast.

Unfortunately, the Burn and Dodge tools are "destructive" tools, meaning their effects are immediately applied to the pixels in your image. Fortunately, by creating a specific burn and dodge layer, you can enjoy the flexibility of nondestructive editing used throughout this book.

Creating a Burn and Dodge Layer

To create a burn and dodge layer, hold down the OPTION (Mac) or ALT (Windows) key while clicking the **Create New Layer** icon at the bottom of the Layers panel. In the resulting dialog, type the new layer name, **Burn and Dodge**; set the layer blending mode to **Overlay**; and check the **Fill with Overlay-neutral color (50% gray)** checkbox. Click **OK** to create your new layer.

Layer blending modes are a means of controlling the appearance and properties of Photoshop's layers. When the default blending mode, Normal, is selected, a layer exists independent of all other layers in the document. As soon as you change the layer blending mode from Normal, you force Photoshop to calculate the appearance of the layer based on the characteristics of the layers below it and by the specific attributes of the blending mode. For example, any painting with white on a layer with the Overlay blending mode causes the pixels on the layers below to appear lighter. Painting with black causes pixels to appear darker. In the Normal blending mode, these corrections would simply create white or black paint strokes.

 On the Web Blending modes are a powerful tool for image correction and creative control. Unfortunately, a full discussion of layer blending modes is beyond the scope of the printed edition of this book, but you can find a thorough discussion on the use of blending modes on our website at www.perfectdigitalphotography.com/photoshop.php.

Burning and Dodging in Practice

Now that you have created the Burn and Dodge layer, you have two types of tools at your disposal: the Brush tool and the Burn

and Dodge tools. The Brush tool is used for broadly burning and dodging specific areas. The Burn and Dodge tools offer an additional level of control, allowing you to adjust a specific portion of the tonal range within a specific area. For example, the Burn tool allows you to darken only the shadows within the image. If your brush passes over a shadow and highlight pixel, the shadow pixel will be darkened, while the highlight pixel will remain unchanged. When using the Brush tool, all tonal areas are affected. When using the Brush tool to burn, passing your cursor over a highlight and a shadow pixel will darken both.

In Photoshop CS3 and earlier, I used the Brush tool primarily for burning and dodging broad areas, and then used the Burn and Dodge tools for working smaller, specific areas. In Photoshop CS4, Adobe improved the way the Burn and Dodge tools work, and I now find myself using Burn and Dodge almost exclusively. My suggestion is to learn how to use both and experiment to see which one best suits your workflow.

Burning and Dodging with the Brush Tool

To use the Brush tool for burning and dodging, select an appropriately sized brush with a low hardness setting and set your brush opacity to 10 percent. The Overlay blending mode is sensitive to changes in lightness, and a low opacity setting is best for making the subtle changes needed for effective burning and dodging.

To burn (darken), set your foreground color to black by pressing D to return to the default foreground and background colors.

To dodge (lighten), set your foreground color to white by pressing D to return to the default colors, and then exchange the foreground and background colors by pressing x.

Begin painting over the areas you want to burn and dodge. Sometimes, the changes are quite subtle, and you'll need to toggle the layer visibility icon (the eye) on and off to view the changes.

If your changes are too strong or you make an errant brush stroke, you can paint over the change by adding a layer mask and hiding your correction by painting with black on the layer mask. You can also reduce the intensity of your brush correction by using the Fade Brush command (**Edit > Fade Brush**) immediately after applying your brush stroke.

Burning and Dodging with the Burn and Dodge Tools

The Burn and Dodge tools add another level of control over your burning and dodging by allowing you to specify which portion of the tonal range you want to affect. For example, I typically dodge the highlights in an image and burn the shadows to give an image additional punch.

To dodge the highlights, select the **Dodge** tool from the Toolbox, set **Range** to **Highlights**, **Exposure** to **10%**, and be sure the **Protect Tones** checkbox is checked.

Paint over the highlights you want to lighten. On a portrait, lightening the reflective highlights, also called *specular highlights*, in the

eyes, on the lips, and on jewelry increases an image's vibrancy. In a landscape, dodge the highlights in clouds, grasses, tips of trees, and bodies of water to add depth to the photo.

To burn the shadows, select the **Burn** tool from the Toolbox, set **Range** to **Shadows**, **Exposure** to **10%**, and be sure the **Protect Tones** checkbox is again checked. Generally, you'll want the Protect Tones option enabled whenever you use the Burn or Dodge tools.

Paint over the shadows in the image to add depth and richness to the photo. Darker areas tend to recede from view, while lighter areas come forward.

Burning and dodging help make your photos more three-dimensional and lifelike. However, learning *how* to burn and dodge is the easy part. Far more difficult is learning precisely *where* to burn and dodge for maximum benefit. This is a skill gained from lots of time working in a traditional or digital darkroom. Fortunately, the Four Rules for the digital darkroom can help guide your corrections.

Learning to burn and dodge effectively is one of the most important steps toward taking full creative control of your photos. Typically, you'll perform your burning and dodging near the end of your image corrections. The last step in most photographers' workflows is image sharpening.

IMAGE SHARPENING

Image sharpening is one of the most widely used, but least understood, tools in a photographer's workflow. Becoming highly proficient at image sharpening takes practice, but that shouldn't deter you from using the tips and techniques presented here to dive in and begin experimenting. Along the way, I'll highlight a few of the key "gotchas" that can crop up when sharpening and teach you how to avoid them.

How Image Sharpening Works

Image sharpening is a clever trick used to fool our eyes into believing more detail exists in the image than there actually is. Here's an example (shown on the next page). In this figure, two red rectangles isolate to shades of gray. Which is lighter, A or B?

Which of the two rectangles is lighter: A or B? Cornsweet illusion adapted from Livingstone's *Vision and Art: The Biology of Seeing*

The answer: They are exactly the same shade of gray. Place your hand over the transition in the center and you'll quickly see that your brain fooled your eyes into seeing a difference where there isn't one. This illustrates the art of sharpening.

Sharpening works by increasing contrast along an edge, lightening one side and darkening the other, so our brain perceives a greater difference between the lightened and darkened edges. Lightroom and Photoshop perform this lightening and darkening along the smallest of edges in our photographs, improving the visible detail in hair, grasses, and other tiny, but critical, textures. A well-sharpened image with lots of detail is a tactile experience. We can almost reach out and touch the roughness of the wood or feel the individual hairs in a dog's fur.

For this illusion to be convincing, you have to be diligent in refraining from excessively sharpening images. Photos that are too sharp appear gritty and saccharine, two qualities best avoided unless that is your explicit goal.

The key to making your sharpening both effective and realistic is learning to set the Radius setting effectively. The Radius setting, as you'll see, is found in all sharpening tools discussed in this section. It controls the width of the lightening and darkening that occurs along each of the edges in your photo. Set your Radius too high and you'll actually diminish the amount of detail in your photos. Set it too low, and the sharpening won't be effective. Keep this in mind as you evaluate Lightroom and Photoshop's sharpening tools and place them within the context of your workflow.

When to Sharpen— Early, Late, or Both?

For many years, photographers and Photoshop experts argued whether sharpening should be a single-step process that occurs at the end of the workflow, immediately prior to printing, or a two-step process with one round of sharpening occurring early in the workflow and a second one happening right before printing.

When using camera raw files, it makes the most sense to adopt a two-step sharpening approach. The first round of light sharpening improves the overall definition and clarity of the image, and the second prepares it for the output method: print, web, or video.

To help clarify the two steps, the first round of sharpening is often called *capture sharpening*, and the second, *output sharpening*.

Capture sharpening is best done in the raw processing software to take advantage of the full range of unprocessed information the raw file contains. Capture sharpening requires a delicate touch so as not to introduce problems that will need fixing later in the workflow.

Creative sharpening, a component of capture sharpening, is a term given to the process of selectively sharpening key areas within the photo, such as the subject of a portrait or a key foreground detail in a landscape. This can be done within Lightroom using the Adjustment Brush, or in Photoshop using a layer mask to restrict sharpening to selected areas.

Output sharpening is usually performed as a final step in the workflow and is geared toward achieving maximum image sharpness for a given output size, output device, and media type. For example, the settings for output sharpening will be far higher on a large image printed on an absorbent watercolor paper than on a smaller web image.

Understanding the role of each type of sharpening will help guide your corrections. Let's look at the sharpening options to get a feel for the controls found in both Lightroom and Photoshop.

Capture Sharpening in Lightroom

Lightroom's sharpening tools are found in the Detail panel of the Develop module. Here, you'll find four controls designed to improve the sharpness of your images:

- **Amount** The Amount slider controls the intensity of the sharpening. Boosting the Amount amplifies the effect of the other settings, particularly the Radius.

- **Radius** The most critical control, Radius, determines the width of the halo created by lightening and darkening each edge in the photo. Images with lots of fine detail require a low radius, while images with coarse detail are best served with a medium radius setting. A high radius setting can be used for creative effect.

- **Detail** This slider controls how deeply Lightroom "digs" into the image to tease out hidden or subtle detail. A high Detail setting will pull detail out of subtle, smooth tones, while a lower Detail setting concentrates sharpening on well-defined edges.

- **Masking** Increasing the Masking slider causes Lightroom to build a layer mask on the fly to restrict sharpening to the higher contrast, well-defined edges. This prevents image sharpening from ruining

the smoothness of skin tones or skies and protects images from becoming overly noisy when sharpened.

When working in Lightroom, your goal is to improve the sharpness of your photo gently, in preparation for future corrections. You have to be careful not to add too much sharpening as it will cause problems when preparing images for output.

Let's go through Lightroom's controls to see how they work together in a real-world context. For each control, I'll highlight what you should be looking for to ensure your sharpening is correct, every single time.

Begin with an image open in the Develop module. Scroll down past the Basic, Tone Curve, and HSL controls to target the Detail sliders. At the top of the Detail panel is a small preview window. Because it is so small, relative to the size of the monitor, go ahead and hide it by clicking the dark gray triangle to its right. Once the preview is hidden, an exclamation point appears to caution you against sharpening while not working at 100-percent zoom.

I strongly recommend heeding this warning. Zoom into your image by clicking the exclamation icon or by clicking in the preview window. Whenever you are applying capture sharpening, it is essential that you are zoomed in to the actual pixels view. Otherwise, you run the substantial risk of oversharpening your images. Many sharpening

errors, or *artifacts* as they are often called, aren't visible when you're looking at the full image. Only by looking at actual pixels, or at a finished print, can you see these problems. So always zoom in to perform your sharpening.

Center your preview over the area in the photo containing the sharpest and most important detail in the photo. Most of the time, these are the same since we set focus on the most important subject. Click and drag the preview to reposition it. For this example, I've zoomed into a detailed section of rock within a broader landscape photo. I've selected this area because it is the prime point of focus and it contains both high-contrast edges and fine details in the grasses.

Adjusting Radius

As mentioned, Radius is the most important control to set correctly, and I recommend you set it first. Press and hold the OPTION (Mac) or ALT (Windows) key while adjusting the Radius slider to see the halos being applied to the edges in your photos.

What to look for: Look for definition along the key areas of your photo. For example, you should see a faint edge along high contrast lines and key areas of detail. Keep an eye out for a strong shadow along high contrast edges, particularly where a light subject meets a darker background. These sharpening halos are visible in the finished print. Reducing the Radius setting will help minimize visible halos.

A lower Radius setting (0.7) creates lighter halos along key lines in the image while still improving the definition of details within the scene.

Too high of a Radius setting (2.2) creates a strong halo along the high contrast edge of the rock on the left and the grasses on the right.

If you are uncertain about your Radius setting, always hedge toward a smaller setting, because it is less objectionable to slightly undersharpen an image than to oversharpen.

Adjusting Detail

Setting the Radius establishes the width of the sharpening halos in your images. The Detail slider builds on your initial Radius setting by allowing you to reach deeper into your image to pull out textures and subtle details. Use the Detail slider with caution, because too high a

setting can add noise or create texture in smooth areas such as skin tones or skies. A very low setting of less than 5 concentrates sharpening only on the highest contrast edges. This can be beneficial for images that are noisy or slightly out of focus.

For well-exposed images, however, you'll want a moderate Detail setting between 10 and 25.

What to look for: As you increase the Detail slider while holding the OPTION (Mac) or ALT (Windows) key, keep an eye on the high contrast

A lower Detail setting (17) highlights the key edges on the rock and grasses while adding some texture to the rock. This lighter setting is more visually balanced between sharply defined and subtle textures.

When the Detail setting is too high (78), the halos along key edges become exaggerated, leading to potential problems in printing. In addition, the subtle textures on the rock are now as well defined as the edge of the rock. Given the soft light source, this is visually confusing—the texture on the rock should be secondary to the edges.

edges in the photo. Increasing the Detail slider setting will exaggerate existing halos and begin adding halos to other details within your photo.

Adjusting Masking

Masking, as the name implies, creates a quick mask to remove sharpening from areas of smooth tone and color, allowing sharpening to be concentrated along higher contrast lines and edges. Masking protects the smoothness of skies and skin tones and is particularly valuable when you're working on noisy images.

When adjusting the Masking slider, be sure to hold down the OPTION (Mac) or ALT

(Windows) key to see the mask preview. As with layer masks, the mask preview uses black to show areas where your sharpening correction is hidden and white to display areas where your sharpening is applied.

What to look for: As you increase the Masking slider value, watch the image to make sure the mask doesn't extend into areas of important detail, eliminating sharpening from those areas. Another potential problem exists when your mask partially covers a shape or contour. In this case, sharpening will be applied only to one portion of the shape, leaving an unnatural transition between sharpened and unsharpened sections. If this occurs, try reducing the Amount or Detail slider to eliminate the problem.

The perfect Masking setting sharpens the smooth tones without reducing sharpening along key edges or highly detailed areas.

Adjusting Amount

The Amount slider is the easiest of the four controls to use, because once you've established your Radius, Detail, and Masking settings, all you need to do is fine-tune the Amount slider to increase or decrease the intensity of the sharpening.

Unlike the other three sliders, pressing and holding down the OPTION (Mac) or ALT (Windows) key while manipulating the Amount slider doesn't result in an esoteric view of the edges within your photo. Instead, the mask preview displays a black and white version of your photo to help you assess how the sharpening is affecting the tonality of your image.

What to look for: While increasing the Amount slider, keep an eye on the highlight details in your photos to ensure that they don't blow out to pure white. Be sure you haven't chosen a setting that makes your photo look gritty, artificial, or saccharine. Capture sharpening should be subtle. Oversharpening at this stage will almost certainly result in an unpleasant looking print.

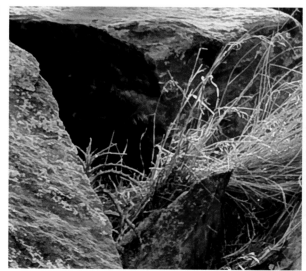

Too high an Amount setting can create a watercolor-like texture in the smooth areas in the print and make detail appear unnaturally sharp.

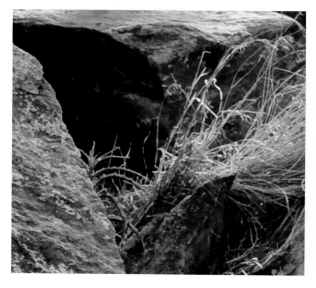

The right Amount setting brings out the natural detail within the photo without appearing unnaturally sharp. There's a "rightness" about correctly sharpened photos that looks richly detailed and natural simultaneously.

For the sample image, I found the following settings to be the most pleasing: Amount: 75, Radius: 0.6, Detail: 18, and Masking: 27. Check out these before and after images for comparison.

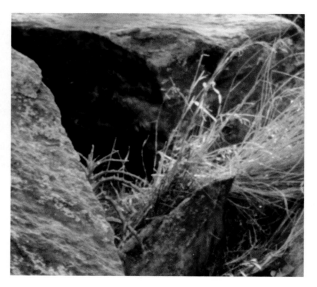

Before

After

Creative Sharpening in Lightroom

Creative sharpening is used to call attention to specific areas in the photo or to make up for a subject being slightly out of focus. While you can perform creative sharpening in Lightroom with the Adjustment Brush, this isn't an ideal solution because the Sharpness settings in the Adjustment Brush and Graduated Filter panel lack the controls found in other sharpening tools within Lightroom and Photoshop. For that reason, unless I just need a quick-and-dirty correction, I perform any creative sharpening in Photoshop.

Output Sharpening in Lightroom

Sharpening for output is the most difficult aspect of sharpening, due to the large number of variables involved. What is the finish of the paper? What size is the print? What is the resolution of the original photo?

Fortunately, output sharpening in Lightroom is greatly simplified through the use of output sharpening presets that take the guesswork out of the equation. In Lightroom's Export and Print modules (covered in detail in Chapters 17 and 18, respectively), you'll find options for selecting both the intensity of the sharpening and the output medium. In the Export module, you're given options to sharpen for Screen, Matte Paper, or Glossy Paper along with Amount levels of Low, Standard, and High. Lightroom then calculates the correct amount of sharpening based on the specified output, image size, and image resolution.

As someone who was initially skeptical of the system, I've gotten results from the system that have transformed my skepticism into a full endorsement. I can't think of a single occasion where the output sharpening presets have oversharpened an image and only a few times where I'd wished more sharpening were added.

I find output sharpening to be a tremendous time-saver, particularly in the creation of web graphics, since it doesn't require that I perform a second manual pass of sharpening. I can choose a sharpening preset as part of my output preset and move on to processing the next image.

Lightroom's sharpening tools are undoubtedly powerful, versatile, and fast. There are occasions in which you need to use the sharpening tools in Photoshop, either because your image is already in Photoshop because you were masking or burning and dodging or you need more control over the creative or output sharpening processes than Lightroom offers.

Sharpening in Photoshop

While you're best served performing your capture sharpening on the raw file in Lightroom, Photoshop offers two excellent tools for sharpening your images: Smart Sharpen and Unsharp Mask. After working with the sharpening commands in Lightroom,

both will feel familiar as their controls are centered around the Amount and Radius sliders.

Both Smart Sharpen and Unsharp Mask can be used for output sharpening or creative sharpening, when coupled with a layer mask. Before you begin the sharpening process, it is important that you take two preparatory steps:

Step 1 Create a separate sharpening layer.

Step 2 Zoom in to 50- or 100-percent view.

Working in Photoshop gives you fewer options for undoing or refining your corrections. Unless you've stored your corrections on a separate layer, your corrections are permanently applied once you save and close a document. For that reason, be sure to create a separate sharpening layer to serve as an escape route in case you change your mind later in the process.

If you are working on a document without any layers, you can duplicate your Background layer by pressing CMD-J (Mac) or CTRL-J (Windows) and using this new layer for sharpening. More likely, you will have several layers in your document. To create a new layer that is a composite of all your corrections, use keyboard shortcuts CMD-OPTION-SHIFT-E (Mac) or CTRL-ALT-SHIFT-E (Windows) to create a new merged layer. Be sure this layer is sitting at the top of your stack of layers; otherwise, your image may change appearance due to some corrections being applied twice.

Once your sharpening layer is created, you'll need to zoom to 100 percent if you are performing creative sharpening or if you will be sharpening images for the Web or screen. If you're sharpening for print, you're best served by zooming to 50 percent. This gives you a better approximation of how the sharpening in your photo will look on the printed page, where paper-absorbing ink causes edges to blur slightly and reduce the overall image sharpness.

I'll talk specifically about output sharpening after introducing the two sharpening tools, Unsharp Mask and Smart Sharpen.

Unsharp Mask

Let's begin with Unsharp Mask (**Filter > Sharpen > Unsharp Mask**), a time-tested sharpening favorite. Two of the three controls found in Unsharp Mask should be familiar to you from sharpening in Lightroom: Amount and Radius. Both perform the same tasks here as they do in Lightroom.

The navigation within the Unsharp Mask dialog is slightly different from that of the Detail panel in Lightroom. First, both a preview window and an image preview appear. The preview window, contained within the Unsharp Mask dialog, is always set to 100 percent, actual pixels, by default. Use this preview for checking key details in your photo to ensure you aren't creating any sharpening artifacts.

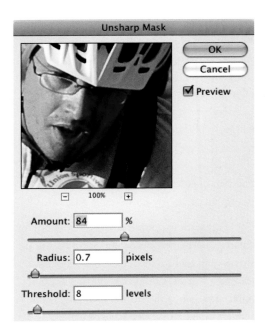

Unsharp Mask

OK
Cancel
☑ Preview

⊟ 100% ⊞

Amount: 84 %

Radius: 0.7 pixels

Threshold: 8 levels

Move your cursor over key areas in the photo and single-click to update the preview window with the region under your cursor. Click and hold inside the preview window and then release for a before and after look at your sharpening.

Your second preview is the image itself. Set this preview to 50 percent view for a more accurate preview of your print, and use this large preview to gauge the effect sharpening has on the overall image. Toggle the sharpening on and off by clicking the Preview checkbox in the Unsharp Mask dialog.

In addition to the Amount and Radius sliders, Unsharp Mask also provides a

Threshold slider. This slider determines how dissimilar two pixels need to be in order to be sharpened. Like the Masks slider in Lightroom, Threshold is used to remove sharpening from smooth areas such as skin tones and skies, or to prevent sharpening from exacerbating image noise on high ISO images. Even though the programming behind the two controls differs slightly, their net effect on an image is the same.

When using Unsharp Mask, like other sharpening tools, set the Radius based on the width of the finest detail in the image. This will ensure that your photo contains maximum detail. The exact Radius setting will vary based on the content of the image, the size of the picture, and the desired effect. For creative sharpening, low Radius and Amount settings are often ideal for gently calling attention to a subject. Output sharpening generally requires higher settings for Amount and Radius to sufficiently prepare an image for print.

Smart Sharpen

You can think of Smart Sharpen as Unsharp Mask's brash younger brother. While Smart Sharpen is frequently faster and more effective, at times Smart Sharpen's inexperience causes problems. Like Unsharp Mask, Smart Sharpen is found in the Filter menu (**Filter > Sharpen > Smart Sharpen**).

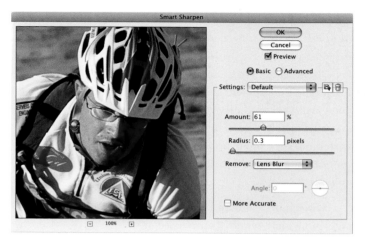

The trouble with Smart Sharpen lies in its handling of smooth areas of a photo. It can be tempting to push the intensity of your sharpening in Smart Sharpen as it makes your photos amazingly clear and detailed. Unfortunately, Smart Sharpen is so powerful, it tries to pull details out of areas that don't have any detail, resulting in grainy and oddly textured images. On noisy images, Smart Sharpen makes the noise jump out from the photo, an obviously undesirable outcome.

That said, use Smart Sharpen carefully for creative sharpening or for performing output sharpening on heavily detailed or textured images for print. On web-resolution images, Smart Sharpen really shines, bringing to life smaller images for a web page or gallery.

Using Photoshop's Sharpening Tools for Creative Sharpening

The goal of *capture sharpening* is to highlight specific regions within a photo to focus the viewer's eye on these areas. Using either Smart Sharpen or Unsharp Mask on a dedicated sharpening layer adds just enough sharpening to give important lines heightened definition or clarity. I suggest using a Radius setting of less than 0.5 to keep your corrections discreet and vary the amount as needed.

Smart Sharpen is best suited to low-ISO images with lots of fine detail or images destined for the Web. Smart Sharpen is a strong tonic and can cause problems if it's not used carefully.

Like Unsharp Mask, Smart Sharpen provides Amount and Radius sliders to control the intensity and effect of the sharpening. As a rule of thumb, you'll want to use a lower Radius and higher Amount for Smart Sharpen than with Unsharp Mask. Additionally, you'll want to set the Remove option to Lens Blur instead of Gaussian Blur for best results with photos from digital cameras. If you're working on film scans, you will be better served using Unsharp Mask.

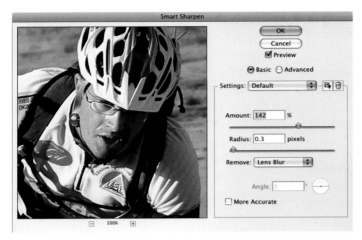

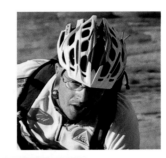

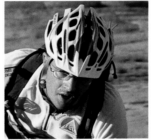

Once you're satisfied with your sharpening settings, click **OK**. Add a layer mask to your sharpening layer and fill the layer with black by pressing CMD-I (Mac) or CTRL-I (Windows), inverting the layer mask from white to black. Your sharpening is now completely hidden by the mask.

The image above has received basic capture sharpening, but no creative sharpening. The image on the left has received a light pass of creative sharpening to call attention to the rider's face, helmet, and jersey. Smart Sharpeni settings: Amount 142, Radius 0.3

Add vector mask

Select an appropriately sized brush, and set the brush opacity to 50 percent and the foreground color to white. Begin painting over the areas you'd like sharpened and you'll begin seeing your sharpening applied to those areas. Vary your brush opacity to increase or decrease the effect of the sharpening and smooth transitions between sharpened and unsharpened areas. Often, a light pass of sharpening goes a long way at this stage. Your

goal is to make the image look acceptably sharp on screen, but don't get carried away, because your image will receive a third pass of sharpening as it is readied for output.

Using Photoshop's Sharpening Tools for Output Sharpening

When sharpening an image for output, several factors will influence the sharpening settings selected:

- Image size and image resolution
- Size and viewing distance of the finished print

- The type of printer, paper, ink, and processes used (inkjet, laser, sheet-fed press)
- Content of the image, including the frequency of fine details, the quantity of smooth tones, and the message contained in the photo (soft and inviting like a baby or sharp like a knife)

Becoming proficient in sharpening takes practice—lots of it—to gauge the correct intensity of sharpening over the predicted softening that will occur as part of the printing process. Sharpening for the Web is far easier since you can see the finished result immediately on the screen.

For more in-depth information on image sharpening, I strongly recommend that you read *Real World Image Sharpening with Adobe Photoshop CS2* by the late, great Bruce Fraser. Bruce was a leading voice in the development and implementation of Photoshop. He helped to design and test the sharpening presets found in Lightroom's output module, and he distilled his deep knowledge of image sharpening in this informative and easy-to-read book.

ADOBE PHOTOSHOP: ESSENTIAL SKILLS

As you continue to refine and craft your photos to match your final vision, you can take many paths and apply many techniques to get where you want to be. From the beginning of the Chapter 15 until now, I've tried to focus on the skills you'll use most frequently—the "bread and butter" techniques you'll use on a regular, if not daily, basis.

Of course, those aren't the only skills you'll want to have. From time to time, it is essential that you dust off an infrequently used technique to reduce image noise, or make a beautiful black and white version of your favorite color image. The rest of this chapter is devoted to those techniques that broaden your repertoire and improve your photos.

Noise Reduction

Digital noise, the errant flecks of tone or color on your photos, isn't the problem it once was. The current crop of digital cameras produce superior results at high ISO settings compared to the cameras available just a few years ago. With that in mind, there are still occasions when you need to clean up a noisy image. A couple of good noise reduction tricks are a helpful addition for any photographer's bag of digital darkroom tricks. In this section, I'll highlight the inherent tradeoffs present with any noise reduction technique and give you tips for making noise reduction effective.

An Ounce of Prevention

The single best noise reduction technique is judicious exposure. The number one cause of digital noise is not high ISO settings; it's underexposure. If you're still in the habit of setting your camera to –2/3 of an f-stop, like many photographers did with slide film, stop. You need to retrain yourself to expose accurately, if not slightly overexpose. Keep in mind that breaking old habits often means you'll run into some roadblocks here and there. However, once you become accustomed

to exposing properly for digital, you will reap big rewards.

In Chapter 14, I discussed the need to overexpose your photos slightly to put more of the image detail in the right half of the histogram. This will give you better shadow detail and less noise, and it's significantly faster and more effective than any noise reduction technique.

That said, mistakes happen. Sometimes you have to rescue an underexposed picture. When this occurs, you'll want to perform as many adjustments as possible in camera raw. This is one area where performing your corrections on the raw file gives markedly better results than performing the same corrections on a processed image.

After you've lightened the image sufficiently, it's time to tackle the noise. Whenever you perform noise reduction on an image, you're faced with a tradeoff. Noise reduction inevitably removes image detail. So you can opt for more detail and more noise, or less detail and less noise. Even though some degree of compromise is unavoidable, the following techniques will help shift the odds in your favor.

Removing Noise in Lightroom

The noise removal tools within Lightroom work best for mild to moderate noise reduction. They tend to work best on *chroma* noise, the color impurities seen most frequently in the dark shadows.

Lightroom's noise reduction tools are located in the Detail panel of the Develop module, immediately below the sharpening tools. By default, the Color slider is set to 25 to gently scrub out any color noise appearing in the shadows. This low setting rarely impacts noise-free images while cleaning up slightly noisy images. To remove more severe color noise, zoom in to your image, adjust your preview to display a noisy image area, and begin increasing the Color noise reduction slider until the color noise disappears.

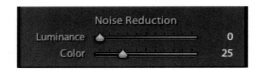

I like to insert my cursor in the numeric readout to the right of the Color slider and hold down the SHIFT key while pressing the UP ARROW key on my keyboard. This increases the noise reduction 10 units at a time and is more precise than using the slider alone. Let go of the SHIFT key to adjust the slider 1 unit at a time. This trick works for all the sliders in Lightroom and is great for making micro-corrections that are difficult to achieve with the sliders.

Use the Luminance slider for removing luminance noise, the pernicious "salt-and-pepper" noise hidden in the deep shadows. Luminance noise is far more difficult to remove than color noise. While it can be mitigated using the Luminance slider in Lightroom, for truly noisy images, you'll need

to use one of the advanced techniques in Photoshop, preferably with a dedicated noise reduction plug-in such as Noise Ninja from PictureCode or Dfine from Nik Software. These specialized tools do the best job of removing digital noise from your photos while minimizing the loss of detail in your images. If you routinely shoot at high ISO settings and find yourself removing noise regularly, these tools will be a worthwhile investment. You can download a free trial or purchase either noise reduction software directly from the manufacturers at www.picturecode.com/ and www.niksoftware.com/dfine/usa/entry.php.

 To learn more about removing noise in Photoshop with Noise Ninja, check online at www .perfectdigitalphotography.com/ advanced-techniques.php.

Black and White Conversions

Expressive and evocative, a high-quality black and white print is still the holy grail of photography. Since the first edition of the book, the tools for creating a good black and white image and creating a stunning black and white print have gotten better. What matters most, however, is not the technique, but the vision. Learning to photograph in black and white tones instead of color is a challenge. Whether you're a dedicated black and white aficionado or a color photographer who dabbles in black and white, learning to see tonal differences in your photos and understanding the digital Zone System will make you a better photographer.

The *Zone System* is a comprehensive method of judging and setting exposure in-camera, determining film development times, and establishing print controls in the wet darkroom. This system was developed and widely practiced by photography luminaries including Ansel Adams, Paul Strand, Edward Weston, and Minor White.

These techniques have been adopted and modified for the digital darkroom and are just as important as their traditional counterparts. I'll apply a simplified version of the digital Zone System to color-to–black and white conversions and will then go deeper into the digital Zone System in Chapter 18. Keep in mind that literally hundreds of different techniques, plug-ins, or methods are available for converting your color images to black and white. However, none will help you create a great black and white image unless you understand what it is you're trying to accomplish. For this reason, this section will be less about technique and more about philosophy.

Introduction to the Digital Zone System

The underlying focus of the Zone System is to help you, the photographer, take control over the tonality within a black and white or color photo. Although tonal separation between elements within a color photo is just as important as it is with black and white, brilliant color can sometimes mask flaws in tonal separation. In black and white, there is nothing to hide behind—problems with poor tonal separation or contrast are visible for the world to see.

This is where the Zone System can serve as a valuable ally, to help you take control over the conversion of your color images to black and white, guide your burning and dodging, and help identify areas in need of correction. The Zone System, combined with the Four Rules introduced at the beginning of the chapter, serves to guide your corrections, helping you make your photos look better than ever before.

The Zone System is a method of controlling exposure in-camera, guiding your corrections in the traditional or digital darkroom, and performing adjustments to maximize image quality in print. In fact, many of the corrections you've already been introduced to follow Zone System principles, even though I haven't described them as such.

The Zone System derives its name from a division of the tonal range from black to white into 11 discrete segments, or zones. Zone 0 is absolute black, and Zone X is pure white. Zone V is middle gray. Ideally, a well-exposed photo will bridge a range of these zones with detail in the highlights, midtones, and shadows.

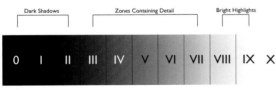

The underlying philosophy behind the Zone System is *previsualization*, the act of imagining the appearance of the finished print before you press the shutter. While composing and capturing your photo, you should have an idea of whether you want the photo to be high key, low key, high contrast, or low contrast. This guides both your initial exposure settings and the corrections you make in the darkroom.

The Zone System in Action

Here's an example of how the Zone System can be applied to your entire photographic process. When judging your exposure, you've been taught to "expose to the right" or slightly overexpose your raw files to ensure full detail in the shadows with the least amount of digital noise. In doing so, you probably verified your exposure using the histogram on the back of your camera, making sure there are no "cliffs" in either the shadows (Zone 0) or the highlights (Zone X), indicating under- or overexposure.

Once you bring this raw file into Lightroom, you set the brightest highlight and the darkest shadows with the Exposure and Blacks sliders. This stretches the dynamic range of the image to encompass all usable Zones I–IX and improves the overall contrast of the photo. In the next step, you adjust the brightness, shifting the midtones in the pictures lighter or darker, and then adding contrast to the photo using the Contrast slider. From the perspective of the Zone System, you are controlling the distribution of tones through the midtones (Zones III–VII).

The Zone System, with only 11 zones, is limited in its ability to describe the selective changes you perform. However, the underlying philosophy is the same. You're adjusting tonal values within the photo to add visual interest, separate the tonal values between adjacent objects (localized contrast), and call attention to the important elements within the photo. You are able to accomplish all this within the philosophical framework of the Zone System using tools unimaginable to the Zone System's founders.

Let's look at how you might apply the philosophy behind the Zone System when converting color images to black and white in Lightroom.

Creating Black and White Photos in Lightroom

Whenever possible, I prefer to perform my color-to–black and white conversions in Lightroom. It gives me access to the unprocessed raw file while still providing me a sophisticated set of image correction tools for carefully shaping the tones in the black and white image.

Here, I'll describe a typical black and white conversion in Lightroom. The underlying methods and philosophy can easily be translated for use with any black and white conversion technique such as the black and white adjustment in Photoshop or any of the black and white conversion plug-ins for Photoshop.

Tip When working in Lightroom, create a virtual copy of your original raw file for your black and white conversions. Virtual copies take up minimal space on your hard drive while allowing you to keep the original color image. In the Filmstrip, right-click the image and select **Create Virtual Copy** from the context menu. Or, from the **Photo** menu choose **Create Virtual Copy**.

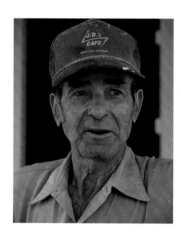

Begin by performing the global tone and color corrections as outlined in Chapter 14. Start by setting the White Balance manually, and then use the Exposure slider to set the brightest tone in the image (Zone X), the Blacks to set the darkest shadow (Zone 0 or I), and the Brightness slider to balance the midtones (Zones IV–VI). As needed, use Recover to improve highlight detail or Fill Light to open blocked shadows. Your goal at this stage is to expand the tonal range to encompass the full histogram and begin distributing and balancing your photo's tones throughout the tonal range.

Next, begin manipulating contrast in the photo to enhance the shapes and forms of your subject. Feel free to use either the Contrast slider or the Tone Curve, whichever best suits your image. For this photo, I used the Targeted Adjustment tool (TAT) in conjunction with the Tone Curve to lighten the highlights on the man's face, while darkening some of the shadows around his collar and neck. My aim is to give his face shape and depth to reveal his character—the lines on his face tell the story of his life.

Once your broad tonal adjustments are completed, convert your color image to black and white by clicking the **Grayscale** option under the Treatment heading immediately above the White Balance options in the Develop module. Your photo should be a relatively flat, black and white image lacking contrast, but otherwise nicely balanced between the highlights, midtones, and shadows.

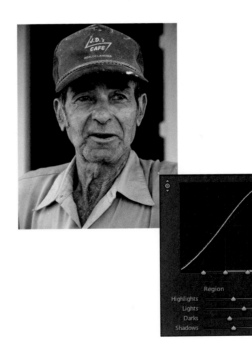

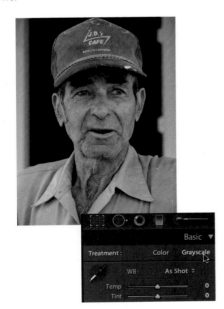

Once you are satisfied with your overall contrast, you can begin adjusting the lightness values for individual colors in your photos by adjusting the Grayscale Mix sliders located in the HSL/Color/Grayscale panel. Use the TAT

to nudge colors lighter or darker to improve their separation with one another and with the background. Since this photo contains similar colors throughout, the effect of adjusting the Grayscale Mix is minimal.

Tip For dramatic blue skies, drag the Blue and Aqua sliders to −100. This will create a dark gray sky similar to the effect created by placing a red #25 filter over your lens while shooting black and white film. You can fine-tune the darkness of the sky by adjusting the Temperature slider toward blue, but be careful as this can negatively impact other areas within your photo.

At this point, you should be fairly satisfied with the overall tonality, contrast, and tonal separation. You can now shift attention to performing selective corrections using the Adjustment Brush or Graduated Filter, or by making small adjustments to earlier corrections.

To improve localized contrast, consider using the Adjustment Brush:

- Add more Clarity to improve definition of key lines in a person's face, or use a negative Clarity setting to smooth out skin tones and skin detail.

- With a moderate Contrast or Sharpness setting to add definition to key lines or shadows. Pay particular attention to the eyes in a portrait, because this is the first place a viewer's eyes will travel.

- Add Brightness or Exposure to lighten the shadows surrounding the eyes in a portrait.

For this image, I used the Adjustment Brush as follows:

- Brighten and add clarity around the eyes

- Darken the man's neck, shirt, and hat

- Add pop to the lettering and paint spatters on his hat, add definition to the gray hair in his sideburns, and lighten the catchlights in his eyes using the Exposure slider at a low opacity

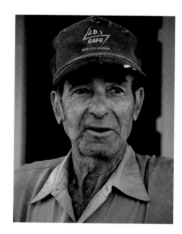

With all of these corrections, I performed the initial brush strokes with a higher intensity to accurately view the location of the corrections, and then I reduced the intensity of the correction to blend it with the surrounding area.

Finally, consider adding a light vignette to the corners of the image and a moderate amount of sharpening to improve the appearance of detail.

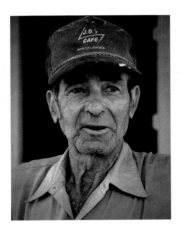

Although Lightroom's tools are sophisticated enough for most black and white conversions, you can always export your photo into Photoshop to take advantage of additional tools or incorporate advanced techniques.

Sepia Toning

Sepia-toned pictures impart a feeling of nostalgia, history, and age. Think of Edward S. Curtis's famous photographs of Native Americans or Edward Weston's photographs of Carmel, California. Sometimes, sepia tone

is the perfect match for the photo's content. In this section, I'll show you my favorite method for adding a sepia tone or any color tint in both Lightroom and Photoshop.

Sepia Toning in Lightroom

Once you've completed your black and white corrections in Lightroom, you can add a sepia tint using the Split Toning panel. The Highlights and Shadows sliders allow you to apply a separate colored tint to the highlights and shadows of your photos, and then you can blend the two with the Balance slider.

Begin by selecting a Hue value for the Shadows between 35 and 45. This is the color range between reddish-orange and yellow-green. After some experimentation, you'll find the hue that suits your preference. It is often helpful to increase the Saturation to between 30 and 40 when setting the hue, as the color is more visible. Once you've selected your Hue value, reduce the Saturation to your desired level. For this image, I selected a Hue setting for the Shadows of 41 and a Saturation of 22. This adds an antique warmth to the shadows that trails off toward the highlights.

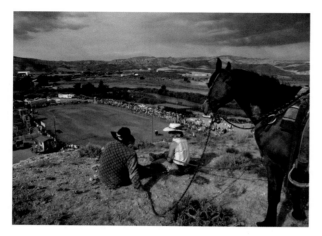

You can use the photo filters, Curves, or Hue/Saturation for this technique, but I tend to use Hue/Saturation because I like the controls it offers.

Tip If you want to add a sepia tone to a black and white image but find your color options grayed out, you may have converted your photo to the Grayscale color mode. You'll need to convert your photo to RGB (**Image > Mode > RGB**) before adding a sepia tone. Color modes will be covered in greater detail in Chapter 17.

Step I With a black and white image open, create a new Hue/Saturation adjustment layer. Check the **Colorize** checkbox near the bottom of the dialog box. This will apply a colored overlay to your photo. Set the **Hue** between 25 and 40 and adjust the Saturation based on your preferences. Don't change the Lightness as this will affect the tonality of your photo. For this image, I set the **Hue** to 37 and the **Saturation** to 21.

Once you've established your base tint, fine-tune your sepia tone with the Balance slider. Positive values limit the sepia tint to the darkest shadows, while negative values allow the sepia to flood into the midtones. I suggest setting your Balance on a case-by-case basis, so you can allow the image to dictate the settings used.

If you'd like to try my Sepia Toning preset, you can download it at www .perfectdigitalphotography.com/ advanced-techniques.php.

Sepia Toning in Photoshop

Creating the same sepia-toned look in Photoshop is a bit more difficult. You can use shortcuts, but they apply the color throughout the photo instead of concentrating the color in the shadows. To do it right, you need to incorporate a special trick.

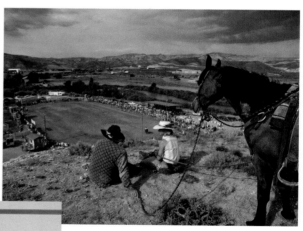

Step 2 In the Layers panel, target your Hue/Saturation adjustment layer and then click the **Add a layer style** button at the bottom of the Layers panel and select **Blending Options** from the top of the pop-up menu.

Step 3 Near the bottom of the Layer Style dialog are the Blend If sliders, which can be used to apply an effect to a specific region of the tonal range. The Layer slider controls the appearance of an effect on the current layer.

The Blend If sliders work by making visible any portion of the tonal range that falls between the two sliders. To remove the sepia tone from the highlights, you need to move the right slider toward the midtones. This causes the highlights to fall outside the range of the sliders, making those pixels transparent.

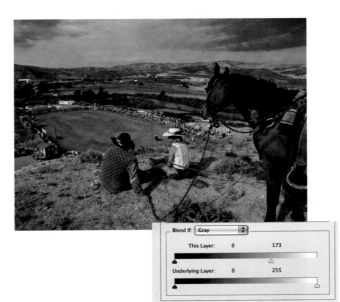

Step 4 The hard transition between opaque and transparent looks unnatural, so you'll want to feather the transition along the right slider. OPTION-click (Mac) or ALT-click (Windows) on the slider to split it into two separate elements. The gap between the two halves of the slider is a transition zone where pixels in this section of the tonal range are partially transparent. This makes the effect more natural looking.

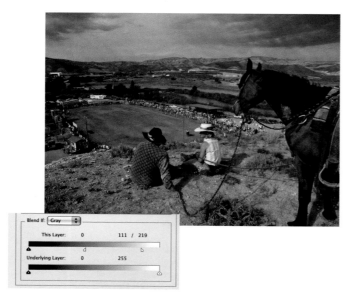

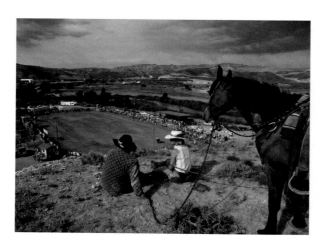

Saving Your Master File

After investing so much work into processing your photos, you'll want to archive a layered version of your photo. I call this a *master file* because it contains all your corrections, stored on separate layers, and is only mildly sharpened and saved at your camera's native resolution. This is the file you will always return to for reference when you need to make prints or create an image for posting to the Web.

To save a master version of your layered photo from Photoshop, click the **File** menu and click **Save As**; then choose **Photoshop** as the Format and be sure the **Layers** checkbox is checked. This will preserve all layers used for image corrections, allowing you to go back and tailor or adjust your corrections later. If you've opened the image from Lightroom and save the master file back in your original folder, Lightroom will add the image to the library, placing it next to the original raw file in your library. This makes it easy to keep track of your raw and master files.

Step 5 As a final step, you'll often want to adjust the saturation level slightly by moving the Saturation slider within the Hue/Saturation dialog, or decreasing the layer opacity. For this image, I've opted to decrease the layer opacity from 100 to 77 percent to achieve the final result.

I'll show you how to save your photos in additional file formats in Chapter 17.

Multiple Image Photography

In the last several years, photographers have begun blending multiple images into a single image that breaks free from the traditional ratios or print sizes of standard photographs. This allows photographers to create images with an infinite depth of field impossible to achieve in-camera, or a single image with an expansive dynamic range. The common denominator between these multi-image techniques is a desire to create images that mirror the way our eye sees the world, not the way the camera sees the world.

 Several new digital techniques have opened doors for photographers to experiment and rethink the process, tools, and techniques of photography. In my opinion, the future of photography lies in these still somewhat experimental processes. To help you get a handle on these new techniques, I've provided condensed discussions on creating panoramas, images with an extended depth of field, and high-dynamic range images. Since these technologies are evolving so quickly, I'll post updated and expanded information and additional tutorials on our website at www .perfectdigitalphotography.com/multi-image .php.

Panoramas

I've long been enthralled with panoramic photos and drawn to their all-encompassing angle of view and tremendous detail. The latest improvements in Photoshop's blending of multiple images into a seamless panorama makes the process so easy, you owe it to yourself to begin playing with this powerful tool.

Back in Chapter 3, Jay Dickman walked you through many of the steps needed to set up a panoramic shot. Whether you create your panorama with a medium focal length lens on a tripod set to the nodal point, or you quickly snap a series of hand-held pictures, the techniques for processing panoramic images are the same. Obviously, you can expect less distortion and higher accuracy if you carefully lay out your shot, but you can still get good results from hand-held panoramas.

Building the Panorama

You cannot yet create a panorama entirely in Lightroom. You need Photoshop to merge multiple images. Fortunately, Lightroom makes it easy to select multiple images in your library and deliver them to Photoshop for processing. Here's how you do it:

Step 1 Select the images for your panorama in Lightroom. Under the **Photo** menu select **Edit In > Merge to Panorama in Photoshop**.

Step 2 In the resulting Photomerge dialog box, you're presented with a list of the Source files Photoshop will use to create the panorama, along with a column on the left that lists the six layout options. Each layout option is designed for a specific type of panorama. Selecting the correct one will greatly improve your panorama's quality.

- **Auto** Blends images automatically using the layout method Photoshop determines is best for the image. This is typically, but not always, Perspective or Cylindrical. I use Auto as a first choice for panoramas with hand-held images.

- **Perspective** Distorts the image to keep the horizon line true. The Perspective layout has a tendency to create panoramas that wrap around the viewer. Unfortunately, this can cause problems as the elements within the photo are greatly exaggerated.

- **Cylindrical** Ideal for blending images taken with a wide-angle lens. The Cylindrical layout will compensate for the slight vignetting that occurs at the corner of wide-angle lenses and the slight distortion along the horizon.

- **Spherical** Designed for 360-degree panoramas. Spherical panoramas hold promise for photographers to create interactive worlds for the viewer and certainly should be an avenue of exploration for photographers with the technical inclination and temperament to pursue this craft.

- **Collage** Positions the photos as though in preparation for a panorama, but does not blend the images into one. Instead, the intact edges of each photo give the appearance of a scrapbook collage made from multiple prints.

- **Reposition** Repositions the photos without performing any blending. This is ideal for photographers shooting from a technically accurate setup who want to blend the images in the panorama manually.

Additional options are available at the bottom of the Photomerge dialog:

- **Blend Images Together** Automatically blends images by creating layer masks for each image.

- **Vignette Removal** Useful if you are using a wide-angle lens that has a tendency to vignette at the corners. Without Vignette Removal, your blue skies will have a tendency to appear mottled near the seams between images.

- **Geometric Distortion Correction** Designed to correct for the distortion imparted by wide-angle or fish-eye lenses. Although these lenses aren't ideal for panoramic photography to begin with, this feature can mitigate arcing horizons and bending buildings.

Step 3 After selecting your layout method, click **OK** and Photoshop will begin processing your panorama.

Tip Always check your panorama. Stuttered roads, bent fences, power lines that split in midair—these are a few of the problems that can plague panoramas. After your panorama is completed, zoom in to 100 percent and check any line traversing more than two images. The newer versions of Photoshop are far more reliable than those of the past, but Photomerge can still make mistakes. It's far better to catch it at this stage than halfway through a giant banner print.

If you do find a mistake, try rerunning the Photomerge process, this time with a different Layout option selected. For important panoramas, I'll try at least the first three options and pick the one I like best.

 For more panoramic tips, techniques, links and examples visit www.perfectdigitalphotography.com/multi-image.php.

Auto-Align and Auto-Blend

You can also build your panoramas entirely within Photoshop using the Auto-Align and Auto-Blend features.

Select the images you want to align in the Layers panel by clicking the first layer and then SHIFT-clicking the last layer in the stack. Then under the **Edit** menu, select **Auto-Align Images**. In the resulting dialog, you'll be presented with the six Layout options listed earlier. Click **OK** to align the images.

The Auto-Blend Layers feature (**Edit > Auto-Blend Layers**) can be used to blend images in a panorama, to blend several images taken with different focal points extending the depth of field, or to automatically blend two or more photos taken at different exposure settings.

First use the Auto-Align feature to ensure that your photos are correctly aligned. Next, select the **Auto-Blend Layers** feature. The Auto-Blend Layers dialog gives you the option to create a Panorama or Stack Images. The Panorama option uses layer masks to blend images into a seamless composite. The Stack Images option can be used to blend two or more images taken of the same composition with different exposure settings (extend dynamic range) or at different focal points (extend depth of field).

In my experience, Stack Images works reasonably well for extending the dynamic range, but it isn't quite as good as blending them manually. I believe this has to do with the difference between a technically correct rendering of the scene versus an artistic rendition of the scene. More often than not, I'm looking for an artistic interpretation of the scene. Experiment and see which one you like best.

Extending the depth of field holds great promise for landscape and macro photographers, letting them create photos that were once impossible due to the laws of physics. By carefully capturing several photos, each with a slightly different focal point, you are able to ensure that every part of the photo is in focus.

To extend the depth of field, follow the preceding steps to align images automatically; then in the Auto-Blend Layers dialog, select **Stack Images**. Photoshop will preserve the in-focus portion of each image, masking out the out-of-focus areas. This creates a photo with sharp focus from foreground to background.

Tip When working with macro photos, be sure to shoot several overlapping photos, each with a maximum depth of field. With close focus, or macro photos, it is more difficult to gauge the amount of the scene that will be in focus when compared to landscape photos and will be more prone to error. Hedge your bets and shoot a few extra photos to ensure that you cover the full distance between foreground and background.

High Dynamic Range Images (HDR)

One technology promising to significantly impact the art and process of photography is High Dynamic Range (HDR) photography. Photographers have long been frustrated by the camera's inability to capture the range of brightness they see with their eyes. In a digital camera, this limitation is caused by the sensor's inability to capture detail across a wide brightness range. Instead, a typical photo captures a slice of the possible tonal range. Dark shadows lose detail, becoming solid black. Excessively bright highlights overwhelm the sensor and are reproduced as pure white.

An HDR image overcomes this problem by merging together several images, taken at different exposures, to reproduce detail throughout the tonal range. By blending the best information from several different exposures, a well-constructed HDR image delivers richer, noise-free shadows; smooth transitions at every portion of the tonal range; and clear, crisp highlight detail. In Chapter 4, you were introduced to the techniques necessary to capture the raw images for creating your

HDR image. In this section, I'll concentrate on summarizing the steps needed to combine your unprocessed images into a single HDR photo and prepare it for printing or publishing to the Web.

Currently, the biggest difficulty in working with HDR images lies not in image capture, but in image processing. The tools for working with HDR images are still rather crude and produce artificial or overworked-looking images. While these limitations can be used creatively, most photographers will continue to desire more effective HDR-processing software.

The most common HDR-processing software applications are Photomatix and Photoshop's Merge To HDR command. Photomatix (www.hdrsoft.com) is easier to use and is more widely used by amateur and professional photographers who want to create HDR images.

Regardless of the HDR processing application used, the basic steps for creating and processing HDR images are similar. Since the technology is still evolving rapidly, I'll focus the discussion on these key steps, highlighting specific areas you'll want to evaluate when testing HDR software or creating HDR images.

Assembly and Registration The first step in the workflow is merging your bracketed exposures to create a single HDR image. Several potential pitfalls will need to be navigated along the way. The biggest obstacle at this stage is the registration of the images

used for HDR creation. Even if you are careful to keep the camera firmly mounted on a tripod, changing your shutter speed for each exposure often introduces slight movement into the composition. Good HDR processing programs should be able to align the images without too many problems. Hand-held HDR images are often more difficult, if not impossible, to align correctly. Misalignment can be corrected later in the process, but the more effective this step is initially, the more time you will save later in the process.

Another important consideration is the way a software application handles motion. A moving car, tree branches blown by the wind, or a person walking through your composition can cause problems in HDR images. Often, movement creates odd ghostlike blurs through the photo. Occasionally, the object will be truncated by the software, leaving half of the object in your photo unaffected while blending the other half with existing exposures. Moving objects often require some manual compositing or cloning later in the workflow.

During the assembly process, the HDR processing software will need to convert your photo to a linear gamma space, similar to the one used for storing your camera raw data. For this reason, you will get better results creating HDR images from raw files than from JPEGs, because using raw files prevents the image from undergoing a second gamma conversion.

Image Adjustments Your composited HDR image isn't like other photos you've worked with. An HDR image uses floating-point 32

bits per channel (bpc) math, as opposed to the 8 and 16 bpc you've worked with in the past. These 32-bpc images have tremendous editing potential. The downside is that very few tools work with images in the 32-bpc mode. For example, Photoshop restricts you to the following adjustments for editing 32 bpc: Levels, Exposure, Hue/Saturation, Vibrance, Channel Mixer, and Photo Filter. Compounding problems is the fact that many of the tools work differently with 32-bpc images than with their 8- and 16-bpc counterparts. This makes it difficult to perform color or tone corrections on 32-bpc images.

The 32-bpc images are also difficult to work with because you cannot see the entire range of tones present in the image on your monitor, because the range between light and dark is far greater than your monitor can display. Photoshop provides a display slider for you to select which portion of the tonal range you'd like to preview. This makes it exceptionally difficult to correct HDR images. Not only are your tools limited, but you often can't see the effects of your corrections.

For that reason, many photographers bypass the image adjustments stage, moving directly into tone mapping. This is a shame, since small changes applied to the image in this stage can make the tone mapping process much easier.

Tone Mapping The corrections and processes used to create and adjust an HDR image are so abstract they seem to border on the theoretical. It isn't until you convert your

32-bpc image into a usable 8- or 16-bpc image that can you really find out whether your HDR image will be successful or not. This process is called *tone mapping* because the tonal range of the HDR image needs to be compressed into the standard tonal range and contrast range used for non-HDR images. The problem with this step is that you're taking a large tonal range and squishing it together to fit within the dynamic range of a normal image. It's a bit like trying to stuff a large pillow into a small box; it can be done, but a lot of struggling is involved in the process.

The tone mapping stage is frequently the greatest source of disappointment for photographers learning to shoot HDR. During the compression process, the separation of tones is often lost, creating an image that shows detail from the brightest highlights to the deepest shadows, but often lacking contrast and losing the tonal relationships between objects. At this stage, many HDR images take on an ashen, artificial appearance. There are two ways of avoiding this problem:

- *Perform basic corrections to your image in the 32-bpc stage.* If your image appears a little too dark, lighten it using Exposure or Levels. If your shadows are weak, boost them using Levels *before* tone mapping to 8 or 16 bpc. These seemingly small moves make a *big* difference in the final image quality.

- *Convert your HDR image from 32 bpc to 16 bpc for further editing.* Working in 16 bpc gives you more leeway in adding back lost contrast or massaging the tonal relationships between objects in the photo.

Creating HDR images is a challenge, to be sure. Still, I'm convinced HDR images will play a central role in the future of photography as more photographers gravitate toward capturing what the eye can see, bypassing the artificial limitations imposed by the camera.

For more information on HDR images and a review of current HDR tools, visit www .perfectdigitalphotography.com/workflow.php. To view a vast collection of HDR images, visit the Flickr HDR photo pool at www.flickr.com/ groups/hdr/pool/.

Workflow Automation

Mastering the digital darkroom is more than just learning a broad range of techniques. True mastery comes when you're working both effectively and efficiently with the tools available to you. Chapters 14 and 15 focused mostly on working effectively. To take your workflow to the next level, I want to introduce you to some of the productivity boosters found in Lightroom and Photoshop.

Keyboard Shortcuts

Excellent retouchers almost never move their right hands from the mouse or their left from the keyboard. They work quickly, with an economy of movement that is impressive to watch. One key to their success is the use of keyboard shortcuts for all their commonly used commands. I've posted a list of Photoshop and Lightroom keyboard shortcuts at www .perfectdigitalphotography.com/workflow.php.

If you cannot find a Photoshop keyboard shortcut for a command you use frequently, or the keyboard shortcut isn't to your liking, you can create a custom set of keyboard shortcuts under the **Edit > Keyboard Shortcuts** menu. Here you can assign new keyboard shortcuts, create additional keyboard shortcut sets, or reset to the default set of shortcuts.

Lightroom Presets

Lightroom is one of the few programs that becomes smarter the more you use it. The way you add to Lightroom's intelligence is by creating presets for frequent tasks, corrections, and templates. For example, you're probably already using a Lightroom preset for your file naming and metadata entry during the download process. Work efficiently by building custom Lightroom presets for performing black and white conversions, adding vignettes, correcting blue skies, or adding a gradient to lighten the foreground. Once you've created a series of presets, you can quickly move through the bulk of your corrections by selecting

presets and then making small adjustments to fine-tune the correction for the specific needs of your photo.

To create an editing preset, click the plus (+) icon in the upper-right corner of the Presets panel in the Develop module. In the New Develop Preset dialog, click **Check None** to clear the Settings fields used in the preset, and then manually add the Settings you want to have applied with the preset.

For example, if you want to create a sharpening preset, check the **Sharpening** checkbox and leave the others blank. This protects any corrections you may have already made to your photo and adjusts the Sharpness setting based only on the values currently in use at the time the preset is created.

I frequently use presets for my black and white conversions, gradient filters, printing, and web galleries. I'll show you how to create and apply print and web creation presets in Chapters 18 and 19, the printing and multimedia chapters later in this book.

Photoshop Actions

Unfortunately, Photoshop doesn't have presets to expedite your workflow. What Photoshop does have are *actions*, which are similar to macros used in other applications to perform a routine set of steps automatically.

 I've compiled an actions tutorial on the *Perfect Digital Photography* website at www .perfectdigitalphotography.com/workflow.php.

Scripts

The truly geeky among us may want to look at using scripts to control image processing in Photoshop. Scripts are far more difficult to use than either presets or actions, but they are far more powerful, allowing you to automate a long series of steps involving both the operating system and Photoshop. For example, a script may take a folder of images, resize and sharpen them to a specific size, add metadata, and then save a copy of each photo in a specific folder on your hard drive. Once the processing is complete, the script can post the images to a web server using an FTP connection.

If you have experience with JavaScript, AppleScript, or Visual Basic, you may want to take a look at the *Adobe Photoshop CS4 Scripting Guide* for information on how to control Photoshop and other Creative Suite applications using Scripts: visit www.adobe .com/devnet/photoshop/scripting/.

Wrap-up

I've covered a lot of ground in this chapter. Of course, when you begin working with the advanced features in Photoshop, you'll find an infinite range of techniques at your disposal. While the physical limitations of the book prevent us from covering everything we'd like to include, the flexibility of the Web allows us to share several bonus sections with you. Here's a sampling of the information available to you online:

- A bonus chapter on scanning, including recommendations on purchasing a scanner, selecting the appropriate scanning software, and getting the best scan from your film

- Additional Photoshop and Lightroom techniques to help your photos look their very best

In the next chapter, we'll turn our attention from enhancing images to preparing them for print or publication online.

How To: Using Complex Masks to Enhance Focus and Attention

Once you master using simple layer masks, you'll find your creative well running deeper and deeper as you think of new and intriguing ways to use layer masks for compositing multiple images or applying creative effects. This How To will demonstrate several real-world image refinements, each using a different method for using layer masks to limit the correction to a specific region, color, or section of the tonal range. There is no single "perfect" method for creating layer masks. Instead, strive toward mastering a handful of techniques for building selections and layer masks. This will make your corrections more versatile as you can adapt your approach to the specific needs of the photo and select the technique that allows you to perform your corrections quickly.

A primary reason for performing selective contrast correction is to emphasize the subject and de-emphasize the background to make the photo appear more three-dimensional, calling attention to your main subject. Layer masks, in conjunction with Curves and other adjustment tools, are perfectly suited to this task.

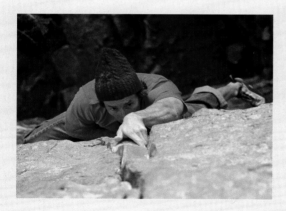

In this photo, the climber isn't as prominent in the picture as he should be. By performing a few selective corrections, his focused expression will take center stage in the photo. For that to happen, four corrections need to take place:

- **Darken the rock in the foreground** Since the rock is one of the lightest elements in the photo, your attention naturally gravitates toward it. Darkening the rock will cause the viewer's gaze to focus more on the climber's expression.

- **Darken the background** Light objects appear to be closer to the viewer than dark objects. Darkening the background will make the ground appear farther from the climber, increasing the appearance of height and depth in the photo.

- **Lighten and increase contrast on the climber's face** One of the difficulties in photographing climbing is that the climber's face is always shaded. By lightening his face and increasing the contrast, it will be easier to see his expression and make for a more compelling photo.

- **Darken and add contrast to the climber's hand and arm** The second most important element in the photo is the climber's hand and the crack in the rock he's using for a hand-hold. Since it is the second most important element, it needs to be darkened slightly so it is less prominent than the climber's face.

I'll use a separate adjustment layer and layer mask for each correction. This way I can fine-tune the balance of each element in the photo. Let's get started.

The first step is to use a Curves adjustment layer to darken the image considerably. This addresses the need to darken the rock and the background.

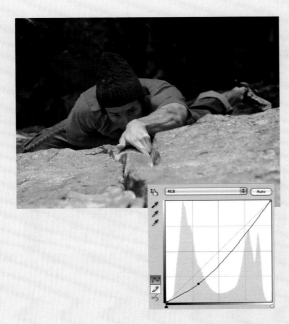

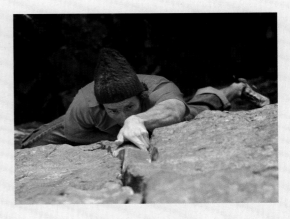

Next, I'll create a second Curves layer using the Adjustments panel. I want this curve to lighten and increase contrast on the climber's face, so I'll select the On-image adjustment tool near the upper-left corner of the Curves dialog. This allows me to hover my cursor over the climber's face to see exactly where those tonal values lie on the curve. Setting two curve control points just outside the range for the climber's face, I drag the top point up and left to lighten and add contrast through the midtones. This improves the climber's face, but it makes the rest of the image look overly saturated and "contrasty."

To remove this correction from the climber, I'll select a soft brush at 50 percent opacity and zoom in on the image to paint with black over the climber to remove the darkening correction. If at any point my brush strokes extend outside the edges of the climber, I press the x key to exchange the foreground and background colors (in this case, black for white) and paint out the errant brush strokes. This makes it easy to correct the edges of a layer mask.

The mask used for removing this Curves correction from the climber. Notice how, in this case, the mask doesn't need to be perfect—it just needs to look natural.

By using a layer mask, I can restrict this correction to the climber's face, leaving the rest of the image unaffected. While I could paint the entire layer mask with black, save

the area of his face, it's far more efficient to press CMD-I (Mac) or CTRL-I (Windows) to invert the layer mask from white to black, hiding the correction from the entire image. At this point, selecting the Brush tool and using white allows me to brush in the correction on the climber's face. To help disguise the correction, I decrease the brush opacity to 20 percent and paint in the correction on the climber's hat as well.

After painting in the correction and zooming back to see the full image on my screen, his face seems artificially bright and contrasty when compared to the rest of the photo. Reducing the layer opacity to 88 percent makes the correction appear more natural.

The layer mask with transparent areas showing the white (revealed) areas of the mask

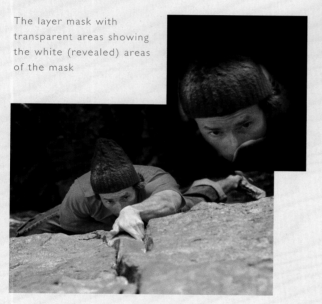

The final major correction I need to make is to darken the climber's hand and arm slightly. In doing so, I can increase the definition in the climber's forearm as well, emphasizing the climber's strength. I'll create a third Curves adjustment layer and use the On-image adjustment tool to locate the tonal values of the climber's hand on the curve. Since these values lie so high on the curve, it isn't practical to make an S-curve as I did in the preceding step. Instead, I'll place one

point a quarter of the way down from the top of the curve and drag down and to the right to darken and improve contrast in the highlights. As an extra step, I'll nudge the highlight point on the curve to the left, along the top margin of the Curves dialog. This has the potential to cause a loss of detail in the extreme highlights. Since I don't have any extreme highlights in his hand, I'm okay using this technique to improve the contrast in the selected area.

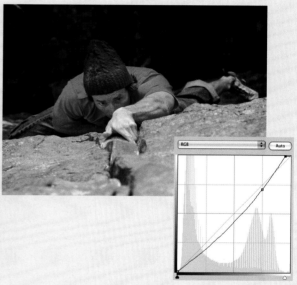

As in the last step, the adjustment doesn't improve the overall look of the image, so I'll invert the layer mask to temporarily hide the correction entirely, and then I'll brush in my correction only where I need it using a soft brush, set to 50 percent opacity with white as my foreground color.

The layer mask with transparent areas showing the white (revealed) areas of the mask

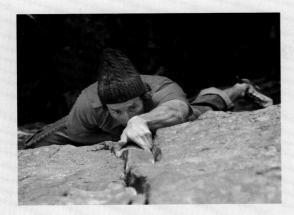

Using these three Curves adjustments, I am able to address the four problem areas. After completing a correction like this, it is always beneficial to toggle on and off all the adjustment layers for a before-and-after view of your corrections. This allows you to make sure your corrections are positively impacting the image and that no odd edges to the mask will be visible in the finished print.

To toggle on and off all of your layers quickly, hold down the OPTION (Mac) or ALT (Windows) key while clicking the layer visibility icon (the eye) next to the Background layer.

Holding the OPTION (Mac) or ALT (Windows) key while clicking the Background layer's visibility icon allows you to quickly see a before-and-after preview of your corrections.

After performing my before-and-after preview, I feel my first correction was a little strong, so I decrease the layer opacity of the Curves 1 layer to 82 percent and change the Layer Blending mode to Luminosity to balance the corrections. The Luminosity blending mode isolates the Curves correction to tonal information only, without affecting color. In this image, it removes a color and saturation shift imparted by the steep curve.

This ability to fine-tune your corrections without affecting any other layers is one of the greatest time-savers of working with adjustment layers and layer masks.

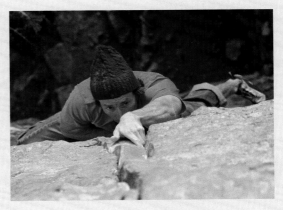

The image before corrections

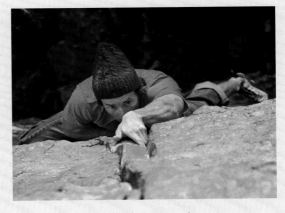

The image after selective corrections

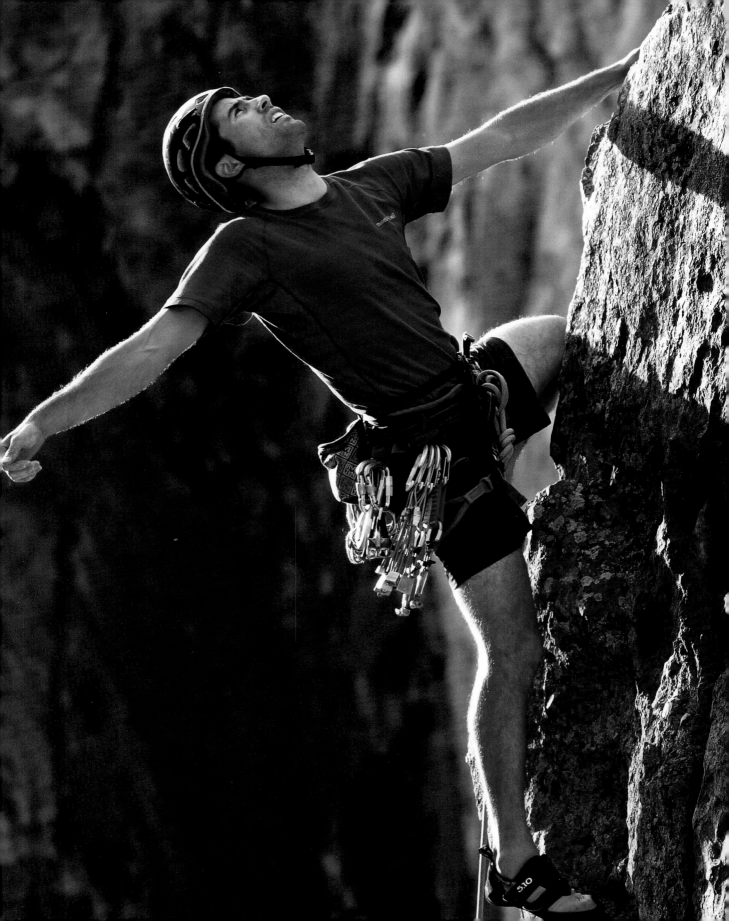

OUTPUT

It's one thing to make sure your photos look good on screen. It's quite another thing to ensure that your corrections are rendered faithfully in print, your photos display at the correct size, and your color is communicated to others who are incorporating your photos into a page layout or making prints at a digital photo lab.

Climber, Eldorado Canyon State Park, Colorado. Olympus E-3, 90–250mm lens, 1/250 second at f2.8, ISO 250

Whenever you share files with others, either casually or professionally, you must address a host of technical and aesthetic challenges to ensure that your vision is accurately represented. This chapter aims to demystify the practice of preparing images for print, slay misconceptions about image size and image resolution, and help ensure that you deliver photos in the correct file format every time. To do all this, we have to start at the very beginning with the most fundamental element in a digital photo—the *pixel*.

WHERE DO PIXELS COME FROM?

Pixels are the building blocks of digital photos. In much the same way bricks can be used to build a home, pixels are assembled in an elaborate mosaic to create digital photos.

When you press the shutter on your digital camera and light passes through the lens, you get pixels. Of course, this doesn't all happen directly, and the engineering is rather complicated, so instead of ruining this magic moment that creates pixels, I'll give you the quick and not-so-dirty version.

The surface of your camera's sensor is made up of millions of tiny lenses, each covering a tiny opening roughly 1/8 the width of a human hair. Each opening and its corresponding lens is called a *pixel site*. Electrons are gathered and counted in each pixel site, generating an electrical signal. This simple electric signal is sent by each of the pixel sites to the digital to analog converter

(DAC), where the individual light signals are analyzed and compared with signals from adjacent sites. This is where the magic happens. The DAC does all this measuring, calculating, and comparing and creates pixels, one for each pixel site. Together, all of these pixels blend to create a seamless, richly detailed, vibrant mosaic that is your digital photo. It could be a photo of the beaches of Barcelona or polar bears in the Arctic—the process is exactly the same for each and every photo you take with your camera.

While you pause for a moment to catch your breath, I'll take this opportunity to tell you that pixels are the most valuable commodity you have as a digital photographer. They are the raw material you shape, sculpt, and hone to create your masterpiece, and as such, pixels deserve your respect. Preserving and caring for your pixels is of the utmost importance if your photos are to look their very best. Don't laugh—there are lots of ways you can damage or even waste pixels, and a pixel is a terrible thing to waste.

The number of pixels you have to work with depends on your camera. The total number of pixels created with each and every photo depends on your camera's *megapixel rating*. For example, each photo created by a 10-megapixel camera has 10 million pixels.

More Is Always Better, Right?

The old school of thought was to try and get a camera with the largest number of megapixels possible. This way of thinking is slowly

changing, and photographers are beginning to come to the conclusion that more isn't necessarily better. You need enough pixels to ensure good quality in your largest sized prints, but having too many pixels slows down your workflow and increases the difficulty in storing, managing, and backing your image library.

In my opinion, the sweet spot for digital SLR cameras is 10 to 12 megapixels. This provides more than enough information for 11 × 17 and 16 × 20 inch prints without taking up too much space on your hard drive.

To understand the relationship between a camera's megapixels and your printing options, you must understand two fundamental concepts: *image size* and *image resolution*.

Image Size

The image size is the width and height of all pixels in an image. You know that a photo from a 10-megapixel camera has 10 million pixels. The exact dimensions of the photo will vary from camera to camera due to the camera's *aspect ratio*. Some cameras are based on the 35mm film ratio of 3:2, while the Olympus cameras I use follow a medium-format image ratio of 4:3. A photo from a 10-megapixel Olympus camera has an image size of 3648 × 2736 pixels. I'll use this as our starting point, but your exact dimensions may differ.

Since pixels are just points of information without any physical size, you can't determine how large a print you can make from a 10-megapixel camera without an additional piece of information: the image resolution.

Before moving on, I want to reiterate one important point: When you press the shutter, you capture light and convert it to a finite number of pixels. While you can crop and resize images in Lightroom and Photoshop, you'll get the best results when you compose carefully in-camera and crop minimally in your software.

Image Resolution

The image resolution determines how many pixels are packed into an inch or centimeter of paper when you make a print. Image resolution is listed in the number of pixels per inch (ppi). Here, too, conventional logic holds that the more pixels you compress into an inch of paper, the more detail and sharpness you'll see in your finished print. Image resolution also has a sweet spot, above which additional information yields diminishing returns and below which image quality suffers. Preparing your image correctly for printing can be a little tricky, because each output device has a slightly different sweet spot for image resolution. For example, your inkjet printer works best with an image resolution between 240 and 360 ppi, while the sweet spot for newspapers is around 200 ppi. Preparing images for web, video, or other screen-based output works a little different, so I'll cover that later in this chapter.

PPI or DPI?

You'll often hear photographers talk about their image resolution in *dpi* or *dots per inch* instead of *ppi, pixels per inch*. The two terms are incorrectly used interchangeably and this can cause confusion. Here's a quick rundown of when to use each:

ppi (pixels per inch) Use ppi whenever you refer to the *resolution* of an image, as in "I set my photo to 240 ppi for printing on my inkjet printer."

dpi (dots per inch) Strictly speaking, dpi refers to the number of dots of ink a printer applies to an inch of paper during the printing process. Most photo-quality inkjet printers can print a maximum of 2880 dpi. A correct statement would be "I set my photo to 240 ppi and printed it at 2880 dpi on my inkjet printer."

The acronyms *ppi* and *dpi* refer to very different things, and no correlation exists between the two measurements. Using the two acronyms correctly helps reduce confusion when you're sharing photos with others.

Here is a list of the sweet spots for several common forms of printed output:

- **Inkjet printer** 240–360 ppi

- **Digital minilab (commercial prints up to 8 × 12 inches)** 240–300 ppi

- **Large format photo printer (commercial prints above 8 × 12 inches)** 240–403 ppi or less, depending on the final print size and expected viewing distance

Tip You'll often hear a generic recommendation to set your photos to 300 ppi for printing. While this is a sensible guideline, it is not always the optimum resolution for all situations. Use 300 ppi when you don't have a more definitive recommendation.

While the image size is fixed, the image resolution is elastic and can be adjusted easily for different forms of output without any loss of quality. However, you'll often need to adjust both the image size and image resolution to create a photo of a specific size. How you do this will depend on whether you're working in Lightroom or Photoshop. To make sure you have all your bases covered, I'll demonstrate how to resize images in both applications.

Resizing Images in Lightroom

One of the advantages of Lightroom's database system is that it simplifies the entire file management process, allowing you to eliminate many of the image resizing steps you have to perform in other applications. For example, let's say you want to make a 5 × 7 inch print of your favorite photo. In Photoshop, you'd have to resize the photo manually to the correct print dimensions and image resolution. Otherwise, you'd get either a poor quality print or an incorrectly sized print. In Lightroom, all you have to do is select the print size you want, tell Lightroom what image resolution you want to use for printing, and Lightroom does the rest. This works for both camera raw files and layered Photoshop document (PSD) files stored in your Lightroom database.

The only resizing decisions you face in Lightroom occur when you use the Export module to export a processed version of your raw file or an additional version of a processed photo. You'll use the Export module to create a version of your photo for an e-mail

attachment, or when you want to make your 5 × 7 inch print at a photo lab instead of on your inkjet printer.

You can open the Export module one of four ways:

- From the Library module, click the **Export** button on the bottom panel on the left side of the screen.

- From the File menu, click **Export** in any of the five Lightroom modules.

- CONTROL-click (Mac) or right-click (Windows) any image thumbnail in the Filmstrip to activate the context menu, and then click **Export**.

- Use the keyboard shortcut CMD-SHIFT-E (Mac) or CTRL-SHIFT-E (Windows).

Each of these options will bring you to Lightroom's Export module. At the end of this chapter, I'll provide an in-depth How To about using the Export module; for now, I'll concentrate on the image sizing options found in the module.

The Export dialog offers several Image Sizing options. Here you can adjust the resolution or image size of exported photos. This doesn't change the resolution of the original photo in the library—it changes the resolution or size of the exported version only. Lightroom always works from the full-resolution file in the library, allowing you to make smaller sized copies for export.

Whenever you adjust the image size or resolution of your photos, you're looking to accomplish one of two things:

- *Preserve the original image size of the photo, but change the image resolution.* If you're submitting a photo for professional reproduction or printing, you'll often need to give designers the full-resolution file, but you'll adjust the image resolution for printing.

- *Change the image size and image resolution for a specific output condition.* When you create an e-mail version of your photo to send to a friend, or you create an appropriately sized print file for your photo lab, you'll specify both the image size and the resolution.

To export the full resolution file while changing the image resolution, uncheck the **Resize to Fit** checkbox and enter your desired resolution in the Resolution field. Here you can specify whether you'd prefer the image resolution to be in pixels per inch or pixels per centimeter.

Configure the remaining options in the Export dialog and export the high-resolution photo.

To change the image size *and* the image resolution, check the **Resize to Fit** checkbox and choose from the following options:

- **Width & Height** Specify your image size in pixels, centimeters, or inches. Lightroom will resize the *longer* dimension of the photo according to the values entered in the input fields and resize the shorter dimension proportionally. This doesn't take into account the rotation of the photo.

- **Dimensions** Set your image size in pixels, centimeters, or inches. This works very similar to Width & Height with a little intelligence added. To resize both vertically and horizontally oriented images correctly using Width & Height, you need to set both Width and Height fields to the same dimension. (So, for example, for a series of 5 × 7 inch prints, you would set both the Width and Height fields to 7 inches to ensure that all images are resized correctly.) Using the Dimensions controls, you can specify the dimensions of your exported photo, and Lightroom will take care of the rest. Using Dimensions, you would specify 5 × 7 inches for all photos, and all photos would be resized to the correct dimensions.

This is a subtle, yet potentially problematic difference between the two options that can cause confusion. To be safe using either method, set your W and H to the same value so both vertically and horizontally oriented images will be resized consistently.

Resizing Images in Photoshop

Adjusting the image size and resolution of photos in Photoshop is more complicated than the adjustment process in Lightroom. In Photoshop, you'll need to resize images for every type of output. Unlike in Lightroom, in Photoshop it is possible to damage your photo's image quality.

Most of the time, you'll adjust your image size using Photoshop's Image Size dialog found under the Image menu (**Image** > **Image Size**).

Three main sections lie within the Image Size dialog: the Pixel Dimensions show the current dimensions of your photos in pixels, the Document Size section displays your current document or print size, and a series of checkboxes contain options for resizing images. By this point, these top two sections should be fairly familiar, but the options at the bottom of the dialog can get you into trouble. For that reason, we'll start at the bottom.

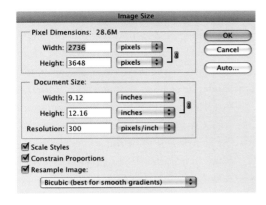

Scale Styles You will rarely need to use the Scale Styles checkbox. Keeping this checked ensures layer styles such as drop shadow or a beveled edge will be resized with the document. Go ahead and leave this option checked.

Constrain Proportions Normally, when you resize a photo, you'll want to keep the overall proportions of the photo the same; otherwise, the image will look stretched or squeezed. Leave the Constrain Proportions checkbox checked unless you want to distort the proportions of your image. (Even if you do want to distort it, there are better ways of achieving the effect than with this option—such as using the Warp tool.)

Resample Image The Resample Image option is like a sharp knife, a potentially dangerous tool you must use on a regular basis. Therefore, you want to make sure you use it correctly and with care.

When the Resample Image checkbox is checked, Photoshop allows you to add or remove pixels from your photo. This is ideal when you need to resize an image for e-mail or for a smaller print. The danger comes from the fact that it adds or removes pixels from the original, working image. Therefore, if you take a 10-megapixel image, resize it to 1 megapixel to e-mail to a friend, and click Save, you're left with a 1-megapixel image. While you can undo this mistake or return to your original raw file, the best advice is this: If you check the Resample Image checkbox, when you save your photo, use Save As instead of Save. This will keep the full resolution of your original intact by creating a *copy* of the photo in the smaller size.

When the Resample Image checkbox is unchecked, you can change the image resolution, but you cannot adjust the photo's pixel dimensions. As you'll notice, the Pixel Dimensions options at the top of the dialog cannot be adjusted.

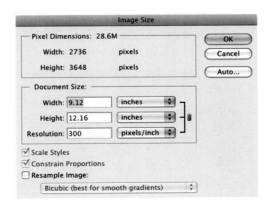

Here's a quick way to remember which option to use: When you need to change the document size, leave Resample Image checked.

If you need to change the resolution but you want to preserve the current size, uncheck Resample Image.

At the bottom of the dialog is a pull-down menu with five options: Nearest Neighbor, Bilinear, Bicubic, Bicubic Smoother, and Bicubic Sharper. The three Bicubic options are the only ones you need to know about. The other two are older methods of adjusting the image size and are used infrequently for digital photos.

With the first two options eliminated, your three choices for resizing images are as follows:

- **Bicubic** This method is the most versatile of the three options and is effective for making images larger or smaller. This is the default option in Photoshop and my preferred option for making images smaller.

- **Bicubic Smoother** This option is designed to give better results when enlarging, or *upsampling*, images. Several techniques can be used for creating large prints from small files, and I'll discuss the merits of each in Chapter 18. I use Bicubic Smoother for upsampling photos.

- **Bicubic Sharper** As you may have deduced, Bicubic Sharper is designed to make images smaller, a process sometimes

called *downsampling*. Bicubic Sharper attempts to compensate for the softness caused by downsampling by adding a bit of image sharpening. This works okay for moderate changes in image size. With larger jumps—say, from a full-resolution image to an e-mail–sized photo—I find the sharpening to be too strong for my liking. I prefer instead to use Bicubic for downsampling, and then I can add image sharpening as needed before saving a copy of the file.

Changing the Image Resolution in Photoshop

With Resample Image unchecked, you can enter a new image resolution in the Resolution field and the Width & Height will adjust automatically to the new print dimensions. Once you've set the resolution, click **OK** to close the Image Size dialog box.

Changing the Image Size in Photoshop

To change the size of your photos, make sure the Resample Image checkbox is checked, and then adjust any of the image attributes—Height, Width, Resolution, or pixel dimensions. Click **OK** to apply your size changes and exit the dialog.

Tip Use the image preview to validate your corrections. I always watch for changes in the size of my image in the document window after clicking OK in the Image Size dialog. If I've downsampled my photo, the preview should get smaller as well. This helps me catch any mistakes I may have made when adjusting the image size or resolution.

If your photo's dimensions don't quite match your intended print size, you'll need to correct this by resizing your image and then cropping the photo to match the proportions of the print. Enter the dimension of the short edge of the photo in the appropriate Document Size field, and then crop the long dimension after exiting the dialog.

Recommendations

Given the choice, I prefer to perform my resizing in Lightroom instead of Photoshop. Not only is the process simpler, but I never have to worry about accidentally changing the size of the original. It is also far easier to select a group of images in Lightroom and resize them through the Export module than it is to create a resizing action in Photoshop.

Recommended Image Sizes

Now that you have achieved the technical skills necessary to resize your images, use the following guidelines to help you prepare photos for a variety of different output types.

Print

For most print images, you're safe using the default print resolution of 300 ppi, particularly when preparing images for commercial reproduction (you'll be looked at askance when you deliver files at anything other than 300 ppi). This is a good rule of thumb when printing at a photo lab. Unless the lab specifies a different resolution, 300 ppi is a good starting point.

For inkjet printing, many photographers prefer to set their image resolution at a

fraction of the print resolution. For 2880 dpi printers, this means setting your image resolution at 240, 360, or 480 ppi. Most, but not all, photographers think 480 ppi is overkill and use either 240 or 360. I'd suggest running a few tests with your printer and paper combination to see what works best for your fine art prints.

Web

When images are displayed on a web page or incorporated into a multimedia presentation, your resolution is irrelevant; all that counts is the image size. Because graphics are displayed online at their absolute size, pixel for pixel, you're best served by specifying image dimensions in pixels instead of inches or centimeters.

For an e-mail attachment, I recommend setting the long dimension of your photos somewhere between 600 and 800 pixels, which displays nicely in most e-mail applications.

Selecting the appropriate dimensions for a website can be trickier since there is no standard size for pictures on a site. Most web pages are designed to use either 800 × 600 or 1024 × 768 pixel images, but photos used on the site are often considerably smaller. As an example, Flickr resizes images posted to the site to the following sizes:

- 75 × 75 pixels
- 100 pixels (long side)
- 240 pixels
- 500 pixels
- 1024 pixels for large display

Check out www.flickr.com/help/ photos/#18 for more information.

This gives you a ballpark set of image sizes for use on a website. The smallest is a thumbnail-sized image, the middle sizes could accompany an article, and the two larger sizes are to be used when a photo is the dominant (or only) element on a page.

Video and Multimedia

Like preparing images for a web page, sizing images for video or multimedia production depends on how the image will be used. Here, too, image resolution is ignored in favor of the absolute image size. Further complicating the issue is the fact that digital video often uses non-square pixels, requiring a special compensation to ensure that the photo appears correct in video.

You can also base your image sizing on the pixel dimensions for common video formats. Consider adding 200 to 300 pixels in either dimension, as video producers often like to pan through a photo and need the extra pixels to ensure that your photo looks good at full size in the video.

Ultimately, you'll be best served by asking the producer what size photos he or she would like to receive for the project.

COLOR MODES/COLOR SPACES AND COLOR MANAGEMENT

Understanding the image size and image resolution helps you assess how large a print you can make from a given photo and allows you to reduce the image size for posting to a website. These two attributes of your photos, however, don't tell you anything about the color and tone of your photos. To glean the most basic information about a photo's color and tone, you have to dig a little deeper into the technical attributes of your digital photos.

Understanding color is important, because on some occasions, technical issues relating to color require you to troubleshoot problems or convert colors for use with a particular output method, such as inkjet printing or displaying photos online. For these reasons, it is essential that you have at least a basic understanding of color modes, color spaces, and color management.

Color Modes

Every single picture taken with your digital camera is captured in the RGB color mode. That is to say, every pixel in your picture contains red, green, and blue values, which when combined create all the color, tone, and detail in your photos.

The RGB color mode is not the only one used in digital imaging. Grayscale and CMYK color modes are also commonly used at different points of a digital photography workflow. In this section, I'll examine the three commonly used color modes to help you get a handle on how color is represented in Lightroom and Photoshop.

In the "Color Management" section, I'll demonstrate the best methods for converting photos to other color modes.

Grayscale Mode

As the name implies, the Grayscale mode contains only tonal, not color, information. Grayscale images were once commonly used when scanning black and white film or when creating black and white images from digital photos, because the file size for grayscale images is significantly smaller than that for color images. As the speed of computers has improved and hard drive storage space has expanded, this has become less of an issue.

Grayscale images contain only one channel, the Gray channel, used for storing your photo's tonal information. The lightness value for each pixel is listed as a percentage of total black. A deep shadow pixel will have a Grayscale value of 80 percent or higher. A bright highlight will have a Grayscale value of 10 or less.

In all likelihood, you will need to work with grayscale images only if you are preparing images for use in a print newsletter, newspaper, or magazine.

Lightroom does not allow you to import grayscale images into a Lightroom library, nor does it allow you to export photos in the Grayscale color mode. To work with grayscale images, you will need to work in Photoshop.

Fully saturated values of red, green, and blue create white and are thus called *additive colors*. As a photographer accustomed to working with light, you will work almost exclusively in RGB mode unless you are preparing images for reproduction on a commercial printing press.

RGB (Red, Green, Blue) Mode

Since RGB (red, green, blue) is the native color mode for your digital photos, it is worth highlighting a few important points about the RGB color mode.

Equal values of RGB correspond to a neutral shade of gray.

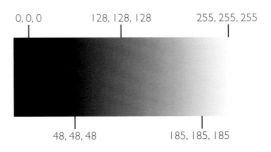

0, 0, 0 128, 128, 128 255, 255, 255

48, 48, 48 185, 185, 185

The greater the difference between the primary colors, the more saturated the individual color.

200, 180, 180 240, 180, 180

RGB values affect not only color, but tone as well. Low RGB values equate to darker tones, and higher RGB values equate to brighter tones.

15,12,40 75, 85,130 150, 210, 240

Increasing the amount of any of the three primary colors makes the color more saturated and the tone brighter.

150,128,128 220,128,128

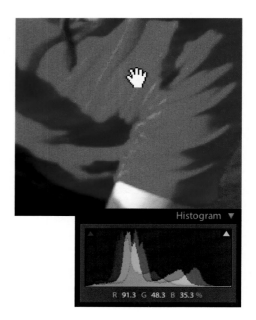

When working in the Develop module in Lightroom, you can hover your cursor over any pixel in the image and the pixel values will display immediately below the histogram. Lightroom displays RGB values as percentages (0–100), with 0 percent being fully desaturated and 100 percent being fully saturated. Therefore, a pixel value of 100, 0, 0 is a fully saturated red color with no green or blue color.

In the real world, colors are rarely that saturated. Even this bright red jersey contains some green and blue.

Photoshop uses the older convention of displaying RGB values on a scale of 0 to 255, with 0 being fully desaturated and 255 being fully saturated. Photoshop displays RGB values in the Info palette (**Window** > **Info**).

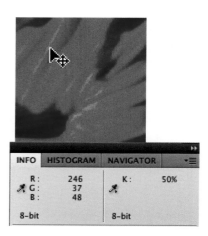

Personally, I find the percentage system more intuitive and easier for new photographers to learn, but either system works for assessing color casts by comparing the pixel values between red, green, and blue. Equal values will always indicate a neutral shade of gray, while unequal values can indicate a color cast. For example, in a wedding photo, as a test you can often look at the RGB values on the groom's white collar. If blue is higher than either red or green, you'll likely need to remove a blue color cast.

CMYK (Cyan, Magenta, Yellow, and Black) Mode

While the RGB color mode is used for light-based devices, the CMYK (cyan, magenta, yellow, black) color mode is used exclusively for printing. RGB and CMYK can be thought of as opposites. Increasing values of red, green, or blue in an RGB photo lightens the photo

(*additive color*). Increasing values of cyan, magenta, yellow, or black darkens a photo by adding more ink to the page (*subtractive color*).

In contrast to your monitor, which transmits light, ink on paper absorbs light. Fully saturated values of cyan, magenta, and yellow equal black. In the real world, the pigments we use to create cyan, magenta, and yellow inks aren't perfect, so we add black (K) to the mix to get truer, richer blacks on an inkjet printer or printing press. If you look at the ink cartridges in your inkjet printer, you will find the base colors of cyan, magenta, yellow, and black are used to print all of the colors of your digital photo. This leads to an obvious conclusion that during the printing process, your RGB photos will, at some point, need to be converted to CMYK for printing.

Additive

Subtractive

While this is true, even if you frequently create prints from their digital files, you will rarely find the need to work in CMYK color mode. The RGB to CMYK conversion takes place within the printer software, often called the print driver, allowing photographers to continue to work exclusively in RGB.

Lightroom does not allow you to import CMYK images into a Lightroom library, nor does it allow you to export photos in the Grayscale color mode. To work with CMYK images, you will need to work in Photoshop.

Color Profiles

The color mode provides general information about a photograph and its intended purpose, but it isn't precise enough to give you the exact color of a pixel. For this, you need a *color profile*, often called an *ICC profile*. (ICC stands for International Color Consortium.) ICC serves an important role as part of a broader system of color management to help you preserve the appearance of your photo as it is converted to, or accessed by, different devices such as monitors or printers.

Most ICC color profiles are created by displaying a series of colored patches on screen or printing a test target containing dozens, if not hundreds or thousands, of colored patches, and then measuring them with either a colorimeter (screen) or spectrophotometer (screen or print). The measured color values are compared to the actual color values stored within the color management software, and a lookup table is created by the color management software to offset the differences between the *expected* and *actual* color reproduction. This lookup table, based on specifications set by the ICC, is a color profile and can be used in a wide variety of imaging applications. Most often, the ICC profile is embedded in a photograph and travels with the photo as it is copied from computer to computer or from device to device.

For a practical example, let's look at the RGB values 200, 15, 18. Since the red value is much higher than that of either green or blue, we can determine that this pixel is red, but we are unable to assess exactly what *shade* of red it is. If we look at this RGB combination in three different color profiles, we get three clearly different results.

Adobe RGB 1998

Apple RGB

Epson 2880 Printer with Premium Luster Photo Paper

When a photograph has a color profile, it becomes easy to convert between different color profiles for printing or more accurate reproduction on the Web. Converting between two profiles changes the RGB values of each pixel to preserve the color appearance when used in this new color space.

Ultimately, the color profile acts as a secret decoder ring to help Photoshop or Lightroom determine what the RGB values contained in your pictures should actually look like. When color profiles are embedded within digital photos,

- you can make accurate color and tone adjustments more confidently;

- your pictures don't change color when you move between computers or share photos with others;

- printmaking becomes easier and more predictable.

Color spaces are one essential component in a broader color management system. In the next section, I'll look at how color management fits into a digital photography workflow.

Color Management

Color management in a digital photography workflow brings consistency to your color and tone corrections and predictability to your printing. The keystone for a digital photography workflow, a calibrated monitor, and proper use of ICC profiles allows you to trust with confidence what you see on the monitor and in print.

Unfortunately, color management comes with its own vocabulary to describe the features, functions, and options of a color managed workflow. Following is a list of the most commonly used terms to bring you up to speed:

- **Color gamut** The colors reproducible by a particular device or color space. The color gamut is determined by the physical properties of the device—for example, how cyan is the cyan ink—and is calculated as part of the ICC profile.

- **Display profile** An ICC profile describing the color reproduction characteristics of a display such as an LCD or LED display. The display profile is stored at the operating system, allowing it to be used and accessed by any color management–aware application.

- **Editing space** In an RGB workflow, the color space is used as the primary color space for tone and color corrections. RGB editing spaces do not represent the color behavior of a physical device, making them ideal as an intermediate space between input and output for conducting tone and color corrections. In Photoshop, editing spaces are selected in the Color Settings dialog as working spaces.

Think of editing spaces as a specific class of color spaces designed specifically for image editing and corrections. While all editing spaces are also color spaces, not all color spaces can be considered editing spaces. Editing spaces need to be mathematically generated and well-

behaved, meaning equal values of red, green, and blue always equal a shade of gray. This is not necessarily the case with other classifications of profiles, as they describe the color response of specific devices.

How Does Color Management Work in a Digital Photography Workflow?

To achieve consistent color throughout the input, editing, and printing stages of a digital workflow, an ICC profile embedded in the image tells the software programs what the colors in the image should look like. As the image file moves from one device to another (such as from scanner to computer), the color numbers are converted from one color space to another to preserve as accurately as possible the color appearance of the file. Here's an example of a common workflow:

Step 1 RGB information is captured by the digital camera or scanner. Camera raw photos have an ICC profile applied during processing. (See the sidebar "Color Management in Raw Files.") Scanner software allows the use of ICC profiles to describe the scanner's color behavior. After the initial scan, photos are converted from the scanner profile to a common editing space.

Step 2 During the editing process, the information is converted from the editing space to the monitor profile on the fly, ensuring that the image displayed on your monitor is as accurate as possible. This process is referred to as *display compensation*.

Step 3 After the necessary adjustments are made to the file, the color values in the file are translated to the printer's color space and the information is sent to the printer.

Color Management in Raw Files

As you are well aware by this point in the book, camera raw files are unprocessed information that comes directly from the camera. As such, they cannot be color managed in the same way that other processed file types, such as JPEGs, can be.

Raw processing applications such as Lightroom and Photoshop's Adobe Camera Raw use a modified color management system to preview raw files internally. Then, when the photo is processed, the raw data is converted to color-managed RGB values and the ICC profile is embedded.

Commonly Used Editing Spaces

If you spend any time on the popular digital photography forums or chat rooms, you'll find that photographers have strong opinions about which color space is best. In truth, there is no "best" color space, but some color spaces are preferred for specific uses. RGB editing spaces, in particular, have to strike a delicate balance. They should have a larger

color gamut than the anticipated output methods to ensure that you're maximizing reproduction quality. However, the downside with larger color spaces is they have a tendency to show banding in areas of smooth transitions if great care isn't used when you're making adjustments.

Allow me to take a moment to introduce you to some of the commonly used color spaces. Along the way, I'll point out each color space's pros and cons.

Adobe RGB 1998 The Adobe RGB 1998 color space is the most popular color space for digital photography. It is large enough to exceed the color gamut of most inkjet printers, save for a few highly saturated cyan blues, but it isn't large enough to cause significant problems with banding in smooth areas.

Adobe RGB 1998 has emerged as the default RGB workspace for commercial print-based workflows. It is also a fine choice for landscape, portrait, and travel photographers, particularly those who perform their own inkjet printing.

If you're shooting JPEG on-camera, you'll want to select Adobe RGB 1998 as your preferred color space on the back of your camera to give you the best information from your JPEG files.

sRGB Originally designed to represent the "average computer monitor," standard RGB (sRGB) has gotten a bad reputation in recent years. sRGB is the ideal color space for many wedding and portrait photographers, as most online print-fulfillment services prefer to receive sRGB files for printing. Wedding and portrait photographers aren't sacrificing much by using this smaller color space, since the most important colors for their work—skin tones—are not very saturated and fall well within sRGB's color gamut. Since it was designed to mimic an average monitor, sRGB is also ideal for web, video, or interactive projects.

A graph comparing the color gamuts of Adobe RGB 1998 (wireframe) against sRGB (solid). The farther from the center axis, the more highly saturated the color.

ProPhoto RGB When compared to Adobe RGB 1998 and sRGB, the color gamut of ProPhoto RGB is huge. While ProPhoto has advantages for photographers, particularly from an archival perspective, it also has significant drawbacks. First, since ProPhoto is so large, you must work with high-bit files (discussed later in the section "What Is Bit Depth?") to avoid introducing banding and uneven steps in smooth transitions. Second,

even though ProPhoto can retain detail in heavily saturated colors, the monitor you're working on can't display them since it likely has a color gamut similar to sRGB. This means you are doing your corrections blind and cannot preview, or even print, many of the colors you're manipulating.

I see ProPhoto as an expert color space. There are specific reasons for using such a large color space; however, they are very specialized and require a high degree of technical Photoshop skill to use effectively. For the rest of us, the negatives associated with ProPhoto RGB outweigh the benefits.

A graph comparing the color gamuts of Pro Photo RGB (wireframe) against sRGB (solid). The farther from the center axis, the more highly saturated the color.

The Moral: Don't Sweat It

Some photographers get themselves all worked up over which profile to use for their editing space. My suggestion is to choose the one that best matches your current output types.

For wedding and portrait photographers, or those photographers who display their work primarily online, that is sRGB. For landscape, travel, and fine-art photographers, the best choice is Adobe RGB 1998, since that will give you the best results in print, both from desktop inkjet printers and from commercial printing presses.

The biggest reason you don't need to agonize over the selection of your editing space is that you're shooting in camera raw and performing most of your corrections on the raw file. Since this unprocessed file doesn't have a color space applied to it, you can always go back to the raw file and reprocess it into a larger color space if the situation warrants it.

Most likely, as technology improves, you'll want to go back to the raw file and re-export it using the latest camera raw processing. With every new version of the software, the tools and the conversions improve, so you can go back and rediscover your old photos all over again.

Color Management in Lightroom

Lightroom takes a unique approach to color management, hard-wiring the color management policies within the library, while offering full color management controls over exporting, printing, and interfacing with Photoshop. This makes color management in Lightroom both easy to use and very effective. Here's how it works.

Your Lightroom libraries are always color managed using Lightroom's own internal color management policies. There are no options for you to choose, buttons to click,

or checkboxes to check. You don't need to know anything about color management in Lightroom to make it work. This is a marked improvement over many applications, where color management is turned off or restricted until it's manually activated by the user.

Because Lightroom is designed for maximizing the image quality of camera raw files, the program uses a variation of the ProPhoto RGB color space for generating high-resolution previews of raw files and generating thumbnails. The use of a wide-gamut color space such as ProPhoto RGB is advantageous at this stage, because Lightroom has access to all the raw information in your photos to ensure that your gradients and transitions are smooth and that no colors are unnecessarily clipped during the editing process.

For processed images such as JPEGs and TIFFs that you've brought into your Lightroom library, Lightroom uses the color profile embedded in your images or defaults to sRGB if no profile is embedded.

Tip Because the default color spaces differ between Lightroom and Photoshop, you may notice a discrepancy in the RGB numbers displayed in the Info panels of each application. Normally, this does not affect the appearance of colors, only their RGB values.

When exporting photos for use in other applications, Lightroom allows you to select your preferred RGB editing space in the Export module.

During the export process, Lightroom will convert the unprocessed pixel values in your raw files to processed RGB values based on the color profile selected in the Export dialog. As with image resizing, this conversion applies only to the duplicate copy of the file created during export, not to the original photo in the library.

Lightroom also provides control over the color management policies for delivering photos to Photoshop and other external imaging applications. In Lightroom's Preferences dialog (**Lightroom > Preferences** on Mac or **Edit > Preferences** in Windows), click the **External Editing** tab to adjust Lightroom's external editing policies.

Recall from the beginning of Chapter 15, when I had you change your default Color Space from ProPhoto RGB and bit depth from 16 bits/component to use the Adobe RGB 1998 color space and a bit depth of 8 bits/component. I'll discuss bit depth and why I suggested you make these changes in the next section.

I suggest you leave the following current settings in Lightroom:

- File Format: PSD
- Color Space: AdobeRGB (1998)
- Bit Depth: 8 bits/component
- Resolution: 300

These are sound defaults for the workflow outlined in this book. If you decide to work with a different set of color management or image processing parameters, feel free to change the settings in this dialog to better suit your workflow.

When generating web galleries, Lightroom converts your photos to the sRGB color space, which is better suited for display on the Web.

When printing photos, Lightroom allows you to take full control over the conversion of your photos from the editing space used in Lightroom to your printer's output profile. I'll cover this process in full detail in Chapter 18.

That rounds out our tour of Lightroom's color management capabilities. Since Photoshop takes a slightly different approach, let's look at Photoshop's color management options.

Color Management in Photoshop

Unlike Lightroom, Photoshop makes all the color management options in the application available to the user. While this gives advanced users more control, beginners are sometimes overwhelmed by the color management decisions they are forced to make. We'll start by looking at Photoshop's Color Settings, the default color management settings.

Color Settings

Photoshop's Color Settings (**Edit** > **Color Settings**) store the default color management policies for displaying and converting colors in your Photoshop documents. In a digital photography workflow like the one described in this book, the Color Settings will have minimal impact on the efficiency of the workflow, since most of the color management decisions are made in the raw processor. In our case, that will be Lightroom's settings selected for editing photos in Photoshop.

A few items are worth pointing out in Photoshop's Color Settings dialog.

The Working Spaces are the default ICC profile Photoshop uses when you create a new document or open a photo that does not have an embedded ICC profile. When this occurs, Photoshop displays the photo using the Working Spaces profile.

The Color Management Policies are used to specify what Photoshop should do when it encounters a photo containing an embedded ICC profile that differs from what is specified in the Working Spaces settings. By default, all

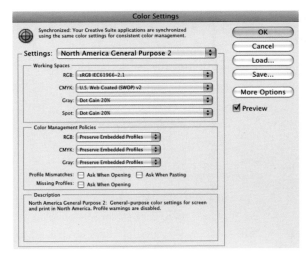 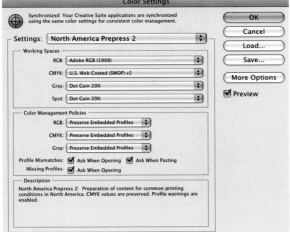

three policies are set to Preserve Embedded Profiles. This is a safe setting and similar to the one used within Lightroom. The three checkboxes at the bottom of the window are used to indicate whether or not you'd like Photoshop to notify you when it encounters photos containing an embedded profile that differs from your Working Spaces settings. By default, all three are unchecked, but we'll change that in the next step.

Configuring Photoshop's Color Settings

For a smooth workflow between Lightroom and Photoshop, synchronize Photoshop's Color Settings with Lightroom's color management. Change the Settings file used from **North America General Purpose 2** to **North America Prepress 2**. This changes your Working Spaces RGB setting from sRGB to Adobe RGB (1998) and activates the Profile Mismatches and Missing Profiles checkboxes.

With these new settings, you may receive a warning dialog when opening your older pictures. There are, in fact, two possible warnings you could receive, neither of which is cause for alarm. Let's look at the two dialogs to learn what they are trying to tell you.

> **Editing Space vs. Working Space**
>
> One common source of confusion is use of the terms *editing space* and *Working Spaces*. An editing space is a class of profiles used for image correction and archiving. Working Spaces are settings within Photoshop, where you will often select an editing space profile. In most cases, you can safely use the two terms interchangeably. Just remember that editing space refers to a type of profile and Working Spaces refer to settings within Photoshop.

The Profile Mismatch Dialog

When photos contain an embedded profile different from the one specified in the Color

Settings, Photoshop gives you a head's up to highlight the difference and asks you what you'd like to do. This indication, called the Embedded Profile Mismatch warning, is not serious. It simply means the photo you're opening has an embedded profile that's different from the one in your Working Spaces settings.

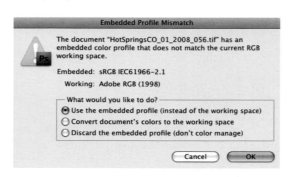

The Embedded Profile Mismatch dialog box offers you three options:

- **Use the embedded profile** This is the preferred option. There's nothing wrong with opening and working with photos in other color spaces. If you are compelled to convert the photo to your Working Space you're better served by opening the photos as is for now, and then using the Convert to Profile dialog to perform the conversion.

- **Convert document's colors to the working space** Selecting this option probably won't cause significant harm to your photos, but it's better to perform your color corrections manually using the Convert to Profile dialog

because you'll have a preview of what effect the conversion will have on your photo. With this option, you are performing the conversion blindly.

- **Discard the embedded profile** Selecting this option will increase your color management problems. Avoid it at all costs.

Converting Between Profiles

At several different stages in your workflow, your photo will undergo a conversion from one color space to another. For example, when you print an image, you'll convert it from an editing space, such as Adobe RGB 1998, to the output space used for your printer. During the conversion process, the color values are adjusted to maintain an accurate appearance of your photo.

You'll usually perform your color conversions in the print dialog boxes of either Photoshop or Lightroom, or in Lightroom's Export module. Should you need to perform a color conversion in Photoshop, you'll want to use the Convert to Profile command (**Edit > Convert to Profile**).

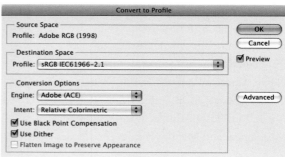

The Convert to Profile dialog allows you to convert between any two ICC-based color profiles. Free of the limitations imposed in Lightroom, Photoshop allows you to convert between RGB profiles or from RGB to a specific CMYK or grayscale profile. This is essential if you're ever asked to deliver photos in the CMYK mode for reproduction on a commercial printing press.

Within the Convert to Profile dialog, you'll see headings for Source Space, Destination Space, and Conversion Options. The Source Space is a listing of the ICC profile currently embedded in your photo. The Destination Space is the profile to which you'll be converting. In this case, I've selected U.S. Web Coated (SWOP) v2, a commonly used profile for commercial printing.

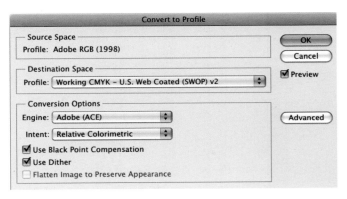

Because there are colors in the Adobe RGB 1998 color space, such as highly saturated reds and greens, that cannot be reproduced accurately on a printing press because they are out of the press's reproducible gamut, I have to use my rendering intent, in

the Conversion Options, to specify how I'd like these *out-of-gamut colors* to be handled.

Although four rendering intents are available here, two options are the most appropriate for photography: Relative Colorimetric and Perceptual.

The Relative Colorimetric rendering intent converts in-gamut colors as accurately as possible from the source and the destination profiles, and it then converts out-of-gamut colors to the closest possible match in the destination profile. The net effect of using Relative Colorimetric is a high degree of color accuracy for in-gamut colors at the expense of out-of-gamut colors. This is the preferred rendering intent for most photographs, including black and white images.

The Perceptual rendering intent scales the color gamut between the source and destination to preserve the color relationships among out-of-gamut colors. Unfortunately, this sacrifices color accuracy among in-gamut colors, making it less desirable for photographers. Use the Perceptual rendering intent only when the

detail in saturated colors (such as vivid flowers) is more important than overall color accuracy.

The Use Black Point Compensation checkbox is used to scale the *black point*, or darkest black, in the source profile to the black point of the destination profile. This preserves shadow detail during conversions and should be left checked.

The Use Dither checkbox preserves the smoothness in areas of continuous tone or subtle transitions. This, too, should be checked for your color conversions.

Whenever you're performing a color conversion, it is worthwhile to toggle the Preview checkbox to look for any colors or tones that will shift during the conversion. If a color shift occurs, you can try a different rendering intent to see if it improves the conversion.

Once you're satisfied with the conversion, click **OK**.

Note For most RGB to RGB conversions, you will not see a significant change in color or tone. When converting from RGB to CMYK, however, you will often see dramatic shifts in tone or color. To improve the results of your RGB to CMYK conversion, you'll want to use the Soft Proof feature, discussed in Chapter 18, to preview the effects of the conversion and perform adjustments to minimize the visual effects of going from RGB to CMYK.

When creating web galleries through Photoshop or Adobe Bridge, or preparing images for the Web using the Save For Web feature, Photoshop converts images to the sRGB color space.

The final color management option you need to be aware of when working with Photoshop is the Embed Color Profile checkbox in Photoshop's Save As dialog.

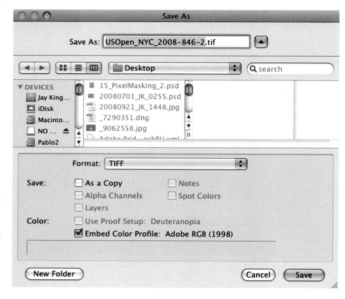

When saving images in Photoshop, you'll want to be sure the Embed Color Profile checkbox is checked. Otherwise, your photos will not have an embedded color profile and will not display correctly the next time you open them in Photoshop, prompting the Assign Profile routine. Do yourself a favor and visually check to be sure you're embedding an ICC profile with your image whenever you're saving your photos.

Bit Depth

During our discussion of color management, the topic of bit depth came up a couple of times in our decision to work with Adobe RGB 1998 over ProPhoto RGB and in our Lightroom preferences. While the topic of bit depth isn't necessarily a difficult one, it is a technical subject, and for some reason it has attracted some heated discussion in online forums. In this section, I'll help you wade through the complexity to get a handle on bit depth and how it impacts your workflow.

What Is Bit Depth?

Every pixel in your photo is stored with a combination of mathematical values. For the most part, the math involved in digital photography is hidden, but every once in a while, digital photography's mathematical roots break the surface. Bit depth is one of those mathematical concepts arising at critical junctions in the workflow.

Without getting too deep into computer programming, I'll describe the bit depth as the amount of information used to describe a given pixel mathematically. Generally speaking, the higher the number of bits, the more discrete colors are available for programs such as Photoshop to help differentiate all the hues and shades of the world.

The majority of the digital photos you've worked with to date use 8 bits of information per channel to describe the colors and tones in your photos. An 8-bit per channel (bpc) image has 256 possible colors per channel. This is the reason Photoshop's Info panel displays RGB values of 0 to 255. The 8-bpc RGB images are sometimes called *24-bit images* (8 bps × 3 channels = 24 bits) in scanning parlance.

Images with a higher bit depth define the same range of colors as an 8-bpc image, but with higher mathematical precision, often 12, 16, or even 32 bpc. Instead of having only 256 possible color values per channel, a 16-bpc image has approximately 4096 color values per channel.

It is important to underscore that higher bit images don't give you whiter whites or deeper shadows. Instead, they slice the range between black and white into finer increments. It is not uncommon for the digital to analog converter (DAC) on your camera to use 10 or 12 bpc for recording the analog light signals as digital values.

These extra bits become important the more work we do in correcting a photo. While performing image corrections, we routinely lose information to rounding errors. Normally, this does not pose a problem, but cumulatively, if we are not careful with our corrections or we have to rescue an underexposed image, these rounding errors can become visible in our photo as abrupt transitions between tonal values. These unnatural transitions are called *posterization*.

Since high-bit images have so much extra information, they rarely show banding or posterization. The downside in working with higher bit depth images is file size. Photoshop treats all higher bit depth images

17_BitDepth_1: This gradient transitions smoothly between two shades of gray.

17_BitDepth_2: This transition has been heavily edited and shows signs of posterization where the gradient jumps abruptly from one tone to another.

as 16 bpc, causing photos to require twice as much RAM to process and hard drive space to store as 8-bpc images. As you begin to add layers and masks to your images, this difference taxes your computer's ability to perform image corrections quickly and quickly fills your hard drives. For these reasons, I recommend performing all your adjustments in Adobe Camera Raw (ACR), which uses a high bit depth for all corrections on raw files and exports files in 8 bpc—except in special circumstances, where 16 bpc will give you superior image quality. These special circumstances are as follows:

- *You need to upsample an image to make an exceptionally large print.* Upsampling in 16 bpc will give you smoother transitions and cleaner detail at large sizes.

- *You need to rescue shadow detail from an underexposed photo.* Digital capture inherently uses less information to store shadow detail. If you need to salvage an image from the shadow detail, you'll have less noise in your photo if you use 16 bpc.

- *You're performing a radical color-to–black and white conversion.* You'll usually want to perform your black and white conversions on the raw file, but if you are significantly changing colors—such as making a middle gray sky black for dramatic effect—you'll want to work in 16 bpc.

- *The post-production work required on a photo is so time consuming you want to do it only once.* If you're creating a complicated composite from 50 images, or you're spending the better part of a week retouching a photo, your time is best served by working in 16 bpc. With most of your photos, if you revisit them in 5 or 10 years to make prints, you'll want to return to the original raw file and start over, since your skill and the processing tools available will be vastly improved, giving you a better print. If you have a significant time investment now, and you know you won't be returning to the raw file, find a fast computer, load it up with RAM, and work in 16 bits.

Outside of these circumstances, I'm hard-pressed to find occasion where a 16-bit image offers a visually superior photo. I strongly encourage you to perform a series of tests and see for yourself.

Tip On those occasions for which you want to work with a high–bit depth file in Photoshop, use a Smart Object. Smart Objects will always perform corrections on the unprocessed raw data, usually 10 or 12 bit, which is equal to, and sometimes superior to, working on a processed, 16-bit image.

Working with High–Bit Depth Photos in Lightroom and Photoshop

Lightroom will automatically adjust its corrections to work with high-bit images when they are available, so you don't need to adjust any settings. If you infrequently need to work on high-bit images in Photoshop, consider using Smart Objects. If you want to work exclusively with 16-bit images, you'll need to change your External Editing preferences (**Lightroom** > **Preferences** on Mac or **Edit** > **Preferences** in Windows).

Under the External Editing preference, change the Bit Depth pull-down menu from **8 Bits/Channel** to **16 Bits/Channel**. Lightroom will now export only 16-bpc images into Photoshop or other image editing applications.

Photoshop will work with images in 8, 16, or 32 bpc. The bit depth of an image is controlled using the Image menu (**Image** > **Mode**).

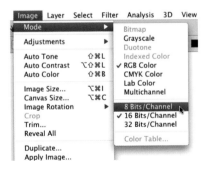

Generally, you'll need to use this feature only when you're reducing the bit depth of high-bit images in preparation for the Web or delivery to others. Since high-bit files are not widely supported in other imaging applications and cannot be used on the Web, you'll need to convert your 16-bpc images to the standard 8 bpc.

To convert from a high bit depth to a normal bit depth, do this:

Step 1 Save a copy of your layered file in the PSD format, preserving your layers.

Step 2 Flatten the layers in your file (**Layer** > **Flatten**). This applies the changes in your adjustment layers to the original pixels. It is advantageous to perform this before converting to 8 bpc to take advantage of the extra bit depth in each pixel.

Step 3 Click the **Image** menu, then click **Mode**, and then **8 Bits/Channel**.

Step 4 Although it is possible to increase the bit depth of an already processed image from 8 to 16 bpc, you don't gain any benefits, since your pixels have already been converted to 8 bpc when they are exported from your raw processor.

File Types

One of the final steps necessary to ensure your digital photo can be read, printed, or displayed by other applications is to save your photo in a file format appropriate for its intended use. The four most common digital photography file formats are JPEG, TIFF, PSD, and DNG. In the following section, I'll offer recommendations of when to use each format and help you avoid some file format pitfalls.

- **JPEG (Joint Photographic Experts Group)** Fast, nimble, and read by almost every imaging program on the planet, JPEGs are a good choice when you want images to take up the least amount of space or move very quickly through an image processing workflow. JPEGs make images small by compressing or "averaging" data into smaller bites, such as "these 9 pixels of sky have roughly the same values." This results in a small file but can also result in a loss of subtle image detail. Opening and resaving a JPEG with a different compression setting compresses (averages) the photo a second time, which is a bit like making a copy of a cassette tape, and then making a copy of the copy, and so on. Each subsequent generation loses quality compared to the original. JPEGs can't store layers and do not support 16-bit data. JPEGs are adept for the Internet and for quick processing or e-mailing, but they aren't appropriate for image archiving or intermediate processing.

- **TIFF (Tagged Image File Format)** A versatile format for printing, TIFF files can be read in almost any imaging or page layout application. Unlike JPEG, TIFF doesn't average or lose data when it is saved, making it an ideal format for archiving. TIFF is also the format your service bureau or minilab will request. TIFF can store layers and it works with 16-bit data. Beware of sending layered or high-bit TIFFs to designers or digital labs, as they can cause problems. TIFF is an excellent format for long-term archiving because they can be read by many different imaging programs, and TIFF offers zip compression, a lossless form of image compression used to save hard drive space. If you're ever asked to provide a high-resolution photo for publication, consider saving your flattened photo in the TIFF format.

- **PSD (Photoshop Document)** This is the native file format for Photoshop documents. As you would expect, just about everything you can do in Photoshop, you can save in a PSD. Layers, yup; 16-bit data, yup; type layers, shape layers, and alpha channels, yup, yup, and yup. PSD has traditionally been the archive format of choice for most photographers, as it ensures that all layered Photoshop file characteristics will be retained. For a long time, photographers used PSD to indicate whether the file was a layered master file or TIFF for a flattened print-ready file.

With TIFF now able to store layered and high-bit files, this distinction has become less cut and dried. For the sake of simplicity, I still recommend using PSD to denote layered master files. But if you decide you'd rather use TIFF, by all means, go for it.

- **DNG (Digital Negative Format)** As discussed earlier, the Digital Negative Format aims to unify the multitude of camera raw formats into an open source, nonproprietary raw-file format. Photoshop allows you to convert your camera's raw files to the DNG raw-file format and to edit and adjust DNG files as you would any other raw file. Some photographers are more comfortable archiving their raw files in the DNG format because it is an open standard instead of a proprietary, closed system. If you're ever asked to deliver a raw file, convert your raw file to a DNG file prior to delivery. With proprietary raw formats, it is too easy from the XMP sidecar file to become separated from the original raw pixel data. The DNG file format wraps all this information together in an easily transportable package, making it an ideal option for delivering or transferring raw files. You can save DNG files only from Lightroom or from within Photoshop's ACR plug-in.

The file format you select will have a direct impact on the file size and the amount of space required to store your photo on your hard drive. JPEG files require the least space since they are a compressed file format. However, this compression can degrade image quality. The TIFF format offers two types of compression, LZW (Lempel-Ziv-Welch) and zip, both of which bypass the compression problems and subsequent quality loss found with the JPEG format.

PSD and uncompressed TIFF files take up the most disk space but allow you to store your layers, masks, and Smart Objects for future editing. As a rule of thumb, I always save my master images, complete with all my corrections, as a layered PSD. Print-ready photos, often resized and sharpened, are saved as flattened TIFF files. Web-ready photos are saved in the JPEG format. This system incorporates the strength of each file format and provides an easy means for me to differentiate among multiple copies of the same file. When I look in my file system, I may have three images with the same filename saved in different file formats. I know the JPEG is safe to e-mail, the TIFF is ready for printing, and the PSD is ideal if I want to make additional changes to my photo.

Building these types of routines into your workflow helps you work faster and eliminates mistakes. In most cases, you will need to archive only an original raw file and a layered PSD for each image. Saving additional copies of each photo takes up more space on your hard drive and has the potential to slow down your workflow by forcing you to sort through several different images to find the one you need. Whenever possible, keep your workflow simple and versatile.

Saving Photos in Photoshop

Saving photos in Photoshop is similar to saving documents in any other application. Photoshop gives you both Save and Save As options for saving photos. Save applies your changes to the current document, overwriting the previous version on your hard drive. Save As creates a new copy of your photo. Using Save As, you can select a file format that's different from the one you originally used to save your photo.

> **Tip** If you do not see the JPEG option in your Format list, your document likely contains 16 bpc. Click **Cancel** in the Save As dialog, change the bit depth to **8 bpc**, and try saving again.

When using Save As, select the destination for your new file just as you would any other document. Under the Format heading in the Save As dialog, select the file type in which you'd like to save the new document.

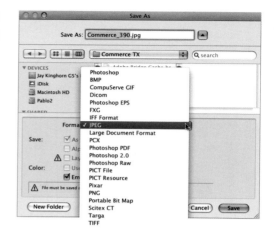

If, after selecting your desired file format, a warning icon appears, this is an indication that not all file attributes of your current file can be stored in your desired format. This is likely caused by saving a layered file in the JPEG format, which does not support layers. Go ahead and use the Save As command to create your flattened JPEG file, and then use the Save command to save any changes you've made to your layered document. Be sure the Embed Color Profile checkbox is checked, and then click **Save**.

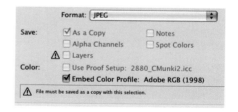

How To: Using Lightroom's Export Module

Now that you're up to speed on the technical ins and outs of digital photography, from image size to bit depth, it's time to put your skills to practice exporting images from your Lightroom library. Lightroom's Export module is the quickest, most efficient means of creating TIFFs and JPEGs from your camera raw or layered master images. This How To will help you take full advantage of Lightroom's Export module.

Begin the export process by launching the Export module using one of three methods:

- Click the **File** menu and then click **Export**.
- Click the **Export** button in the lower-left corner of the Library module.
- CONTROL-click (Mac) or right-click (Windows) an image in the Filmstrip and choose **Export**.

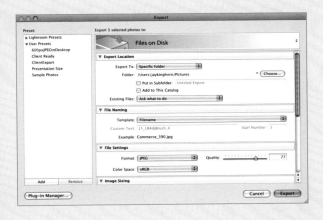

I'll cover other export-related options in the File menu at the end of this How To.

Step 1
In the Export module, you can either export photos to your hard drive or burn the exported photos directly to a CD or DVD. Specify which export option you prefer by clicking the pop-up menu at the upper-right corner of the dialog.

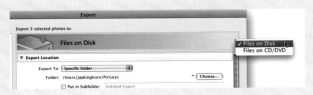

Step 2
Immediately below the export pop-up is the Export Location panel, where you can specify whether you'd like the exported images saved to a new folder or to the same folder as the original photo. I recommend saving to a specific folder to avoid creating duplicate versions of your primary photos, cluttering your Lightroom library.

Step 3
From the Export To pull-down menu, select **Specific Folder**. Then click **Choose** to navigate to the location on your hard drive where you'd like the exported photos saved. Click **Choose** to select the folder and return to the Export dialog.

Step 4
Leave the **Put in Subfolder** and **Add to This Catalog** checkboxes unchecked, and from the Existing Files pull-down menu choose **Ask what to do**.

Step 5

In the File Naming panel, set the Template pull-down to **Filename** to use the existing filename. Otherwise, choose from any of the existing file naming templates to create a new filename for the exported photos.

Step 6

The File Settings panel is used to select the file format for the exported images. Choose from JPEG, PSD, TIFF, DNG, and Original. When Original is selected, the original, unadjusted file will be exported. Often, you will lose any adjustments, keywords, or ratings applied to the image within Lightroom.

Depending on the file format chosen, you will see additional export options, including bit depth (TIFF and PSD), Quality Settings (JPEG), and Conversion Options (DNG). For processed images, you will also be prompted to select your output color space.

Step 7

The Image Sizing panel, discussed earlier in this chapter, allows you to resize images during the export process. Using the Width & Height resizing option, enter the long dimension for both portrait and landscape oriented photos and select your image resolution.

Step 8

The Output Sharpening panel complements the creative sharpening you've added during the image correction process by adding a second pass of sharpening based on your image size and output method. Use the Sharpen For pull-down menu to specify whether sharpening routines should be based on Screen Display, Matte, or Glossy Paper. Further tailor your results with the Low, Standard, or High Amount setting.

Step 9

The Metadata panel allows you to reduce the amount of metadata included in your photos during export. Some professionals like to remove camera and exposure information before sending photos to clients. That isn't much of a worry for our workflow; I suggest leaving the Metadata fields unchecked and setting the Post-Processing panel's After Export option to Do Nothing.

At this point, your photo is ready to export. If your export settings are unique, and you're unlikely to need them again, go ahead and click **Export** to create your new file. If, on the other hand, you regularly export files of this size and file format, create a preset to save yourself time in the future. Creating export presets allows you to bypass the Export module entirely by storing your commonly used export settings for easy access.

To create an export preset, first make your selections in each of the Export panels. Your preset will remember these selections exactly, so be sure you have each of the settings configured correctly. Here are a few tips:

- Select a destination that won't change or be moved. For example, exporting photos to your Desktop, Documents, or Pictures folder will be more effective than exporting to a custom folder that you might discard at a later date.

- Go easy on the sharpening. Selecting a lighter sharpening setting will help ensure that your photos aren't oversharpened during export.

- Give your preset a useful name. Be sure you can decipher what the export does, solely by the preset name.

Once you've configured your export settings, click **Add** in the lower-left corner of the Export module. Then, in the New Preset dialog, give your Preset a descriptive name and click **Create**.

Your export preset will now appear in the User Presets list on the left side of the Export module. Use this preset in the future by clicking the preset name to recall your export settings.

At this point, go ahead and export your photos if you haven't already done so. This will return you to the Lightroom library. Within the library are a few additional ways to leverage your settings in the export preset without having to go through and reconfigure your settings in the Export module:

- Under the File menu, clicking **Export as Previous** will export your photos using the most recent settings in the Export dialog.

- You can export photos using your Export presets by selecting the preset in one of three places:

 - **From the File menu** Click **Export with Preset**.

 - **From the context menu** CONTROL-click (Mac) or right-click (Windows) an image and click **Export**, and then click the export preset.

 - From the left column of the Export module.

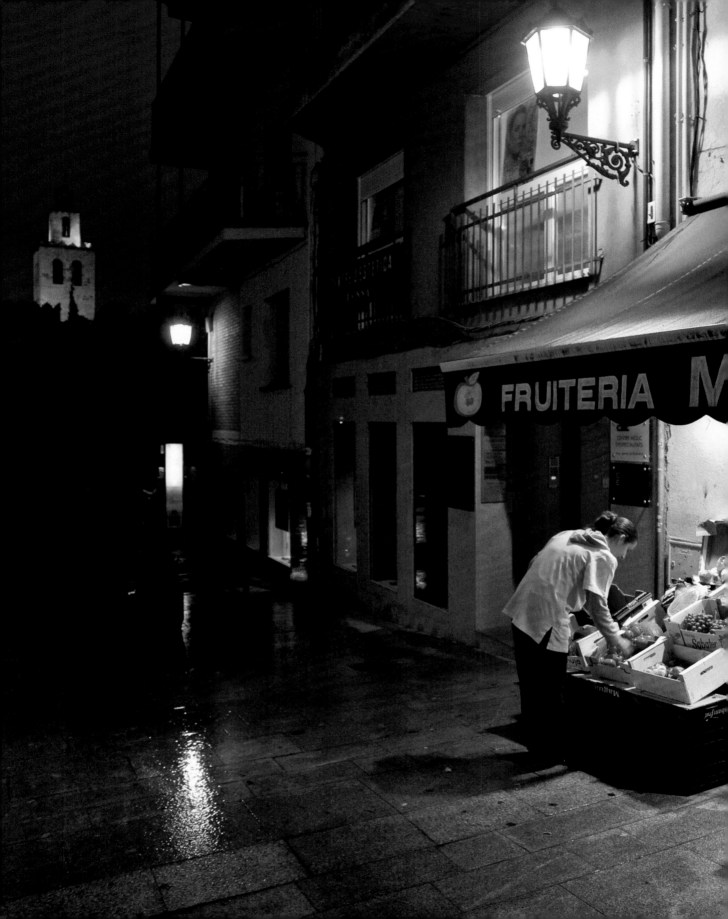

PRINTING

Despite all the advances in screen technologies, multimedia publishing, and the explosion of mobile devices, a print is still the best way to view a photograph. A high-caliber print has an almost magical quality, allowing your eyes to linger and absorb the details, colors, and textures in the photo. A good print has presence in a room and commands attention. This chapter is devoted to helping you make prints that become the focal point in a room, that elicit *oohs* and *aahs* from admirers, and that showcase your very best work.

Fruit stand, Sant Cugat, Spain. Olympus E-3, 12–60mm lens, 1/25 second at f2.8, ISO 400

The tools for creating great prints—incredible cameras, robust technology, and precision printers—are better than ever. Unfortunately, the printing process still isn't easy. Push-button printing yields good, but not great, results. The very best prints come from photographers who have a deep understanding of the printing process. From calibrating the monitor, to selecting a paper and optimizing your photos for the printing process, the more invested you become in the printing process, the better and more consistent your prints will be.

In this chapter, I'll introduce you to the printing options available to you. Then I'll help you get the best results regardless of the printing method you use. Don't be daunted; by following a few simple steps, consistent, brilliant prints are within reach.

Before you begin any part of the printing process, it is essential that you calibrate and profile your monitor to ensure that what you're seeing on screen is an accurate representation of the colors and tones in the original file.

Monitor Calibration and Profiling

One of the most critical components in a digital photography workflow is an effectively calibrated and profiled monitor. At every point in your workflow, you're making judgment decisions on tone, contrast, color, and saturation. These judgments are all based on the assumption that what you see on the monitor is an accurate representation of the

pixel values in your photograph. Calibrating and profiling your monitor ensures that the display of your photos isn't altered by any color biases or inaccuracies in your monitor.

On the Web

I can't emphasize the importance of calibration strongly enough. Without a calibrated monitor, your corrections are little more than educated guesses, and when you begin the printing process and your prints don't match your monitor, these guesses usually come back to haunt you. For this reason, I consider this section to be among the most important in the entire book. I've tried to pack as much information about monitor calibration as possible here, but this is a complex topic with details that change frequently. I continue the monitor calibration discussion and provide my recommendations online at www.perfectdigitalphotography.com/monitors.php.

What Is Monitor Calibration?

Before diving into the nitty-gritty of monitor calibration, let's take a step back and look at what monitor calibration is and why it is important. Here I'll define the two commonly used terms, *calibration* and *profiling*.

Try and remember the last time you walked into an electronics store and looked at the wall of televisions. Many of the TVs were tuned to the same station, but all of them displayed a slightly different picture, even those by the same manufacturer. If you were to perform the same test with computer monitors, you'd see the same phenomenon. Every monitor displays color

in a slightly different way. This is a part of the *color characteristics* of the monitor that are caused in part by the materials used to build the monitor, the video card used on your computer, and the specific settings selected on the monitor itself. These differences are less acute with more expensive monitors, but they are still present.

If you can't trust the color on the screen, it is impossible to perform accurate image corrections, because you can never be sure whether the blue color cast you see in the image is actually present in the photograph or is imparted by the monitor. To work efficiently, you need to be able to trust that what you see on screen is accurate and make decisions confidently. This is why monitor calibration is a necessity.

When most people say *monitor calibration*, they are actually referring to two separate processes: monitor *calibration* and *profiling*. Monitor calibration is the process of changing the behavior of the monitor to match a known state. With old CRT monitors, you could physically change the amount of red, green, and blue used by the hardware within the monitor. With newer LCD monitors, this degree of control isn't possible because of the way LCD monitors are constructed. With LCD monitors, the only control we can calibrate is the monitor brightness, bringing it to a known brightness value. During the monitor calibration process, after the brightness is set, you'll begin the profiling process. Profiling means measuring the color characteristics of a device in its current state, and then building a lookup table to compensate for the differences.

To reiterate, calibration changes the physical controls of the monitor to match a known state. Profiling measures the color characteristics of the monitor in that state and builds a color profile to compensate for any differences. This two-part process minimizes the differences among monitors, printers, scanners, and other devices integrated into your digital photography workflow. It also ensures that when you and I look at the same photo, we see the same photo, regardless of our monitor type, brand, size, or age. For simplicity's sake, I'll be referring to both calibration and profiling when I use the term *monitor calibration*.

Now that you understand the critical role monitor calibration plays in your workflow, let's look at the devices you'll use to calibrate your monitor before getting into specific recommendations for calibrating your monitor for best results.

Monitor Calibration Tools

All good monitor calibration packages combine a physical device you place over the front of the monitor and a software application to assist in the calibration and profiling of the monitor. Avoid software-only packages that rely on your eyes to guide the corrections. Human color vision is too subjective a way to perform a monitor calibration—it's like trying to measure the thickness of a piece of paper with a yardstick. It can be done, but the results are far from accurate.

Two types of hardware devices are used to calibrate your monitor: *colorimeters* and *spectrophotometers*. Colorimeters can be used only for measuring light emitted by another source, such as a monitor. This makes them ideal for calibrating monitors or digital projectors, but useless for creating print profiles. Spectrophotometers can measure either *emissive* or *reflective* light, which allows them to build profiles for monitors, projectors, and printers. Colorimeters are generally more accurate than similarly priced spectrophotometers, but this discrepancy is becoming less the case.

So Which Do You Need?

If you plan to have others perform most of your printing, you'll need only a colorimeter for calibrating your monitor. If you plan do to a significant amount of printing on your own inkjet printer, you may be better served with a less-expensive spectrophotometer. If you're a real stickler for quality and will perform all your own printing, often on specialized paper types, you'll want both a colorimeter and a spectrophotometer.

Monitor Calibration with i1Display 2

The i1Display 2 from X-Rite is one of several excellent monitor calibration packages for photographers to choose from. In this section, I'll walk you through the steps needed to calibrate and profile your monitor. Although the exact steps will differ

if you're using another monitor calibration package, the fundamentals are the same.

Begin by plugging the measurement device into one of the USB ports on your computer. Avoid using the USB ports on your keyboard because these lack sufficient power to allow the colorimeter or spectrophotometer to communicate with the monitor calibration software.

Step 1 In the initial screen, select the type of device you want to profile and choose the **Advanced** calibration option. Don't worry—you'll see there's nothing too advanced about it. Click the right arrow to continue.

Step 2 Next, you're prompted to select your monitor type. This helps the software tailor the options available to you in the software and ensures that the measurements taken by the colorimeter are interpreted accurately. Make your selection and click the right arrow.

Step 3 Next, you need to specify your White Point, Gamma, and Luminance settings. Almost all monitor calibration utilities allow you to set white point and gamma, but only a few allow you to set luminance. This is a shame, because setting luminance is the key to matching the lightness of your screen with your prints. Since these terms are most likely new to you, here are quick definitions.

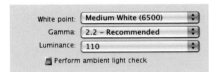

- **White Point** Your monitor's white point setting determines the color of the brightest white on screen. Much in the same way you adjust white balance on your camera or in Lightroom to match the color of the ambient light in the scene, you can adjust the white point of your monitor to match a print viewing condition.

 For best results, I recommend selecting a White Point of 6500 Kelvin. Some advanced users may need to vary from this recommendation, but 6500 Kelvin is a perfect starting point for most users.

- **Gamma** The Gamma setting controls the amount of contrast through the midtones. A gamma of 2.2 is recommended for both Mac and Windows users because it better matches the contrast of most inkjet printers and reduces cross-platform differences when previewing and displaying photos online.

- **Luminance** Providing a recommendation for a Luminance setting is tricky, because the ideal setting is the one that matches your typical print viewing condition. Since I can't sit with you in your studio, you may have to do a little experimentation. I recommend starting with a luminance of 110 cm2 (candelas per meter squared), but you may need to adjust this value up or down depending on the lighting in your studio. See the "Lighting" section a little later in the chapter for more information.

 Many of the newer and less expensive monitors on the market cannot be set dimmer than 150 or 200 cm2. In this case, set your monitor at the lowest setting.

Step 4 When prompted, place your measurement device over the center of your monitor. Avoid placing the device in the corners of the monitor as you will likely get an inaccurate reading, because monitors vary most significantly at the edges. You may want to tilt the monitor back slightly to help the device sit flush against the face of the monitor. I also recommend dimming or turning off additional lights in your studio to eliminate ambient light that may affect

the readings taken by the device. Click the right arrow to continue.

Caution If you're using an LCD or LED monitor, do not affix the suction cups to the front of the monitor because this can ruin your monitor! Simply rest the device against the monitor face.

Step 5 If prompted to set Contrast, click **Start** in the lower corner of the dialog, and then use the feedback from the measurement device to decrease your Contrast to the correct range. Your aim is to make the vertical bar come to rest in the center of the green range in the Contrast Indicator. For many monitors, you will not need to perform any adjustment.

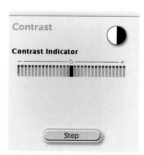

Step 6 In the next screen, you are prompted to select which kind of white point control your monitor contains. For LCD monitors, there is no real control over the monitor's white point. Some monitors offer a software control over the

monitor white point, but this is usually less effective for correcting the monitor's color than letting your monitor's ICC profile compensate for any color casts. Click the right arrow to skip this step.

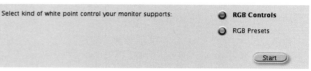

Step 7 Next, you're asked to set the monitor brightness. Click **Start** to enter the Brightness module. Use the controls on your monitor to match your monitor brightness to the recommended range indicated by the green bars.

Tip After making an adjustment, allow the software time to take a couple measurements, as a change in the brightness setting often takes 15 to 30 seconds to settle into your new adjustment.

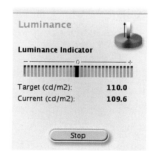

After configuring your settings, click on the right arrow to continue with the profiling portion of the monitor calibration.

Step 8 The Eye-One Match software displays a series of colored patches on the screen. The measurement device measures the displayed color values, and then the software compares the measured colors against the expected colors, creating a lookup table that compensates for the unique characteristics of your monitor.

Once this process is completed, you'll see a summary screen. The most important aspect of the summary screen is the Curve. Ideally, the red, green, and blue curves should appear as diagonal lines. Any deviation from a straight line indicates an area where the software had to compensate for a deficiency in the monitor. The greater the compensation, the more likely you will encounter problems in the accuracy and gray balance of your monitor. This screen is taken from an HP w1907, a $200 secondary monitor I use for displaying my palettes. I'm pleased with this result, but I would be concerned if the curves showed more variation than this.

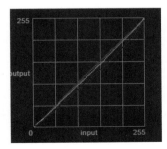

Step 9 Click the **Finish Calibration** button to save and activate your monitor profile in your operating system. You will be reminded to recalibrate your monitor in four weeks, a good guideline for most photographers. If you're doing a lot of printing, or you're about to embark on a large printing session, you may want to calibrate more frequently.

See, that wasn't so hard! As monitor calibration tools have evolved, they have become more accurate and easier to use. If you're serious about your photography, you really have no excuse not to calibrate your monitor regularly.

LIGHTING

It might strike you as odd that in the introduction to a digital printing chapter, I'd insert a section on room lighting. The truth is, lighting is one of the biggest bugaboos for photographers who create their own prints. Lighting and room color can influence the appearance of colors in a photograph significantly enough to make the print no longer match the photo on screen.

While most photographers won't want to paint their studio or workspace neutral gray, block up the windows, replace their room lighting, and wear nothing but black, you do need to be aware of the influence your viewing environment has on a finished print. Here you'll learn some of the steps you can take to mitigate potential problems.

Discounting the Illuminant

You've undoubtedly encountered this problem: your eye sees color one way, and your camera records it another. The most common example occurs when you take pictures indoors with daylight film or a daylight white balance. Even though your eyes saw the colors as neutral, the camera recorded the orange light imparted by the incandescent light illuminating the room. Our eyes don't regularly perceive the orange light in the room because our visual system has a unique ability to filter out colors imparted by different light sources, so we see colors the same, whether they are illuminated by an incandescent light, fluorescent light, or daylight. This phenomenon, called *discounting the illuminant,* is why we have to change the white balance setting on our digital cameras or adjust the White Balance settings in Lightroom to make colors in our photos match what we saw in the original scene.

This system works well in our everyday environment. We see skin tones correctly regardless of the light source, and we see white paper as white even though the light reflected off the page might be orange, green, or blue. However, our ability to selectively filter out colors imparted by a light source becomes problematic when we're critically judging the color of prints. Our eyes want to see the paper as white, and usually do, but we cannot always account for the shift in colors. Hence, when viewing a print under an incandescent light, skin tones may appear warm or ruddy and neutrals may appear orange. Under fluorescent lights, neutral colors may appear pink or green

depending on the printer used. The mismatch between colors viewed under two different light sources is called *metamerism.* These differences become particularly pronounced when you compare a print viewed under one light source with your monitor, which is itself a light source, and is typically set to a daylight white balance. The color differences between the two light sources causes your print not to match the color on your monitor.

Improving the Screen-to-Print Match

The simplest solution for improving the screen-to-print match is to install daylight-balanced lightbulbs in your workspace. This inexpensive solution is often satisfactory for most amateur to semipro photographers. When shopping for light bulbs, look for a color temperature of 5000–6500 Kelvin (K) (5000 K is ideal) and a color-rendering index (CRI) of 92 or better. You can find these specifications listed on many bulb manufacturers' websites. To simplify your search, here are a few suggestions.

Incandescent Lights If you use incandescent fixtures in your workspace, you're best served by switching to daylight-balanced compact fluorescent lightbulbs. Not only will the compact fluorescent bulbs use less energy and last longer, but they are a better match than any of the daylight-balanced incandescent bulbs I've tested.

The downside of fluorescent lights is they don't illuminate all colors evenly. This can cause problems with print viewing, but

fluorescents are a good, all-purpose solution for most photographers.

Halogen Lights If you use halogen lighting in your workspace, look for the 5000K bulbs from SoLux (www.solux.net). These are the bulbs of choice for many discriminating fine-art photographers and are superior to fluorescent bulbs because they illuminate colors across the spectrum more evenly.

Fluorescent Lights There are several commonly available daylight-balanced fluorescent bulbs to fit most any fixture. Look for the GE Chroma 50 or the Sylvania Designer 5000K.

Daylight The most effective and inexpensive light source for viewing photos is north-facing daylight. Whenever I'm judging prints or comparing color accuracy between prints, I always try to find indirect daylight. Of course, the disadvantage with daylight is it isn't always available, nor is it always consistent. Nevertheless, I prefer to use daylight as my guide unless I have access to a commercial viewing booth.

Viewing Booths The best solution for print viewing, particularly when comparing prints to your monitor, is a print-viewing booth. These booths use the highest quality, daylight-balanced fluorescent bulbs, and many allow you to dim the light source to create an accurate match to your monitor brightness. Using a viewing booth in a dimly lit room minimizes any additional color contamination

caused by paint color, clothing, furniture, or other objects in the room.

Photo courtesy GTI Graphic Technology Inc.

Room Brightness The intensity of the light in your workspace matters just as much as the color of the light used to illuminate the room. Dimly lit rooms cause colors to muddy, shadow detail to disappear, and sharpness to fade. Prints in a brightly lit room look sharp, saturated, and brilliant. The ideal setup is a dimmable viewing booth in an otherwise dimly lit room. Since most of us don't have that luxury, you can install blinds to control the amount of daylight striking your monitor and your prints since the light levels can vary significantly throughout the day.

I recommend establishing the best lighting setup you can for performing your color-critical tasks, and then tailor your workflow around these conditions. For example, if you prefer to use indirect window light for print viewing, set your monitor's luminance level to match the lightness of prints displayed in the window light. Refrain from making color decisions unless you can view the results in ideal lighting conditions.

When you have calibrated your monitor and your lighting is under control, you can truly begin printing with confidence. Without addressing these elements, troubleshooting any print problems becomes difficult, time consuming, and can often lead to inferior results.

THE ART OF PRINTING

Before committing ink to paper to create a print, it is well worth your time to think through the printing process and ask yourself why you're printing this photo and what you hope to achieve with the print. This process offers valuable insight into the type of printing process you should use, the paper type that will best suit your print, and any additional corrections that may be necessary to refine your photo for the best print.

To simplify the discussion, I'll use three classifications of prints and discuss the preparation and printing procedures for each:

- Snapshot and keepsake prints
- Portfolio prints
- Fine-art prints

Note these are hypothetical categories used to describe a particular type of print or device. In reality, there is significant overlap between the categories.

Snapshot and Keepsake Prints

As the name implies, snapshot and keepsake prints recall a place, event, or person rather than play a central role in preserving your photographic legacy. Snapshot prints require

a lower degree of color accuracy and print quality than a fine-art print because snapshot prints are designed to be stored in albums or small picture frames on a desk, rather than hung on a wall and viewed as art.

When printing snapshots, you will often favor speed over quality. Most snapshot prints are 8 × 10 inches or smaller, making them ideally suited for printing at a digital minilab due to the low cost per print and quick turnaround time that digital minilabs provide.

Most digital minilabs use a Fuji Frontier printer, or a similar printer, which uses RGB lasers to expose your image on to photosensitive paper. These printers are commonplace in photo retailers, the photo departments of big-box stores, and online print retailers. These printers make good quality prints very quickly and inexpensively, making them ideal for printing snapshots and keepsake prints.

To prepare your photos for printing on a digital minilab printer, you'll want to set your photos to the correct size and proportion for printing (4 × 6, 5 × 7, and so on), convert your photo to the sRGB color space, and save your photos in either the TIFF or JPEG format at an image resolution of 300 ppi.

TIFF is the preferred format when delivering image files in-person to a photo lab, and JPEG is preferred if you are uploading photos via the Internet to an online photo lab. When saving JPEG files for printing, use a high Quality setting (10 or higher in Photoshop; 80 or higher in Lightroom). This

makes the upload process smoother for you while maintaining image quality for printing.

While digital minilabs are great for quick printing, they often lack the quality and consistency needed for portfolio-grade or fine-art printing. Because these machines print high volumes of photos every hour, the print quality drifts throughout the course of the day, which can mean that a print made in the morning can appear different from the same file printed in the afternoon. Additionally, digital minilab printers often have a difficult time maintaining detail in the deep shadows or bright highlights.

Despite those limitations, digital minilabs produce good quality prints less expensively than you can print on your own inkjet printer. For quick proof prints of a wedding or portrait session, a keepsake of a family gathering, or a volume of prints for an album, digital minilabs can't be beat.

Tip Some photographers are able to improve the quality of prints they receive from digital minilabs by using an ICC profile created for their favorite digital minilab. The Dry Creek Photo website (www.drycreekphoto.com/icc/index.html) stores custom ICC profiles for many popular labs around the world. Check to see if a profile exists for a lab near you.

Portfolio Prints

When you're sharing your work with others in a photographic portfolio, you want to present the best reproduction of your work. However, you are often limited in print size and constrained by the cost of producing a large number of prints. (For the purposes of this discussion, a portfolio print is any print larger than letter size up to 13 × 19 inches in size.)

These prints are really the bread-and-butter prints of serious photographers and are most commonly produced on a desktop inkjet printer capable of making prints up to 13 × 19 inches in size. This category of photo printers is compact, affordable ($400 to $700), and produces stunning prints. In fact, the only real differences between a printer of this size and a wide-format printer costing several times more is print size and the size of the ink cartridges, which is more economical for printing a large number of photos. In short, these 13 × 19 inch printers are remarkable and, dare I say, revolutionary machines.

Image courtesy Epson America Inc.

One of the many advantages of using an inkjet printer over a digital minilab is the range of papers from which you can choose. With minilab printers, you can choose between glossy or matte paper. The glossy papers tend to show fingerprints and they scuff easily, while the matte option is really more of a semi-gloss finish. With your inkjet printer,

you have literally hundreds of different papers and finishes, colors, and weights from which to choose—from high-gloss to cotton rag art paper. Each paper imparts a unique quality to the print, making paper selection an art unto itself.

Photographers new to the printing process are best served using a paper produced by the same manufacturer as your printer (that is, Epson paper on an Epson printer). This simplifies the print-making process, as the paper's finishes are designed to be used with the manufacturer's printers and the ICC profiles are installed on your computer when you install the printer software. This eliminates many of the potential pitfalls that can occur when making your own prints.

I'll discuss the specific steps required to print from both Photoshop and Lightroom in the respective sections that follow.

Fine-Art Prints

Viewing a great fine-art print is an awe-inspiring experience. A large print displayed in a gallery or home is like a window into another world. Digital printing processes have made it easier and more affordable for photographers to make very large prints. It is not uncommon for photographers to make 20 × 30 or 30 × 40 inch prints from their digital photos.

Fine-art prints are most commonly produced on a large-format inkjet printer or wide-format photographic printer such as the Océ LightJet. A large-format inkjet printer is similar in function and construction to a 13 ×

19 inch printer, but with a longer carriage and larger ink cartridges, and it's designed to print from long rolls of paper instead of cut sheets. These printers are significantly more expensive to purchase, but the per-print costs are less owing to the bulk inks and roll papers.

Image courtesy Epson America Inc.

The Océ LightJet and similar printers use a photographic printing process that's similar to that of digital minilabs, but the LightJet produces a higher quality print and can make prints up to 48 inches wide. This class of printers is found in professional digital photo labs. The quality control among these printers is much higher than that of digital minilabs, and most professional photo labs can provide you with a custom ICC profile for use with the printer in use. These professional labs are a great way for photographers to make large prints without investing thousands of dollars in purchasing and maintaining a large-format inkjet printer. Plus, you will often get the benefit of working with a trained lab technician who can recommend the optimal steps for preparing photos for the lab's printer. Many will give you a smaller proof print and allow you to make minor corrections before

the final print is created. This is a valuable service and can make the printing process significantly easier for photographers.

When preparing photos for printing on a large-format printer at a professional photo lab, I recommend first asking the lab for its print specifications. Ask which ICC profile you should use, file type the lab prefers, and recommended image resolution. If the lab does not have this information, you are safe giving the lab the highest resolution photo you have in the Adobe RGB 1998 color space at 300 ppi, saved in the TIFF format. Often, the lab will have to make adjustments in its workflow to tailor your file for optimal reproduction on its printers, but a professional lab should have no problem working with a file delivered with these specifications.

Preparing photos for a large-format inkjet printer is much the same as printing to a 13-inch inkjet printer, with one notable exception: image size. When producing jumbo prints, the image size needed frequently exceeds the native image size from your camera. You will need to upsample your photo for the larger print size. For recommendations on maintaining the image quality while upsampling, be sure to read the "Go Big! Image Upsampling in Photoshop" section later in this chapter. Otherwise, follow the directions included in the "Printing from Lightroom" and "Printing from Photoshop" sections that follow.

How Long Will My Prints Last?

Early digital printers produced prints that initially looked brilliant, but then faded or changed color in a matter of months or a few years. This led many photographers to question the longevity of digital prints. Fortunately, the last 10 years has seen a remarkable improvement in both print quality and longevity in inkjet prints.

The best resource for print information on longevity and print permanence comes from Wilhelm Imaging Research (www.wilhelm-research .com). Wilhelm conducts accelerated aging tests on individual printers and print processes to gauge the longevity of digital prints created today and displayed in a variety of environmental conditions. A sampling of permanence ratings for common printers and processes suggests inkjet prints created today will not only outlive you, but will also look good for generations to come.

- Océ LightJet with Fujicolor Crystal Archive Preferred Paper (used in professional photo labs): 40 years (prints framed under glass)

- Epson R1900 with Epson Premium Photo Paper, Semi-gloss: 85 years (prints framed under glass)

- HP DesignJet Z3100 with HP Professional Satin Photo Paper: more than 250 years (prints framed under glass)

On the Web For information on selecting an inkjet printer for your studio, visit www .perfectdigitalphotography.com/printing .php

PRINTING TO AN INKJET PRINTER

Most photographers own some type of inkjet printer and use it for creating prints at home or in the studio. Some of my best photographic memories are of seeing a favorite photo roll out of the printer, ready for framing. Conversely, some of my greatest frustrations with digital photography have occurred when trying to troubleshoot an inkjet printer producing off-color or incorrectly sized prints. At these times, the inkjet seemed like an impetuous child, determined to stonewall my printing efforts and bring me to tears in the process. In this section, I'll walk you through the steps necessary to print from both Lightroom and Photoshop, helping you avoid potential pitfalls in the process. At the end of this section, the troubleshooting portion will provide assistance when things go awry.

The Printing Process

Printing from a program such as Lightroom and Photoshop is a two-part process. In the first part, you select from a series of application-specific print options. This prepares the photo for delivery to the printer driver, the software used to convert your pixels into ink dots. Most problems occur at the interface between the application's print options and the print driver. At the default settings, most applications and print drivers conflict in the color management settings, causing poor-quality prints and immense frustration for photographers. The newest versions of Lightroom and Photoshop help eliminate some of these frustrations, but problems can, and will, occur unless you learn how to control the color management settings within your application's print dialogs *and* in the print driver.

Printing from Lightroom

Of all the photo-editing programs currently on the market, Lightroom makes printing the easiest. Once you dial in your print settings with Lightroom, printing becomes a joy, not a hassle, with consistent prints only a few clicks away.

All printing in Lightroom is handled through the Print module. Within the Print module, panels on the right side of the screen control your print options and panels on the left side of the screen allow you to create, store, and access frequently used print templates, or presets. Use the Collections panel to quickly access photos grouped in a collection.

Step 1 In the upper-left corner of the print layout window, your current Print Settings and Page Setup are displayed along with the number of pages needed to print the photos currently selected in the Filmstrip. If this display does not reflect your current setup, click the Page Setup option to specify the printer and the paper size you will use for printing.

Step 2 For now, leave the Settings at their default settings. During the printing process, you'll create a printing preset you can use for future prints.

Step 3 At the upper-right corner of the Print module is the Layout Engine panel. Here, you'll specify whether you want to make a Contact Sheet/Grid or Picture Package. The Contact Sheet/Grid option is used for printing a single photo or several different photos. The Picture Package option is used when you're printing several copies of the *same* photo. For standard printing, select **Contact Sheet/Grid**.

Step 4 The Image Settings panel offers several options that affect the layout of photos on a printed page. The two most important are the Zoom to Fill and Rotate to Fit options. Lightroom adds photos to the printed page by creating "cells," or spaces on the page, where a photo can be added for printing. You can have a single cell on a page for printing a single photo or many cells on the page for printing a contact sheet. In the Image Settings panel, you can control how the photos are added to the cells.

The Zoom to Fill option allows the photo to fit the dimensions of the cell, even if the proportions of the photo don't match the proportions of the cell. This saves you from having to manually crop the dimensions of your photo to match the dimension of the print. I recommend leaving this option checked.

The Rotate to Fit option automatically rotates photos to fit within the dimensions of the cell. Leave this checked as well.

Step 5 In the Layout panel, specify the page margins, number of cells on the page, spacing between cells, and the cell size. Your inkjet printer often requires that a minimum margin exists between the edge of the photo and the edge of the paper to help feed the paper through the machine. Set these dimensions in the Margins area. Many printers use a 0.25-inch margin on the top, right, and left sides of the paper with a

When Zoom to Fill is not checked, the photo doesn't extend to the top and bottom of the cell because the image proportions differ from the print proportions.

When Zoom to Fill is checked, the photo fills the cell, giving you a full-sized print by slightly cropping the photo. You can reposition the crop by clicking inside the cell and moving the photo within the cell.

0.56-inch margin on the bottom. If you are printing borderless prints, set all Margins sliders to 0.

Step 6 Specify the number of cells per page using the Page Grid sliders. For a single photo, set both the Rows and Columns sliders to 1. Increase the number of cells to print multiple photos per page or to create a contact sheet. Obviously, as the number of print cells increases, the size available for each one decreases. If you have selected several photos, and not enough cells are available to print all the selected photos, Lightroom will automatically generate additional pages to print all selected photos. When multiple cells are added to a page, the Cell Spacing option is activated, allowing you to control the space between each cell. If only a single cell is selected, this option is grayed out.

Step 7 Using the Cell Size sliders, set the cell size. Any selected cell size will be applied to all cells. When using the Contact Sheet option, all cells on the page will be the same size. If you need to produce several different print sizes per page, go back and select the Picture Package option in the Layout Engine panel.

Step 8 When making portfolio and fine-art prints, you can safely skip the Guides and Overlays panels. The Guides panel allows you to show or hide page layout guides within Lightroom. The Overlay panel allows you to add identity watermarks, crop marks, or metadata displays to your photos.

The Print Job panel is used to specify your print resolution and output sharpening, and to select your printer's ICC profile. These are the most important printing options in Lightroom and it is essential that you check the Print Job panel before each and every print.

Step 9 In the Print Job panel's Print To section, be sure Printer is selected and Draft Mode Printing is unchecked. The Draft Mode Printing option is used for making quick contact sheets. Lightroom will use the preview image instead of the high-resolution original for printing. This saves time but sacrifices quality in larger prints.

Step 10 In the Print Resolution field, enter your print resolution. Although philosophies differ on the optimal print resolution for fine-art printing, I recommend using a print resolution between 240 and 360 ppi. See the sidebar "Print Resolution Tests" later in this chapter for more information.

Step 11 Use the Print Sharpening field to tailor your output sharpening for the paper type and your personal preference. Select **Glossy** or **Matte** to match your paper type, and select the intensity of sharpening you'd like applied to the photo—low, standard, or high.

Step 12 Use the 16 Bit Output option to send high-bit data to your printer, provided the printer manufacturer supports 16 bpc printing in its print driver. Support for this feature is limited at this time, but I expect it will gain wider acceptance in coming years. See the sidebar "Print Resolution Tests" later in this chapter for additional information.

Step 13 The Color Management panel includes the final options within Lightroom that must be addressed before you print. Here, you'll select the ICC profile for the printer and paper combination you're using for printing. Unlike many applications, which list all the ICC profiles installed in your operating system, Lightroom allows you to show only the profiles you use on a regular basis. If this is your first time printing from Lightroom, this list will be blank. From the Profile pull-down menu, click **Other**, and then in the resulting Choose Profiles dialog box, check the box next to each of the papers you use on a regular basis. This populates the pull-down menu with your commonly-used ICC profiles, facilitating the printing process. When you are finished, click **OK** to exit the dialog.

Step 14 Now that your list is updated, select the ICC profile that corresponds to the printer and paper combination currently in use, and then choose a Rendering Intent. For most images, I recommend the **Relative** rendering intent, as this will give you the best color accuracy between your screen and the final print.

Step 15 At this point, you can click **Print** to enter your manufacturer's print dialogs. Yes, unfortunately there *are* more options to choose from. To make your life easier, I recommend saving this setup as a print template. This allows you to bypass all the above options with a single click, saving much time in the printing process. If you

would prefer not to create a print template, skip the next section and continue with "Navigating the Print Driver."

Creating a Print Template

Lightroom's print templates store all your settings associated with a particular print setup. This includes the paper size, number of images printed on a page, print resolution, sharpening, ICC profile, and so forth. You will want to create a print template for each of the papers and print sizes you commonly use.

Step 1 After configuring all the print options discussed in the preceding section, click the plus (+) symbol in the upper-right corner of the Template Browser panel on the left side of the Print module screen.

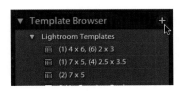

Step 2 Give your template a descriptive name. I recommend including the printer, paper type, and print size—plus *1-up* or *2-up*, and so on—to indicate the number of prints on the page. This will help you quickly select the correct template from the list.

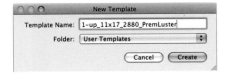

Step 3 Click **Create** to save your template in the User Templates folder. This template will now be available from within the Template Browser panel in the Print module.

Navigating the Print Driver

After you've configured all of Lightroom's print settings, just a bit more work needs to be done before your masterpiece can be created. When you leave Lightroom and launch the print driver, you must set your paper type, set your print resolution, and turn off color management. The exact steps necessary to accomplish all three actions differ between print manufacturers and printer model, making it impossible for me to provide exact directions. The screen shots shown in the following sections are from the Epson 2880 printer and are common to the newest generation of Epson printers. Read your owner's manual or visit one of the many online forums for the exact steps necessary to print on your printer. The websites www.RobGalbraith.com and www.luminouslandscape.com offer printer reviews and discussions on printing to various printers.

Set Paper Type The Paper Type, or Media Type, setting helps your printer control the amount of ink applied to the paper. Each paper finish requires a slightly different mix. Too much ink and the ink cannot be absorbed correctly into the paper, causing streaking. Too little ink limits the color gamut, resulting in weak and desaturated colors. Choose the

Media Type that best matches the paper currently installed in the printer. Selecting the wrong Media Type is one common reason for poor print quality.

When using manufacturer-branded paper, you should see your paper type listed exactly. For third-party papers, read the insert included in the paper's box for the correct media setting to use with your printer.

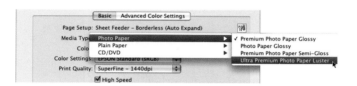

Tip If your paper type isn't listed, your printer may use two different types of black ink: one for glossy or luster surfaces and a second for matte papers. If you are using a matte paper and see only glossy papers listed in the Media Type settings, you may need to swap your black inks. Refer to your owner's manual or online documentation for instructions.

Set Print Resolution The *print resolution* is the number of ink dots your printer applies per inch of paper. It does not directly correlate to your image resolution, but it does play an important role in the quality of the final print. Generally speaking, the higher the print resolution, the sharper your print. The downside of selecting a high print resolution is that your print takes longer to create. For keepsake or portfolio prints, I recommend

printing at 1440 dpi. For fine-art prints, I recommend setting your print resolution at the maximum setting. In recent print tests, this improved image quality more than a higher image resolution or printing from 16 bpc photos. See the sidebar "Print Resolution Tests" for more information.

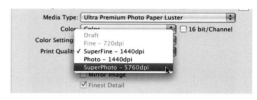

Turn Off Color Management After specifying the ICC profile within Lightroom, it is essential that you turn off color management in your print driver. Otherwise, your photo will be color managed twice. The results usually aren't pretty. This is the single most common cause of poor printing from inkjet printers. *With every print, manually check to make sure color management is turned off in your print driver.*

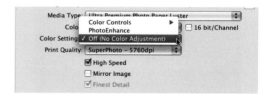

Once you've addressed all three steps, click **Print** to create your masterpiece.

Tip My printer doesn't let me turn off color management. All modern 13 × 19 inch and larger printers allow you to disable color management in the print driver. This is not true for the smaller, consumer-grade printers. If you're printing to one of these devices, you will not be able to fully color manage your prints. For best results, follow these steps:

Step 1. In the Color Management area of the Print Job panel, click the **Profile** pop-up menu and click **Managed By Printer**.

Step 2. In your print driver, set your **Paper Type** and **Print Resolution** as recommended earlier, and then use the default option for color management. This will give you good quality prints. You may want to experiment with other color settings, sometimes referred to as *quality settings*, to see if other options produce better prints.

Printing from Photoshop

After creating your master file in Photoshop, complete with adjustment layers, masks, and selective corrections, you have two options for printing this photo. You can save the photo as a layered PSD and print from within Lightroom, or you can print directly from Photoshop. Generally, I find it simpler to print from Lightroom because I can utilize presets to ensure all my prints are created with the same settings.

When you're preparing to print from Photoshop, I recommend that you save your layered master file in the PSD format, and then create a duplicate copy of your photo for printing (**Image > Duplicate**). This allows

Print Resolution Tests

When writing this section, I conducted a test to assess the differences that changes in image and print resolution have on print quality. I also wondered whether using a 16 bpc print driver improved print quality.

Unfortunately, the large number of variables addressed by the test made it difficult to draw firm conclusions. What is apparent from the test is that selecting the highest print resolution setting made a significant difference in image quality. Very little, if any, improvement was visible when I selected the 16 Bit Output option in both Lightroom and the printer driver. Differences between printed images with image resolutions between 240 and 480 ppi were minimal, at best.

The one definitive conclusion I can draw from the test is that proper image sharpening makes a bigger difference than any of the tested variables. As is so often the case with digital photography, a highly skilled, well-trained practitioner makes more of a difference than technological changes alone.

you to make print-specific corrections, like sharpening, without affecting your master file.

Preparing Images for Printing in Photoshop

Unlike Lightroom, where many preparatory steps for printing are handled automatically, Photoshop requires that you set the image dimensions and image resolution and perform your output sharpening before clicking the Print button. Since each of these steps has been covered in detail elsewhere in this book, I'll give you a quick refresher, along with a few tips, before moving into the printing options in Photoshop.

Image Size and Resolution Set your photo's print size and image resolution using the Image Size dialog box (**Image** > **Image Size**). You'll want your image resolution between 240 and 360 ppi, depending on the size of your print and the size of your original file.

If the dimensions of your photo don't exactly match your print dimensions, you will need to crop the photo to fit the print dimensions. The quickest way to do this is to select the **Crop** tool (C) and then enter the width and height of your print, along with the desired image resolution in the **Options** bar.

Drag your crop square over the image. Photoshop will automatically restrict the crop square to the print proportions. Press ENTER or RETURN to accept the crop, and your photo will automatically be resized to the correct print size and image resolution.

Output Sharpening Create a new layer for storing your output sharpening. This allows you to apply the sharpening selectively to the most important areas within the image and helps protect against oversharpening. When printing to matte or watercolor paper, you will often need to make the photo appear oversharp on screen to compensate for the loss of sharpness that occurs as the ink bleeds through the absorbent paper.

Be sure to perform your sharpening after you've resized your image to the final print size, as this will ensure the best image quality in the finished print.

Printing to an Inkjet Printer from Photoshop

After you've completed all the preparatory steps, printing photos from Photoshop is fairly straightforward and similar to printing in Lightroom.

Step 1 Click the **Print** command from the File menu (**File** > **Print**) to begin the printing process.

Step 2 In the left third of the Print dialog is the print preview, which you can use to check the layout and positioning of your photo on the paper. Immediately below the print preview are three checkboxes: Match Print Colors, Gamut Warning, and Show Paper White.

- **Match Print Colors** Performs a soft proof of your photo using the currently selected ICC profile.

- **Gamut Warning** Adds a gray overlay to the preview of any colors that are outside the printer's color gamut.

- **Show Paper White** Adjusts the preview to reflect the actual paper color instead of a standard white background.

Step 4 Specify the number of copies you want to print, and, if necessary, change the orientation of your print from portrait to landscape using the orientation buttons. Should you need to select a new paper size, click the **Page Setup** button.

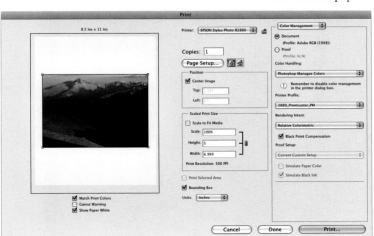

Step 3 The center column of the Print dialog contains options related to printer selection, layout, paper size, and image size. Beginning at the top of the dialog, verify that your printer is selected from the Printer pull-down menu.

Step 5 The Position and Scaled Print Size sections allow you to tailor the layout and print size options quickly prior to printing. In the Position section, leave **Center Image** checked to have your photo placed in the center of the page, or uncheck this option to position the print manually on the page.

The Scaled Print Size section displays the scale, height, width, and print resolution. If your print size is larger than the paper size, you can quickly scale the photo to the maximum print size by checking **Scale to Fit Media**. For best results, you will want to specify your print size and image resolution *before* using the Print dialog and leave these options at their default settings.

The right side of the Print dialog contains the Color Management and Output printing options. The Output options are accessed through the pull-down menu at the top of the screen. Fortunately, these options are not necessary for printing to an inkjet printer and can be set at their default settings. This allows you to focus your attention on the Color Management options.

Step 6 At the top of the column below the Color Management heading you will see your document ICC profile listed. Verify that your document has an embedded ICC profile, and then proceed to the Color Handling options.

Step 7 From the **Color Handling** pull-down menu, select **Photoshop Manages Colors**. This will give you complete control over the color management options and the best prints from your printer.

Step 8 From the Printer Profile pull-down menu, select the ICC profile that matches the printer and paper combination you're using. Next, set the Rendering Intent to **Relative Colorimetric** with **Black Point Compensation** checked.

Step 9 Click **Print** to leave Photoshop and enter the printer manufacturer's Print dialog. See the earlier section, "Navigating the Print Driver," for recommendations on settings and options within the print driver.

What Are the Proof Options For?

The Proof options in Photoshop's Print dialog are used when you're creating proof prints for commercial printing on an inkjet printer. For example, if you need to create proof prints to preview how your photos will look when printed in a book, you can enable the Proof option and then select the ICC profile given to you by a commercial printer. This will simulate the print gamut, contrast, and appearance of photos on the specified printing press. This is for proofing only and is not the process you want to use when making prints to showcase your work.

ADVANCED PRINTING OPTIONS

The troubleshooting instructions will help you print reliably in a wide variety of circumstances on most any commercially available inkjet paper. Inkjet printers are, for the most part, remarkably consistent. Once you configure the printer's settings, you can feel comfortable that a print you make today will look the same as one made a month from now.

Once you've established this printing foundation, you may want to explore different paper finishes and weights, try printing in black and white, and create your own ICC profiles for maximum color accuracy. This section will help you on your path toward printing mastery.

Selecting Papers

Today's inkjet printers give you the option of printing on hundreds of different papers, each with slightly different finishes, weights, colors, and textures. For snapshot and portfolio prints, your best bet is often choosing an inexpensive, good-looking paper and using it for the majority of your printing. For important prints, it pays to spend some time matching the paper type with the content of the photo. For example, the feeling of a dreamy cloudscape will be enhanced by a cotton-rag paper with a velvety smooth finish, such as the Moab Entrada Rag Bright 190. A moody black and white texture study of rock formations will feel rougher when printed on a watercolor paper that isn't smooth, such as the Arches Infinity Textured Finish paper. For pictures like these, the paper adds an additional dimension to the visual feel of the photo. By seeing the texture of the paper, we feel the textures in the photo.

On the Web

Unfortunately, there is no easy, or inexpensive, way to test all papers on the market to find the one that will work best for you. To help narrow the search, I've compiled a list of paper characteristics to look for when evaluating paper types. Jay Dickman and I posted a listing of our favorite papers at www.perfectdigitalphotography.com/printing.php.

Paper Finish

With traditional photo printing, you had two options for printing your photos: glossy or matte. Today the options are seemingly infinite. You can choose between glossy, matte, luster, semi-gloss, smooth rag, or textured rag. The list continues into esoteric papers such as bamboo, mulberry, and silk. Choosing the correct paper finish is both a technical and aesthetic decision.

From the technical perspective, certain printers and ink types perform best on papers designed specifically for the ink delivery method. For example, most dye-based inkjet printers require the use of a paper with a swellable coating. When the ink droplet reaches the page, it is absorbed by the paper, causing the micropores on the surface of the paper to close, encapsulating the ink droplet within the paper surface. If a paper does not contain a swellable coating on the surface, the dye ink is exposed to the elements and quickly fades. For best results from dye-based printers, be sure the paper is manufactured specifically for your printer's ink type.

With pigmented inks, the individual fragments of pigment are encapsulated in a carrier medium that protects the pigment from the environment, maintaining a long archival life regardless of the paper used. This makes pigment-based printers more versatile for photographers wanting to experiment with different paper types and finishes.

Another factor to consider when selecting among glossy or semi-gloss paper types is whether or not these papers will display a *gloss differential*, sometimes called *bronzing*. Bronzing is most commonly seen when viewing prints at an oblique angle. Areas of the photo with a high concentration of ink, such as deep shadows, appear metallic, often with a copper color. Bronzing isn't usually visible when viewing the print head-on, as you normally would, but it can be seen as you walk past a print. This is most commonly seen on glossy or semi-gloss prints made on pigment-based printers. For this reason, many photographers prefer to use luster, satin, or semi-gloss papers on pigment-based printers. Dye-based inks are less frequently affected by this problem because the inks are absorbed by the paper and therefore don't create a reflective surface on the paper.

Aesthetically speaking, you want to select a paper finish to complement your photo's content. Selecting a heavily textured paper for a softly lit portrait of a young girl at play would be as incongruous as playing heavy metal music in a fancy restaurant. Bright, vivid colors are best suited to semi-gloss, pearl, or

luster finishes, as these papers have a wider color gamut and a deep black for maximum contrast.

Softer images, muted colors, and black and white photos reproduce well on cotton rag, watercolor, or other matte papers. Matte papers have a wide variety of finishes from smooth to heavily textured, so be sure to examine the paper finish carefully before buying. Papers with a smooth finish are more subdued, making them more versatile. When printing on matte papers, you will often need to boost the saturation of your photos and add contrast to your shadows and preserve shadow detail. Matte papers absorb ink, particularly in the deep shadows, causing shadow details to bleed together unless there is sufficient contrast.

Paper Color

If you carefully examine a half-dozen different inkjet papers, you will be surprised at the differences in paper color. While it is natural to think of these papers as white, very few are truly neutral. Some contain a blue tint, while others are more yellow, making them warmer. The paper color imparts a subtle, yet tangible accent to your photos. A slightly blue paper often appears brighter than a pure white or yellow paper, yet a warmer paper is often better for portrait photography.

Some matte papers are very yellow, almost cream colored, and their use evokes an antique quality, similar to a sepia tone.

Paper Weight

The physical weight of a paper, often listed in grams per square meter (g/m^2), is an indication of the paper thickness and density. The heaviest papers—watercolor, rag, and other matte papers—impart a sense of quality, elegance, and durability to photos.

Heavy papers above 250 g/m^2 are too thick to run through the normal paper path on your printer. Instead, they need to be fed flat through the back of the printer. Most higher quality photo printers have a special paper feed for printing on heavy materials. Be sure to indicate the correct paper type and paper path in your print driver to ensure that the paper is fed correctly into your printer.

Optical Brightening Agents

Optical brightening agents (OBAs), sometimes called *bluing agents*, are added to papers to increase their apparent brightness. This can be disadvantageous for archival prints, as the OBAs can diminish over time, causing the print to dull. OBAs can also cause prints to change color in different light sources and can complicate the creation of custom ICC profiles for printing. Whenever possible, select papers without OBAs for fine-art printing. Look in the paper's specification sheet to determine whether a paper contains OBAs.

Printing Black and White

The last photographers slowly making the transition from film to digital are dedicated black and white photographers. The primary reason for their slow adoption to digital is

not the lack of tools for image processing, but the inferior quality of digital black and white prints. For years, digital photographers struggled to achieve the neutrality, contrast, and richness found in traditional black and white prints. The latest round of inkjet printers and specially formulated papers are quickly winning converts from traditional darkroom printing.

Three primary attributes are necessary to create a digital black and white print—neutrality, detail throughout the tonal range, and dmax:

- **Neutrality** Only the most trained eyes can discern subtle variances in rich colors, but even a novice photographer can see slight color shifts in a black and white image. This makes printing black and white images using cyan, magenta, yellow, and black inks particularly problematic. Any imperfection in the mix of inks imparts a color cast to the photo. For many years, digital black and white photographers were forced to purchase separate printers and specialized ink sets to ensure neutral black and white prints. The most recent printers from HP, Epson, and Canon are changing this, allowing photographers to make beautiful black and white and color prints from the same printer, without any specialized equipment.

- **Detail** Another frustration with digital black and white prints has been the lack of deep shadow detail. Frequently, deep shadows would print as pure black,

limiting the effective tonal range of the printer. This was particularly problematic as the foundation of most outstanding black and white images is the detail in the shadows. This has been largely remedied in modern printers. Any remaining issues can easily be corrected in Photoshop using the "Zone System Test for Printers," discussed a bit later in the chapter.

- **Dmax** Traditionally measured with a densitometer, the *dmax*, or maximum density, is used to indicate the darkest black achievable on a given printer, paper, and ink combination. Since the white of the paper (*dmin*) is fixed, the deeper the maximum density, the wider the contrast range available to the photographer. When comparing prints from different printers or papers, compare samples of maximum black, RGB 0, 0, 0. This will help you determine whether this printer and paper combination is well-suited for black and white printing. Deeper, richer blacks create powerful shadows in the print and serve as a visual anchor for the midtones and the highlights, making your photo appear more dynamic and lifelike.

The digital solution to these issues is the use of multiple gray ink cartridges. Instead of printing the entire tonal range using a mixture of cyan, magenta, yellow, and black, many inkjet printers today use black ink for the shadows, a mid-gray for midtones, and one or more gray inks for midtones and highlights. Additionally, many printers offer a matte black ink option for the best dmax on matte papers.

For example, my Epson 2880 uses either a matte black or photo black depending upon the paper type, and it adds a light black and a light-light black to improve detail and neutrality through the midtones and highlights.

You can also improve the quality of your black and white prints by creating a custom ICC profile for your printer. This improves the color conversions between Photoshop and your printer driver, resulting in more neutral prints and better shadow detail. I discuss the creation of custom ICC print profiles in the next section.

If you haven't tried printing black and white on today's inkjet printers, give it another try. More than likely, you'll be pleasantly surprised by the quality of the prints and the tonal control Photoshop and Lightroom give you. To get the very best from your inkjet printer, be sure to read the How To on applying the Zone System for digital printing at the end of this chapter.

Go Big! Image Upsampling in Photoshop

The increased affordability of large-format printers has led photographers to begin using these tools to make oversized prints from their digital photos. Whereas a 16 × 20 inch print used to be among the largest size printed, photographers today can print 44 × 55 from a single file and go even larger with panoramic photos.

No digital SLR creates files natively large enough for printing at such enormous sizes. Photographers need to upsample their photos to reach the final image size for printing. As you might expect, having read this far into the book, you can use some tricks to improve the quality of upsampled images in Photoshop.

Upsampling is the process of enlarging a photo's image size by adding pixels. Adding pixels can degrade the image quality, so the process is best avoided unless it's absolutely necessary. To help you maintain image quality while upsampling, I'll begin this section by demonstrating the base upsampling technique, and then I'll show you variations to use when upsampling images to more than 400 percent of their original size.

Your upsampling results will depend on the following:

- **Image sharpness and focus** When upsampling images, you need a sharp, well-focused image. During the upsampling process, Photoshop attempts to add pixels in a way that preserves the integrity of edges and maintains detail. It does this by evaluating the RGB values of surrounding pixels, and then adds a pixel of like color and tone. The sharper your images are to begin with, the more accurate Photoshop will be in this process. When upsampling, a sharp photo doesn't give *marginally* better results than a soft image; it gives *exponentially* better results.

- **Image quality** In addition to a sharp photo, you'll get the best results when your image is free from image noise, chromatic aberration, or other imaging problems. These flaws become magnified

many times in a large print. A colored highlight caused by chromatic aberration along a high contrast edge may be barely perceptible in the original file, but it will be easy to see in a large print. Make sure you've carefully scrutinized your photo at 100 percent view before beginning the upsampling process.

- **Bit depth** The upsampling process gives better results from a high-bit image. Export your image from Lightroom as a 16-bpc image for the upsampling process.

If your image meets these three criteria, it is a good candidate for upsampling. One of the great advantages of digital capture over film is the ability to upsample digitally created images without a significant loss of detail. In a recent test, I used a variety of methods to upsample an image 800 percent and was stunned by how good the results were. I could never have made enlargements this big from my film images!

Upsampling: Base Method

Open an image you want to upsample into Photoshop.

Step 1 Duplicate the background layer by pressing CMD-J (Mac) or CTRL-J (Windows)—or, if you have a layered image, create a separate, merged layer exactly as you would for sharpening by pressing CMD-OPTION-SHIFT-E (Mac) or CTRL-ALT-SHIFT-E (Windows). To maintain quality during the upsampling process, you'll need to add some sharpening to preserve detail. It is helpful to perform this sharpening on a separate layer for flexibility.

Step 2 Using Smart Sharpen or Unsharp Mask, add a light amount of sharpening to the image. I typically use Smart Sharpen set to an Amount around 100 and a Radius at around 0.5. The sharpening helps improve the definition of edges in the photo, making upsampling more effective.

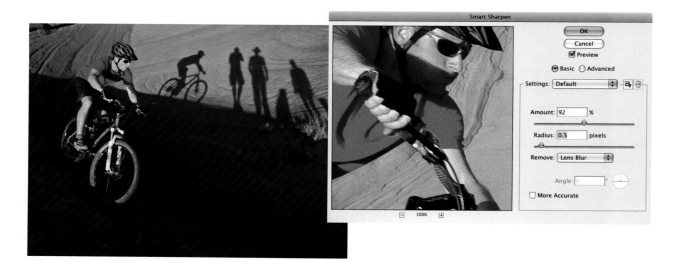

Step 3 After applying the sharpening, change the layer blending mode from Normal to Luminosity. This prevents the sharpening from exaggerating any chromatic aberration or color fringing in the image.

Step 4 In the Image Size dialog box (**Image** > **Image Size**), make sure Resample Image is checked, and then change the units in the Document Size fields from inches to percent. Enter **150** in the Width or Height field to enlarge the image 150 percent. By enlarging the photo in 150 percent increments, you get a smoother, more natural-looking image than performing a big enlargement in one step. If you are enlarging your photo less than 150 percent the original size, enter the desired image size in the Width, Height, and Resolution fields. Finally, change the Resampling method from **Bicubic** to **Bicubic Smoother** and click **OK**.

Step 5 Repeat steps 2 and 4 until you reach your desired image size. If your image size does not fall exactly on a 150 percent increment, simply enter the remaining values into the Width, Height, and Resolution fields. For example, you may perform three passes of sharpening and enlarging (150 percent, 150 percent, and 120 percent) to reach your final image size.

Step 6 Mask out any areas that have become too sharp as a result of multiple passes of sharpening.

This technique works very well for upsampling images up to 400 percent. Once you go above a 400 percent enlargement, you need to begin adding contrast in addition to sharpness and increase the Radius setting in either Smart Sharpen or Unsharp Mask. Since the original detail has been enlarged considerably, a Radius setting of 0.5 will

have little or no effect on the sharpness of the image. A better choice is to switch to Unsharp Mask and use a Radius setting between 2 and 4 pixels with an Amount around 100. Use the threshold to remove the sharpening from areas of smooth tone that may be negatively impacted by additional rounds of sharpening.

Tip As you continue enlarging the photo, you will find yourself working on a very large file, several gigabytes in size. Opening, closing, and saving such a large file can become problematic, particularly on an older computer or one with insufficient RAM. I tend to work on big enlargements in the evening so I can adjust the image size, leave the computer for 30 to 45 minutes, and then come back for the pass. Once your file surpasses 2 gigabytes, you will need to save your photo in Photoshop's Large Document Format (PSB).

Note Many older Windows machines use NTFS (Windows NT+ File System) formatting for their hard drives. NTFS-formatted drives cannot store a file larger than 2GB in size. If you encounter this problem, you can save your photo to an external hard drive instead of your computer's internal hard drive.

Make a Small Sample of a Large Print

An oversized print is an impressive sight to behold. Unfortunately, large prints are also time-consuming and expensive to create, making it essential that you get the color, contrast, and sharpness of the print right the first time.

For any large print, you'll want to create a smaller proof print to check overall color and tone. In addition, I recommend creating a second proof of a segment of the photo, printed at actual size. For example, if you are creating a 20 × 30 inch print, make an 8 × 10 inch proof print of the most important detail in the photo. I call this a *detail proof*. This way, you can use one proof for judging overall tone and color and a detail proof for judging the results of your upsampling technique, image contrast, and sharpness.

Step 3 Click the image near the area of most important detail. This will create a selection at the size of your detail proof.

To create a detail proof in Photoshop, follow these steps:

Step 1 After performing your upsampling and other image corrections, duplicate your photo (**Image** > **Duplicate**).

Step 2 Select the Rectangular Marquee tool from the Toolbox, and then, in the Options bar, set the Style to **Fixed Size** and enter the dimensions for your detail proof.

Step 4 Crop the photo to the selected area (**Image** > **Crop**). This crops the photo to the correct size for printing your detail proof.

If you are printing to a wide-format printer using roll paper, you may want to print a strip of the image to serve as your detail proof. For example, if you are printing on a 24-inch roll, you can set your Rectangular Marquee to 8 × 24 inches, creating a short banner from the full image.

While color management is a powerful tool to help streamline the printing process and dramatically improve print consistency, it cannot fully account for many aspects of the human visual system. For the best fine art prints, you will often need to make a test print to evaluate tone, color, contrast, and sharpness at the final print size.

Zone System Test for Printers

Frequently, inkjet printers are unable to print detail in the deepest shadows, causing them to print as solid black. For photos with important shadow detail, particularly black and white images, you'll want to adjust the tonal range within your photo to match the printable tonal range of the paper and printer combination you use. This clipping is sometimes visible in a soft proof with the Black Ink option enabled. Your most accurate tool for assessing shadow clipping will be a test target to help you determine the exact point at which your printer is unable to reproduce deep shadow detail. You can then correct your image prior to printing to ensure that all the highlight and shadow detail in your photo will be present in the finished print.

A good print target contains a combination of synthetic tests to assess specific image attributes, such as shadow detail or gray balance, and a handful of images to see how the printer reproduces actual images. I've created this test target to assess the black and white printing capabilities of various papers and ICC profiles.

 The white and gray swatches at the bottom of the target are designed to test a printer's **On the Web** ability to hold detail in extreme highlights and shadows. If you'd like to incorporate these patches into your test target, you can download the target at www.perfectdigitalphotography.com/printing.php.

Examining the target closely, you'll find both a numbered swatch corresponding to a specific print density and a continuous gradient to help you assess the smoothness of transitions between tones.

Step 1

Print the test target exactly the same way you would any other print, and look for the darkest two blocks containing visible separation between them. Ideally, this will be between 0 and 2 percent. More often, you'll find separation between 4 and 6 percent. Note this on the file.

Step 2

Examine the corresponding gradient, looking for any abrupt transitions or breaks in the continuity of the gradient. There should be a smooth transition from one tone to the other.

Step 3

Repeat steps 1 and 2 for the highlight blocks, making a note of the first highlight block separate from paper white.

Step 4

In Photoshop, use the soft proof feature to proof your test target using the ICC profile you use for printing. Check to see whether or not the preview correctly displays the loss of detail at the highlight and shadow ends. If not, you will need to adjust the tonal range of the image to match the printable range of your printer.

Step 5

Switch from the test target to the photo you want to print. Select the topmost layer in your document and then create a new Levels Adjustments layer. Here, you'll adjust the Output Levels to contract the tonal range of your photo to match your printable tonal range. Unfortunately, this requires a little math. Calculate the difference between the absolute highlight or shadow end and the actual end of the tonal range, and then multiply by 2.5 to translate the percentages used in the charts to the 0–255 scale used in Photoshop. For example, if your first shadow appears between 4 and 6 percent, average the two numbers and then multiply that by 2.5 to calculate the correction needed. In this example 5 × 2.5 = 12.5, or 13, since Photoshop works only in whole numbers. Enter **13** in the Shadows portion of the Output Levels field.

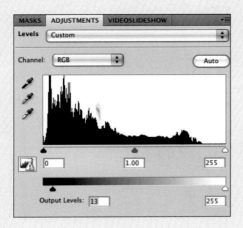

Step 6

Repeat the calculations for the highlights and enter the difference in the highlight field to the right of the Output Levels field of the Levels dialog. In my example, the print showed highlight detail between 96 and 98 percent, so I set my highlight levels adjustment at 248. The average of 96 and 98 = 97. 100 − 97 = 3, and 3 × 2.5 = 7.5. In this case, I rounded down to allow a few highlights to print as pure white to preserve some of the contrast range of the photo.

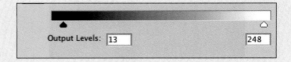

After performing this correction, I could see that my image lost a little midtone contrast. I restored this by adding a Curves adjustment to boost contrast in the midtones, being careful not to adjust the deep shadows or extreme highlights.

You may wish to experiment with different numbers in the Output Levels correction depending on image content. If you have bright specular highlights or deep silhouetted shadows, you'll want those to print as pure white or full black. Go ahead and leave the Output Levels set at 0 for those images. Most other images fall somewhere in between. Use the images included on your test target as a guide for your corrections.

Feel free to apply an Output Levels correction to the test target and reprint it. Compare the quality of the corrected images in the second target to the uncorrected images in the first. This will help you determine what, if any, correction is necessary for your printer and paper. I find this technique most useful when printing to a watercolor or other highly absorbent matte paper, where the loss of shadow detail is significant. As you continue to develop as a photographer, you'll be better able to predict the corrections necessary for creating a great print every time.

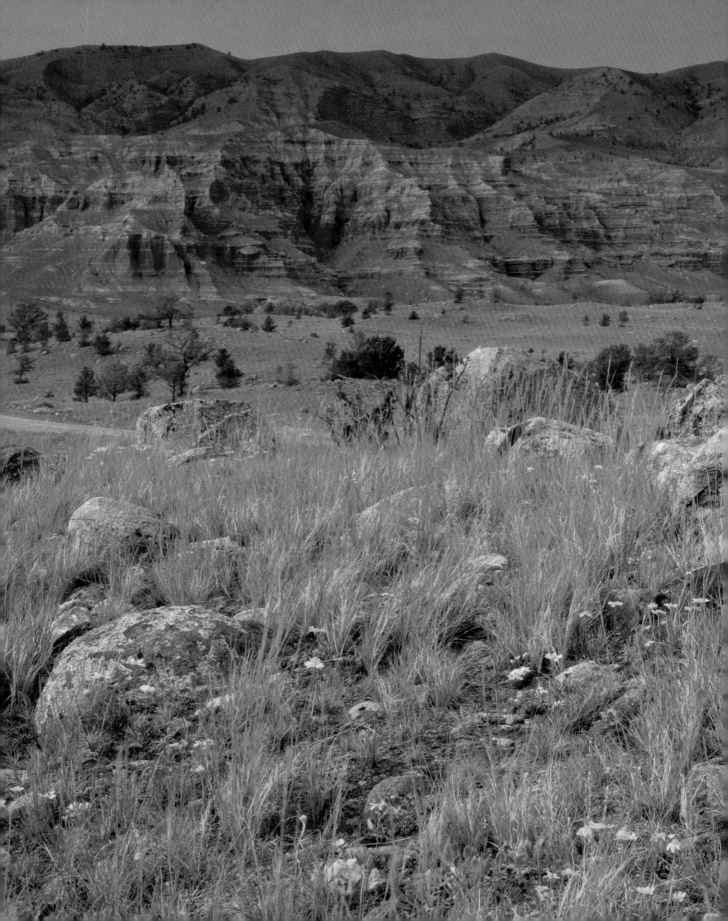

MULTIMEDIA EXPLORATIONS

The World Wide Web has become more than a bulletin board for posting simple galleries of text and images. It has evolved into a rich, experimental platform for combining still photos with video, text, audio, and graphics to create complex visual stories. These multimedia presentations challenge our conventional notions of photography while simultaneously allowing photographers great freedom to tell broader, more dynamic stories than a single still image can convey. Although a print is still considered the purest presentation of photography, multimedia is deeply engaging, informing and entertaining audiences around the world.

Dubois Badlands, Dubois, Wyoming. Olympus E-3, 12–60mm lens 1/25 second at f22, ISO 100

Multimedia photo presentations are nothing new—photographers have created multi-carousel slideshows for many years—but the Internet has emerged as a sophisticated publishing platform for photographers to realize ideas that cannot be conveyed with a single photo or static set of slides. For example, compare the differences between a slideshow of your friend's trip to Italy with a series of static slides, versus an online presentation incorporating the same photos and adding ambient sounds of the waters in the canals lapping at the hulls of Venetian gondolas, the banter and ambient sounds of a lively café in Milan, and a map allowing you to follow each day's travels.

Because this discipline of photography is a state of flux, and multimedia presentations don't lend themselves to the printed page, I'll concentrate on describing the tools for multimedia production, the types of presentations, and accessible means of publishing your multimedia work online. On our companion website, www .perfectdigitalphotography.com/ multimedia.php, you'll find more information on multimedia publishing and dozens of links to our favorite multimedia presentations. The possibilities provided by multimedia publishing makes this an exciting, and possibly lucrative, time to be a photographer.

TYPES OF MULTIMEDIA PUBLISHING

Today, several distinctly different forms of multimedia publishing are available. I'll walk you through the options, from the simplest to the most complex.

Preparing Images for the Web

The simplest means by which to begin publishing your photos online is to upload your photos to an online sharing site such as Flickr.com, Snapfish.com, or Shutterfly.com. These sites handle all the technical details associated with web publishing, from creating the HTML pages to hosting the website. All you need to do is upload a folder of images from your computer and you're published online.

Although these sites take care of all the technical details associated with web publishing, you'll want to perform a few simple preparatory steps to get the best results and make your photos more web-friendly. For example, you'll have better image quality and your upload will progress more quickly if you resize your photos and convert them to the sRGB color space prior to uploading. You will also need to save your photos in the JPEG format before uploading, as most photo-sharing sites cannot accept camera raw files or files in the TIFF or PSD format. You can use the Save As command, demonstrated in Chapter 17, or use Photoshop's Save for Web & Devices command.

To get started with online photo sharing, check out these popular sites:

- **Flickr** www.flickr.com
- **SmugMug** www.smugmug.com
- **Photo.net** http://photo.net
- **BetterPhoto.com** www.betterphoto.com

Resize Images

To ensure that your photos upload quickly and display correctly, you should resize your photos from their native resolution to a size more appropriate for display online. Many websites list technical specifications and preferred image sizes. If not, resize your images to 800 × 600 pixels for web galleries or 1024 × 768 for galleries that allow you to display your images in a full-screen mode. This size is large enough to display beautifully at any screen size, while being small enough to upload relatively quickly.

In Lightroom, resize your images during the export process. Specify width and height in the Image Sizing portion of the Export dialog. Set the Resolution to 100 pixels per inch.

In Photoshop, use the Image Size command (**Image > Image Size**) to downsample your image to the correct size. Be sure Resample Image is checked and select Bicubic or Bicubic Sharper for your Resampling method.

After resizing, sharpen your image at the final output size for the best quality.

Convert to sRGB

On the Web

Currently, the Web lacks widespread support for color management. Unfortunately, this ensures that your photos will look slightly different on every monitor. Currently, only Safari and Firefox 3 and later versions honor ICC profiles embedded in digital photos. You can test your browser's color management capability by visiting www.perfectdigitalphotography.com/multimedia.php.

The best approach for the Web is to convert your photos to the sRGB color space before posting them online. The sRGB color space will offer a reasonable match to the monitors of most of your site's visitors. Although this won't guarantee that your photos will appear exactly as you intended, it will bring them closer to the ideal.

In Lightroom, select the sRGB color space from the File Settings portion of the Export dialog. Lightroom will convert your original file to sRGB during the export process.

In Photoshop, use the Convert to Profile command (**Edit > Convert to Profile**) to convert from Adobe RGB 1998 to sRGB.

Make sure **Use Black Point Compensation** is checked along with **Flatten Image to Preserve Appearance**.

Save as JPEG

Most web browsers support three types of image file formats: JPEG, GIF, and PNG. Of these three, the JPEG format is the most widely supported and offers the best image quality. As you'll remember from Chapter 17, the JPEG format saves space on your hard drive by compressing the pixel information in your photo. The amount of compression applied to your photo is determined by the Quality setting. The higher the Quality setting, the less compression will be applied to your image. This will result in an image with good quality but a large file size, making for a slow download. An image with a low Quality setting will be heavily compressed and have a small file size. Although it will download quickly, it won't look very good, as the heavy compression eliminates details, making a photo appear blocky and unnatural.

Whenever you save an image in JPEG format, you are forced to choose between a small file size for quick download or a high image quality. Since most web visitors in the United States and Europe are using high-speed, broadband Internet connections, it is probably safe to use a larger file size because the difference in download time likely will be minimal to the user.

In Lightroom, select the JPEG Format and Quality settings in the File Settings portion of the Export dialog. For most images, a Quality setting of 70–80 strikes a nice balance between file size and image quality.

A JPEG image with a high Quality setting

In Photoshop, select **File** > **Save As** to save your photo in the JPEG format and prevent overwriting your full resolution photo. In the Save As dialog, select **JPEG** from the Format pull-down menu, then click **Save**.

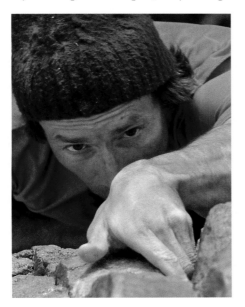

A JPEG image with a low Quality setting

In the next dialog box, choose your Quality setting. Use the image preview to see the effect different quality settings will have on your image quality. The expected file size is listed below the Preview checkbox. This is useful for balancing file size with image quality, as decreasing the Quality sometimes has a minimal effect on file size. In these cases, use the higher Quality setting.

Publishing Web Galleries from Lightroom

It is hard to beat the ease of publishing photos to a photo-sharing site, but you are limited to the gallery displays created by the site, and you cannot host photos on your own web domain. This can be limiting if you are a professional or semi-pro photographer who wants to publish a promotional gallery of your best work or a gallery from a recent photo shoot for a client. Fortunately, Lightroom makes it easy to publish professional-looking web galleries of your work with minimal effort.

Tip Before you can publish your web galleries, you need to have a web-hosting account to store the files used in your web gallery and make them accessible online. If you have a website with a personalized domain name, such as www.*yourcompanyname*.com, you can publish your web galleries to this hosting account. If you don't have a web-hosting account, check to see if your Internet service provider (ISP) includes a personalized domain for storing your files. If not, you can choose from hundreds of different web-hosting companies. One of my favorites is MediaTemple at www.mediatemple.net. You'll need to gather some basic information from your web host to publish your web galleries and make them accessible on the Web. I'll cover the specifics after you create your web gallery.

Before you create your web gallery, you'll want to select the images for your gallery and store them in a *collection*. This allows you to arrange the order in which images will appear in your gallery manually and edit your gallery to the very best images.

Newspapers conducting research on visitors to their online slideshows find that viewers tend to lose interest with a slideshow of more than 15 images. To keep your viewers engaged and interested, I recommend publishing no more than 15 images in a single gallery. You can always publish multiple galleries, each covering a different topic. You're better off leaving your viewers eagerly wanting to see more of your photography than having them wearily click through a 100-image slideshow.

Once your images are edited and sequenced inside a collection, enter Lightroom's Web module to begin preparing your web gallery. The images from your collection should appear in the Filmstrip at the bottom of the screen. If not, be sure your collection is selected from the Collections panel on the left side of the screen.

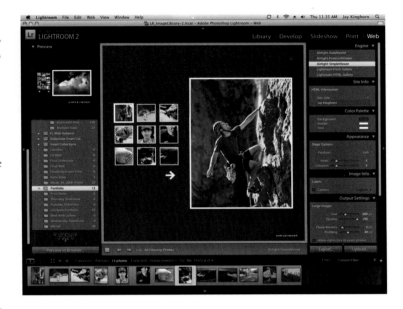

Step 1 Like most procedures in Lightroom, you'll follow a clockwise rotation through the module's options, beginning in the top-right corner. Here, in the Engine panel, select the template design Lightroom will use for your web gallery. Choose between HTML-based and Flash-based templates. Both HTML and Flash are widely supported on all web browsers, but Flash is not supported on all mobile browsers. If you think users may be visiting your site with mobile devices, such as a cell phone, you might decide to use an HTML-based template.

Step 2 Select a template from the Engine panel, and Lightroom begins creating a preview gallery in the main window using images from your collections. For my gallery, I'm using the Airtight SimpleViewer.

The options you see in the following panels may vary depending on the template you choose for your gallery.

Step 3 Enter your name or Site Title in the Site Info panel. Your site name will appear at the top of the viewer's browser window and will serve as a descriptive clue to the gallery's contents.

Step 4 The Color Palette panel allows you to customize the color scheme used for your web gallery. The Background, Border, and Text colors can all be modified from their defaults to match your site's existing color scheme, or set to colors of your choosing.

Tip Looking for color inspiration? Visit the Adobe Kuler site at www.adobe.com/ products/kuler/ to view a broad range of prebuilt color palettes, or to generate your own color palette using common color relationships.

Typically, when I'm creating a web gallery, I try and keep the colors in the gallery subtle so as not to draw attention away from the colors in the image. This is particularly true with black and white images, as the colors used in the gallery design will cause viewers to "see" colors in the photos.

Step 5 The Appearance panel is where you adjust the positioning of the thumbnail images relative to the large preview image. Here you can also adjust the layout and size of the thumbnails by adjusting the number of thumbnail Rows and Columns. If you have more images than spaces for thumbnails, Lightroom displays a large arrow to point the user to additional images.

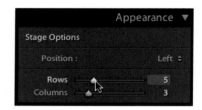

Step 6 The Image Info panel lets you select what, if any, image metadata you would like displayed with the preview image. You can select from several common presets (Caption, Date, Exposure, and so on), or you can click the **Edit** menu and make other selections to create your own preset.

The Text Template Editor, used for creating your preset, works similarly to the template editor used for creating your file naming preset. Click the **Insert** button to add a badge for each of the file attributes you'd like to be displayed automatically in your web gallery.

I prefer to show the image's filename and my copyright notice alongside the preview image. After you insert the Filename and Copyright badges separated by a colon, selecting **Save Current Settings as New Preset** allows you to name and create your new preset. This preset will now appear in the Image Info panel for easy access the next time you create a web gallery.

Tip The color of the displayed text is controlled by the Text option in the Color Palette panel.

✓ **Filename (edited)**

Caption
Custom Text
Date
Equipment
Exposure
Filename
Sequence
Title

Save Current Settings as New Preset...
Update Preset "Filename"

Tip To help your photos appear more prominent in the gallery, change the Border and Text colors in the Color Palette from white to light gray. This allows your photos to be the lightest, and therefore most important, element in the gallery.

Step 7 Using the options in the Output Settings panel, you can adjust the size of the large preview image, the JPEG Quality setting used when creating the gallery, and the width of the borders surrounding your photos.

I recommend leaving the Large Images Size set at the default 600 pixels and decreasing the Quality setting to 70–80. This will help your gallery load more quickly, which is particularly important if you want to include a large number of images. I also recommend decreasing the Photo Borders slider from 5 to 2 pixels.

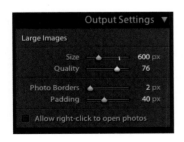

Step 8 Although configuring the Upload Settings is an optional step for web gallery creation, it is one of the most valuable time-savers in Lightroom's Web module. Normally, publishing a web gallery is a two-step process. First, you create the gallery, building all the HTML pages, Flash elements, thumbnail images, and large previews. Second, you upload the gallery folder to your web host to make it visible on the Internet.

The Upload Settings feature allows you to automate the process by creating and publishing the gallery simultaneously. Once you've configured the Upload Settings, creating your web gallery is literally a one-step process.

In the Upload Settings panel's FTP Server pull-down menu, select **Edit** to open the Configure FTP File Transfer dialog. FTP stands for File Transfer Protocol, a commonly used method for transferring files between a desktop computer and a web server. Here, you'll need to enter the login information for your website to allow Lightroom to publish directly to your site.

Configure FTP File Transfer

Preset: Custom

Server: ftp.yourdomainname.com

Username: Username Password: ••••••••

☐ Store password in preset

Server Path: /Projects Browse

Protocol: FTP Port: 21 Passive mode for data transfers: Passive

Cancel OK

You may need to ask your web hosting company for the following information:

- **FTP server address** Typically, your FTP address will be something like ftp.*yourdomainname*.com.

- **Username and password** This is the screen name and password used for administrative access to the files on your host's web server.

- **Server path** Your hosting company may want you to publish your web galleries to a specific folder to avoid overwriting or corrupting any of the text pages in your website. If this is the case, entering the folder structure in the Server Path field ensures that Lightroom will always publish to the correct location. For my example, I publish to a Projects subdomain used specifically for storing web galleries, client projects, and downloadable files.

Step 9 Enter your server information, and then save this information as a preset for future use. Click **OK** to close the dialog.

Step 10 Before leaving the Upload Settings panel, be sure your FTP server preset is selected, and then check the **Put in Subfolder** option and type a short name for your web gallery. This places your web gallery in a specific subfolder to avoid conflicts with your other web galleries.

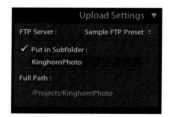

Step 11 If you've configured your FTP settings and server destination in the preceding two steps, all you need to do is click **Upload** to create and publish your web gallery. If you've skipped those steps, you'll want to click **Export** to export the gallery to your hard drive and then manually upload the gallery to your website.

If you've selected the Upload option and the upload process was successful, your web gallery is live and ready to view. Unfortunately, Lightroom doesn't show you the URL (web address) you should use to access your website. Fortunately, the URL is easy to deduce.

If you've published to a normal folder structure (not a subdomain) on your website, the URL will be as follows (URLs are case sensitive):

- http://www.*yourdomainname*.com/ *ServerPath*/*Subfolder*/index.html
- (*domain name*)/(*folder used in Server Path section of FTP Setup*)/(*subfolder from Upload Settings panel*)/index.html

For my sample gallery, this would be www .prorgb.com/Projects/KinghornPhoto/index .html.

The subdomain system I use works a little differently. You may need to contact your web hosting company to find out which folder system you're using for your site. With a subdomain, the URL looks like the following:

- http://*subdomain*/*yourdomainname*/ *Subfolder*/index.html
- (*subdomain folder specified in FTP Setup*)/ (*domain name*)/(*subfolder from Upload Settings panel*)/index.html

For my sample gallery, this would be http:// projects.prorgb.com/KinghornPhoto/index .html.

If you encounter difficulty, try contacting your web host's webmaster for assistance. Once you've established the base URL for your web galleries, the only element to change will be the subfolder name at the end of the URL.

Creating a Web Gallery Template

After configuring the settings for your web gallery, you'll want to save these settings in a template for two reasons: First, it saves you a lot of time when you're creating future galleries. Once your first gallery is created, subsequent galleries can be created in less than 30 seconds. Second, you want the galleries on your site to be consistent. If a visitor to your site sees gray text in one gallery and blue text in another, it reflects poorly on your photography.

So, in the interest of speed and consistency, take a few moments to create a template for your web gallery.

Step 1 After following all the preceding steps, direct your attention to the Template Browser panel on the left site of the Web module, immediately below the Preview panel. Click on the plus (+) sign to the right of the Template Browser title to open the New Template dialog.

Step 2 In the New Template dialog, type a descriptive name for your template and click **Create**. Your template will be saved in the User Templates section of the Template Browser panel.

Step 3 Next time you need to create a web gallery, you can select the template from the Template Browser panel, change the Subfolder name in the Upload Settings panel, and click **Upload**.

Multimedia Explorations

One of the hallmarks of a multimedia presentation is the synthesis of two or more artistic disciplines. Adding audio to still photos or incorporating video footage, ambient sound, and still photos into a single, cohesive video presentation are common multimedia presentation methods. Because these packages involve more that just photos, Lightroom and Photoshop alone are insufficient to assemble the disparate pieces of a multimedia presentation. You'll need to use Lightroom and Photoshop in conjunction with other software applications to produce true multimedia presentations. In the following sections, I'll introduce several common multimedia presentation types. Where appropriate, I'll include links to additional resources to help you begin exploring the creative frontiers in multimedia.

Geotagging

Geotagging, or adding Global Positioning System (GPS) coordinates to photos, isn't the first type of multimedia presentation that comes to mind for most photographers. That's unfortunate, though, because geotagging is a unique means of adding context to a photo, enriching its value to the viewer.

Consider, for example, a photo of the tailings from an abandoned mine shaft. By itself, it is a poetic reminder of the expansion and development of the American West. When GPS data is added to the photo, the physical location of the photo may reveal that the mine tailings lie directly above a creek that serves as the source of the town's drinking water several miles downstream.

Connecting photos to their geographic location opens the door to increased collaboration among photographers by allowing several photographers to publish and group their photos collectively by the photo's physical location. Geotagging improves a

photo's value as a historical record and creates a unique means of sorting, identifying, and filtering photos within your Lightroom library.

The most common workflow for embedding GPS data within your digital photos is to bring a GPS receiver with you while shooting. At the beginning of your photo shoot, check to ensure that the clock on your camera matches the GPS receiver and that your GPS is set to record waypoints at frequent intervals to track your movements correctly.

Image courtesy Garmin Ltd.

When you return to your computer, you'll match the GPS coordinates from the GPS log with your photos using a specialized geotagging software application. The software matches the coordinates in the GPS log with the time/date stamp embedded in your photos' metadata by the camera. This embeds each photo's latitude and longitude in the photo's metadata.

Once the information is embedded within the files, you can geolocate your photos on one of several world maps, such as Google Earth, Flickr, or Microsoft Virtual Earth.

To get started, check out these sites:

- **Lightroom Journal** http://blogs .adobe.com/lightroomjournal/2007/11/ geocoding_your_photos_with_lig.html

- **Adobe Bridge CS3 Geotagger** www.hoeben.net/%5Buser%5D/ adobe_bridge_cs3_geotagger

- **Flickr** www.flickr.com/groups/ geotagging/pool/map?/mode=group

 For additional resources, visit the geotagging page on our website:
On the Web www.perfectdigitalphotography .com/multimedia.php.

Audio Slideshows

Adding audio to your photos is a powerful storytelling tool. Hearing an audio clip of an old woman telling the story of her life while viewing her portrait and seeing her complete her daily routines provides an immediate link to her character. Unlike other multimedia options, audio slideshows are among the easiest and least costly to produce. All you need is a digital audio recorder or a music track for the audio, basic audio-editing software, and Soundslides, a unique application for assembling and publishing audio slideshows.

creativity to begin experimenting in the world of multimedia.

To begin creating audio slideshows, visit these sites:

- **Soundslides** www.soundslides.com
- **Olympus VisionAge** www.pdnonline .com/pdn/cp/olympus/index.jsp

For additional resources on creating audio slideshows and links to our **On the Web** favorite audio slideshows, visit www.perfectdigitalphotography .com/multimedia.php.

The brilliance of audio slideshows lies in their simplicity. Using simple tools and a knack for storytelling, you can create compelling presentations that engage, enlighten, and entertain viewers. Soundslides is multimedia at its most egalitarian, allowing virtually anyone with a camera and some

Rich Media Narratives

Once you master the art of the audio slideshow, you may want to begin experimenting with *rich media narratives*. These presentations incorporate video, graphics, audio, photos, and text to tell dynamic,

multidimensional stories. You can think of rich media narratives as short documentaries that emphasize the use of still photos in lieu of video. Because of the increased complexity of these presentations, you'll need to use professional-level software for editing video and generating 3-D graphics.

While you may not have the funds, or inclination, to purchase and learn these professional applications, you can often create comparable quality from consumer-level video-editing programs, such as Apple Final Cut Express or Adobe Premiere Elements.

Creating a rich media narrative requires far more preproduction than creating a web gallery or an audio slideshow. You'll want to develop your script or idea fully and outline the components you'll need to capture to your footage. Expect to spend far more time in post-production than you would with an audio slideshow.

With a strong story, some patience, and a willingness to experiment, you can make rich media narrative a cutting-edge and meaningful way to use multimedia to tell your unique story.

For the best examples of this new genre, visit these sites:

- **MediaStorm** www.mediastorm.org
- **Merge Group** www.mergegroup.com

 For additional resources, samples, and guidelines on getting started with your own rich media narratives, visit www.perfectdigitalphotography .com/multimedia.php.

Index

X

Y

Z